A Cinematic Artist

A Cinematic Artist

The Films of Man Ray

Kim Knowles

Peter Lang Oxford

Peter Lang Ltd
International Academic Publishers
52 St Giles
Oxford OX1 3LU
United Kingdom

www.peterlang.com

A catalogue record for this book is available from the British Library.

Cover image: Still from *Emak Bakia*. Image courtesy of Man Ray Trust.
Copyright Man Ray Trust/ADAGP, Paris and DACS, London 2009.

ISBN 978-1-906165-37-6

Printed in the United Kingdom
by TJ International.

Contents

Acknowledgements

This book grew out of a passion for early avant-garde and experimental film, for which I owe sincere thanks to the late Dietrich Scheunemann. I also benefited greatly from the many discussions with my good friends and fellow avant-garde scholars Monika Koencke, Anna Schaffner and Ruth Hemus. I am especially grateful to Barbara Brown, John Glendinning, Alan Whyte, Fiona Carmichael and Peter Glasgow at the Language and Humanities Centre, University of Edinburgh, for years of invaluable support and assistance. Elza Adamowicz and Ramona Fotiade offered their expert advice on the first draft of the manuscript and gave me the confidence to put it into print, and Pip Chodorov set me on the right path in terms of illustrations. Thanks to Laura Ward-Ure at DACS, Sophie Perrot at ADAGP, and Raphaëlle Cartier, Caroline De Lambertye and Vladana Jonquet at Réunion des Musées Nationaux for all their help with obtaining copyright, film stills and photographic reproductions. Sincere thanks to Hannah Godfrey and Mette Bundgaard at Peter Lang Publishers for their patience and advice with practical issues, and to George May for the French translations. Special thanks also to Marion Schmid for her friendship and encouragement and to Dee Atkinson for moral support and health-boosting herbs. Much respect and gratitude goes to Martine Beugnet; I would not have got this far were it not for her unwavering faith and guidance over the years. Finally, to Laurence for unconditional love, companionship and, above all, for sharing my passion for film.

This book was published with the generous assistance of The Carnegie Trust and the University of Edinburgh Moray Endowment Fund.

Introduction

In the preface to the only comprehensive study of Man Ray's cinematic activity Jean-Michel Bouhours draws attention to the relative lack of interest shown towards the artist's films in comparison with the rest of his oeuvre. As he points out, although Man Ray was one of the key figures of the cinematic avant-garde of the early twentieth century, his work with the medium of film remains relatively unknown.[1] Indeed, the name Man Ray is not immediately associated with the cinema, but rather with photography, admittedly the domain in which his creative talent was most effectively realised. Beginning his career as a painter, he turned to photography in 1915 with the simple aim of creating reproductions of his paintings for commercial purposes.[2] A fascination with the technological basis of photography and a desire to explore, master and push the boundaries of the medium led to him becoming one of the most innovative photographers of the twentieth century.

This interest in photography and its mechanical apparatus gradually led Man Ray into the field of cinema, and between 1923 and 1929 he made four short experimental films: *Le Retour à la raison* (1923), *Emak Bakia* (1926), *L'Etoile de mer* (1928) and *Les Mystères du Château du Dé* (1929). In addition to this body of works, his cinematic oeuvre also comprises a number of films that were made privately without the intention of being publicly screened. Discovered only from 1985 onwards, these films range from home movies to short visual experiments, featuring both friends (Paul Eluard, Pablo Picasso, Roland Penrose) and lovers (Lee Miller, Ady, Juliet). Although critics and historians generally acknowledge the existence of Man Ray's films, they are seriously undervalued and misrepresented within the broader context of his artistic output; and whilst there exist a number of essays dealing with individual works, the edited volume *Man Ray: directeur du mauvais movies* by Jean-Michel Bouhours and Patrick de Haas remains the only full-length study of the subject. This is particularly

surprising considering that these films constitute a large proportion of French avant-garde filmmaking of the 1920s. Aside from the significant contribution they made to the development of experimental film, paving the way for new forms of cinematic expression, Man Ray's films are also intricately linked to his broader artistic approach, and demonstrate the aesthetic problems with which he was occupied.

This book is the first monograph on the cinema of Man Ray, which employs a systematic and unified approach that complements the essay collection by De Haas and Bouhours. It aims to provide an understanding of the development of one film to another, as well as to situate Man Ray's filmmaking within the broader context of his artistic sensibility by tracing links between concerns expressed in different domains. It hopes to make a significant contribution to the study of this influential figure of twentieth-century art by bringing into the spotlight perhaps the most ambiguous area of his creative output. It is also an exploration of a particular moment in film history, which saw the emergence of avant-garde film activity and the development of a dialogue between film and the other arts.[3]

An interdisciplinary artist

The art of Man Ray incorporates a wide range of media, sometimes mixing different forms of expression within a single work. Like many of his con-temporaries, notably his friend Marcel Duchamp, he moved fluidly from one art form to another, choosing the one that would most effectively express a particular idea. This interdisciplinary approach has made him a difficult artist to assess, as Neil Baldwin states at the beginning of his biographical study:

> The problem of Man Ray begins with the matter that he cannot be classified as an artist in any one genre. Painter, photographer, filmmaker, printmaker, object-maker, poet, essayist, philosopher – his eclecticism flaunts the grounded rules of art history. Man Ray is a chain of enigmas. Paradoxes characterise each phase of his long and complex career and combine to make him the quintessential modernist personality.[4]

If we use this trans-artistic approach as a starting point, Man Ray no longer poses the problem to which Baldwin refers, but instead offers new perspectives from which to view his work. This diversity must be embraced rather than overcome if we are to understand and appreciate his very distinctive form of expression. If Man Ray seems to move unpredictably from one mode of expression to another, evading categorisation and constantly reinventing himself, the incorporation of film into his repertoire also demonstrates a logical progression from the static arts to the art of movement.

In an interview with Pierre Bourgeade, Man Ray highlights his initial resistance to the medium of film, stating, 'j'ai résolu de ne jamais m'occuper du cinéma, sauf comme spectateur de temps en temps.' [I vowed I'd have nothing to do with cinema except, from time to time, as a spectator.][5] Yet, as Patrick de Haas observes, 'Plusieurs oeuvres plastiques témoignent du fait qu'avant même de toucher une caméra Man Ray était concerné par le cinéma.' [Several of Man Ray's sculptural works show that he was interested in cinema long before he ever laid his hands on a camera.][6] This can be seen either through direct references to film in other art works or in the move towards a kinetic form of expression. *Admiration of the Orchestrelle for the Cinematograph* (1919), produced using the aerograph technique,[7] demonstrates both tendencies. As De Haas points out, the left-hand side of this painting is a segmented, numbered column bearing a strong physical resemblance to a film strip, whilst the abstract combination of disks and lines and the suggestion of three-dimensional space gives the impression of suspended movement – a dynamic feature that will later play a key role in Man Ray's films.[8] An early collage piece entitled *Theatr. Transmutation* (1916) also points to an interest in the medium of film. It features a sheet of newspaper turned on its side and over which are pasted the almost imperceptible letters 'THEATR'. At the top of the page can be seen the title of the column, 'Cinema Ideas To Have a Chance', indirectly referring to Man Ray's own cinematic ideas that would be expressed some years later. In this work, then, narrative and movement are brought together in a visual collage based on text.

As we shall see, Man Ray's films all deal to some extent with the relationship between text and image, with this theme becoming a major concern in those produced towards the end of the 1920s. These works therefore

not only demonstrate the use of cinema (and theatre) as a thematic reference, but also reflect some of the formal and visual concerns that were later incorporated into his explorations into the moving image.

Man Ray was certainly not alone in his references to the cinema in his static works, and the above discussion reflects a more general fascination with the medium amongst artists and writers at the beginning of the twentieth century.[9] Movement itself is a central theme of Man Ray's art around this period, and stretches across a range of disciplines. *The Rope Dancer Accompanies Herself With Her Shadows* (1916), another aerograph piece to which subsequent chapters will return, incorporates the art of dance in a static medium and attempts, through a juxtaposition of vibrant shapes and colours, to suggest dynamic relationships.[10] The photograph *Moving Sculpture* (1920) features the simple everyday scene of sheets hanging on a washing line, which manages to create compositional complexity purely by capturing the movement made by the wind. Again, the title of the piece is significant since, although it overtly refers to the idea of movement, it simultaneously emphasises the limitations of its expression in a static medium. The photograph asks us to imagine the movement that is present at that particular moment in time, whilst commenting on the discrepancy between the event and its photographic representation.[11] The title is thus an effective interdisciplinary reference as the subject of the photograph is neither a sculpture in the traditional sense of the word nor is it moving. Yet, in its transformation through the photographic freezing of time, it takes on the static, suspended qualities of a sculpture. Elements of sculpture and movement are combined in a number of Man Ray's objects of this period. *Lampshade* (1917) (see figure 1), an unravelled lampshade in the form of a spiral, incorporates the elements of suspension and perpetual movement in the same way as *Obstruction* (1920), a pyramidal arrangement of coat hangers.[12] Neil Baldwin has also suggested that the rayographs – photographs produced by placing objects directly on or above the photosensitive paper – testify to Man Ray's interest in movement as an artistic tool. The unique quality of these static works, argues Baldwin, owes much to the movement of objects above the photographic paper coupled with the movement of the light source. This has the effect of adding depth and tone to what is essentially a two-dimensional medium.[13]

These observations are crucial in the context of Man Ray's relationship to the cinema in the way that they point to his gradual progression towards the art of the moving image. In the works prior to his experimentation with film he explores the way movement can be expressed in different domains. Yet he also uses movement as a basis for exploring the limitations of particular art forms and as a way of crossing artistic boundaries. One of his first experiences with film was in assisting Marcel Duchamp with his explorations into cinema optics and his attempts to create depth and perspective through movement. In 1920, Duchamp constructed *Rotary Glass Plates (Precision Optics)*, a machine consisting of a motor attached to five glass panels, the ends of which were painted white with black curves, and which, when set in movement, 'produced the illusion of a series of continuous circles.'[14] During an unsuccessful attempt at filming the machine, Man Ray barely escaped being injured by one of the plates that detached itself whilst in movement.[15] A later machine, *Rotary Demisphere (Precision Optics)* (1925), was conceived by Duchamp with the intention of producing 3-D effects. This was to culminate in the making of the film *Anémic Cinéma* (1926), on which Man Ray collaborated along with Marc Allégret.[16] These explorations with Duchamp into optical illusion are particularly important in understanding Man Ray's own approach to the moving image, especially from the perspective of interdisciplinarity. They represent a natural progression from the works discussed earlier, where movement, or at least the impression of movement, is a key concern. Man Ray's use of film to create moving versions of his photographic compositions thus seems to derive partly from Duchamp's marrying of his mechanical constructions (works of art in themselves) with the unique spatio-temporal characteristics of the cinema. As we shall see, *Le Retour à la raison* and the later *Emak Bakia* involve the animation of a number of Man Ray's works and often play on the element of optical illusion and distorted vision. Most important, however, is the overriding presence of mechanical intervention in Duchamp's optical experiments, a factor that is also clearly evident in Man Ray's film work, where an awareness of, and fascination with, the technical apparatus becomes an integral part of his cinematic vocabulary.

Man Ray's interest in the cinema is clear from a number of other films of the period that bear his stamp. In René Clair's *Entr'acte* (1924), written

by Francis Picabia to accompany his ballet production *Relâche*, Man Ray is seen playing chess on a rooftop with Duchamp. He also had a key influence on *Ballet mécanique* (1924), a film that is commonly attributed to the painter Fernand Léger and the cameraman Dudley Murphy. The issue of authorship in this film has been widely debated, with numerous accounts of its creation offering differing version of events and making it difficult to ascertain the extent of each artist's input.[17] Nonetheless, judging by the similarity of some of the images with parts of Man Ray's own films, along with the presence of Kiki de Montparnasse (his lover at the time), it is clear that he was involved to a large extent and that some sections were either created or suggested by him.[18] Of his own four films Man Ray has stated:

> Tous les films que j'ai réalisés ont été autant d'improvisations. Je n'écrivais pas de scénario. C'était du cinéma automatique. Je travaillais seul. Mon intention était de mettre en mouvement les compositions que je faisais en photographie. Quant à l'appareil photo, il me sert à fixer quelque chose que je ne veux pas peindre. Mais il ne m'intéresse pas de faire de la 'belle photo' au cinéma. Au fond, je n'aime pas les choses qui bougent. Peut-être est-ce parce que je suis devenu paresseux [...] Il faut que ce soit le spectateur qui bouge.[19]

> [All the films I made were just so many improvisations. I didn't write any screenplays. It was a sort of automatic cinema. I worked on my own. My intention was to set in motion my photographic compositions. As for the camera, it enables me to fix something I do not want to paint. But I have no interest in making 'la belle photo' in the cinema. Basically I just don't like things that move. Perhaps it's because I've become rather lazy [...] It's the spectator who should be doing the moving.]

This statement incorporates many of the questions surrounding Man Ray's filmmaking and also highlights the element of contradiction that characterises the comments he made about his art. What emerges as a key concern here is the use of film as a way of creating moving photographs, a theme to which the following pages will return.

Cinema played an unquestionable role in the development of Man Ray's visual ideas, allowing the qualities of one medium to feed into another. It is precisely this artistic cross-fertilisation that characterises his working method and which provides a valuable starting point for any evaluation of his work in the cinema. Yet surprisingly few connections have been made between the concerns expressed in his photographic works and the

content and form of his films. In Emmanuel de l'Ecotais' book dedicated to the study of his extensive activity in the field of camera-less photography, little reference is made to his first two films, *Le Retour à la raison* and *Emak Bakia*, both of which involve the exploration of the rayograph in motion. This exclusion seems particularly striking since it was only in the time-based medium of film that Man Ray was able to create clear juxtapositions between the rayographs and the more traditional camera-based images, establishing a visual discourse that stretches beyond that of his work in still photography. In the context of an historical study of the photogram, Floris M. Neüsuss makes a fleeting reference to this aspect of *Le Retour à la raison* and notes additionally that the film 'appears to be the only photogram movie in film history.'[20] Man Ray's early cinematic works therefore illustrate an important dialogue between the techniques of photography and film and, as such, demand a corresponding theoretical approach. Ramona Fotiade has recently drawn attention to the relationship between Man Ray's rayographs and his films through a concentration on the notion of the 'spectre', linking the indexical traces of these photographic images with the techniques found in *Le Retour à la raison* and *Emak Bakia*, such as superimposition, double exposure and the creative use of light and shadow.[21] The theme of presence and absence that is to varying extents worked into the four films on both a formal and thematic level demonstrates a common point of interest between the two media, which, up to now, remains relatively unexplored.

If these formal connections have been generally overlooked by critics of Man Ray's films, it is largely due to an insistence on artistic categorisation that characterises many accounts. Existing discussions demonstrate a tendency to isolate individual works and to read them exclusively in terms of either Dada or Surrealism and the more general literary and artistic tendencies related to the movements. Very few analyses actually question the usefulness and relevance of such frameworks or attempt to explore how Man Ray's cinematic works either present unique and individualist interpretations of Dada and Surrealist principles or merge these principles with other artistic approaches of the period. I would like to look briefly at the origins of this critical framework before going on to outline the ways in which this book will show Man Ray's films as both engaging with, and going beyond, Dada and Surrealism.

Beyond Dada and Surrealism

The period during which Man Ray produced his films represents a crucial moment in the history of twentieth-century art, which saw the dissolution of the Paris Dada group led by Tristan Tzara (see figure 2) and the gradual emergence of André Breton's Surrealist movement. Man Ray was involved in both groups and became a key asset to both Tzara and Breton, especially in creating new methods of photographic representation that seemed to give visual form to their literary ideas. However, his idiosyncratic personality and his dislike of any kind of artistic doctrine led him to occupy a relatively marginal position in relation to both movements, a position that allowed him both a sense of belonging and an element of artistic freedom. Despite his declared willingness to participate in the activities of the groups, he also acted as a kind of documentor, giving him a certain objective distance that he maintained throughout his life. Thus, he was not only a photographer *within* the Dada and Surrealist movements, but also *of* them, and many photographs of their various members bear his name. Yet presence behind the camera meant absence within the frame and, as a result, a large number of these images do not include Man Ray himself – a symbolic illustration of his relative marginality. In one comment he suggests that his involvement was more a case of being appropriated by the groups rather than a straightforward affiliation: 'the Dadaists and the Surrealists called me a pre-Dada and Breton called me a pre-Surrealist [...] they saw certain things, they didn't accept everything of mine any more than they did of Duchamp's philosophy. But certain things we thought seemed to fit in with their ideas, so I was accepted.'[22] Throughout his recollections of Dada and Surrealism, Man Ray refers constantly to being accepted in spite of his divergent ideas and artistic approaches. In his conversations with Pierre Bourgeade, he evokes his contribution to Surrealism, stating, 's'ils choisissaient certaines oeuvres qu'ils trouvaient s'identifier à leurs idées, j'étais flatté; si on m'a invité à participer à une exposition, ou à écrire dans une revue, c'est très bien. Je trouve que ça ne change pas ma personalité.' [if they chose certain works that were in accordance with their ideas I was

flattered, and if I was invited to participate in an exhibition, or write in a journal, that was fine. I don't think that this changed my outlook.][23]

Yet despite his individualism, the films are generally perceived as demonstrating a fundamentally critical and negativist attitude that relates them to both Dada and Surrealism. J.H. Matthews states, for instance, that, 'Man Ray's experiments with film were never intended to do anything more than express dissatisfaction with the cinema as an art form and curiosity to see how difficult it might be to resist the influence of art on movies.'[24] This description does little to account for the visual richness and diversity of expression contained within the works. It also ignores the fact that each film was made within significantly varied circumstances and that Man Ray developed a different approach to the medium with each production. Furthermore, rather than 'express dissatisfaction with the cinema as an art form', it would be more accurate to suggest that he tested the adaptability of film to his own artistic ends.

Paradoxically, the general lack of understanding about the way these films alternately relate to, and diverge from, the practices of Dada and Surrealism can be seen to stem from the content of Man Ray's autobiography *Self Portrait*. First published in 1963, this captivating and at times amusing account of the artist's life and career has come to dominate scholarly research in the field. Nowhere is this more evident than in discussions of his cinematic work. This is perhaps due to the relative absence of written commentaries by Man Ray himself that would explain and contextualise what initially seems to be an extremely diverse and disparate body of works. Unlike other artists who turned to film for the expression of their ideas, such as Hans Richter and Fernand Léger, Man Ray did not take a defined theoretical stance in relation to the cinema.[25] His comments on film are sparse and he is often at pains to point out that he was never particularly interested in the medium as an art form, a view that, as the following chapters will demonstrate, seems to contrast with the actual content of his films. Except for programme notes and occasional passing references in interviews and questionnaires, there are frustratingly few instances in which he engages seriously with the content of his cinematic work. In the programme notes for *Emak Bakia*, he positively dissuades any critical assessment of the film: 'In reply to critics who would like to linger on the merits or defects

of the film, one can reply simply by translating the title "Emak Bakia," an old Basque expression, which was chosen because it sounds prettily and means: "Give us a rest.""[26] Aside from a number of brief comments, Man Ray's autobiography is the only example of a sustained discussion of his films, and, as such, remains a valuable source of information. However, it is by its very nature an anecdotal description of remembered events, characterised, as autobiographies tend to be, by a nostalgic perspective of the past and, above all, a theoretical reticence.

The major problem here is that, although Man Ray's autobiographical account does not provide a theoretical background, it has nonetheless been used by many writers in the field as a basis for their interpretations of the thematic and formal characteristics of the films. This is evident in the frequent and lengthy quotations from the autobiography that feature in most studies.[27] What is most problematic about the over-reliance on this text is that Man Ray describes his films largely within the parameters of Dada and Surrealism, often restricting his discussion to sequences or procedures that most effectively demonstrate the principles of either movement. This is particularly the case with *Le Retour à la raison*, where the connections with Dada nonchalance are constantly reiterated, obscuring the more considered formal approach and clearly defined plastic concerns. He also remembers *Emak Bakia* in terms of a compliance with the 'rules' of Surrealism and *L'Etoile de mer* as a visualisation of a Surrealist poem, yet makes no real connection between the films and offers little explanation as to how and why his formal approach developed from one film to another.

In the recollections of his filmmaking period, Man Ray seems to present himself as simply following the paths dictated by the movements of Dada and Surrealism, an outlook that contrasts starkly with those comments referred to earlier, in which he emphasises his individualism. Indeed, it is well known that his position was not straightforward, and that his artistic sensibility consisted of a complex mixture of approaches that could be assimilated into both movements without ever completely giving itself over to either mode of expression. Jane Livingston's examination of Man Ray in the context of Surrealist photography highlights some of these issues, arguing that although he played a major role in the movement, his own artistic principles diverged from those established by Breton: 'Man Ray was

perhaps too much the reflexive, dualistic Western thinker, too much the pragmatist and too much the invested classicist, ever to capitulate totally to surrealism's cultural agnosticism.'[28]

This book attempts to deal with some of the issues described above. The following pages set out to create an understanding of how Man Ray is situated at the crossroads of several experimental strands of filmmaking in the 1920s, bringing Dada and Surrealism into a dialogue with a multitude of approaches, from abstract film to French Impressionist cinema. Although it too will draw from Man Ray's recollections in *Self Portrait*, these statements will be accompanied by an extensive investigation of the visual content of the films. The contradictory nature of Man Ray's reflections on his own work will be a central consideration, allowing us to understand the spirit in which they were made and to create a broader framework from which to analyse them. In doing so, it adds to the large body of research into Dada and Surrealism, providing new perspectives on Man Ray's cinematic expression. The approach to Dada and Surrealism developed through his films demonstrates a fluid interweaving of the principles related to the two movements. As Arturo Schwarz has noted, 'It is hard to classify Man Ray's films; they are provocative in their originality and pioneering in their content [...] they are products of his deep-rooted individuality and independence. His films anticipated moods and modes. It may be said that they are the most Dada of the Surrealist film, the most Surrealist of the Dada films.'[29] The perspective that guides this book is similar to that of Schwarz in privileging Man Ray's method as individualist and distinct, interacting and playing with the ideas related to Dada and Surrealism in such a way that they can no longer be separated and simply become part of a single, idiosyncratic cinematic voice.

The book is divided into five chapters, the first four of which will look individually at each of the 'official' works, that is, those that were theatrically released under Man Ray's name, whilst the final chapter will consider those works that exist outside this main corpus. Chapter 1 examines the relationship between Man Ray's first film *Le Retour à la raison* and the principles of Dadaism. It explores the significance of the film's association with the last Dada soirée organised by Tzara in 1923, which has to a large extent defined the way it is understood and theorised. By looking at the

intricate structure of the film, this chapter draws attention to the limitations of the negativist discourse into which it is frequently assimilated. It is argued here that existing discussions create an imbalance in our perception and understanding of Dada by focusing heavily on the destructive, anti-art tendencies of the movement. A consideration of how the more constructive characteristics of Dada can be detected in Man Ray's film opens up previously neglected areas of discussion. One of the fundamental questions is how do the themes of contradiction and duality that appear as Dada's defining qualities relate to Man Ray's own artistic expression in *Le Retour à la raison*?

Chapter 2 assesses the more complex positioning of *Emak Bakia* between the separate, but not unrelated, movements of Dada and Surrealism. As Edward A. Aitken has noted, this film 'sits on the threshold between the playfulness of Dada and the seriousness of Surrealism.'[30] The fact that *Emak Bakia* contains elements particular to both movements has led to an ambiguous situation in which categorisation alternates between the two modes of expression, with the film often being discussed in terms of a post-Dada, pre-Surrealist approach. Post-Dada because by the time the film was made the official movement in Paris had definitively broken up, with many of its members either joining ranks with Breton or becoming involved in other avant-garde groups such as International Constructivism.[31] Pre-Surrealist since, although Surrealism was officially established two years before the making of the film and had already entered into the realms of the visual arts, Surrealist expression in the cinema remained relatively unexplored. By looking into the way in which *Emak Bakia* interprets Surrealist principles, this chapter brings into focus some of Man Ray's more general artistic tendencies that have kept him at a distance from the movement. It focuses particularly on the way the film works through formal problems associated with various strands of avant-garde theory, such as abstract cinema, pure cinema and Impressionist cinema, with which Dada and Surrealism were often in conflict.

A similar approach is adopted in Chapter 3, through the analysis of what is generally understood to be the most Surrealist of Man Ray's films, *L'Etoile de mer*. Of central importance here is the collaboration between Man Ray and the Surrealist poet Robert Desnos. This relationship is rarely

discussed since it is widely accepted that Desnos simply provided Man Ray with an idea for the film. Yet, as we shall see, recent research in this area has revealed Desnos' input to be more significant than previously thought. This relationship will thus be used as a basis for understanding the film as a fusion of sensibilities, comparing the scenario with the final film in order to draw out stylistic traits particular to each artist. This chapter therefore departs from previous analyses, and, rather than providing an exclusively Surrealist analysis of the film, attempts to uncover some of its more purely formal qualities that demonstrate a strong link with the content of Man Ray's other films. Emphasis will therefore be placed on Man Ray's visual interpretation of the written outline, particularly the way it reveals patterns, structures and techniques that were not part of the original scenario.

It is this overlapping of disciplines that to a large extent characterises Man Ray's final film *Les Mystères du Château du Dé*, dealt with in Chapter 4. The film has attracted very little attention amongst critics and is often omitted from surveys of Man Ray's cinema.[32] Described by Helmut Weihsmann as 'a film story about architecture',[33] this multi-layered work defies any straightforward description. Made as an architectural document and inspired by the poetry of Mallarmé, *Les Mystères du Château de Dé* is the film in which Man Ray most clearly demonstrates his interdisciplinary sensibility, particularly in its reference to Stéphane Mallarmé's poem *Un coup de dés jamais n'abolira le hasard* (1897). Again, reference will be made to the historical context and the positioning of the film in relation to Surrealism. This has proved to be one of the most problematic areas of the film since, although it is often discussed in relation to the principles of the movement, it is largely dismissed due to its overtly formal preoccupations. The formalism of *Les Mystères* has been described in terms of a return to the concerns of the earlier films,[34] a characteristic that this chapter will explore in detail.

Finally, Chapter 5 delves into the body of works that exists on the periphery of what is commonly accepted as Man Ray's cinematic oeuvre. His collaborative involvement in projects such as the attempted Surrealist film written by André Breton and Paul Eluard, *Essai de simulation du délire cinématographique* (1935), and Hans Richter's *Dreams That Money Can Buy* (1948) have similarly received very little critical attention and

will be reassessed and discussed in detail. Also of crucial importance are the recently discovered short films, fragments of films and home movies dating mainly from the late 1920s and 1930s. Although it would seem that Man Ray never intended these works to be seen publicly, they nonetheless constitute a vital area of his interaction with the moving image, demonstrating stylistic and thematic links with his main cinematic corpus on the one hand and, a more intimate use of the medium on the other. Indeed, perhaps the most interesting aspect of these short films and home movies is the presence of Man Ray in front of the camera. It is here that we gain a true sense of his personality – his humour and creative energy – as well as his close personal relationships with other crucial figures of the avant-garde scene, such as Lee Miller, Meret Oppenheim and Pablo Picasso.

As this brief outline demonstrates, each film presents a number of specific problems that require reassessment within the context of corresponding historical circumstances. Despite his desire to work alone and to develop artistic processes and techniques that would demonstrate his own concerns, Man Ray's art constantly reflects tendencies of a specific period. 'Quand on me disait que j'étais en avance sur mon temps', he states, 'ma réponse était invariablement: "Non! Je vis dans *mon* époque".' [Whenever they told me I was ahead of my time, my invariable reply was: 'No! I am living in *my* time.']³⁵ Each film, then, seems to tell us something about the gradual development of avant-garde cinema and the association with the movements of Dada and Surrealism. The paradox of Man Ray and his ability to simultaneously belong and remain on the margins must be acknowledged since it allows us to understand his films as commenting on, rather than being completely absorbed in and inspired by, those movements with which they are associated. It is precisely for this reason that we must view the films from the wider perspective of Man Ray's persona. This is particularly important since the overall goal of this study is to provide an overview and analysis of the films that presents them as interrelated building blocks in an entire oeuvre, which, as short as it may have been, succeeded in establishing a fiercely idiosyncratic approach to the medium. It is this dual process of focusing, widening and refocusing the lens of analysis that will characterise the following discussion.

Between chaos and order: *Le Retour à la raison*

(1923, 35mm, 2 min, black and white, silent)

Man Ray had been in Paris for two years by the time he made his first film *Le Retour à la raison*. This short period represents one of the most important in his career since it is during this time that he became involved with the Paris Dadaists through his friendship with Marcel Duchamp. Perhaps the most significant detail relating to Man Ray's arrival in France in the summer of 1921 is that it coincides with the moment at which a series of ruptures between members of the Dada group were to have a lasting effect on the future of the Paris art scene.[1] Shortly after being introduced to the Dadas by Duchamp, an exhibition was devoted to him at Philippe Soupault's gallery Librairie Six, which, as Michel Sanouillet observes, allowed the group to momentarily recover a sense of unity.[2] Writing about this event in later years, Man Ray stated, 'Evidently, *my* exhibition was the occasion and pretext for the group to manifest their antagonism to the established order and to make sly digs at those who had seceded from *their* movement'[3] (my emphasis). This comment serves to highlight the relationship between Man Ray and the Dada movement and focuses attention on the marginal position he occupied in relation to their activities, manifestations and, most importantly, their personal quarrels. As the introductory chapter has already suggested, his association with Paris Dada seems to be characterised by a kind of passive collaboration in contrast to the more active role he played, along with Duchamp and Francis Picabia, in the significantly less militant New York Dada group.

Few avant-garde films are considered as historically significant as *Le Retour à la raison*, which was made for the last Dada event 'La Soirée du Coeur à barbe' held at the Théâtre Michel on 7 July 1923. The circumstances that gave rise to Man Ray's first film assured its subsequent unequivocal

acceptance as a Dada manifestation. In fact, the film has rarely been sepa-
rated from the various anecdotal descriptions of the conditions in which
it was made and screened, involving Tzara's initial announcement to Man
Ray a day before the event that his (then inexistent) film had been included
in the evening's programme. Lasting just under three minutes, the film
itself was hastily constructed in less than twenty-four hours and consists
of a number of individual camera shots alternated with sequences of rayo-
graphs. According to Man Ray, his inept gluing together of the strips and
the consequent intermittent projection caused by the continual breaking
of the film eventually led to an eruption of disputes and battles within the
theatre, during which the police were forced to intervene.[4]

Thus, the spirit of chance and spontaneity that surrounded the making
of the film, and its ability to rouse audiences of the time serve, in the minds
of most critics, to demonstrate the principal goals of the Dada movement.
For example, in the *Journal du Mouvement Dada*, a section devoted to the
'Soirée du Coeur à barbe' is given the subtitle 'Retour à la raison', signalling
the widely accepted connection between the film and the event itself.[5] *Le
Retour* therefore represents a paradoxical situation in the sense that it is
hailed as an archetypal work of Dadaism but one that marks the end of
the movement. As Thomas Elsaesser observes, the majority of films that
are categorised under the banner of Dada were made after 1923, historically
placing the cinematic medium on the margins of Dada expression.[6] That
film is associated with the movement from the very moment of its demise
raises a number of important questions about the relationship between
Dada and the cinema in general, and, more importantly in relation to the
present discussion, between Dada and Man Ray's film in particular.

The context from which it emerged has in many ways prevented
Le Retour from being discussed beyond very simplistic observations about
its connection with what are commonly seen as the destructive tendencies
of the Dada movement. Deke Dusinberre highlights this problem when
he states, 'Historians of avant-garde film have perpetuated this impres-
sion by stressing the importance of the film solely in terms of its provoca-
tive intent and anarchic effect; it is never studied in terms of its content
or construction.'[7] Indeed, there are relatively few in-depth analyses of
Le Retour despite the almost universal acceptance of the film as representing

one of the most important stages in the development of avant-garde film aesthetics. When discussed, it is often subjected to a rather superficial analysis that emphasises its relationship with Tzara's brand of unwavering nihilism and his commitment to provocation and scandal as artistic principles. In many cases it is described as nothing more than a rejection of cinematic conventions. René Clair for instance refers to the film as a 'desperate but not useless revolt against descriptive and anecdotic cinema',[8] whilst Peter Weiss states that 'Le film se veut une réaction violente contre toutes les formes de conventions.' [The film is endeavouring to be a violent reaction against all that is conventional.][9] Elsewhere, the unconventional structure of the film is highlighted as expressing the subversive tendencies of the Dada movement. Rudolf Kuenzli argues, '*Retour à la raison*, commissioned by Tzara, expresses through its anarchic arrangement of sequences and strips of rayographs Tzara's Dada spirit of spontaneity and chance, which were the Dadaists' strategies to disrupt logic and rational order.'[10] Allen Thiher, extending his assessment to include Man Ray's second film, argues that '*Retour à la raison* and *Emak Bakia* are essentially Dadaist negations, exercises in antiesthetics, that are part of the destruction of forms that the avant-garde undertook in the first part of the 1920s.'[11] Similarly Barbara Rose describes the film as 'hardly more than an assemblage of unrelated images', preferring to reserve her enthusiasm for the later *Emak Bakia*, without understanding the earlier film as a necessary foundation for this second 'far more ambitious' project.[12] Her discussion of *Le Retour* is restricted to a brief summary of its realisation in the context of the Dada soirée, adding simply that '[a] fight broke out, so the film was a success by Dada standards.'[13] Norman Gambill's short survey of Man Ray's films treads very much the same path, stating, '*Le Retour à la raison*, his first film, is thankfully, short, for it is amateurish – a good avant-garde student work. Except for its relationship to the evening of Dada that sparked a riot and its influence on his other works, it remains only a historical curiosity. More important is his second film, *Emak Bakia*.'[14]

Ado Kyrou in his brief summary of Man Ray's films describes *Le Retour* in the following terms:

Man Ray, dans le but de choquer et de scandaliser par la négation de tout ce qui se faisait jusqu'alors, filma les mouvements d'une spirale en papier [...] et parsema la pellicule vierge d'épingles et divers objets visuels tels que des boutons et allumettes, qui impressionnèrent la pellicule d'une telle façon qu'à la projection, on avait l'impression d'assister à une curieuse chute de neige métallique. Un corps de femme nue et des lumières de foire sont les seuls éléments concrets de ce film qui, par sa nouveauté et par sa volonté de détruire le 'spectacle' cinématographique, provoqua un des plus grands scandales de l'histoire dadaïste.[15]

[Man Ray, with the aim of shocking and scandalising by negating everything that had been done before, filmed the movements of a spiral of paper [...] and sprinkled pins and other visually distinctive objects such as buttons and matches onto the unexposed film, which affected the film in such a way that when it was projected it was like witnessing a curious metallic snowfall. The torso of a naked woman and some fairground lights are the only recognisable objects in this film which, by its novelty and its desire to destroy the cinematic 'spectacle', caused one of the greatest scandals in the history of Dada.]

The extent to which the film has become synonymous with the negative connotations of Dada as represented through the final swan song that was the 'Soirée du Coeur à barbe' is particularly evident here. The elements of shock and scandal that came increasingly to characterise the movement during its development in Paris, and particularly in the later years prior to its demise, are posited as the main driving force behind the film. By stating Man Ray's intention as that of negation, Kyrou assumes that a simple description of the material is enough to justify its Dada status. What Kyrou – and indeed many other commentators working along these lines – fails to demonstrate is exactly *how* certain aspects of the film, such as the movement of a paper spiral and what appears as a 'metallic snowfall', equate to a Dada gesture beyond the fact that they constitute a turn away from the conventions of narrative film. In other words, the further implications of the imagery involved in the film are left undiscussed in favour of demonstrating negation as an end in itself.

In this sense, *Le Retour* carries the burden of representing one of the most significant moments in the history of Dada and Surrealism. The fact that it was not only shown during the event, as was the case with Hans Richter's *Rhythmus 21* (1921), but commissioned *for* it by Tzara – the Dada

movement's central and most influential figure – has had the effect of turning it into a historical document. From this perspective the formal intricacies of the film wane in importance compared to the Dadaist state-ment it is seen to make. The problem is therefore twofold: the historical circumstances have created a situation in which *Le Retour*'s significance is tied to its Dada status, but also that this relationship is defined prima-rily in terms of destruction. So, whilst Thiher and others are content to highlight the 'destruction of forms' and the reaction against conventional cinema in *Le Retour*, there is also a distinct lack of understanding about the ways in which Dada also went further than straightforward negation. Christian Lebrat underlines these problems when he asks, 'Pourquoi le Retour à la raison ne figure-t-il dans aucune histoire "officielle" du cinéma, pourquoi l'a-t-on toujours considéré comme un exercice de provocation dadaïste, une expérience isolée, un coup d'essai ou une sorte de boutade anarchisante?' [Why does *Le Retour à la raison* not appear in any 'official' history of the cinema, why has it always considered been an exercise in Dadaist provocation, an isolated experience, a first attempt or some kind of anarchistic joke?][16]

This chapter aims to develop a broader understanding of the film by drawing attention to its underlying formal structures. It argues that the dual, contradictory nature of Dadaism is a fundamental aspect, not only of *Le Retour*, but also of Man Ray's work more generally. As such, the analysis that follows constantly relates the content and concerns of the film back to his work in other areas – notably photography – in order to demonstrate a wider perspective that will provide a model for the following chapters. Whilst acknowledging that the elements of destruction and refusal play a role in the film, the principle point of enquiry will be the way these aspects are brought into a fusion with a broader exploration of the medium. This will involve looking at the various ways in which Man Ray examines the creative possibilities of film, opening up new directions in terms of repre-sentation and introducing a plethora of formal patterns and visual relations between everyday phenomena.

Dada, film and performance

Before discussing the film in detail, it is useful to first briefly describe the historical context in which it was made, and to outline some of the main principles of the Dada movement, particularly in the way they relate to the cinema. This will allow us to understand Man Ray's position within Dada-related activity, as well as providing the foundation for a discussion of *Le Retour* that ultimately goes beyond these limits.

Dada in context: Zurich, Paris, New York

Dada officially began in Zurich in 1916, with the poet Hugo Ball's Cabaret Voltaire, a cabaret nightclub that invited all kinds of revolutionary artistic expression. The climate was one of disillusionment and scepticism in the face of the violence and meaninglessness of the First World War, and many artists and writers, including Emmy Hennings, Richard Huelsenbeck, Tristan Tzara, Hans Arp, Sophie Tauber and Marcel Janco had exiled themselves to the capital of neutral Switzerland. Out of this pacifist setting grew an artistic sensibility that aimed not simply to comment on, but to physically rip open contemporary life in order to reveal the corruption, hatred and injustice that lay behind its superficial layers. Dada was thus an attack on the values, morals and traditions of the bourgeois society that had allowed barbaric destruction of human life on such a massive scale. The Cabaret Voltaire, which was situated on the same street as that which also housed the political revolutionary Vladimir Lenin, presented poetry readings, dance and theatre performances and exhibitions, all characterised by an air of provocation and a strong desire to shock and scandalise. Huelsenbeck remembers these evenings in terms of 'a violently moral reaction' and as a 'spontaneous aggressive activity.'[17]

Dada was thus defined in terms of its social function, challenging the notion of art for art's sake that characterised many works of modernism, and turning instead towards a new mode of expression capable of reflecting and reacting against bourgeois morals and traditions based on reason and rationality. As Ball stated:

> It can probably be said for us that art is not an end in itself – more pure naïveté is necessary for that – but it is an opportunity for true perception and criticism of the times we live in, both of which are essential for an unstriking but characteristic style.[18]

The Dadaists' principle tools for social criticism were spontaneity, absurdity, illogic and chance, but it also became clear that existing modes of artistic expression were unsuitable since they were themselves deeply ingrained in the corrupt bourgeois system and thus partly responsible for the climate of apathy. Although lacking a unified style, as highlighted by Ball, Dada works generally involve a sustained, often radical questioning of the materials and traditional formulas for the construction of works of art. This necessarily moves away from the more purist ideals of modernism where the search for medium-specificity results in a self-conscious exploration of paint on a canvas or words on a page. Hugo Ball's phonetic poems, which were regularly performed at the Cabaret Voltaire, explode linguistic signification from the inside by freeing the basic components of language from their subservience to logic and reason.

At the end of the war and the reopening of national borders, the movement spread throughout Europe, manifesting itself differently in each city and giving rise to a number of different 'Dadaisms' (Zurich, New York, Berlin, Hanover, Cologne, Paris) depending on the artists involved. It was the Romanian poet Tristan Tzara who brought Dada to Paris at the beginning of 1920, having been in close contact with the French literary circles since 1917.[19] A number of writers whose direct involvement in the war had left them damaged and disillusioned were particularly responsive to Tzara's anarchic personality and welcomed his arrival with enthusiasm. The ground had already been laid for the flourishing of Dada in Paris through various activities and publications, notably Arthur Cravan's *Maintenant*, Pierre Reverdy's *Nord-Sud*, Francis Picabia's *391*, and *Littérature* – established in 1919 by André Breton, Philippe Soupault and Paul Eluard. The title of this latter journal points to the literary emphasis of Paris Dada and the predominance of poets and writers amongst those who contributed to the movement. Fuelled by the anarchistic spirit of Tzara and based largely on the model provided by the Zurich performances, Dada in Paris was characterised by its numerous spectacular manifestations and public

assaults. These events were usually preceded by the circulation of printed programmes which falsely announced performances and appearances of well-known figures (including Charlie Chaplin), intentionally challenging the expectations of an initially unsuspecting public. Yet, as Hans Richter, a member of the Zurich group states, 'it was in Paris that Dada achieved its maximum volume and here that it met its dramatic end.'[20] After a series of manifestos, manifestations, public demonstrations, exhibitions, soirées and the appearance and disappearance of a number of journals devoted to the movement, Paris Dada eventually ran out of steam. The public was no longer capable of being shocked and lost interest in recycled tactics that aimed only to provoke. Members of the group began to disagree on the basic principles that had initially brought them together, with many of them, including André Breton, opposing Tzara's dead-end nihilism. Despite the undeniably subversive and destructive nature of Dada, the entire movement seems to pose the fundamental question of whether 'anti-art' is at all possible, if indeed desirable. 'Dada's propaganda for a total repudiation of art', remembers Richter, 'was in itself a factor in the advance of art.'[21] This contradiction, which in many ways brought about the Dada movement's ultimate dissolution, is at the heart of Man Ray's film, effectively demonstrating its complex positioning and thwarting any attempt to discuss it exclusively in terms of its destructive qualities.

Although Zurich and the Cabaret Voltaire are the widely accepted origins of Dada, a similar attitude was being expressed in New York as early as 1915 through the activities of Francis Picabia, Man Ray and Marcel Duchamp. The latter had arrived there from France the same year and quickly became part of the nightly meetings of artists and writers at the poet Walter Conrad Arensberg's apartment.[22] As Rudolf Kuenzli states, 'these gatherings provided a first extensive opportunity for some young American painters and poets to interact with important European figures of the avant-garde.'[23] Whilst encouraging their American counterparts to reject traditional forms of expression, Picabia and Duchamp were in turn influenced by their new surroundings, which gave a characteristic slant to their works and indeed to New York Dada more generally. Picabia, for instance, commented at the time:

Almost immediately upon coming to America it flashed on me that the genius of the modern world is in machinery [...] I have been profoundly impressed by the vast mechanical developments in America. The machine has become more than a mere adjunct of human life. It is really part of human life – perhaps the very soul.[24]

The anti-art sensibility that arose in New York was thus defined by a desire to unite art, life and technology,[25] giving rise to an interest in mechanical objects. Despite Duchamp's independence and indifference to labels, statements and manifestos, correspondence soon began between Tzara and the New York group, and 1921 saw the publication of the first and only issue of the journal *New York Dada*, in which Tzara's response to Man Ray and Duchamp's letter asking his permission to use the word 'Dada' in the title was published: 'Dada appartient à tout le monde. Comme l'idée de Dieu ou de la brosse à dent.' [Dada belongs to everybody. Just like the idea of God or a toothbrush.][26] The content and layout of the journal was much more sober than the publications that appeared in other countries, such as *Dada* in Zurich and *Der Dada* in Berlin. In June of the same year, Man Ray wrote to Tzara, stating, 'dada cannot live in New York. All New York is dada, and will not tolerate a rival, – will not notice dada. It is true that no efforts to make it public have been made, beyond the placing of your and our dadas in the bookshops, but there is no one here to work for it, and no money to be taken in for it, or donated to it. So dada in New York must remain a secret.'[27] The letter was signed 'Man Ray directeur du mauvais movies',[28] and incorporated, at the beginning and end, two different pieces of film strip. One of these features frames of Man Ray's own face placed underneath his signature. The other, at the top of the letter, is that of a naked woman, the Baroness Elsa von Freytag-Loringhoven – a minor, yet renowned Dada figure whose eccentric behaviour gained her a reputation amongst the group. Sometime during 1921, Man Ray, along with Duchamp, had produced a film of the Baroness in the act of shaving her pubic hair, and, although no trace of it remains, it would seem that the images in the letter were taken from this film.[29]



The mechanical eye: Dada cinema

Thus, whilst proclaiming the impossibility of Dada's existence in New York,[30] Man Ray introduces a field of artistic expression that would only later become part of the movement: the cinema. His reference to himself as a director of 'mauvais movies' is important in this context since it highlights one of the central aspects of Dadaism, that is, a rejection of traditional notions of the skilled artist, as well as all aesthetic criteria associated with the reception of works of art. The term probably seemed appropriate to Man Ray at the time as his cinematic projects with Duchamp not only departed radically from the organised and polished nature of conventional filmmaking, but also often produced disastrous results. The film mentioned above was 'ruined during the process of developing and never saw the light',[31] a fate that also befell their attempt to produce a stereoscopic film using two cameras that were joined together.[32] As Elsaesser has pointed out, the contradictory nature of the cinema – the artificiality of its mechanical and chemical foundation and the illusory effect of its final product – make it a 'quintessentially Dada artifact.'[33] Yet despite this, the medium of film attracted very little attention amongst the Dadaists and few films were made during the movement's most prolific period.

The cinematic experiments undertaken by Man Ray and Duchamp in New York can thus be seen as the earliest attempts to incorporate the moving image into the Dada project and to highlight the dualistic nature of cinematic representation evoked by Elsaesser. Indeed, one of the central questions in the discussion of film within the context of Dada is the way the movement's ambivalent attitude towards technology and the machine as representing the promise for progress – a characteristic that is most effectively expressed within the realms of New York Dada and the work of Picabia, Duchamp and Man Ray – is incorporated into a medium that is defined through its technological basis. 'The Dadaists' dilemma', explains John Elderfield, 'was how to be modern and progressive in a way that escaped the technological and the rational, in a way that did not damage the present in the name of the future, when the modern and the progressive meant quite the opposite.'[34] The answer, in the realms of cinematic expression, seemed to lie in the ability to fragment and rearrange the hierarchies of experience and to

lay bare the mechanical and ideological workings of the medium. Dada film thus provides a critique of cinema's claim to truth and reality by revealing it to be a construct of modern technology. Yet, as the following analysis of *Le Retour* will demonstrate, this necessarily leads to the creation of new visual experiences that, whilst challenging the illusory nature of film, also point towards a politically and aesthetically progressive use of its materials.

However, according to Elsaesser, the notion of Dada in the cinema is complex and depends not so much on the Dada content but the Dada *context*, bringing us back to the performative element of the Von Freytag-Loringhoven affair. This film is particularly significant in the way it emphasises the importance of the Dada 'act' and the role of film in producing a trace or a document of that act. The relationship between film and performance would later emerge as a key characteristic of 'neo-Dada' developments in art such as the Fluxus movement during the 1960s, with the invention of video pushing performance art to a new level and allowing an instantaneous relationship between the act and its representation.[35] The Man Ray–Duchamp experiments in many ways pre-figure these later developments by creating a crucial link between cinema and performance as an artistic statement.[36] Elsaesser's discussion reverses this formulation to show how the performance dictates the status of a film contained *within* it. He states:

> What was Dada in regard to cinema was not a specific film, but the performance, not a specific set of techniques or textual organisation, but the spectacle. One might argue that in order for a film to have been Dada it need not be made by a Dadaist, or conversely, that there were no Dada films outside the events in which they figured. 'What is Dada film?' would resolve itself into the question '*When* was a film Dada?' This gives special place to the screening of *Entr'acte* as part of *Relâche* [...] and to the Soirée du Coeur à barbe.[37]

Our understanding of Dada film must, as Elsaesser's comment suggests, take into account the element of performance that was one of the defining characteristics of the movement.[38] The ultimately nihilist character of Tzara's Dada soirée succeeded in making out of Man Ray's film a statement about the nature of cinematic representation and spectatorship. According to Man Ray, the film broke numerous times during projection, adding to the already tense atmosphere in the theatre.[39] The disruption of those

very conditions vital to the conventional Western cinema-viewing experi-
ence – the continuous projection and the immersion of the viewer into
the world of the film – represents the ultimate Dada gesture. It is there-
fore the fragmentary nature of the entire performance that prevents the
establishment of the usual film-spectator relationship. Furthermore, the
discontinuous projection of the film demonstrates another aspect of Dada
that Peter Bürger defines as the fundamental aim of the historical avant-
garde more generally: the reintegration of art into the 'praxis of life.'[40] The
different reactions of the audience during the screening of Man Ray's film
at the 'Soirée du Coeur à barbe', alternated as they were by the intermittent
appearance of images on the screen, would have become part of the whole
cinema 'performance'. This merging of the inherent unreality of the film
with the reality of the event can be seen in later Fluxus works such as Nam
June Paik's Zen For Film (1962–4), which involves the projection of roughly
one thousand feet of clear, unprocessed leader film. Here, the blank screen,
the perceivable bits of dust and debris, and the reactions of the audience
all become part of the half-hour long performance. As mentioned earlier,
the context has the effect of framing and defining the content, and it is for
this reason that Le Retour's connection with the last Dada soirée should
not be completely overlooked. Nonetheless, it is important to shift the
emphasis onto the actual content of the film if we are to understand how
the complex relationship with Dada is expressed on a visual level.

Despite the film's very short running time, the amount and diversity
of cinematic innovation is breathtaking. Within these few minutes Man
Ray establishes clear visual themes and motifs and poses a variety of ques-
tions about the nature of visual representation and cinematic materiality.
It begins with a seemingly abstract mass (actually grains of salt and pepper)
that flickers across the screen for eight seconds. The second image, a draw-
ing pin, appears suddenly and dances across the screen. If the first image
is characterised by ambiguity, verging on the abstract, the second brings
with it a feeling of concreteness, a reinforcement of identification with an
object. A few seconds later, the drawing pin is joined and then replaced by
a handful of nails that execute a similar frantic movement (see figure 3).
For another three seconds the first image reappears, followed by a flicker of
text – sections of film onto which Man Ray wrote directly – that is virtually

imperceptible when viewed at normal projection speed. The drawing pin returns but this time in negative, so that the pin itself appears as a white object against a black background. The nails also reappear, followed once again by the unidentifiable abstract mass. For two seconds the image of a light bulb passes across the screen, followed by another two seconds of moving circular forms that spill over the edges of the frame (see figure 4). Except for the fleeting glimpse of the light bulb, the camera-less rayograph images dominate this section.

The film then changes tone. Up to this point, separate images have lasted only a few seconds, preventing the viewer from becoming fixed on any one visual impression, and producing what could be described as a 'fairground effect', where the viewer is bombarded with a constantly changing visual stimulus. Either by coincidence or by direct reference to this effect, the next set of images is made up of various impressions of a fairground at night. However, only the lights of the rides are perceptible to the viewer, echoing the stark tonal contrasts of the previous sequence, white against black. Man Ray films the lights of the rotating carrousels from a static position, allowing the lights to simply move past the viewer, and then by moving the camera itself, physically following their trajectory. These shots have a generally improvised feel most evident in the movement of the camera, which is jerky and in no way follows a smooth, pre-planned path. The next fifteen seconds of the film represent Man Ray's attempt to cinematise his own work *Danger/Dancer* (1920). This 'airbrush composition of gear wheels' was apparently 'inspired by the gyrations of a Spanish dancer',[41] and thus demonstrates a static mechanical representation of human movement. In order to give kinetic life to the static image, wisps of smoke are blown in front of it.

After being briefly exposed to the 'realism' and familiarity of the camera-based images, the viewer is once again presented with a sequence of rayographs, involving a similar mixture of identifiable and unidentifiable objects, such as paper, springs and spiralling forms (see figure 5). This is followed by another short section, an arrangement of black lines resembling the layout of a poem moving frantically from side to side. In between this and the following set of images are two frames on which Man Ray's name appears, which again pass almost unnoticed by the viewer at normal

projection speed (see figure 6). The final section of the film consists of three optical experiments brought together by their focus on light and movement. They can in many ways be seen to express one of the main principles of the film, and indeed much of Man Ray's work in general, that is, the ability of an object to transform itself, expressing hidden qualities and reversing the associations traditionally attached to it. We are first presented with a spiralling piece of paper, the movement of which conceals the identity of the object for a significant amount of time. This is followed by a series of images of a rotating egg crate divider, casting shadows onto the wall against which it is filmed. As the crate made to rotate in alternate directions, a superimposition of the same object is added, rendering the composition visually complex. As with the spiralling paper, the movement is executed at varying speeds. At times, the crate spins rapidly, whilst at others, the movement is slower, allowing the formal details of the object to be more fully absorbed. The final images of *Le Retour* feature the only human presence in the film. In *Emak Bakia* a few years later, Man Ray would extensively explore the cinematic potential of the human form, reflecting his career-long interest in both the portrait and the naked female body. Here, again in a number of separate shots, a nude torso moves from side to side in front of a window obstructed by blinds, the light from which casts complex shadows onto the body (see figure 7). As the torso turns, the shadows appear to mould themselves to the contours of the body, creating circular formations around the breasts. In ways similar to the image of the egg crate, the striking visual effect betrays a meticulous composition.

On first viewing, one cannot help but notice the unconventional nature of the film. In his characteristically experimental method, Man Ray subverts the rules of cinematic construction, combining images produced without the use of a camera (working directly with the film strip) with those created with the traditional filmmaking apparatus. Positive images are juxtaposed with negative ones and different forms of movement are presented from one image to the next. The erratic, spontaneous activity of the first half contrasts with the more studied nature of the second. This combining of approaches and the bringing together of contrasting effects demonstrates a very clear challenge to the impression of unity that is traditionally associated with the cinema. *Le Retour* presents reality not as a continuous whole,

but as a fragmented discontinuum that confuses and disorientates. The notion of objective reality is rejected in favour of a series of impressions or interpretations of that reality, which emphasise their own artificiality. The content of the film represents a further turn away from traditional cinematic representations, opening up the debate on the relationship between form and content. Man Ray uses banal everyday objects as the basis of his cinematic observations, which, because of their specific, often utilitarian nature, are not traditionally subject to artistic depictions. This is because objects such as drawing pins, nails, grains of salt and pepper and bits of paper are not generally perceived in terms of their pictorial qualities and reproducibility. By employing the rayograph technique, Man Ray opens up the representative possibilities of film, whilst at the same time allowing the material to express hitherto hidden qualities. How else, he seems to ask, could we perceive, cinematically, the expressive possibilities of a drawing pin or the patterns created by salt and pepper?

The painter Fernand Léger spoke of the cinema's ability to transform everyday reality and to provide the viewer with a new perceptual experience, stating,

> Very few people like the truth, with all the risk it involves, and yet the cinema is a terrible invention for producing truth when you want. It is a diabolical invention that can unfurl and light up everything that has been hidden. It can show a detail magnified a hundred times. Did you know what a foot was before seeing it live in a shoe under a table, on the screen?[42]

Although Léger is referring specifically to the possibilities created through the use of the close-up and its presentation of a fragment of reality, Man Ray's approach demonstrates a similar process by which the cinema enhances and transforms reality. The difference is that whilst Léger is talking about conventional cinematic techniques and accepts its technological basis, Man Ray, through his use of rayography, allows a direct physical relationship to be brought about between filmic materiality and the material of reality. What brings the two approaches together, however, is the concentration on the plastic qualities of the image and the exploration of representation outside of narrative concerns.

Pro-visual/anti-narrative

Aside from the combination of techniques and the nature of the material featured in the film, one of the strongest features of *Le Retour* is arguably its unconventional structure, often understood in terms of a rejection of narrative and therefore as representing once again the negative aspect of Dada. However, this aspect must be considered from the wider context of avant-garde cinema of the 1920s if we are to fully grasp the role of narrative in relation to Dada in general and Man Ray's film in particular.

Avant-garde film and narrative

The term 'avant-garde' as it is employed in relation to the cinema refers to a wide range of works that explore the possibilities of the medium outside established commercial and aesthetic frameworks. The 1920s gave rise to the first sustained wave of interest in the cinema and its promotion as a legitimate art form, which gradually developed into a number of different schools of thought. Despite the diversity of individual theoretical positions, this has, in the case of France, frequently been divided into a series of 'waves' or general shifts in the conception of cinematic expression, leading to what is commonly referred to as the first, second and third avant-gardes.[43] Constantly evolving and rarely unified, the first wave of theories and cinematic approaches, often termed 'Impressionism', emerged from figures such as Louis Delluc, Ricciotto Canudo (founder of the *Le Club des Amis du Septième Art*), Léon Moussinac, Emile Vuillermoz, and later, Germaine Dulac and Jean Epstein. It was based on a narrative conception of the cinema and concentrated largely on the ability to liberate man from an oppressive industrialised society by offering either an escape into an imaginary world 'where our faculties find freer exercise',[44] or by utilising the story as a 'pretext for personal vision and lyrical expression.'[45] Delluc and Moussinac's vision of the cinema as a 'democratic art'[46] hinged on the use of realist narratives and settings, depicting characters in harmony with the surrounding landscapes. Towards the second half of the 1920s, attention

began to focus on the specific language of the cinema and many theorists and filmmakers, especially Dulac, sought to define film as an autonomous art and to separate it from other modes of expression. Léon Moussinac, for example, proclaimed that 'the cinema is no more literature than it is painting, sculpture, architecture or music.'[47] Emphasis was placed on the unique visual qualities of the film medium (such as superimposition, slow and fast motion, soft focus) and on the shot as the basic unit of cinematic syntax. Developing Delluc's notion of 'photogénie', Epstein stated, 'The cinema must seek to become, gradually and in the end uniquely, cinematic; to employ, in other words, only photogenic elements. *Photogénie* is the purest expression of cinema.'[48]

Along the same lines, Dulac's article, 'L'essence du cinéma: l'idée visuel', published in 1925, expressed a formally based theoretical stance that would later become known as 'cinéma pur' (pure cinema).[49] This concept, which occupied a number of filmmakers of the period, shifted emphasis from a cinema of the story to a cinema of the image, privileging the use of visual techniques for their own sake (reflecting the concerns of artistic Modernism).[50] Following the release of Abel Gance's *La Roue* of 1924 – a narrative film that demonstrated a pioneering use of montage – editing and rhythm became a key focus of attention.[51] Although Dulac was a fervent promoter of cinematic rhythm, these ideas were also expressed in the writings of Elie Faure (formulated in terms of what he called 'cinéplastics'), Fernand Léger, René Clair and Moussinac. Here, the purely plastic expression of static and moving forms and the rhythmic relations between shots are foregrounded as the cinema's most powerful inherent qualities. 'Pure cinema' thus represents what is commonly described as the 'second avant-garde', where narrative concerns are replaced with formally determined ones. One of the main features of this kind of cinema is the presence of musical analogies, which were developed particularly by Dulac, but which can be seen as early as 1912 in the cinematic drawings of Leopold Survage. In Germany, a group of painter-filmmakers were demonstrating a similar approach from the beginning of the 1920s. The works of Hans Richter, Viking Eggeling and Walther Ruttman turned away from mimetic representation in order to recreate musical structures through moving abstract shapes and forms.

Whilst Dada seems to overlap with some of these developments (particularly in Léger's film *Ballet mécanique*), Surrealism is positioned in opposition to the formalist tendencies of the Impressionists, as well as the exponents of 'pure' or abstract cinema. Although there initially appear to be significant correspondences between the Surrealists' concern with narrative and representation as a means to recreate the dream experience and the Impressionists' attempt to express character psychology within a narrative context, their fundamental point of divergence arguably lies in the *function* of the narrative structure itself. The Surrealists returned to a more conventional use of storytelling and optical realism in order to recreate the structure of dreams and 'realistically portray the symbolic order, which they then disrupt with shocking, terrifying images.'[52] By contrast, the narratives of Impressionist cinema give rise to the emotional states that provide the visual focus of the films, thus creating a lyrical and harmonious relationship between image and narrative, form and content. Dada films, on the other hand, are frequently understood in relation to their self-reflexive rejection of traditional narrative structures. The scrolling text at the beginning of *Ballet mécanique* introduces it as 'le premier film sans scénario', immediately situating it in terms of cinematic conventions and the traditional reliance on narrative. The film defines itself not in terms of what it *is*, but rather what it *isn't*, thus establishing the perspective from which it should be viewed, i.e., as a kind of counter-cinema. Various moments in the film, such as the image of a girl on a swing and the presentation of a newspaper headline, arouse narrative expectations which are then subverted and replaced by formal play. Similarly, René Clair's *Entr'acte*, from a script by New York Dadaist Francis Picabia, uses a funeral as the pretext to take the viewer on a visual (and literal) roller coaster ride to an illogical and nonsensical ending. This film demonstrates the influence of early silent comedies of the period, in which the chase functions as a narrative device, providing a linear trajectory for the development of a series of unrelated visual gags.[53]

As this brief outline suggests, the diverse range of approaches to narrative renders problematic any broad attempt to define avant-garde film specifically within these terms. Nonetheless, the films of the 1920s are regularly discussed in relation to a storytelling and of those stylistic conventions now widely referred to as the classical Hollywood cinema.[54] For

example, Noureddine Ghali, in his extensive study of French avant-garde film of this period, observes:

> L'une des caractéristiques du cinéma d'"avant-garde" à partir de l'année 1924 fut le refus de toute forme de scénario traditionnel. Les cinéastes d'"avant-garde" qui se trouvaient à la pointe des recherches ont pris des positions radicales et ont cherché à éliminer de leurs films tous les développements du cinéma dramatique courant.[55]

> [One of the characteristics of the 'avant-garde' cinema starting in 1924 was the refusal to use any form of screenplay. The 'avant-garde' filmmakers at the forefront of research took up radical positions and sought to eliminate from their films any developments that reflected current film dramaturgy.]

The collective desire to break free from the conventions of an emerging cinematic norm is understood as giving birth to a range of films without narrative structure. Ghali states that *Le Retour à la raison*, and films such as *Ballet mécanique* and *Jeux des reflets et de la vitesse* (Henri Chomette, 1924), can be defined in terms of a common denominator: the total refusal of narrative. However, Ghali describes this development solely in terms of rejection and elimination – both, in effect, negative processes. So whilst his observation helps us to understand the way in which avant-garde film developed, bringing together the multitude of cinematic expression in terms of a single aim, it can also be counter-productive in the sense that it focuses attention primarily on the destructive, rather than constructive, qualities of this strand of filmmaking. This view has the effect of blurring some of the distinct concerns and approaches outlined above, which, although often related and existing together in a single film (as is the case with *Ballet mécanique* and *Entr'acte*'s simultaneous expression of Dada aesthetics and 'pure cinema' or 'cinéplastics'), do not necessarily share the same theoretical basis. Also questionable is the way this collapsing of multiple intentions into a single approach encourages the understanding of avant-garde cinema solely in terms of cinematic conventions, without taking into account the fact that these films often emerge out of a desire to create a dialogue between film and other art forms. The German abstract filmmakers who began making 'non-narrative' films slightly earlier than their French counterparts made various statements on the nature of cinema

and its subservience to storytelling, which they saw as an essentially non-cinematic element. However, their criticisms were mainly founded on the idea that film had not yet been allowed to demonstrate its creative potential and express itself as an art form. This, they believed, could only be achieved through a focus on form as opposed to content. Whilst the films of Ruttman, Richter and Eggeling were essentially non-narrative, their focus was primarily the creation of a purely visual experience and not necessarily the simple destruction of narrative conventions. Although the two remain intertwined, the latter can be more accurately described as a by-product of the former.

It is important therefore to acknowledge other historical factors that were involved in the process of making 'non-narrative' films. The majority of those involved in the creation of avant-garde film came not from the cinema itself but from other arts such as painting and photography – as is the case with Man Ray – and pursued the new medium as a kinetic extension of their work in other domains. The expression of movement had become a key concern in many areas of art, first with Cubism's multiple perspectives and then more forcefully in the work of the Italian Futurists, such as Umberto Boccioni's *The City Rises* (1910) and Giacomo Balla's *Dynamism of a Dog on a Leash* (1912). Artists of the period were becoming increasingly frustrated with the static nature of painting, realising its ultimate inadequacy in representing the world around them – the modern world of movement, and above all, speed. They looked towards film as a way to express sensations that depended upon movement. For the German filmmakers this most often involved eliciting physiological responses through moving abstract shapes and forms, a process that developed from a desire to create a mode of visual expression analogous to that of music.

What must be considered, then, is whether turning away from the use of narrative as an organising principle necessarily constitutes an act of rejection. Referring again to Kuenzli's definition of Dada film, in which he states, 'Dada films are radically non-narrative, non-psychological', it can be deduced that there is a predominant tendency to view films that do not deal with narrative as 'non' narrative, 'anti' narrative, in other words specifically *in opposition* to narrative, an attitude that is most often understood in terms of Dada's anti-art programme. That the majority of films from this

period have been classified in terms of Dada makes the issue all the more pertinent. Indeed, in the case of *Le Retour*, the absence of a traditional narrative structure is considered primarily as a Dadaist device. As we have seen, most accounts of the film highlight the negative connotations inherent in such an approach. However, what I would like to propose here is that the concentration on exclusively visual elements outside of narrative concerns does not automatically translate as 'anti-narrative'. Clearly there is a need for a new theoretical perspective that goes beyond the narrative/non-narrative divide and acknowledges the unique position of particular films as occupying their own space, more or less *removed* from that of narrative film. What is required therefore is a more detailed account of the inherent concerns of individual films and the visual ideas expressed by them, thus opening up the field of avant-garde film theory to extend beyond restrictive generalisations. This also allows us to understand the relationship between *Le Retour* and Dadaism from a much broader perspective. One of the main issues raised by the film is the importance of individual visual 'moments' which emphasise the cinematic spectacle outside of narrative considerations. This highlights an aspect of Dada that has less to do with narrative destruction and subversion than with the return to an earlier form of cinematic spectatorship.

A cinema of attractions

Despite the frequent concentration on its 'non-narrative' quality, few accounts of *Le Retour* have looked seriously into the questions it raises about the film-spectator relationship. It seems to be a general assumption that in rejecting traditional forms of cinematic construction Man Ray also problematises the smooth transmission of meaning typical of commercial cinema of the period by presenting a series of apparently unrelated images. Yet, as Merry Foresta points out, 'As a filmmaker [Man Ray] realised it was not the narrative of the cinema that the audience found compelling but the often delightfully incongruous dramas emerging from unexpected juxtapositions.'[56] Foresta's observation suggests that, in making films that are at odds with the reliance on accepted narrative principles, Man Ray did not

simply adhere to the principles of rejection and negation, but in actual fact turned towards what he – and indeed many other artists and filmmakers of the period – saw as a fundamental element of cinematic construction – that is, a concentration on the purely visual. In other words, he does not aim to shock the viewer so much as to appeal to their visual sensibility, which is, as Foresta suggests, stronger than their desire for narrative causality.

This can be understood in relation to Tom Gunning's notion of the 'cinema of attractions'. Whilst the spectator is denied the pleasure of narrative absorption, they are presented instead with a series of visual attractions, designed for the most part to reveal and revel in the creative possibilities of the cinema. Gunning observes that the avant-garde film continues an early fascination evident in the films of the Lumière brothers and Georges Méliès, which 'sees cinema less as a way of telling stories than as a way of presenting a series of views to an audience, fascinating because of their illusory power [...] and exoticism.'[57] Gunning states that this early tendency

> directly solicits spectator attention, inciting visual curiosity, and supplying pleasure through an exciting spectacle – a unique event, whether fictional or documentary, that is of interest in itself. The attraction to be displayed may also be of a cinematic nature, such as the early close-ups [...] or trick films in which a cinematic manipulation (slow motion, reverse motion, substitution, multiple exposure) provides the film's novelty.[58]

The cinema of attractions stems from the early association with the fairground and its traditional placement amongst other visual attractions. That images of an actual fairground are present within *Le Retour* is not insignificant since they emphasise on a denotative level the sensual impact of the fairground, which can be read as a metaphor for the film as a whole.

Drawing on Sergei Eisenstein's formulation of the 'attraction' as having a 'sensual or psychological impact' on the spectator, in direct opposition to the passive immersion in conventional illusionism, Gunning highlights the similar exhibitionist approach of avant-garde cinema and the desire to transcend the narrative limits of the medium. However, Eisenstein's formulation of the (theatrical) attraction is based on the direct reaction of the audience and is 'mathematically calculated to produce certain emotional

shocks.'[59] The attraction is thus a political tool, used to manipulate the audience towards a desired response. Eisenstein places the attraction in opposition to the 'trick', which he describes in terms of pure spectacle, where the artist draws attention to his or her creative talent. Although Eisenstein's formulation would seem to stand in opposition to Gunning's appropriation of it, the avant-garde film as represented by *Le Retour* marks out a middle ground between the political attraction and the pure spectacle of the trick – a dichotomy that, interestingly, seems to mirror the way Man Ray fuses Dada with his more formal concerns. Rather than simply draw attention to the artist-as-magician,[60] the 'attraction' of the avant-garde film provokes a change in the traditional conditions of film viewing and the psychological responses made by the audience.[61] As David Macrae argues, the uniquely visual aspect of the avant-garde film

> urges an empowered, active engagement of the viewer's faculties, which transcends the conventionalised closed-circuit aesthetic treadmill interlocking the artefact with the authorial presence of the artist and onlooking passive participation of the viewer. Perhaps more than any other examples of early avant-garde artefact, such as photomontage, assemblage, installation, or ready-made, it is the avant-garde film which most lucidly – if unsettlingly – presented itself as a work of art purely by inviting, strangely and seductively, the urge to participate in the process of understanding vision through embracing construction of image.[62]

A crucial element of this relationship is the way both practices involve a direct relationship between the filmmaker and the viewer. To return to Gunning:

> The aesthetic of attraction addresses the audience directly [...] Rather than being an involvement with the narrative action or empathy with character psychology, the cinema of attractions solicits a highly conscious awareness of the film image engaging the viewer's curiosity. The spectator does not get lost in a fictional world and its drama, but remains aware of the act of looking, the excitement of curiosity and its fulfilment.[63]

Indeed, we could use Foresta's notion of visual 'dramas' in Man Ray's films to understand the excited pleasure of looking and the curious anticipation of each new visual spectacle. Throughout *Le Retour*, Man Ray uses a number of techniques that focus specifically on the act of viewing. The spectator is

confounded by a multitude of visual signifiers and becomes involved in a game of unravelling the mystery contained within them. Gunning's reference to cinematic novelty thus provides a useful framework from which to view the film.

For Man Ray, the cinema was indeed a novelty, a medium that opened up new creative possibilities and allowed him to extend his photographic explorations of pictorial representation. Many aspects of *Le Retour* attest to this position, betraying a fascination with cinematic language and its ability to widen the gap between signifier and signified through techniques such as movement and superimposition. Were the film intended as a simple negation, as many have suggested, it would surely not engage in such meticulous compositions, such as the moving paper spiral, the egg box divider and the nude torso simply to shock the spectator. It presents instead a process by which visual certainties are questioned and replaced with seemingly limitless representational possibilities. The film progresses through a series of kinetic compositions, which, through their shared visual characteristics, actively invite the viewer to make formal connections between them. A key indicator of this relationship is the emphasis on movement, which creates a kind of continuity from one shot to another. Man Ray's interest is clearly directed towards the quality of movement within the frame. Each section appears as a carefully composed illustration of different visual effects and their ability to transform the nature of the object being presented. For example, we are invited to consider the strange magnified image of a drawing pin dancing across the screen, its usually banal and relatively insignificant status as an everyday object making its sudden grandiose appearance all the more mesmerising. Since no camera was used in the creation of this particular image, the apparent movement of the object becomes all the more significant. The viewer's attention is drawn to the fact that the movement of the film strip through the projector turns a succession of static images into an *impression* of movement. This self-reflexive device forces us into an awareness of the illusory nature of cinema, one of the key Dada strategies of questioning the representation of social reality. Man Ray therefore makes use of a self-reflexive approach to create an element of surprise or wonder that derives from an early pre-narrative interest in cinematic novelty and illusionism.

What seems to have prevented *Le Retour* from being considered seriously from this perspective is the continued insistence on its negative qualities and its positioning within a 'cinema of refusal'. One of the major characteristics of this approach is the over-emphasis on the role played by chance and its association with notions of illogic and disorder.

Chance, logic and order

Chance – submitting oneself to unknown, unmediated forces – was of crucial importance to the Dada movement since it was the principal means by which logic and order could be overthrown. The privileging of chance in the creative process was generally understood as bringing about a more truthful representation of reality through the suppression of rational thought. Automatism, as it became known during the Surrealist years,[64] referred to the act of speaking, writing, drawing or painting in a spontaneous manner or 'without thinking'. This involves a suppression of the conscious, rational mind, allowing the unconscious – the part of the brain that is usually latent during waking life – to be expressed. Although automatism only became codified and theorised within Surrealist discourse, automatic processes also played a significant role in Dada art and writing. Tzara's Dada Manifesto of 1918 is to a large extent characterised by this 'stream-of-consciousness' style, jumping from one thought to another without any real sense of logic or progression:

> To launch a manifesto you have to want: A.B. & C. [...] To impose one's A.B.C. is only natural – and therefore regrettable. Everyone does it in the form of a crystal-bluff-madonna, or a monetary system, or pharmaceutical preparations, a naked leg being the invitation to an ardent and sterile Spring. The love of novelty is a pleasant sort of cross, it's evidence of an naive don't-give-a-damn attitude, a passing, positive, sign without rhyme or reason. But this need is out of date, too. By giving art the impetus of supreme simplicity – novelty – we are being human and true in relation to innocent pleasures; impulsive and vibrant in order to crucify boredom. At the lighted crossroads, alert, attentive, lying in wait for years, in the forest.[65]

Whilst we can pick out a thread of an argument from this excerpt, the status of the manifesto as an exercise in writing freed from the normal constraints of intellectual logic is evident. Tzara continually thwarts the reader's desire for meaning and coherence. As if in anticipation of this, he periodically alerts his audience to the Dada state of mind through self-reflexive cues, such as 'a naive don't-give-a-damn attitude', 'without rhyme or reason' and 'impulsive and vibrant'.

In the visual arts, chance was employed by a number of individuals associated with Dada. Long before the *frottages* of Max Ernst or the automatic drawings of Joan Miró and André Masson, artists such as Jean Arp in Zurich and Marcel Duchamp in both New York and Paris were introducing chance as a main element in their work. Using similar processes in which objects were randomly dropped onto a surface and fixed into position, Arp and Duchamp invented new systems of creation in which conscious intention becomes only the secondary aspect of the work. Man Ray, whilst still in New York, had also seized on the element of chance whilst working on *The Rope Dancer Accompanies Herself With Her Shadows* (1916). Here he describes the way in which he became aware of the creative possibilities of chance:

> I began by making sketches of various positions of the acrobatic forms, each on a different sheet of spectrum-coloured paper, with the idea of suggesting movement not only in the drawing but by a transition from one colour to another. I cut these out and arranged the forms into sequences before I began the final painting. After several changes in my composition I was less and less satisfied. It looked too decorative and might have served as a curtain for the theater. Then my eyes turned to the pieces of colored paper that had fallen onto the floor. They made an abstract pattern that might have been the shadows of the dancer or an architectural subject, according to the trend of one's imagination if he were looking for a representative motive. I played with these, then saw the painting as it should be carried out.[66]

In a way similar to the process used for Duchamp's *Three Standard Stoppages* (1913–14) or Arp's series of abstract collages, the arrangement of Man Ray's pieces of paper representing the contours of cut-out images could be seen to express his unconscious since the trajectory taken by them was determined by an automatic gesture of the hand as it threw them onto the floor.

It is useful here to compare Man Ray's recollections of *The Rope Dancer's* construction with Tzara's instructions for the making of a Dada poem:

> Take a newspaper.
> Take some scissors.
> Choose from this paper an article of the length you want to make your poem.
> Cut out the article.
> Next carefully cut out each of the words that makes up this article and put them all in a bag.
> Shake gently.
> Next take out each cutting one after the other.
> Copy conscientiously in the order in which they left the bag.
> The poem will resemble you.[67]

Just as Man Ray recognised the artificiality of conscious intention and ultimately embraced the beauty of his unconscious (or automatic) creation, so too does Tzara reject all illusions of artistic skill in advocating a direct expression of the mind through chance compositions (in fact, in his emphasis on the simple processes of cutting and pasting, Tzara seems to encourage a regression to the kind of artistic activity carried out by children). However, despite their insistence on a random, disorderly approach to the creative process, Tzara's guidelines betray an underlying element of ordered intention that seems to question the possibility of pure chance. The very act of choosing the newspaper, isolating particular words, placing them in a bag, taking them out one-by-one, and then copying them 'carefully' represents a controlled framework from which the chance creation is born. From the ironic tone of these instructions and the inherent contradiction in providing guidelines for the production of a Dada work of art, it is very likely that Tzara was aware of the paradoxical issues involved in the notion of chance. These issues are similarly expressed in Man Ray's use of chance as a creative method. Arguably more so than Duchamp and Arp, Man Ray incorporates unconscious expression into an ordered practice, controlling and structuring it in such a way as to bring about a creative tension between the conscious and the unconscious, order and chance.

Rayography

The element of chance plays a complex role in *Le Retour* and has been a key concern in discussions of the film. This emphasis is often related to the context in which it was made, with Tzara's last-minute request requiring Man Ray to quickly produce some extra footage. It had apparently been Tzara's idea to employ the same process of camera-less image production – rayography – to the medium of film. Man Ray's still rayograph images had already been appropriated by the Paris Dada group by way of Tzara, who wrote the preface for a catalogue of twelve such images published in 1922 as *Champs délicieux*.[68] This publication was announced a few months earlier in the Dada journals *Le Coeur à barbe* and *Les Feuilles libres*, firmly situating the new photographic method within Dada aesthetics. Furthermore, the title of the catalogue was a reference to an earlier publication by André Breton and Philippe Soupault, *Les Champs magnétiques*, a collection of their automatic poems.[69] An analogy was thus made between the process of 'écriture automatique' and Man Ray's technique of producing traces and imprints of objects in his rayographs. His initial discovery of the process, the details of which are now widely known, is itself hailed by commentators as the ultimate chance event. Whilst developing prints in his darkroom, he had accidentally placed a couple of objects on a sheet of photosensitive paper. On turning on the light and then subsequently developing the paper, he noticed the shadows of the objects gradually appear.[70] An accident that turned out to be one of the turning points in his career and a dual demonstration of the way chance can be used artistically.

Although Man Ray was not the first photographer to use the camera-less process – the first photograms were produced by Henry Fox Talbot in 1835 and Christian Schad, a member of the Zurich Dada group, began experimenting with the technique around 1918, followed by László Moholy-Nagy – he explored it so vigorously that it became one of his trademarks and attracted the attention of both the Dadaists and the Surrealists to the poetic potential of photography. Yet, a number of critics have expressed their doubt about the authenticity of Man Ray's account. Tzara had been in close contact with Schad in Berlin and had in his possession a number of camera-less images produced by him. As Jan Svenungsson argues, it is

highly probable that Tzara had shown these images to Man Ray, encouraging him to produce similar effects.[71] In any case, in the transformation of the term 'photogram' into 'rayograph', Man Ray asserted his authorial control over the technique and became its principal practitioner. Throughout the 1920s, these rayographs illustrated a range of Dada and Surrealist journals, becoming the official mode of photographic expression associated with both movements. In commentaries by both Dada and Surrealist writers, it was often the element of automatic visual poetry that was highlighted and celebrated.[72] The rayographs were said to express the poetic hand of the artist or the secret aura of the object (these qualities will be discussed in more detail at a later stage), but were mostly admired for the way in which they eschewed the reliance upon the technical apparatus of the photographic medium. The relationship between the photographer and reality was no longer defined in terms of distance and mechanical intervention, but could achieve the same level of self-expression and subjective interpretation of reality as the writer or painter.

It is from this perspective that rayographs can be seen to open themselves up to the forces of chance, but also to the notion of negation, both crucial aspects in existing accounts of *Le Retour*. In his autobiography, Man Ray remembers the manner in which he went about creating the extra rayograph footage for the film, stating:

> Acquiring a roll of a hundred feet of film, I went into my darkroom and cut up the material into short lengths, pinning them down on the work table. On some strips I sprinkled salt and pepper, like a cook preparing a roast, on other strips I threw pins and thumbtacks at random; then turned on the white light for a second or two, as I had done for my still Rayographs. Then I carefully lifted the film off the table, shaking off the debris, and developed it in my tanks. The next morning when dry, I examined my work; the salt, pins and tacks were perfectly reproduced, white on a black ground as in X-ray films, but there was no separation into successive frames as in movie films. I had no idea what this would give on the screen. Also, I knew nothing about film mounting with cement, so I simply glued the strips together, adding the few shots first made with my camera to prolong the projection.[73]

This extract raises a number of important questions for a discussion of *Le Retour* in relation to the Dada principles with which it is frequently associated since Man Ray seems at pains to emphasise a casual, haphazard

process of creation. Indeed, the most interesting aspect of the film seems to derive from the relationship between the artist and his material. Man Ray's description of his method of filmmaking as analogous to that of a cook preparing a roast[74] subverts conventional notions of the cinema as involving a high level of technical expertise and requiring a certain amount of pre-planning and logic. By taking away the cinematic apparatus and submitting the filmmaking process to the laws of chance, Man Ray rejects the very basis of the art form, just as he had rejected the conventions of photography by the same means.

Although *Le Retour* demonstrates a turn away from the structures of conventional filmmaking, the use of chance as a creative method does not automatically equate to the destruction of logic, as argued by Rudolf Kuenzli for example. Although he describes his application of the rayograph process to the strips of film in terms of a random and inattentive method and a lack of knowledge about the final result, Man Ray was not entirely ignorant to the effects that could be created with different kinds of objects. Looking at some of the photographic images he produced during this period, one can detect an increasing awareness of the way particular forms and textures could be juxtaposed to create compositional tension. Referring to the way chance plays a role in another of his photographic techniques – the process of solarization[75]– Man Ray stated, 'Avant c'était le hasard. C'est moi qui l'ai pris sérieusement, qui l'ai perfectionné, qui l'ai contrôlé, pour obtenir une certaine qualité [...] on croyait que j'avais retouché mes photos, mes négatifs, que j'avais cerné le sujet avec une ligne noire. Mais c'était un procédé connu [...] et je l'ai contrôlé pour le répéter. Alors quand on répète une chose, ce n'est plus le hasard.' [Initially it was a matter of chance. It was I who took it seriously, who perfected it, who controlled it, in order to obtain a certain quality [...] They thought I had touched up my photos, my negatives, that I had the emphasised the subject with a black line. But that was a well-known process [...] and I controlled it in order to repeat it. And when one repeats something, it is no longer a matter of chance.][76] This tension between chance, repetition and control can equally be understood in relation to the rayograph technique and its use in the film.

It is safe to say that the objects used in the rayograph sections of the film would have been selected with some foresight as to the kind of visual impression they would leave once the strips had been developed. With this in mind, is it by chance that a single drawing pin is juxtaposed with multiple nails, producing a kind of visual harmony? Similarly, can we simply attribute to chance Man Ray's choice to begin *Le Retour* with the strip of film on which he had placed grains of salt and pepper, rendering identification of the image impossible and thus plunging the viewer into a state of confusion? Furthermore, if we examine closely the structure of the film, it seems unlikely that the separate sections were assembled without any consideration of visual progression, a key aspect that will be dealt with later in this chapter.

Visual compositions

Even if we accept that chance plays a role to a certain extent – Man Ray could not have accurately predicted the exact nature of the impression of movement created during projection in placing the objects onto the film strip – it cannot be related to those sequences already produced before Tzara's request. These sections strongly suggest their status as studies in light, form and motion, once again calling to mind Man Ray's declaration that his initial interest in film was to create moving versions of his still compositions. Indeed, they reflect some of the recurring themes in his work: the naked female body, spiralling forms and complex compositions of an object and its shadow. The inclusion of his own static work *Danger/Dancer*, attests to his desire to explore the way in which his previously developed visual ideas could be enhanced through motion. As such, these moments take on a more constructed quality, displaying little of the spontaneity that characterises the rest of the film.

Whilst Man Ray clearly draws attention to the process by which the rayograph images were created and the specific conditions that gave rise to them, he is particularly evasive in his description of the camera-based sections that make up the latter half of the film:

> I made a few sporadic shots, unrelated to each other, as a field of daisies, a nude moving in front of a striped curtain with the sunlight coming through, one of my paper spirals hanging in the studio, a carton from an egg crate revolving on a string – mobiles before the invention of the word, but without any aesthetic implications nor as a preparation for future development: the true Dada spirit.[77]

His reference to 'sporadic shots' is interesting in its insistence on their trivial nature. In contrast with the description of the rayographs, we are given very little information about the construction of these shots and the state of mind with which they were approached, outside, of course, the vague reference to the Dada spirit. Considering this account, it seems that Man Ray was more compelled to foreground the connection with Dada than to point to any specific aesthetic framework, positively avoiding the notion that any part of the film could have been the result of an 'artistic' approach – the perceived enemy of Dada. Yet few critics have been concerned about this omission, preferring, like Man Ray, to concentrate on those areas of the film that attest to its significance in terms of reaction, rejection, negation and subversion.

As I will demonstrate, these individual sections develop a consistency not only with each other, but also with the sequences of rayographs against which they are placed. Although Man Ray describes these images as unrelated – a view which would be recycled for many years to come – they are only unrelated in terms of *what* they present, not *how* they are presented. A naked torso has little in common with a suspended paper spiral or an egg carton so their juxtaposition is accepted as a subversion of the linearity and logic of conventional film. However, to subscribe to such a limited interpretation is to ignore one of the unifying themes of the film, that is, the building of a simultaneous awareness of similarity and difference by isolating the object and setting it into motion. Few discussions that point out the disparity between the objects themselves look further into their representative complexities. The short section in *Le Journal du Dada*, for instance, observes that the objects have little in common with each other but also mentions that the nude torso is *moving* and that the egg crate is *turning*, no doubt paraphrasing Man Ray's own description in his autobiography. The same source also refers to the presence of light, but its wider significance is left unexplored.

The intricate relationship between form and content is one of the major characteristics of the film, taking it beyond the idea of a straight-forward negation; yet to arrive at such an interpretation requires looking beyond Man Ray's own descriptions. Therefore, if *Le Retour* is to be related to Dada, it necessarily poses crucial questions about the nature and role of Dada itself. Where does negation end and creative construction begin? Although the scope of this question is too vast to be fully explored here, it is nonetheless possible to relate some of the constructive tendencies of Dada – the desire to create order from chaos – to the structures that emerge from Man Ray's film.

Visual structures

It should be clear by now that the element of chance in *Le Retour* does not appear in isolation, and that the very notion of chance is intricately related to questions of logic and order. This duality that exists at the centre of Man Ray's film creates a strong visual framework according to which the seemingly random material develops. It is from this perspective that, from a film that has been so often described in terms of destruction, incongruity and illogic, emerge patterns of structure and a sense of underlying order. This aspect of the film has been referred to by a number of writers but never fully developed. Michael O'Pray states, 'Although Return to Reason is renowned as a fairly arbitrarily structured film in the Dada spirit, there are nevertheless strong unifying aspects to it.'[78] I would argue that the unifying aspect in fact lies within its structure rather than despite it; but before going on to discuss this point in more detail, it is necessary to broach the issue of juxtaposition, which, as we have already seen, is often used in descriptions of the film's structure.

Juxtaposition and visual transformation

The previous section discussed the way *Le Retour* replaces traditional nar-
rative structures with a system of 'attractions', effectuating a change in
the relationship between the film and the spectator. In order to further
explore the visual content, I would like to return briefly to the observa-
tions made by Merry Foresta. Whilst her account draws attention to the
nature of Man Ray's turn away from narrative, it also points to a common
misunderstanding of his films, notably the physical organisation of the
visual material. Foresta makes reference to incongruity and 'unexpected
juxtapositions', which more or less treads the same path as the views already
discussed – that is, understanding the material in terms of difference and
conflict. Arturo Schwarz also develops this idea, arguing, 'In Man Ray's
films, surprise is achieved through the chance coupling of different reali-
ties.'[79] The bringing together of unrelated material was, of course, one of
the principle techniques of Surrealism, defined by Breton as 'convulsive
beauty' and based on Lautréamont's phrase: 'Beautiful as the unexpected
meeting, on a dissection table, of a sewing machine and an umbrella.'[80] Man
Ray was familiar with the French poets by whom the movement of Surreal-
ism was largely influenced and has stated that 'quand j'ai lu Lautréamont,
j'ai été fasciné par la juxtaposition des objets et des mots inusités.' [When
I read Lautréamont, I was fascinated by the juxtaposition of objects and
unexpected words.][81]

 Yet a closer look at Man Ray's work reveals that it was not a straight-
forward juxtaposition of images in which he was primarily interested.
Jane Livingston highlights this aspect in relation to his photography. 'In
his best photographs', she argues, 'Man Ray was seldom concerned with
overt juxtapositions of unlike things per se. He wanted instead to let the
main object, whether a woman's body or a pair of painted hands, express
its own capacity for self-transformation and for impinging on other objects
in terms dictated by itself.'[82] Similarly, in *Le Retour*, a significant number
of images involve the object in isolation, and, aside from the rayograph
sequences, comparisons are made only by editing the sections together. But
even here, juxtaposition is not presented in order to draw on the incon-
gruous placement of one image next to another (within the sequence)

since this notion of juxtaposition depends on the reception of the images in terms of content. In order for such contrasts to involve a shock or surprise element, the objects must be imbued with a strong sense of realism, with their identity being clearly defined. But, as the following section on abstraction will make clear, many of the images push the boundaries of cinematic representation, approaching but never completely surrendering to visual abstraction.

Man Ray plays with notions of signification through the use of particular objects, such as the egg crate divider and the paper spiral, which transmit meaning primarily on the level of form and thus turn away from relationships based on content. From this perspective, the images in *Le Retour* transcend difference in order to achieve a harmonious balance between formal similarity and contrast. This brings us back to Foresta's initial comment and her use of the term 'dramas' to describe cinematic effects that are ultimately unrelated to narrative. There is thus an implication of the presence of structure akin to that of the traditional cause and effect relationship of narrative, where visual transformations taking place through time mirror the thematic developments of conventional cinema.

Patterns of duality

These considerations are especially important in terms of Dada since the movement expresses a desire for destruction and construction, chaos and order, which are often brought into creative balance. To quote Elderfield, 'Dada is a transfer point between the old and the new; it destroys commonsense outward appearances so as to purify the language of expression, which can then tell of a world that is itself more pure. This is all necessary because the old world is shattered and in chaos. Dada both mirrors its chaos and from within this chaos offers a glimpse of a new world.'[83] As Elderfield's essay demonstrates, this crossover between destruction and construction gave rise to a dialogue between Dada and International Constructivism in the early 1920s, and can be seen particularly in the work of artists such as Hans Richter.[84]

The path that led a number of artists from Dada to Constructivism offers an alternative view to that which represents Dada as developing singularly and un-problematically into Surrealism. Thus, the overlapping tendencies of Dada-Surrealism and Dada-Constructivism create a new perspective from which to view the works of this particularly indeterminate period. Indeed, Richter's films can be seen to weave a complex path between these different artistic affinities, with the Dada-Constructivist tendencies of the earlier graphic films, such as *Rhythmus 21* (1921) and *Rhythmus 23* (1923), giving way to the later Dada-Surrealist *Filmstudie* (1926) and *Vormittagsspuk* (*Ghosts Before Breakfast*, 1927). However, if this loose categorisation seems somewhat arbitrary, it is used only to demonstrate an interrelationship that becomes crucial in the formal analysis of *Le Retour*, the film that perhaps most effectively plays the destructive against the constructive.

These two poles of expression are related to both chance and order and unconscious and conscious expression. Eric Sellin has argued that both Dada and Surrealism, despite their emphasis on chance and automatism, actually display 'numerous spontaneous patterns of order.'[85] His discussion is based on the notion that the fundamental difference between Dada and Surrealism is 'the degree to which the particular poet or artist recognized the validity of some poetic "interference" from the conscious world.'[86] Whilst Breton, in his pursuit of pure automatic expression, rejected any kind of conscious ordering of these unconscious productions, much Dada and Surrealist art and literature is characterised by a subtle tension between chance and order. So, in Arp's collages mentioned above, the very act of fixing the pieces of coloured paper thrown at random could be perceived in terms of the chance world of the unconscious coming into play with a more ordered conscious processes. Looking at Tzara's 1918 manifesto, these tensions or dichotomous relationships can be evidenced in his statement that 'Order = disorder; ego = non-ego; affirmation = negation: the supreme radiations of an absolute art.'[87] This was a fundamental aspect of Dada, where destructive tendencies often inevitably led to constructive ones.

Throughout *Le Retour*'s short duration, disparate elements come together to form what I shall call a progression of 'harmonious contrast', reflecting Sellin's notion of the polar or binary image. This can be seen to

operate on a number of levels, the first of which emerges through the combination of images derived from radically different techniques – rayograph and camera-based. *Le Retour* is the only film in which Man Ray intertwines the two types of images since, although rayographs also appear in *Emak Bakia*, they are placed together at the beginning, forming a sort of visual prelude that separates them from the other images in the film. They establish the tone for the rest of the film in that they point to the destabilisation of vision that is to follow. By contrast, the visual discourse developed in *Le Retour* depends on the intermingling of the two types of image since it is exactly this dichotomy that establishes the crucial focus on similarity and difference and which emerges as the chief structural force in the film. As mentioned earlier, the very first image is striking in its ambiguity. We are given no clear visual clues as to its pro-filmic source and it is virtually impossible to even make the distinction between abstraction and figuration. Once or twice, tiny circular dots seem to emerge from the formless mass, the first suggestion of figuration. With the appearance of the second image, however, there is little question as to the nature of the object being represented. Uncertainty gives way to certainty, confusion to confirmation and multiplicity to singularity. Even before considering the relationship between differently produced images, it is clear that, right from the beginning of the film, contrast exists within the camera-less sections. Thus, the first oscillations between the figural and the formless created by the salt and pepper grains become more pronounced when contrasted with the unmistakable contours of a drawing pin. But it is exactly this contrast that creates structure and provides the film with its formal and thematic fluidity. Geometric specificity creates another layer of contrast when the single drawing pin is joined by a handful of nails, the circularity of the former being contrasted with the linearity of the latter. Their momentary appearance together allows the juxtaposition to take place between the frames but also within them, strengthening the visual and cognitive effect. Yet another element of contrast can be detected at the level of movement; the subtle movement of the drawing pin is compared to the frenetic activity of the nails, randomly changing position across the frame.

Tonal relationships also play a key role in establishing these structural fluctuations. The ambiguity of the initial image is heightened by the

transformation and non-specificity of various shades of grey, whereas the subsequent image reinforces specificity by presenting a black object against a white background. This is made complex in the image of sequins, where grey, white and black are all present. However, as will be pointed out below, it is not only tonal variations themselves that are important here but rather the impression that is created through an encounter between a particular object and the light source. When the drawing pin and nails reappear, they are presented in negative, reversing tonal relationships and demonstrating that the appearance of an object is ultimately tied to the process involved in its representation. The contrast between positive and negative and black and white is a crucial feature of Man Ray's photographic work and is not restricted to the use of the rayograph technique. For example *Noire et Blanche* (1926) draws upon the contrast between Kiki's pale face and the deep black of the mask she holds next to her. This photograph is interesting also in the way it establishes a comparable play of similarity and contrast to that found in *Le Retour*. Kiki, with her darkly painted lips, slicked back hair and closed eyes, imitates the inanimateness of the mask, which in turn, by being held upright, contrasts with the horizontal presentation of Kiki's face. It is exactly this delicate exchange of characteristics and the weaving of an intricate web of divergence and convergence that furnishes Man Ray's work with its particular aesthetic appeal. The negative print of the photograph (see figure 8) corresponds with the positive and negative sections of rayographs and clearly emphasises how Man Ray's formal concerns in this film have a strong basis in his photographic productions.

The introduction of lens-based imagery creates a more complex interplay of similarity and difference, in which Man Ray's interest in light is further developed. The first is the image of a light bulb, whilst the second features a montage of fairground rides. Their difference is apparent in the sense that they derive from the film camera and thus provide a counterpoint to the rayographs. However, both sections present an image in isolation from its surroundings, a process made possible by filming an artificial light source against a darkened background. The light bulb and fairground lights are not necessarily important in terms of what they represent, but, abstracted and reduced to simple white forms against black backgrounds, a connection can be established between them that goes beyond their

functional significance. Seen from this perspective, a screen of unidentified shapes, as in the sequences of rayographs, becomes comparable to a range of recognisable phenomena since form is privileged over content. Through formal transformation and simplification, the image of a light bulb floating across the screen, white against black, in some way resembles the direct impression left by the drawing pin and the horizontal movements of the fairground lights.

Therefore, objects that in everyday life would rarely be considered together are allowed to shed their formal and functional differences to achieve a level of convergence. Whilst the couplings themselves may be incongruous, the effect created is ultimately one of visual harmony. Considering the relationship between the camera-based images themselves, the singularity of the light bulb can again be compared to the multiplicity of fairground lights, further reflected in the single shot of the former and the multiple shots of the latter. Taking this analysis further still, we could argue that the light bulb and the fairground lights compare and contrast artificial light in opposing surroundings: interior and exterior. The sequence of fairground lights is particularly significant in the sense that it mirrors the frenetic movement of the previous rayograph images. There is a constant focus on movement, but the nature of this movement changes from one shot to the next, just as the separate sections of rayographs all create their own unique kinetic activity. In addition to the filming of different rides moving in opposite directions, there is also the movement of the camera itself. That this montage of activity is immediately followed by the film's most static image – the single shot of *Danger/Dancer* – allows further parallels to be drawn at the level of tempo.

The last three sections of *Le Retour* are perhaps the most interesting in terms of formal structure. The visual complexity of the previous sequences of rayographs pushes the viewer towards an increased level of optical awareness. As is the case with the preceding images, the strongest structural link is that of movement. However, it is not simply the presence but the nature of the movement that is of crucial importance during these sections. It is the only instance in the film where movement is controlled to produce a specific effect – a fact that seriously throws into question Man Ray's claim that these images were produced 'without any aesthetic

implications.' In fact, the aesthetic implications become clear when we consider the relationship that is established from one shot to the next. The paper spiral, echoing the formal characteristics of the spring featured in the rayograph section, winds around itself as it rotates from an unseen source. It is this rotation that leads to both the literal and metaphorical 'unravelling' of the object, the identity of which is, up to a point, obscured by the movement itself.

The subsequent shot of the egg crate divider advances the visual complexity by adding another layer of perception: that of a shadow cast onto the blank wall behind it. Again, the object rotates in the same direction as the paper spiral, left to right, but this time the accompanying shadow rotates in the opposite direction. The object is duplicated to produce its own antithesis. Yet the shot goes much further in developing structural contrasts. We are again exposed to different visual effects as the movement is executed at varying speeds and multiple layers are gradually superimposed one on top of another, making vision complex and bringing the image closer to abstraction. Man Ray is clearly experimenting with the way in which perception is modified at a temporal level, a process that inevitably depends on comparison.

The final shots of the film – those of the nude torso – both confirm and conclude the themes of rotation and modulation. The movement, although not attaining a full 360-degree rotation, mirrors that of the previous two shots in that the orientation is from left to right and right to left. Visual complexity is achieved by using the body itself as a background for the projection of shadows, which creates, as before, a multi-layered composition. This projection-within-a-projection looks ahead to a similar mise-en-abyme structure of the swimming pool sequence in the later film *Les Mystères du Château du Dé*, where Man Ray films sunlight reflected off the water and onto the surrounding walls. In *Le Retour* this process is given additional significance through the body-as-screen analogy and, in turn, the notion of the screen as a kind of 'skin'.[88]

The effects achieved in these sequences are intricately related to the objects from which they emerge. The compositional tension that arises from the shot of the egg divider is a direct result of its geometric specificity. Similarly, it is the subtle contours and controlled movement of the

human body that allow shadows from the curtained windows to take on a life of their own, stretching and moulding themselves to the curves of the breasts. This celebration of formal specificity is a thread that weaves together the film's individual sequences and offers a convincing argument against the notion of incongruity.

Approaches to representation

One of the most revealing aspects of *Le Retour* is its approach to cinematic representation. It should be clear by now that rather than presenting a series of random, unrelated sequences, which adhere to the anti-logic of chance and accidental juxtaposition, the film can be seen in terms of an intricately structured work that involves the gradual development of similarity and difference. The above discussion highlights the fact that formal qualities – the way in which an image appears on screen – constitute the foundation of such structures. However, it is only by exploring the interaction between abstraction and figuration that the main concerns of the film within these realms can be seen to emerge.

Abstraction

Le Retour is often discussed in terms of its abstract or 'semi-abstract' qualities, neither of which accurately describe the complex visual permutations that take place within its short duration. Although the film does engage with the idea of cinematic abstraction, concrete reality nonetheless remains at the centre of these explorations. It seems that at the heart of *Le Retour* is the desire to throw into question the very notions of 'abstract', 'concrete' and 'figurative', and many of the images, particularly those produced using the rayograph technique, highlight the limitations of such categories and demonstrate the need for a more flexible framework for understanding different modes of visual representation. Man Ray was somewhat resistant

to the notion of abstraction and always argued that his art existed within the realms of the concrete. 'Je faisais des choses qu'on appelait abstraites', he stated, 'et pourtant je n'ai jamais rien pu faire d'abstrait: tout est concret! Dès qu'on utilise des matériaux pour une peinture ou une sculpture, elles deviennent quelque chose de concret!' ['I created works that were called abstract', he stated, 'and yet I've never been able to make anything that was abstract; it was always concrete! As soon as you use materials for a painting or a sculpture, they become something concrete!']⁸⁹ The idea behind this paradoxical statement is most effectively illustrated in an abstract sculpture, *Fisherman's Idol*, made in 1926 from pieces of cork found on a beach in Biarritz.⁹⁰ Although the sculpture resembles nothing in a figurative sense, it is nonetheless rooted in concrete reality due to the origin of its basic material. Man Ray's very pragmatic personality and attitude towards the relationship between art and life gave rise to a certain tangible presence even in those works that are most removed from physical reality. This is what distinguishes them from the metaphysical complexity of works produced by artists such as Duchamp.⁹¹

Man Ray's scepticism towards abstraction was equally evident in his approach to cinema. Asked in a questionnaire published in *Film Art* in 1936 to comment on the future of abstract cinema, Man Ray replied simply, 'There is no future for the abstract film.'⁹² Indeed, the majority of his art, be it photography, sculpture, painting or film, maintains a strong link with the outside world. The fascination with the external world expressed by the works derives from their ability to transform themselves into something unfamiliar or to communicate unknown, hidden qualities. Yet despite this continued fascination with the objects of everyday reality, it would appear that abstraction, or at least a particular notion of it, was indeed central to his artistic practice, determining his unique approach to the relationship between life and art, reality and representation. Whilst there are very few examples of pure abstraction in Man Ray's work, he nonetheless seems to have been occupied with the search for alternative modes of representation that would enable reality to speak through the chosen medium, simultaneously revealing and reinventing itself. Throughout his art the idea of reality exists not exclusively in the concrete appearance of things, but in the apparently infinite number of visual and conceptual

possibilities created by them. It is only through art, he demonstrates, that these possibilities can be discovered. '[J]e n'aime pas les choses qui sont une imitation', he states. 'J'aime la réalité pure et simple. Ou alors, j'aime ce qu'on ne trouve pas dans la vie. Mais ça, c'est difficile à trouver.' [I love reality, pure and simple. Rather, I love that which one cannot find in real life. But it's difficult to find that kind of thing.][93] Thus, his separation of the traditionally synonymous concepts of life and reality provides us with an invaluable starting point from which to consider the unique quality of his cinematic works. It can be assumed from this statement that Man Ray considers 'reality' in terms of something that is sought out, discovered or unveiled. A comment by the critic Georg Lukács on the nature of cinematic representation demonstrates a similar approach. 'The images of cinema', argues Lukács, 'possess a life of a completely different kind; in one word, they become – fantastic. But the fantastic is not the opposite to living, it is another aspect of life.'[94]

Le Retour tries to make evident precisely such hidden dimensions of the world around us. This is achieved by bringing objects into play with their abstract visual qualities. In a way similar to that with which the film approaches chance – balancing disorder with order – and visual structure – playing one element against another to create harmony and contrast – this aspect of de-familiarisation is characterised by duality since abstraction and figuration are almost always simultaneously present. Deke Dusinberre relates this aspect of the film to the formal tendencies of painting and sculpture in the 1910s and 1920s, where the tension between the two poles of representation can be seen as a central concern.[95] This opens up the perspective beyond the limits of Dada expression and relates the formal characteristics of the film to more general aesthetic tendencies in modern art. Man Ray's early painting displays distinctly Cubist traits, and in 1916 he wrote a pamphlet entitled *A Primer of the New Art of Two Dimensions*, in which he developed a theory that brought together the arts of painting, sculpture, music, architecture, literature and dance based on their potential to be expressed on a flat surface.[96] Francis Naumann has noted that this formalist program with which Man Ray was then occupied determined to a large extent the subject matter of his works.[97] Interestingly, although the pamphlet does not mention the medium of film, *Le Retour* clearly draws

on this idea of two-dimensionality. By using salt and pepper as material, the film begins with a resolutely flat image that draws attention to the actual, rather than 'imaginary', screen space, in which depth is perceived but does not exist. Steven Kovács has referred to this aspect of the film in the way it, 'negates the representative nature of the movies.'[98] I would argue that, whilst this process admittedly prevents the perception of depth that is so common to the cinematic experience, it also opens up the spectrum of representative possibilities, *extending* vision rather than denying it. *Le Retour* introduces a kind of 'cinema of the banal' but goes beyond other avant-garde films of the period by transforming the means of representation to suit the material.

Man Ray employs the camera-less process to make everyday phenomena visible, yet at the same time the absence of depth seems to render it abstract. Unlike conventional photography, rayography provides a physical imprint of reality, reducing it to its most basic form. In other words, it presents us with the ultimate representational-abstraction, an image that is at once both abstract and figurative, yet which does not seem to fit into either category. Sarane Alexandrian has argued in this respect that, 'Il n'y a aucune abstraction dans les rayographies de Man Ray: on reconnaît presque toujours l'objet qui a servi à l'impression [...] Les rayographies sont des nus d'objets, les premiers dans l'histoire de la photographie, et peut être dans l'histoire de l'art.' [There is no abstraction in Man Ray's rayographs; one almost always recognises the object used to make the image [...] The rayographs are bare of objects, for the first time in the history of photography, possibly in the whole history of art.][99] But it is the ambiguity that characterises these images that comes close to what is commonly understood as abstraction, and Man Ray clearly aims to heighten this sensation whilst remaining within the realms of reality. The white circular forms that feature in one short section of the film, for example, could be identified as decorative sequins, but, stripped to a basic outline and greatly magnified, their appearance on the screen bears little resemblance to our experience of them in daily life. Any decorative connotations they may have are reduced to denotative simplicity. In this sense, the rayographs are the perfect example of what Lukács refers to as the 'fantastic' element of the cinema's representation of external reality.

In a discussion of *Le Retour*'s representational qualities, Malcolm Le Grice speaks of the 'separation of visual qualities from their object of reference.' He argues, 'In Man Ray's film, close-up shots of a torso and paper rolls are filmed in such a way as to maintain an ambiguity about their object nature and identity.'[100] In a similar vein, Steven Kovács observes, 'Man Ray plays everyday objects against the abstraction which he can evoke from them.'[101] In both cases, abstraction is discussed as something disconnected from the objects themselves, with Le Grice using the term 'separation' and Kovács referring to the opposition between the object and the abstraction that emerges from it. The assumption is clearly that an object is figurative before it is abstract. However, it is possible to reverse this logic to suggest that abstraction exists as a basic characteristic of material phenomena, which can be sought out through the creative process. In order to arrive at such a perception, the artist must empty the object of its conventional signification. It is here that we find the most useful link between abstraction and Dada. 'Anti-art withdraws from things and materials their utility', states Berlin Dadaist, Raoul Hausmann, 'but also their concrete and civil meaning; it reverses classical values and makes them half-abstract. However, this process was only partially understood and only by some of the Dadaists.'[102] As different as Man Ray's work may have been from those associated with Berlin Dada, such as Hausmann, Hannah Höch and George Grosz, his work appears to achieve the kinds of effects referred to here. Hausmann's formulation can be seen in a number of Man Ray's most famous works of the period, notably *Cadeau* (1921) and *Indestructible Object* (1923) (see figure 9), where the object's traditional function is subverted through a subtle transformation of its form.

Suspensions in time and space

Whilst Hausmann's notion of the 'half abstract' Dada object seems pertinent to the oscillation between abstraction and figuration found in *Le Retour*, its content here is related to the visual rather than social implications of this process. One of the main strategies that leads to this oscillation between one mode of representation and another is the use of what

Man Ray calls 'mobiles'. This involves filming suspended objects in such a way that they appear to simply float and rotate in space with no visible anchorage to the real world. Although only two images involve actual suspension – those of the paper spiral and the egg crate divider (although this in itself is a reverse suspension – the crate is held up by a barely visible stick attached to its bottom edge) – many other sections of the film are characterised by their impression of suspension. The nude torso discussed above is compared with these suspended objects, not only in the movement of the body but also in its fragmented suspension within the screen space. Through camera framing, it is 'cut' at both the top and the bottom, the dismembered torso floating in an imaginary space. Interestingly, Man Ray's next film *Emak Bakia*, seems to offer *Le Retour*'s torso its missing parts by focusing predominantly on faces and legs.

The sequence of fairground lights represents one of the best examples of the way suspended motion formulates a metaphorical suspension between abstraction and figuration since the viewer is only able to clearly perceive the lights of the various rides and locations against the black background of the night. They are in a sense 'abstracted' from their source and although we are aware that the lights do not literally float in the night sky they are nonetheless separated, as Kovács puts it, from their object of reference and are suspended against an indeterminate background. It is this suspension that allows a comparison to be made between these images and those of the rayographs that precede them. As I have already mentioned, these sections of the film, produced by working directly on the film strip, create a ghostly presence of the objects to which they refer. The rayograph process provides a perfect example of suspension since the images are literally suspended between presence and absence. The black background is the ultimate representation of nothingness, whilst the white imprint of the image delineates only where the object *was*. Thus, physical suspension (of the object against a black background) gives way to temporal suspension and/or conflation, in which present and past are intertwined.

Le Retour looks forward to Man Ray's subsequent films in a number of ways. The most evident is in the approach to space and depth, which will become major themes in both *Emak Bakia* and *Les Mystères du Château*

du Dé. The majority of images in *Le Retour* reduce cinematic space and enhance the sense of two-dimensionality. Even in the final image, where the curves of the body are emphasised by patterns of light from a window, the body itself is flattened and our interest is focused on the effects that stretch across it. In the shot of the spinning egg crate the impression of depth is problematised through layered superimpositions of the same object.

The reference to writing also precludes later concerns, particularly those found in the final two films. The presence of the abstract poem set in motion effectively demonstrates the interaction between text and the moving image, specifically in relation to problems of signification. Although this image can be understood in terms of Dada negation, refusing the transmission of meaning, it also focuses attention on the privileging of form over content that seems to be at the heart of *Le Retour*. The physical act of writing on the film strip reflects a similar process to that of the rayographs, with the artist forging a more direct relationship with his material and emphasising its concrete nature in opposition to the illusory nature of cinematic representations.[103] These strategies, even whilst they foreground tactility and tangibility, nonetheless give rise to a paradoxical effect in which presence is played against absence, and the images refer less to themselves than to the process that was used to create them. That is, the projected text refers only to the *act* of writing on the film since the speed of projection renders the text incomprehensible and the inability to transmit meaning becomes its central characteristic. The signification processes of writing are also evident in the *Danger/Dancer* composition that appears in *Le Retour*, where formal transformation becomes an integral part of the reading process and double signification is neatly incorporated into the film's concentration on duality.

The following chapters explore the ways in which *Le Retour* provided the foundations for Man Ray's development as a filmmaker, and demonstrate how much of his subsequent cinematic expression revolves around the concerns of duality, cinematic representation and the creative possibilities of light and movement. These independent concerns seem to culminate in Man Ray's continued interest in the oscillation between abstraction and figuration.

The light and the lens: *Emak Bakia*

(1926, 35mm, 17 mins, black and white, silent with musical accompaniment)

Man Ray's second film *Emak Bakia* is arguably his most established cin-
ematic work – the one in which he engages most extensively with the
formal properties of the image in motion. Indeed, as with *Le Retour à la
raison*, the exploration of different forms of cinematic movement is present
throughout. Yet although the two films share many similarities, Man Ray's
formal interests are taken much further in *Emak Bakia*, demonstrating a
wide range of concerns that offer new perspectives on the nature of cin-
ematic representation. The film arose out of a commission by American
patron of the arts Arthur Wheeler, who was eager to become involved in
the burgeoning art world and saw the cinema as a promising field for the
development of creative ideas. Not only did he give Man Ray a considerable
amount of money for the project, he also left him with complete artistic
freedom. As Man Ray tells us, Wheeler was fully prepared to take the risk
of losing money since he would at least be assured that it had gone to a
worthwhile cause.[1] As it happens, the finished film was relatively success-
ful, premiering at the Vieux Colombier in Paris on 23 November 1926 and
showing in London, New York and Brussels early the following year.[2] The
conditions were ripe for its reception: *Le Retour à la raison* had already
demonstrated Man Ray's talents as a filmmaker and a new form of avant-
garde cinema had begun to establish itself through films such as *Entr'acte*,
Ballet mécanique and *Anémic Cinéma*.[3]

Although three years had passed since the making of *Le Retour*, Man
Ray had continued to work on a variety of cinematic projects. As well as
assisting Duchamp with *Anémic Cinéma* and acting in one of the scenes
in *Entr'acte*, he also carried out some of the filming for *Ballet mécanique*,
a project he eventually dropped out of for financial reasons. His approach

to the cinema had inevitably evolved during this period, and *Emak Bakia* perfectly demonstrates this development. The distorting apparatus, such as special lenses, mirrors and crystals – to which Man Ray had been introduced in his collaboration with Dudley Murphy – is employed repeatedly in this film, highlighting the extent to which the involvement in *Ballet mécanique* influenced his subsequent approach to filmmaking. Echoes of the experiments with Duchamp into optical illusion through movement can also be found in *Emak Bakia*, primarily through its use of mechanical apparatus to set in motion a range of everyday phenomena.[4] The influence of these collaborations is most clearly evidenced in Man Ray's concentration on the ability of movement to both deconstruct and transform perception, giving rise to a purely cinematic form of vision comparable to that created in *Anémic Cinéma*, the film which consolidates Duchamp's investigations into optical three-dimensionality through the use of spiralling rotoreliefs. As we have seen, the earlier *Le Retour* focuses on the way film can be used to transform, rather than simply reproduce, concrete reality, and is the first cinematic manifestation of his understanding of vision as a constantly changing and subjective phenomenon. *Emak Bakia* further develops this concern by continually drawing attention to the relationship between signifier and signified, abstraction and figuration, and subjective and objective vision. With a longer running time of just over seventeen minutes, this film is significantly more complex than Man Ray's first short work, although it displays the same kind of sequential structure in which images are linked together in order to develop and work through formal ideas. The diversity of visual expression and the range of iconography used in the film make it a difficult work to approach analytically. A preliminary discussion of its content is therefore required in order to highlight some of the main visual concerns.

The film begins with the written title 'Emak Bakia' followed by 'cinépoème' and 'de Man Ray, Paris, 1926', both of which swing and rotate freely in the middle of the screen, anticipating the series of optical distortions that follow. The opening shot, which functions as a kind of prologue, features a camera and its operator in profile. The image is manipulated so that the lens which should normally appear on the right hand side of the camera actually points directly towards the viewer, with an upside down

eye superimposed directly next to the viewfinder. This striking visual composition drastically rearranges the order of things and draws attention to the theme of distorted vision that will become one of the film's central motifs. The unusual arrangement of eye, lens and operator constitutes a mystification of the filmmaking process reflecting Man Ray's fascination with its mechanical workings. The eye slowly dissolves to reveal the lens, and the shot is immediately replaced by a sequence of rayographs taken from the beginning of *Le Retour à la raison*. A panning shot of a field of daisies momentarily interrupts these images and is then followed by more rayograph sections featuring nails and drawing pins, also from *Le Retour*. It is at the end of this short section that *Emak Bakia* both continues and departs from Man Ray's first film. Two shots of blurred moving lights against a black background create an interesting juxtaposition with the rayographed drawing pins since their perceived formal similarity as simple white circular and oblong forms transcends any difference that may exist on a denotative level. This echoes the juxtaposition in *Le Retour* of the same rayographs with the lights of fairground rides, especially since the second shot of this short sequence features the same rotational movement. Comparisons can also be made with a photograph from 1924, *Bd Edgar Quinet à minuit*, which, placed between the years of the two films, expresses the same formal interest in moving light patterns abstracted from their object of reference. One of Man Ray's rare exterior representations, this picture subverts traditional notions of the documentary image by reducing the details of the street to circles of light (car headlights) of varying intensity against a dark background, making it indistinguishable from his abstract studio photography.

Continuing the theme of light and movement, the following shot presents a scrolling neon sign across the top of a building, which reads 'Au milieu du bassin de Neptune au cours de deux grandes fêtes.' Although the text has little immediate significance – focusing attention on its simple appearance as an arrangement of lights – it represents some of Man Ray's concerns that will become more prominent in subsequent films.[5] As I shall discuss in the following pages, there are frequent allusions in Man Ray's films to the natural elements of earth, fire, water and air. The 'bassin de Neptune' highlights the predominance of water in later sections of the

film, but also looks ahead to the swimming pool sequence in *Les Mystères du Château du Dé*. Furthermore, the reference to Versailles and the Roi Soleil also prefigures the element of decadence and grandeur that Man Ray highlights through, amongst other details, references to the ancient Greek gods and goddesses.

The next section, of a more significant length, further develops this interest in light formations and involves a series of semi-abstract images created using a range of distorting lenses, mirrors, glass crystals, reflecting prisms and a rotating turntable. The first shot presents the reflections projected by a rotating glass object, which appear as simple black and white lines moving from one side of the screen to another at varying speeds, a composition that is repeated a few seconds later in a different shot involving thinner and more regular lines. The next two images are a variation of this idea, using reflective glass objects that give rise to a range of abstract impressions. The last image introduces various techniques of distortion, which involve bending and morphing the image with an anamorphic lens in order to create a series of organic shapes and curves.

In this sequence of five shots Man Ray makes light the central focus of the image, in a way representing the culmination of his experiments in photography up to that point. Indeed, Norman Gambill has argued that this section 'is important to the rest of the film and is related to Man Ray's work as a photographer.'[6] Although Gambill's discussion does not go into detail on either of these points, the connection seems to rest on the creation of abstract forms out of concrete reality and on the creative manipulation of light. Gambill refers to these images as 'Rayographs in motion',[7] forging an important link with Man Ray's photography and highlighting a process of image-making in which the hand of the artist is strongly felt. Yet, however useful it may be, the term is misleading since the actual moving rayographs that feature at the beginning of the film are defined by the process used to create them – that is, without the use of a camera and thus any kind of mechanical intervention. The images to which they give rise are often a vastly simplified and sharply defined trace of the object placed on the film strip. In contrast, this section of light refractions and distortions draws attention to the mechanical apparatus – the camera and, more specifically, the lens – even if light remains the key creative source. Also, whilst the two

types of images lean towards abstraction and describe similar geometric and organic forms, this later section is significantly more determined by a sense of formlessness and flux in comparison with the formal definition of the rayographs.

After this initial alternation between abstract and figurative imagery and the building of formal similarity, the film develops in a significantly different direction, with the introduction of extended figurative sequences that have previously been described in terms of narrative fragments. Here, the emphasis seems to move away from a formally dictated structure to a more conventional sequential progression. This begins with a shot of an eye in close-up, onto which an image of car headlights is superimposed. A subsequent shot shows a woman at the wheel of a car, the camera moving closer towards her. One of the car wheels is presented in close up then disappears as the car begins its journey, which is then experienced from the subjective viewpoint of the driver. In what can be read as a celebration of speed and movement, the camera records the road and surroundings as they race past almost too quickly for the eye to register. Speed is important primarily from the perspective of its ability to distort the image and to present an unstable vision of external reality.

A herd of sheep pass in the opposite direction, their blurred forms creating a flurry of activity. Suddenly the camera takes up a different position, showing the approaching car from a fixed location on the road and giving the viewer the impression of being physically driven over. The theme of collision is further developed in the few shots that follow, in which the image of a pig is juxtaposed with the chaotic movement of the camera. In this way, objective and subjective shots are combined to physically simulate the collision of elements.

Attention subsequently turns to the representation of the female form – particularly legs – beginning with what one assumes to be the driver of the previous sequence stepping out of the car. When the action is repeated and then superimposed so that a multitude of different feet appear simultaneously and leave in different directions, logical motivation gives way to a humorous play on form. In the discussion of *Le Retour*, it was argued that the lack of narrative does not necessarily equate to the subversion of those conventions associated with it. *Emak Bakia* on the other hand makes

a much more self-conscious reference to this absence by presenting certain cues that suggest narrative continuity from one shot, or series of shots, to the next. However, instead of respecting a conventional thematic flow of images, Man Ray subtly alters the rules of cinematic progression by focusing attention on formal relations. The viewer is initially led to assume that the legs descending the car are those of the female driver from the previous sequence, logically linking the two sections together. The getting out of the car is an indicator of subsequent action, perhaps the consequences of the collision that has just taken place. A car journey generally has a very specific narrative function in the way that it represents a forward thrust in time and space, propelling both the characters and the narrative into a new phase of cause and effect development. Here, however, this convention is turned on itself, since the repetition of the same action creates stasis and impedes narrative development. If narrative continuity is left behind, other concerns take their place, and the shot gradually emphasises formal interest through superimposition. Through the duration of this single shot, an impression of reality is transformed into a reality of impressions not unrelated to the 'cinema of attractions' approach discussed in Chapter 1.

This self-reflexive concern with technique leads into the next sequence, which builds on a number of elements present in preceding sections. There is, for instance, a clear focus on movement: shots of a pair of legs dancing the Charleston alternate with those of a banjo player. The two separate events are inter-cut in a total of nine shots, creating a strong impression of simultaneous action whilst at the same time developing a sense of rhythm. As is the case with other films of the period such as *Ballet mécanique*, repetition is a strong feature of *Emak Bakia*, and is important here in the relation between seemingly unrelated sequences. Whilst the previous shot develops multiplicity and repetition within the frame, the dancer/banjo player section is structured through montage and thus brings together two spatially unrelated actions through both alternation and repetition. Parallels are drawn between the aesthetic and emotive effects of superimposition and montage, with humour being central to the former, whilst an awareness of visual rhythm emerges from the latter. This sequence also extends the concentration on the fragmented body that begins with the feet stepping out of the car.

Just as the anonymity of the legs becomes symbolically emphasised through the building sense of ethereality and multiplicity, the hands of the banjo player and the legs of the dancer are similarly denied the unity of identification. Their signification is reduced to plastic expression. In this sense, Man Ray takes what would ordinarily function as a transitory shot or a cutaway and turns it into the main focus of attention. The subversive nature of these sections derives exactly from the fact that they signal some form of subsequent development that is withheld, denying the spectator the pleasure of narrative absorption. We do not find out the destination of the dismounting feet nor the identity of the banjo player and dancer but are instead forced to reassess our expectations and to reconsider the role and nature of the cinematic image removed from character identification.

The following images signal a sort of delayed gratification, presenting a woman whom we physically identify as the driver of the car in the earlier sequence, walking into a room and sitting down at a dressing table. However, narrative development is once again denied when it becomes clear that this scene does not follow on thematically from previous sections, but once again slides into stasis. In a series of shots we see the woman brush her hair, apply lipstick, put on a necklace and finally get up and walk out of the frame (see figure 10). Her slicked back hair and androgynous features function as a subtle reminder of Kiki's mechanised face in *Ballet mécanique*. In the next shot we see the woman approach a window and look outside, a reaction shot revealing a sea view from the window. Thematic relations once again give way to formal ones as the sea itself becomes an object of visual contemplation through a series of shots that show waves rolling onto the shore. The actions of the woman are yet another example of transition since they show her preparing herself for something that the viewer never gets to see. However, rather than presenting this particular phase within the context of an accumulation of details, as is normally the case in conventional cinema, Man Ray seems to argue for a different hierarchy of perception that gives precedence to these transitory, seemingly banal moments normally only considered important in terms of the way they build towards an ultimate narrative crescendo. The liberation of images and actions from logical narrative association therefore allows other relationships to be established. These relationships exist not only on a formal

level – the woman's gaze towards the beach motivates the shift of interest to the aesthetic qualities of water, to which we are moved gradually closer in a series of images of rolling waves – but can also be understood from a thematic perspective; in this case an association is established between the woman and the sea. This is reinforced in the following shot of a female body lying on a beach, her face hidden under what seems to be a piece of clothing, that of yet another pair of legs. Another association – woman/sun (suggested by the act of sunbathing) – is formed that follows on from the woman/sea theme. The subsequent 360-degree camera rotation, in which the image is literally tipped upside and sea and sky change places, is extremely significant in this context. Similar associations are also found to a large extent in Man Ray's next film *L'Etoile de mer*, and, as such, represent an important link between the two works.

The focus on water and nature is present again in the next section of the film, which completes the sequence of shots that gradually narrow down our field of focus and bring us closer to the water until it literally floods our vision. Superimposition is also employed to create a multi-layered and multi-textured impression in which the fish, like the feet dismounting the car, interact with their ghost-like replicas.[8] The nautical theme facilitates the film's next transition to a study of various objects in motion, in many ways reminiscent of the final sections of *Le Retour à la raison*. Man Ray's assemblage *The Fisherman's Idol*, constructed from pieces of cork found on a beach in Biarritz, is shown rotating at different speeds and is played against shadows and superimpositions of itself.

The next few sections of the film concentrate more specifically on the technique of animation in order to bring inanimate phenomena to life. The first of these shows a number geometrical blocks (closely resembling the chess set he made in the same year as the film) appearing one-by-one in front of an early painting *Dance* (1915). The Cubist style of this painting is similar to that of a slightly earlier work *A.D MCMXIV* (1914), one of Man Ray's rare direct visual references to the horrific dehumanising effects of the First World War, 'composed of elementary human forms in alternating blue and red.'[9] Whilst the machine-like figures of the paintings are stripped of their human qualities, the objects in *Emak Bakia*, with their seemingly independent movements, take on anthropomorphic characteristics, at once

examining and defying the natural laws of movement. This theme continues into the following brief shot which shows the animated movement of Man Ray's *Homme d'affaires* (1926), a quasi-scientific drawing that, mimicking the scientist, Etienne-Jules Marey's experiments in chronophotography, examines the various positions involved in a human jump (see figure 11). Another shot of animated objects follows, this time including a pair of dice, a cello neck and some of the earlier geometric blocks (see figure 12). Like the previous sequence, the objects move and transform themselves randomly in front of the camera.

Although Man Ray uses a transitional device to move from one series of visual explorations to another, there is a clear contrast between the section that begins with the car journey and ends with the swimming fish and that which follows it. The former focuses predominantly on natural elements and a fluidity of movement, whilst the latter is made up of artificial movements of abstract and inanimate objects. Steven Kovács has noted that these later shots are also characterised by 'the clarity with which their material is depicted', providing a counterpoint to previous sections of the film which contain an overriding sense of flux and visual ambiguity.

> The way they differ from the two previous fragments is that they are all nonhuman geometric forms whose movement is for the most part jerky and mechanical. Together, they act to stop the fluid continuity of what has gone before and thus serve as a temporal lull in the middle of the film. Their role is the polar opposite of that of the Charleston sequence, for while the dancing legs and banjo highlighted the musical tempo of the film, the jerky movement of sharply defined geometric objects breaks up the musical tempo by an insistence on a staccato rhythm.[10]

This presence of polar opposites relates specifically to Man Ray's sense of dialectical structure that originates, again, in *Le Retour à la raison*. An awareness of one aspect of visual representation is heightened by the presentation of its opposite. In this sense, the contrasts in *Emak Bakia* can be considered not as a means to shock and frustrate the audience with its refusal of consistency, but rather as an exercise in the development of formal relationships based on rhythmic alternations.

Another change of direction is marked by the return of the scrolling text, 'Avec Marcel Doret', 'Le Journal annonce', which is followed by more

abstract light-play, distortions, reflections and superimpositions. A woman's face appears and smiles at the camera then another shot presents a flower onto which a different face is gradually superimposed. These two shots again represent an interest in the female form as an object of aesthetic beauty, particularly in the association of the image of a woman's face with that of an especially voluptuous flower. There is a clear reference to sexuality here: the passive sexuality of the flower is juxtaposed with the similarly passive position of the woman who, no doubt under the instructions of Man Ray, simply stares into the camera, subtly mouthing a few words. This latter detail is noteworthy since the fact that we see her speak but do not know what exactly she has said emphasises a kind of enforced or contradictory silence. At the same time, this gesture can be read as a form of protest, of a woman that refuses to be turned into an object of aesthetic beauty and breaks the illusion by stressing her personality and individuality through speech. The ambiguity surrounding the way in which the act of speaking affects the reading of the image and the dual presence of two opposing interpretations again serves to demonstrate the importance of duality as one of the film's central motifs.

After these figurative moments, more distortions and superimpositions appear as specks of light that rotate and rush past the camera lens. An intertitle – the first and only one in the film – introduces the final sequence, stating, 'La raison pour cette extravagance.' In his autobiography, Man Ray points out that this textual insert 'was to reassure the spectator, like the title of my first Dada film: to let him think there would be an explanation of the previous disconnected images.'[11] It is this aspect of the film that is most often discussed in terms of its Dadaist rejection of cinematic conventions and a direct provocation of the audience by manipulating their expectations. Man Ray's statement is curious, however, since it seems unlikely that even the most naïve spectator could possibly envisage any 'explanation' of the film up to this point. Another section of his discussion offers a more convincing perspective on the action that follows: 'I needed [...] to finish it with some sort of climax, so that the spectators would not think I was being too arty. This was to be a satire on the movies.'[12] Man Ray was therefore clearly aware of the tension between aesthetic invention and the desire to provoke that was central to many Dada-related works of the period.

After the subtitle, another figurative sequence follows, again involving a car. This time, we see not the beginning of a journey as in the section featured earlier in the film, but the arrival of a driver at his or her destination. The car pulls up outside a building and a man steps out of the back seat and walks towards it. A strangely disorientating camera angle shows the man's head from above, which can be read in terms of a defamiliarising device and perhaps a clue to the abstract distortions to which the film will soon return. Once inside, the man opens a briefcase, methodically taking out and ripping apart shirt collars and letting them fall onto the floor below. He then rips the collar off his own shirt, and at this moment the film reverts to the formal explorations that have been its guiding principle throughout; first exploring the movement of the collars in slow motion as they fall to the floor, then reversing the movement so that they appear to jump up from the floor in an animated gesture that recalls earlier moments in the film. The sequence ends with the collars seeming to float and dance in the air (see figure 13), before returning to a final section of rotating distortions and light refractions.

Interestingly, a number of details in this sequence point to aspects of Luis Buñuel and Salvador Dalí's Surrealist film *Un Chien andalou* (1929) released three years later. There is, on a very basic level, the element of repetition, although this is markedly more related to formal interests in *Emak Bakia* than it is in *Un Chien andalou*; the latter focuses more heavily on the repeated motif as a function of unconscious thought. A stronger link can perhaps be made between the two films through their emphasis on the role of clothing. In both films, formal attire functions as a metaphor for suffocating bourgeois social and moral codes. It is difficult not to relate, as a number of critics have already, the tearing of shirt collars in *Emak Bakia* with a rejection of these bourgeois values, and as representing an act of self-emancipation. As the following section demonstrates, the relationship between *Emak Bakia* and *Un Chien andalou* is particularly important to our understanding of the former's position in the context of Dada and Surrealism.

In the final image of *Emak Bakia*, a woman (Kiki de Montparnasse) with open eyes raises her head and, revealing the eyes to be painted onto her eyelids, opens her eyes for real. An upside down version of the same

image is superimposed onto the original, highlighting the confused sense of perception and bringing us full circle to the themes set out in the opening image. A series of repetitions and a trick played on the spectator; yet, as we shall see, this ending has been considered in terms of its much deeper implications. Kovács, for example, has stated that in this final sequence of the film, which involves the 'double awakening' of Kiki, 'a Dada trick is perpetrated on a Surrealistic motif', that of the 'mystery-evoking woman.' He goes on to suggest that, 'The double ending, which features provocative elements and which in itself is a provocative device, is so well woven into the cinematic fabric that we witness the inextricable fusion of Dada and Surrealist intentions.'[13]

No description of the film would be complete without at least a brief mention of the use of music as a complement to the visual material. Although *Le Retour* was entirely without sound (a detail that relates more to the circumstances surrounding its making than to any particular purist intentions), *Emak Bakia* was conceived with well-known jazz music in mind. The instructions left by Man Ray for the musical accompaniment to his films contain W.C. Hardy's 'St Louis Blues' and Douglas Furber and Philip Braham's 'Limehouse Blues', both interpreted by Stephane Grappelly and His Hot Four with Django Reinhardt, as well as other jazz pieces and the Victor Continental Orchestra's 'Merry Widow Waltz'.[14] His own account of the first screening of *Emak Bakia* at the Vieux Colombier emphasises the connection between image and sound: 'The phonograph began a popular jazz tune by the Django Reinhardt guitarists while the screen lit up with sparkling effects of revolving crystals and mirrors [...] Whenever the phonograph stopped, the piano and violin trio took up with a tango or some popular sentimental French tune.'[15] A pause occured during the section where Rigaut tears apart the shirt collars. 'It was a dramatic moment', states Man Ray, 'that might lead into some action with suspense. But when the collars began to gyrate into distorted forms, the orchestra broke out into a lilting rendering of Strauss's "Merry Widow Waltz."'[16]

Man Ray saw the music as a fundamental element of the film's overall structure, contributing to the sense of rhythm and visual dynamism, but also guiding the viewer's expectations and emotional responses. The sequence of the banjo player and Charleston dancer is a clear reference

to musical rhythm and the film's own attempt to create a sense of this through the images. Similarly, the alternation of musical styles and tempo both reflects and contributes to the sense of fragmentation that is present on a visual level.

Man Ray's choice of music situates *Emak Bakia* within the context of popular culture and modern contemporary life – the 'extravagance' as it is referred to in the subtitle that appears towards the end of the film. This is reflected through the recurring presence of motor-cars, bathing suits, music and dance, not to mention the images of the newly liberated woman. Rather than provide a critique of modern society, Man Ray's film seems rather to celebrate it through a fascination with fashion, technology and entertainment. Furthermore, whilst Dada and Surrealist works of art claim to react *against* bourgeois frivolity, *Emak Bakia* emerges precisely *from* this setting. This is especially important when considering the ambiguous positioning of the film in relation to these movements, a subject to which this discussion will now turn.

Between Dada and Surrealism

Emak Bakia raises some crucial questions about Man Ray's relationship with the Dada and Surrealist movements. If his first film *Le Retour à la raison* is, for the majority of critics, easily assimilated into the discourse of Dada, primarily through its inextricable link with the movement's last soirée for which it was made, this is certainly not the case with his second cinematic excursion. The artistic climate had altered dramatically in the three years that separate the two films, as Ian Christie points out:

> Between Man Ray's first film and his second, André Breton emerged from the Paris Dada group with his conception of the Surrealist movement, and many former Dadaists, including Man Ray, followed him into Surrealism. It is at this point that the 'first' Dada cinema gives way to a second, in which the traditional elements of representation and narrative become the subject of Dada subversion.[17]

Although the first Manifesto of Surrealism appeared in 1924, it wasn't until much later, in 1929, that the first quintessentially Surrealist film was made, or at least one that met with the approval of Breton and his followers. This film, *Un Chien andalou*, represented a clear break with the self-reflexive concentration on form and cinematic representation that was so characteristic of abstract and Dada-related filmmaking, and returned to a traditional concern with narrative and optical realism. Elements of narrative and mimetic representation, the rejection of which had characterised many films of the 1920s (particularly those associated with the Dada movement), were now embraced as the principal means of attaining in cinema what the Surrealists had achieved in painting and literature: a fusion of reality and imagination inspired by dreams. Compared with the experiments into movement and rhythm that to a large extent characterise a number of experimental films of the period, such as Henri Chomette's *Jeux des reflets et de la vitesse* (1924) and *Cinq minutes de cinéma pur* (1926), as well as *Ballet mécanique* and *Entr'acte*, *Un Chien andalou* and the critical acclaim it gained, clearly points to a changing sensibility in the realms of avant-garde filmmaking.

It is for this reason that Christie's notion of a second stage of Dada cinema is particularly relevant since it suggests the presence of a transitional period during which Dada techniques were still in use but were accompanied by tendencies that could be considered Surrealist. Furthermore, that Surrealist concerns and motifs can be found in films whose structure and overall aim seems to have more in common with Dada, as the earlier statement by Kovács about *Emak Bakia* seems to claim, puts forward the idea that a certain fluidity exists between the two movements. The question must be asked, however, whether an interrelationship between the tendencies of Dada and Surrealism can exist in the same work and if so, what are the implications of such a duality? Rudolf Kuenzli creates a very definite divide between the two modes of expression, arguing that although Dada and Surrealist films both challenge the conventions of traditional cinema, they do so in radically different ways and in relation to their respective artistic aims. 'The difference between Dada and Surrealist films', he states, 'lies in their different strategies of defamiliarizing social reality. Surrealist filmmakers largely rely on conventional cinematography (narratives,

optical realism, characters) as a means to draw the viewer into the reality produced by the film. The incoherent, non-narrative, illogical nature of Dada films, which constantly defamiliarize the familiar world through cinematic manipulation, never let the viewer enter the world of the film.'[18] So, if we are to accept this divide, which would automatically involve accepting Dada and Surrealism as occupying separate terrain in relation to film, then the notion of a period of interchange, where the explosion of Surrealism affects Dadaist expression, seems particularly problematic. Furthermore, as Thomas Elsaesser has pointed out, the very fact of associating films made after 1924 with Dadaism, when the revolutionary ideals of the movement had long been declared futile, also raises some important questions.[19] *Emak Bakia* evokes this difficult critical position since, although it demonstrates qualities that relate to Dadaism (particularly those cited by Kuenzli: nonnarrative, non-psychological, self-referential, de-familiarisation of social reality), it was made precisely during the period when the destructive practices of the Dada movement were being replaced by the more socially and politically constructive aims of Surrealism. The inclusion in *Emak Bakia* of a sequence of images made for *Le Retour à la raison* further complicates matters. But before exploring these issues in detail it is necessary to outline some of the main principles of the Surrealist movement, its relationship with Dada, along with its impact on avant-garde filmmaking.

The emergence of Surrealism

In a book documenting the various stages of the movement, René Passeron argues that Surrealism 'was born long before the explosion of Dada in Paris', in the collective literary activities of a number of men who came to know each other through their involvement in the First World War: André Breton, Philippe Soupault and Louis Aragon.[20] Together, they established and wrote for the journal *Littérature*, which published, in 1919, one of the earliest examples of Surrealist automatic writing: Breton and Soupault's *Les Champs magnétiques* (*The Magnetic Fields*).[21] At about the same time, the Dada movement was establishing itself and many of the French writers, although hesitant at first, gradually became involved through the powerful

influence of Tristan Tzara.[22] However, between 1921 and 1922, artistic and political disagreements amongst key members, along with the general waning of the movement's effect on the public, led to the break up of the Dada movement. Breton, dissatisfied with the destructive, nihilist attitude of Dada envisaged a new creative mode, which would serve a more politically engaged, revolutionary function, where the liberation of the mind from rational thought would bring about the ultimate emancipation of mankind. The fundamental premise of this new approach was the celebration of unconscious processes and the fusion of the real with the imaginary.

Previously a student of medicine who spent his military service during the war treating shell-shocked soldiers in a psychiatric hospital, Breton was hugely influenced by his exposure to mental illness and hysteria brought on by the atrocities of the war. His interest in the complexities of the human mind, along with the theories of Sigmund Freud, led him to assert that the true liberation of man could be achieved by tapping into the unconscious – that aspect of the mind most clearly represented in a dream state – thus giving rise to a deeper, more truthful form of reality. Borrowing a term first used by Guillaume Apollinaire in 1917, Breton called this envisaged reality 'surreality' and in his Manifesto of Surrealism of 1924 he explained its meaning in the following terms:

> SURREALISM, noun, masc. Pure psychic automatism by which it is intended to express, either verbally or in writing, the true function of thought. Thought dictated in the absence of all control exerted by reason, and outside all aesthetic or moral preoccupations.

> ENCYCL. Philos. Surrealism is based on the belief in the superior reality of certain forms of association heretofore neglected, in the omnipotence of the dream, and in the disinterested play of thought. It leads to the permanent destruction of all other psychic mechanisms and to its substitution for them in the solution of the principal problems of life.[23]

As stated by Patrick Waldberg, 'Imagination, folly, dream, surrender to the dark forces of the unconscious and recourse to the marvellous are here opposed, and preferred, to all that arises from necessity, from a logical order, from the reasonable.'[24]

Although Surrealism was initially conceived in terms of the literary, visual expression also played a key role in the movement, and Breton's principles were soon extended to the field of painting and photography. The first manifesto had placed emphasis on automatic language but this did not necessarily rule out the idea of an automatic image since language and vision are inextricably linked, especially within the realms of the dream. Indeed, Breton's account, in the first Manifesto of Surrealism, of how he 'discovered' automatic writing perfectly demonstrates this relationship. He describes how, just before falling asleep, he encountered an astonishing phrase – along the lines of 'there is a man cut in two by the window' – that seemed to arise from his unconscious. Although he could not remember the phrase exactly, 'there could be no question of ambiguity, accompanied as it was by the faint visual image of a man walking cut half way up by a window perpendicular to the axis of his body.'[25] In the context of this anecdote, the unconscious possesses a strong visual element and a capacity to produce what Breton would later call 'convulsive beauty',[26] derived from Pierre Reverdy's 'juxtaposition of two more or less distant realities.'[27] Interestingly, this *reconstruction in space* of a man leaning out a window'[28] (my emphasis), as Breton describes it, reflects on the representational process of the visual arts such as painting and film and thus creates a link between these primarily spatial arts and the unconscious.

The centrality of visual representation can also be seen in the journal *La Révolution surréaliste*, published between 1924 and 1929. Man Ray's photographs dominate the first issue and were to be joined in later issues by works of both painters and photographers. In that first issue, however, Pierre Naville, who was then the editor, rejected openly the idea of Surrealism in the visual arts, stating, 'Everyone knows that there is no Surrealist painting.'[29] Breton, whose views did not correspond with those of Naville, took over editing the journal and some years later published *Le Surréalisme et la peinture*, a book comprised of a series of essays on ten major artists of the time, some of which were not directly related to the movement, such as Pablo Picasso and Georges Braque.[30] Thus, despite certain apprehensions about the translatability of Surrealism to the plastic arts, the movement developed a strong visual component, extending into the realms of painting, photography, sculpture and film. Surrealist vision relies on a concrete,

recognisable reality that serves as raw material for the irrational juxtaposi-
tions and transformations, from which a new order of things can be seen
to emerge. As Linda Williams describes, 'The Surrealists' expansion of the
poetic image into the realm of the visual arts resulted in the re-adoption of
conventions of figural art abandoned by Cubism. Recognisable objects were
once again given a certain existence in space.'[31] This move from abstraction
– which characterised much Dadaist art – towards an interest in figuration
was also reflected a number of years later in the cinema, and constitutes an
important tension in Man Ray's work.

Surrealist film

Although film was not incorporated into the Surrealist project until rela-
tively late, it nonetheless occupied an important position for a large major-
ity of those involved in the movement. Many of the Surrealists were film
enthusiasts and wrote on various aspects of the medium, giving rise to a
characteristically, although not necessarily cohesive, Surrealist position
on the cinema.[32] Philippe Soupault, Pierre Reverdy, Paul Eluard, Louis
Aragon, Robert Desnos and Antonin Artaud contributed extensively to
the theoretical discourse on the cinema during the 1920s, making up for
the lack of actual Surrealist productions. Their favourite films were not
those of the contemporary avant-garde, against which they positioned
themselves in rejecting bourgeois modernism and gratuitous obsession
with form, but those of the popular commercial cinema, the *Fantômas*
series, for example, slapstick comedy and technologically 'crude' horror
films such as *King Kong* (Merian C. Cooper and Ernest B. Schoedsack,
1933).[33] In addition to this body of critical writing, a number of Surreal-
ist film scripts appeared, although most were never realised. The most
prolific in this area were Robert Desnos and Antonin Artaud. There are,
therefore, two different notions of Surrealist activity and the cinema:
Surrealist spectatorship and Surrealist filmmaking. Rudolf Kuenzli has
argued that these two approaches are contradictory since the viewing of
popular films demanded an active viewer, 'whereas truly Surrealist films
posited a passive spectator.'[34]

The practice of active viewing relates particularly to the behaviour of the spectator in the process of reception and interpretation and is best demonstrated by André Breton's cinematic outings. In a much-cited passage of an article entitled 'Comme dans un bois' he states:

> I never began by consulting the amusement pages to find out what film might chance to be the best, nor did I find out the time the film was to begin. I agreed wholeheartedly with Jacques Vaché in appreciating nothing so much as dropping into the cinema when whatever was playing was playing, at any point in the show, and leaving at the first hint of boredom – of surfeit – to rush off to another cinema where we behaved in the same way, and so on [...] I have never known anything more magnetizing.[35]

Breton's statement provides a context from which Man Ray's own position in relation to Surrealism can be understood since he has also made references to this kind of active participation. He states, for example, 'Je vais au cinéma sans choisir les programmes, sans même regarder les affiches. Je vais dans les salles qui ont des fauteuils confortables.' [I go to the cinema without choosing what film to see, without even looking at the posters. I go to the cinemas with the most comfortable seats.][36] It is not difficult to see the similarity between the two comments. Both men highlight their delight in bringing an element of spontaneity and surprise into the practice of cinemagoing. This represents a rebellious attitude in terms of the conventions of cinema exhibition and spectatorship, especially in relation to the role played by publicity and film criticism in influencing filmgoing habits. Man Ray and Breton refuse to play by the rules dictated by these methods of communicating with prospective audiences, and crucially both statements begin by pointing to this act of rejection – Breton's disinterest in what, according to the amusement pages, was currently the best film and Man Ray's ignoring of film posters. Man Ray's comment also seems to suggest that, like Breton, he entered the cinema at any given moment and not at the advertised starting time. There is thus a very clear recognition of cinema as an industry that embodied and reflected the values of a society against which they were fighting and into which they aimed to inject a revolutionary spirit of chance and irrationality. The gesture of walking randomly into a cinema has the effect of disturbing the logical, ordered and often predictable nature of narrative cinema. It also gives to

the spectator a kind of active freedom in constructing their own film, the physical intervention involved in walking in and out of different cinemas mirroring the manipulation of time and space in the editing process.

However, the practices represented by Breton and Man Ray radically diverge in terms of their interaction with the actual film. Man Ray's active viewing employs an element of re-reading and re-interpretation, which uses the film as raw material for a series of plastic transformations: 'J'ai inventé un système de prisme que j'adaptais sur mes lunettes: je voyais ainsi, en couleurs et en images abstraites, des films en noir et blanc qui m'ennuyaient.' [I invented a system of prisms that I fitted to my glasses; using this I could watch films in black and white that would otherwise have bored me, transformed into colour and abstract images.][37] Through this process, he realigns the focus of attention from that of story to one of formal interest, fragmenting and re-creating the 'reality' on the screen, which is, in itself, a(n) (illusionist) recreation of actual time and space. A similar layering of 'realities' or representations can be found in a number of sequences of Emak Bakia, in which superimposition is employed to create a complex viewing experience, where the original and its duplicate are impossibly intertwined. Furthermore, the reference to a prism system relates directly to the apparatus that was used in the film.

Man Ray's indifference to narrative is also evidenced in his comment, 'The worst films I've ever seen, the ones that send me to sleep, contain ten or fifteen marvellous minutes. The best films I've ever seen contain ten or fifteen valid ones.'[38] He has also stated, 'Je pourrais prendre n'importe quel film de deux heures et le réduire à douze minutes au montage, je suis sûr que ça suffirait.' [I could take any two hour film and, by suitable editing, shorten it to twelve minutes; I'm sure that would be long enough.][39] In his account of his introductory speech to the audience at the premier screening of Emak Bakia, Man Ray tells us: 'I concluded in a more conciliatory tone: how many films had they sat through for hours and been bored? My film had one outstanding merit, it lasted not more than fifteen minutes.'[40] Another statement, this time by Ado Kyrou, further illustrates that Man Ray's interest lay in the ways in which formal, abstract patterns could be drawn from the cinematic image, 'Man Ray has told me that if a film bores him he spontaneously transforms it by blinking his eyes rapidly, by

moving his fingers in front of his eyes, making grilles of them, or placing a semitransparent cloth over his face.'[41] Again, an interest in fragmentation dominates the viewing process, disrupting the illusion of the film image and defamiliarising the reality portrayed by it. Placed side-by-side, these two processes of film spectatorship carried out by Breton and Man Ray allow some significant observations to be made about the conflicting approaches to film within the realms of active viewing, hitherto seen as a predominantly Surrealist exercise. This will be useful when discussing the content of *Emak Bakia* within the context of Man Ray's cinematic sensibility.

Although the behaviour of both men can be seen to derive from a desire to manipulate, transform and ultimately exert some kind of control over the version of reality that is offered to them on the cinema screen, their respective techniques represent their very different positions in relation to reality and its representation. Breton, respecting the form of the work, transforms the 'reality' of the film or films on the level of content, randomly juxtaposing unrelated stories and characters. The idea behind this technique is clearly that of confusing and mingling elements of each film by utilising the capacity of memory to retain particular pieces of narrative information. Conventional film viewing relies heavily on memory for the piecing together of a gradually building narrative and it is highly likely therefore that Breton, whilst watching one film, would confuse it with aspects of the previous one, creating the Surrealist effect of *dépaysement*. Crucially, this process mirrors Breton's notion of 'convulsive beauty', referred to earlier in this chapter and which arises from the juxtaposition of two unrelated phenomena, resulting in the creation of a new meaning and a reformulation/redefinition of its individual constituents.[42] In contrast, Kyrou's comment about Man Ray's cinema viewing demonstrates that the latter is interested less in the juxtaposition of different realities to form a new perspective unhampered by logic and rationality than in altering the very basis of this reality on a formal level. In manipulating the image, he changes the point of focus from content to form, and, in doing so, reverses conventional cinema's form-content relationship, which dictates that the images remain subservient to the narrative and are presented in such a way as to sustain the semblance of reality. In both cases, the film is subjected to a radical reformulation. Breton's technique is founded on the disruption

of temporal and spatial continuity in order to create the effect of surprise and disorientation, but in order for such effects to take place he must allow himself to enter into the reality that is created by each film. Man Ray, on the other hand, resists any such involvement not only by physically placing objects between him and the cinema screen (eyelids, hands, cloth), but also by refusing the mimetic status of the image, instead turning it into a site for plastic exploration. Therefore, if Breton uses narrative and photographic realism as the basis of his Surrealist recreation of the film, Man Ray rejects these elements and replaces them with visually abstract impressions and sensations.

Surrealist expression in film relies on mimesis – the basic foundations that Man Ray wishes to disturb in his manipulation and distortion of the image. The cinema was considered a valuable tool for Surrealism precisely because of its inherent ability to create a convincing replica of reality whilst at the same time offering means to subtly disturb and destabilise it in ways that would mirror the dream experience. Philippe Soupault writes, 'For us the cinema was an extraordinary discovery, and it coincided with the earliest formulations of Surrealism [...] we thought film a marvellous mode of expression for the dream state.'[43] In an article published in 1925, Jean Goudal argued that the cinema 'constitutes a conscious hallucination, and utilizes this fusion of dream and consciousness which Surrealism would like to see realized in the literary domain.'[44] Robert Desnos also viewed cinema-going as analogous to the dream experience and stated that the darkness of the film theatre 'was like that of our bedrooms before going to sleep. The screen perhaps might be equal to our dreams.'[45]

These considerations are important not only in terms of reception, but also in envisaging Surrealist films that aim to recreate the structure of the dream by immersing the viewer in a recognisable reality and introducing unexpected, illogical ruptures and juxtapositions. This mode of filmmaking respects the conventions of spatial and temporal continuity in order for these illogical transitions to be experienced naturalistically, making the psychological effect on the spectator all the more powerful. Kuenzli draws attention to this feature of Surrealist film when he states that the principal aim is to 'put the viewer in a passive role, since their montage of incongruous sequences aimed at breaking open the spectator's unconscious drives

and obsessions. Cinematographic techniques were thus only a means to disrupt the symbolic order, and to let the unconscious erupt.'[46] Film was therefore exploited for its ability to act as a mirror of reality whilst at the same time offering, through its basic technical reliance on editing, ways to upset the laws of space and time.

Surrealist film stands in opposition to the aesthetic experiments of certain strands of the cinematic avant-garde and particularly the use of film by the Dadaists, who drew attention to the illusory nature of the medium by making the material construction of reality the central focus. Surrealist expression in film is not directed towards exploring the plastic possibilities of the medium, but rather towards exploiting its technical characteristics, placing them in the service of psychological effects. Thus, attention is focused not on the form, but on the content of the film. As Ramona Fotiade argues, 'the "technical" aspects of cinema should contribute to heightening the impression of reality, and not attempt to "substitute" reality with an imaginary/artificial world.'[47] However, despite this seemingly clear-cut theoretical distinction between one mode of expression and another, many films of the 1920s have been discussed in terms of both Dada and Surrealism. This situation arises in part from the sheer diversity of both movements and the fact that they lack a unified visual style, but also from the ability to relate particular techniques or approaches to either movement, even if the overall effect does not neatly correspond to accepted definitions of 'Dada film' or 'Surrealist film'. Let us consider again Man Ray's comment, 'Tous les films que j'ai réalisés ont été autant d'improvisations. Je n'écrivais pas de scénario. C'était du cinéma automatique.'[48] His improvisational approach – eschewing conventional methods of structure by leaving himself open to chance events – has much in common with Dada, yet the idea of automatism leans more towards the activities of the Surrealists, in which the irrationality of the mind is explored in a controlled context or environment.

Surrealism and Emak Bakia

Surrealism is important to discussions of *Emak Bakia* not only in terms of its historical positioning, but also from the perspective of Man Ray's conception of the film. In his autobiography he states, 'I had complied with all the principles of Surrealism: irrationality, automatism, psychological and dreamlike sequences without apparent logic, and complete disregard of conventional storytelling.'[49] It is undoubtedly as a result of this comment that many critics have highlighted Man Ray's intention to make a Surrealist film. Robert Short, although accepting that the film is not quite an example of cinematic Surrealism, nonetheless states, 'Man Ray set out quite deliberately to make an unequivocally surrealist film.'[50] Mimi White also shares the view that '*Emak Bakia* was clearly conceived by Ray in the context of Surrealism,'[51] along with Steven Kovács who argues that, although it 'was in no way an official presentation of Surrealist principles, it was conceived as a Surrealist work by a person closely associated with the group.'[52] The analysis provided by Kovács thus highlights what he sees as 'a number of tendencies, themes, and motifs of the Surrealists' of which the film is composed.[53] However, because these elements do not progress towards a total Surrealist work, Kovács continually builds them into a Dada-Surrealist framework, sliding between one discourse and another without ever considering the theoretical implications of such an approach. The reluctance to categorise the film as belonging to either movement gives rise to an equally problematic representation of Man Ray as operating in an ambiguous no-man's land between the two modes of expression. Kovács states for instance, '*Emak Bakia* is a vivid example of the way in which chance was harnessed by a Surrealist filmmaker to create a purposeful film. Man Ray's method of shooting was random not by the careful design of other Surrealist poets who strove to achieve randomness, but simply because of his own Dada temperament.'[54] Although this observation rightly distinguishes Man Ray's relationship with chance from that of the Surrealists, there is nonetheless a slightly confusing notion of Man Ray the Surrealist working in a Dadaist manner. This is reflected also in Kovács' division of the film into 'Surrealist sequences' and 'Dada sequences'.

The problem here is that the film is defined primarily in relation to Dada and Surrealism and is not considered in terms of how Man Ray's individual artistic concerns merge with the principles of these movements. The notion of a fluidly interchanging Dada/Surrealist film drives us into a theoretical dead end because it can, by definition, have no clear aim, and is reduced, as Mimi White has suggested, to pointing out specific images or sequences that can be seen to relate to this or that concern of either movement. In the end, the most detrimental outcome of this approach is that Man Ray is seen as simply employing a range of ready-made motifs and devices. This tells us very little about the position of the moving image in the context of his work in general, and ultimately perpetuates the consideration of early avant-garde film in terms of various cinematic manifestations of previously established ideas.

What Kovács defines in *Emak Bakia* as Surrealist motifs can be taken beyond such restricted interpretations when examined in relation to the development of Man Ray's artistic concerns. There is, for instance the motif of the eye, which recurs throughout the film, and which, for Kovács, represents a strong link with Surrealism. He cites the opening sequence as simultaneously drawing attention to the filmmaking process, whilst presenting the image of the eye as an element of Surrealist iconography. The problem is that, as I have argued above, Surrealist vision relies on mimetic representation and illusionism into which certain motifs are integrated. By drawing attention to the film apparatus, Man Ray instantly breaks with this illusionism, making the motifs themselves seem redundant in the context of Surrealism since they are devoid of a system that would bestow on them some kind of meaning. As a result, the image is significant *as* an image with meaning being directed inwards – in other words, towards an exploration of its formal properties. The presence of self-reflexive devices only serve to enhance and encourage such formal absorption since they invite an active visual awareness on the part of the viewer, as described in the previous chapter's discussion of a 'cinema of attractions'. As I will argue later in this chapter, the image of the eye and the nature of its presentation in various sections of *Emak Bakia* points specifically to the possibilities of cinematic vision, a theme that, whilst not necessarily separate from certain concerns of Surrealism, does not depend exclusively on them.

As Man Ray states in his autobiography, the Surrealists did not accept *Emak Bakia* as an authentic cinematic representation of their aesthetic programme despite his close connections with the movement and their acceptance of much of his photographic work. The main problem lies perhaps in *Emak Bakia*'s overall structure, which is basically a collage of different visual effects organised into thematically coherent segments. The film may well contain all the elements of Surrealist expression to which Man Ray refers, but they remain anchored to a wider interest in cinematography and the formal properties of the image. His description of the film attests to this preoccupation with visual exploration:

> A series of fragments, a cine-poem with a certain optical sequence make up a whole that still remains a fragment. Just as one can much better appreciate the abstract beauty in a fragment of a classical work than its entirety, so this film tries to indicate the essentials in contemporary cinematography [...] its reasons for being are its inventions of light forms and movements, while the more objective parts interrupt the monotony of abstract inventions or serve as punctuation.[55]

The reference to 'a whole that still remains a fragment' is important since it evokes Man Ray's earliest experiences with film whilst working with Duchamp on his optical experiments. To return to the latter's machine *Rotary Glass Plates (Precision Optics)*, it is the element of movement that creates from the fragments an illusion of unity, and this optical impression of wholeness hides the fragmentary nature of that which creates it. This fundamental contradiction is an inherent part of cinematic representation, wherein fragments of reality come to stand in for the whole, and claim to hold up a mirror to reality. That Man Ray makes extensive use of distorting mirrors and lenses in *Emak Bakia* is not insignificant here. It is indeed the fragmentary nature of the film and the way it self-consciously highlights the illusory nature of cinematic representation that keeps the spectator at a distance, preventing any kind of conventional narrative identification. In contrast, Surrealism uses visual and narrative unity as a basis, with the aim of exploding it from the inside, forcing the viewer to reassess their codified patterns of thought in relation to reality, and presenting them with another way of understanding the world. If *Emak Bakia* achieves a similar kind of challenge to the spectator's sensibility, it is rather on the level of vision and

perception and not narrative signification. For instance, the repetition of certain shapes or movements unites otherwise unrelated visual phenomena, and forces the viewer to consider latent relationships between them. This involves, contrary to the techniques of the Surrealists, the downplaying of content and associative meaning in favour of a reinterpretation of the world in formal terms.

The principal way in which Man Ray achieves this effect is through abstraction, that is, by creating a kind of rupture between the image and the object to which it refers. However, it is not simply this visual representation that strikes us as important in this context, but also the way in which the treatment of time and space is worked into an abstract framework. This aspect of the film will be looked at in more detail later in this chapter. For the moment, it is useful to make some basic observations in this area. The first is that temporality in *Emak Bakia*, as is the case in *Le Retour à la raison*, is used predominantly as a formal tool for the development of various visual effects, often involving the repetition of particular movements that serve to create and juxtapose rhythmic structures. As Fotiade observes, this is one of the key areas in which Man Ray's cinematic preoccupations, as presented in *Emak Bakia*, cannot be reconciled with the Surrealist method:

> What Man Ray failed to notice was the incompatibility between the repetitive, mechanic aesthetic which animated early experiments with the abstract film, and the Surrealist understanding of the miraculous of everyday life situations (le merveilleux quotidien), and of the alienating effect (dépaysement) of images grounded in otherwise familiar, recognizable surroundings.[56]

In certain sections of *Emak Bakia*, the viewer is plunged into the unknown, a world that lacks the normal spatial laws of reality and reinvents vision as somehow linked but ultimately detached from our habitual experience of external phenomena. Surrealism, although similarly focused on presenting to the spectator a new order of things, aims to affect vision and experience beyond the film itself, and, as such, must connect with the viewer on the level of reality. This perhaps represents the ultimate difference between Man Ray's film and the practices of the Surrealists.

Optical explorations

In his comment quoted above, Man Ray refers to *Emak Bakia* as express-
ing 'the essentials in contemporary cinematography', in many ways echo-
ing earlier conceptions of *cinéma pur* (pure cinema). That the aesthetic
programme of both the Dada and Surrealist groups was opposed to the
inherent formalism of this notion of pure cinema provides at least one
perspective from which to view the difficult placement of the film within
either camp. Peter Weiss echoes Man Ray's statement in his short descrip-
tion of the film: 'Le film ne prétend pas être autre chose qu'une meditation
subjective, l'expérience d'un artiste qui explore des possibilités optiques.'
[The film doesn't pretend to be anything other than a subjective medita-
tion, an artist's experimental exploration of optical possibilities.][57] Subtly
rejecting Dada and Surrealist interpretations, Weiss instead places empha-
sis on the film as a highly personal work, which derives first and foremost
from the artist's interest in the possibilities of vision. Considering that the
main point of departure for the current study is the realignment of Man
Ray's films with the wider concerns expressed throughout his work, the
notion that *Emak Bakia* functions primarily as a subjective statement is
of crucial importance. Of equal significance is the idea that *Emak Bakia*
functions as an exploration of subjective vision, or to be more specific, that
it examines the relationship between ordinary perception and the kind of
perception that is produced mechanically through the cinematic apparatus.
Le Retour à la raison makes tentative steps towards the development of a
purely cinematic vision, but it is in *Emak Bakia* that Man Ray most effec-
tively creates a world of complex optical impressions that clearly draws a
distinction between reality as we usually experience it and reality as seen
through the lens of a camera.

Film and vision

In what ways then does the film express concerns related to both human and cinematic vision? On a very basic level there is the previously discussed motif of the eye, most notably in the opening and closing shots. As White suggests, 'The film's concern with vision, what we see and how we see it, frames the film in a very literal sense. The opening shot poses the problem specifically with reference to the machinery of cinema, as a cameraman stands by a movie camera pointed forward, toward the film audience, with an upside-down eye superimposed in place of the lens.'[58] In the analogy it makes between the camera and the eye, this initial image seems to embody one of the most influential debates in the history of cinema, and, perhaps, the most defining aspect of the avant-garde film: the relationship between the human eye and the eye of the camera. The French Impressionist film-makers and theorists of the 1910s and 1920s, such as Germaine Dulac and Louis Delluc, argued fervently for the visual nature of the cinema to be acknowledged and utilised as the vital quality that would separate it from the other arts to which it had become subservient, specifically theatre and the novel.

In the climate of modernism, where the search for the 'essential' and medium-specificity in the arts was a key concern, the question of film as possessing distinct qualities and powers of creative expressive that were not available to the other arts was a way of elevating the status of the medium from that of popular entertainment to a serious art form. Dulac, for instance, referred to the cinema as an 'art of vision [...] an art of the eye.'[59] However, the cinema's capacity for visual perception goes beyond the limits of the human eye and shows us things that we would not be able to see normally. This is the terrain occupied by the avant-garde film, as suggested by William Wees in his study of the centrality of vision in avant-garde modes of filmmaking:

> Any cinematic expression of vision must emerge from the optical, photochemi-cal, and mechanical processes of making and showing films. Although these proc-esses differ greatly from those of visual perception, they are designed to produce an image comparable to the world we see when we look around us. Hence the conven-tions of photographic realism accepted by the dominant film industry. Because of

those conventions, most films offer a very limited and highly standardised version of 'visual life': focused, stable, unambiguous representations of familiar objects in three-dimensional space. While it is true that this is similar to the image of the world ordinarily provided by the so-called normal vision, it is also true that we are capable of seeing the world quite differently. To express some of these other ways of seeing, avant-garde filmmakers have chosen to ignore, subvert, or openly break the rules of conventional filmmaking. Whether intuitively or by conscious intention, they have discovered that 'questions of seeing' include questions about the cinematic apparatus itself.[60]

Man Ray demonstrates precisely such an awareness of the film apparatus through a presence/absence dichotomy, as seen in the opening shot where the image of a camera is immediately followed by a sequence of rayographs. Thus, the relationship between the camera and the eye that the first shot seems to establish is destabilised through the presentation of a type of cinematic vision that does not depend on the mechanical apparatus, but on the material substrate of the film strip. It is at precisely this point that Man Ray goes beyond certain assumptions prevalent in avant-garde film theory about the importance of the camera-eye relationship by proposing that the camera represents only one element of cinematic vision. This self-conscious deconstruction of the basic technological properties of the medium has frequently been related to the principles of the Dada movement, in which the status of artistic creation is placed under scrutiny. As I have discussed in the previous chapter, the rayographs produced by Man Ray in both photography and cinema are often seen as a rejection of technique and of artistic skill that has the effect of 'placing the genius in the same rank as the idiot.'[61] By juxtaposing the self-referential image of filmmaking equipment with images created by a process that rejects this very equipment does indeed raise some serious questions about the relationship between the artist/filmmaker and his chosen medium. For instance, does dispensing with the camera and working directly with the celluloid create a more 'truthful' representation of reality? If cinema is fundamentally about illusionism – a fact that Dada films are generally understood to reveal – does this illusionist encoding exist at the level of the camera or the material onto which the images are fixed?

There is an element of paradox here since, although the rayograph process produces an imprint of external phenomena rather than what we could call a 'reflection' of reality created by the machinery of the camera, an 'unrealistic' effect enters into the process through the movement that is created at the moment of projection. Although all film images can be considered as essentially a series of static moments, with movement being created illusionistically through projection, in most cases movement is nonetheless present in the pro-filmic event. In the case of Man Ray's rayography, however, the movement we see on the screen is purely a result of projection, and would never have existed at any stage of the filmmaking process. The significance of the rayograph sequences is therefore more than a statement about the cinematic apparatus. Within the context of the film's concern with vision, they are understood as an exclusively cinematic way of seeing; that is to say they represent a form of vision that is not possible with the human eye. The insertion of the shot of daisies amongst these initial rayograph images has, like the fleeting image of the light bulb in *Le Retour*, a didactic function in that it invites the viewer to make distinctions and connections between the images and thus reflect on the nature of cinematic vision and its ability to recreate the process of seeing according to specific rules.

A key element of this process is the removal of the references that normally guide our perception of external reality. In *Emak Bakia*, as in *Le Retour*, Man Ray demonstrates that cinematic vision does not consist simply in mimetically reproducing reality, but in creating an alternative to those processes to which we have become accustomed. That this is developed as a way of enhancing human perception and making the viewer aware that what we see and how we see are not necessarily interchangeable is evidenced in the alternation of different forms of representation in the film. There are images to which we can easily relate because they have a direct relationship to the world as we usually experience it, and there are others that prove more difficult to assimilate into our visual repertoire because of their ambiguous nature. This is especially true of the sequences that follow the initial rayograph images. Here, distortions and light formations play a central role, with movement facilitating the presentation of these effects. The use of prismatic and other distorting lenses, reflecting crystals and rotating turntables allows Man Ray to create a completely new form

of cinematic seeing that rejects the notion of representation and subject in favour of pure form. Although he recounts in his autobiography that he 'was thrilled, more with the idea of doing what [he] pleased than with any technical and optical effects [he] planned to introduce',[62] there is no doubt that he revelled in the ability of this newly acquired equipment to give birth to a range of images whose subject is nothing more than that of light and movement. Like the previous sequences of rayographs, these images repudiate the traditional mimetic function of film by creating a form of vision that does not reflect the outside world, but rather interprets it cinematically. This interpretation has the effect of liberating the eye from its attachment to rational perceptive processes, and thus goes some way to explaining the way in which Surrealism played a role in Man Ray's conception of the film, even if the film itself does not achieve the effects sought by the Surrealists.

Spatial understanding is a key concern in *Emak Bakia*. The camera-less images are crucial in this respect since, placing emphasis on the materiality of film, they also highlight the depthless-ness of the film strip and, in projection, the screen onto which the images are presented. This is especially important in our understanding of Man Ray's relationship to the cinema as it represents a particularly modernist sensibility in which the technical and physical properties of the medium are foremost in the artist's concerns and are made apparent in the finished work, having as much, if not more impact than that which is represented. This can be seen in early modernist painting through the way in which the flatness of the canvas and the texture and colour of the paint are emphasised as the primary focus, with representation being only a secondary concern, if indeed it is present at all. The rayographs express this tendency since, aside from working directly with the celluloid and creating a one-dimensional image, they also draw attention to the dimensions of the screen.

The cinematic 'I'[63]

Emak Bakia's opening shot goes further than simply pointing to the importance of vision and the relationship between the human eye and the camera eye. It inscribes into the film an awareness of the subjective eye or the

authorial 'I'. What White fails to mention in her discussion of the film's first shot is that the cameraman, presented anonymously in her account, is actually Man Ray. Thus, the interrelationship between the eye and the lens is equated with the 'I', the self-referential statement about the act of creation behind the images. Kovács has argued that this shot 'is at once a personal affirmation of Man Ray as filmmaker, a cinematic trick showing the mechanics of the filming process, and perhaps the first presentation of the human eye as an element of Surrealist iconography. It is an ingenious opening, simultaneously a Dada and Surrealist device which also happens to introduce the author as creator.'[64] The links with the two movements are undeniable, although perhaps more so in terms of the self-reflexive strategies of the Dadaists. What seems more important, however, is the understanding of this self-reflexivity as representing an integral part of Man Ray's work as an artist, a recurring element that points to his life-long need to construct and reconstruct his personality through his art. This is visible as early as 1914, in a painting entitled simply *Man Ray*, where the artist's name and the year serve as the subject. It is also evident in the many different self-portraits he created over the years, beginning with *Self Portrait in ink, Ridgefield* (1914), that features in *A Book of Divers Writings* by Adon Lacroix – a portfolio of poems to which Man Ray added illustrations and published together with Lacroix in 1915 – and *Self Portrait* (1916), a work constructed from an oil painting featuring a hand print, to which were added two bells and a push button. The fact that this piece openly invited the participation of the audience (the pushing of the button), whose disap-pointment was premeditated (the non-ringing bell), reflects an important exchange between Man Ray and his public that demonstrates his own per-sonal dictum: to always do the opposite of what people expected of him.[65] Although the self-portrait is a common device used by the artist to present a version of him/herself to the outside world, it is arguably with the work of Man Ray, and of course his friend Marcel Duchamp, that the personal reference is developed into a truly modernist practice.

The self-reflexivity of *Emak Bakia* also coincides with debates taking place in French film theory and criticism around the nature of cinematic vision and the notion of the objectivity of the camera. In the same year as the film's release, Paul Ramain argued, 'Avant l'objectif, organe physique de représentation, il y a un nerf qui le fait vivre: c'est la volonté et l'âme

sensibilisée du Cinéaste lui-même. L'objectif n'est pas lui-même: il est nous-mêmes.' [In front of the lens, that inanimate recording mechanism, there is a nerve that makes it live: it is the sensitised soul of the filmmaker himself. The lens by itself is nothing; it represents ourselves.][66] Ramain's statement provides a counter-argument to writers such as Jean Epstein, who claimed that the camera eye differed from the human eye in the way it captures and records reality, unhampered by the intellectual processes of interpretation and association that result from the human eye's connection to the brain.[67] Ramain suggests instead that objective reality in an 'état sauvage', to use the term employed by Epstein,[68] cannot exist in the cinema since reality must always be transmitted through the sensibility of the filmmaker. From this we can deduce that the creative power of the cinema lies not in its possession of an objective eye that surpasses that of human perception, but rather in its ability to extend vision to include unlimited subjective perspectives of the world. The Russian filmmaker Dziga Vertov, whose seminal avant-garde work *Man With a Movie Camera* was released in 1929, evoked the complex relationship between the machinery of the camera and the subjectivity of the artist when he stated in a 1923 manifesto, 'I am kino-eye, I am a mechanical eye. I, a machine, show you the world as only I can see it.'[69] Vertov's statement draws an important modernist parallel/interchange between the human and the machine, in other words, the filmmaker and his apparatus.

There are in fact a number of similarities that can be drawn between Vertov and Man Ray despite their clear national and political differences. Vertov, like Man Ray in *Emak Bakia*, made extensive use of cinematic trickery such as superimposition and prismatic lenses. Much of the imagery in *Man with a Movie Camera* mirrors that found in certain sections of Man Ray's film, especially the presence of the female body. The traditional Russian dance in the former also brings to mind the Charleston sequence of the latter. There is also the important position of music in the film, which, as Michael O'Pray signals, Vertov had always envisioned even though the original version is silent. O'Pray argues that the music 'underlines its structure',[70] an observation that could equally be made in terms of *Emak Bakia*, where changes in rhythm and tempo brought about by different musical tracks compliment the visual material. The most interesting correspondence

between Man Ray and Vertov exists in the self-reflexive presence of the filmmaker. In *Emak Bakia* Man Ray draws attention to himself as the creator of the work in, for example, the use of rayographs. Yet, this is also one of the ways in which Man Ray's cinema can be seen as going beyond that of Vertov; the machine itself is eschewed in favour of a technique that involves a more direct relationship between the filmmaker and his material. Indeed, the main reason for which Man Ray's still rayographs were so popular with the Dadaists and Surrealists alike was their apparent transmission of the artist's psyche through a process akin to that of automatic writing. Tristan Tzara, in his introduction to Man Ray's collection of rayographs, *Champs délicieux*, evokes the body and sensibility of the artist in creating the images: 'Le photographe a inventé une nouvelle méthode: il présente à l'espace l'image qui l'excède, et l'air avec ses mains crispées, ses avantages de tête, la capte et la garde dans son sein.' [The photographer has invented a new method; he places an image in a space which is too small to contain it, and the air with his clasped hands and the ideas in his head, he captures it and keeps in his breast.][71] Jean Cocteau, in an open letter to Man Ray published in *Les Feuilles libres*, also stated, 'Vos planches sont les objets eux-mêmes, non photographiés par une lentille, mais directement interposés par votre main de poète entre la lumière et le papier sensible.' [Your photographic plates are objects in their own right, not photographic images created by a lens, but placed by your own poet's hands between the light source and the sensitised paper.][72]

The main issue here is that self-reflexivity in *Emak Bakia* must be seen as a part of a bigger picture that relates not only to Dada and Surrealism, but also to Man Ray's individual concerns and practices as an artist, as well as questions that were being posed at the time in relation to cinematic vision. This is emphasised by the use of similar techniques by other filmmakers working within significantly different contexts unrelated to either Dada or Surrealism, such as Vertov and the Hungarian Constructivist László Moholy-Nagy, whose film *Lichtspiel Schwartz-Weiß-Grau* of 1930 creates comparable compositions to those found in *Emak Bakia*.

To return to the question of reality filtered through the eye of the artist, what we experience in *Emak Bakia* is an awareness of objective and subjective vision that relates to the use of figurative and non-figurative

imagery. Looking again at Man Ray's comment about the film, abstraction is referred to in terms of subjective vision since the 'objective parts' are understood as interrupting 'the monotony of abstract inventions', the latter being, by extension, an expression of subjectivity. It is first of all interesting to consider the reference to parts of the film as inventions, a detail that highlights the role of the filmmaker in constructing images rather than simply representing or copying reality. In using this term, Man Ray also draws attention to himself as a kind of visual scientist, something that is supported in his accumulation of various paraphernalia, which he used to create a variety of optical effects. Again, the concentration on so-called 'subjective', non-figurative imagery characterises early modernist art in its turn away from objective representations of external reality and towards the expression of inner emotional states. It was in the graphic films made in Germany at the beginning of the 1920s that this approach was translated into the cinematic medium, producing what Walther Ruttman described in the title of a paper from 1919 as 'painting with the medium of time.'[73] Hans Richter in his abstract films, aimed to generate emotion and feeling by following the same laws as those of musical rhythm.

The fact that Man Ray conceived of *Emak Bakia* in terms of a figurative/non-figurative and objective/subjective dichotomy supports the notion that his key interests lay within the realms of the formal possibilities of cinematic vision. However, a further crucial observation can be made in relation to this statement: that the film was purposefully structured according to certain rules, in order that the 'objective' imagery would alternate with the more 'subjective' sections. This challenges the common perception that the film expresses, above all, a random, illogical structure. Barbara Rose in particular represents this tendency when she states that due to 'the randomness of Man Ray's approach, one cannot really speak of the structure of *Emak Bakia*, which [...] is basically a series of disconnected visual gags.'[74] Understanding certain sections of the film as expressing a form of subjective vision certainly goes beyond such limited interpretations. Importantly, this perspective allows us to consider Man Ray as a precursor of later avant-garde filmmakers like Stan Brakhage, who used the medium of film to explore and represent the wide spectrum of human vision traditionally absent from the cinema. The move from an external

reality to an internal one is perhaps what Man Ray understood as Surrealist, yet instead of transmitting unconscious thought processes and desires in a sustained figurative context as is found in the dream, *Emak Bakia* concentrates on an abstract interpretation of subjectivity. Thus, the structure of the film can be understood not as representing subconscious thought, but as developing a formally determined system of vision.

Thinking visually

As is also the case with *Le Retour*, a number of theoretical accounts of *Emak Bakia* centre on its non-narrative component.[75] In attempting to highlight its Surrealist qualities, Man Ray himself refers to the film in terms of its 'complete disregard of conventional storytelling.' However, as we have seen from Kuenzli's statement, this would place the film within the realms of Dadaism. The question of narrative is more pertinent in this film than in *Le Retour à la raison* precisely because of the greater emphasis on moments of mimesis, along with the inclusion of certain figurative 'sequences' that for some critics suggest the 'possibility of narrative',[76] and seem to present a counterpoint to the more formally dictated sections. This sense of narrative possibility is brought about by the way in which individual shots relate to each other following the rules of logic and continuity. In the first figurative sequence of the car journey, for instance, there is a gradual accumulation of details through the progression of shots, and each separate shot seems to relate logically to the next. A car with a female driver is followed by a shot of a car tyre; the car begins to move and a travelling shot taken from inside the car describes the speed at which the car is travelling, showing, from a point-of-view shot, what the driver sees. Further on in the film a number of shots are edited together to show a woman walking into a room, getting ready at a dressing table and finally walking towards a window, ending with another point-of-view shot. Like later Surrealist films,[77] certain conventions of cinematic construction are employed, such as continuity editing and shot-reverse-shot, which rely on logical connections to be made between them. In contrast to those films, however, this adoption of classical filmmaking rules does not provide a sustained and

stable framework from which the Surrealist content emerges, but exists simply as an exercise in cinematic construction and deconstruction. Rather than simply breaking the rules of narrative as an end in itself, Man Ray uses them as a springboard for a host of visual effects.

This can be seen in the way montage is employed as a way of breaking down and analysing cinematic perception and exploring particular techniques for their rhythmic possibilities outside of narrative signification. What is important here is the way Man Ray encourages the viewer to make visual associations on a number of levels. In two sections of the film, he experiments with different types of editing to create specific perceptual effects. Towards the end of the travelling sequence mentioned above, a shot of a herd of sheep moving alongside the car suddenly creates a sense of chaos that arises from the convergence of two sets of objects moving in opposite directions. The following shot enhances this feeling by having the car actually drive over the camera placed on the road. A close-up image of a pig is followed by a very brief blurred shot, which is in turn juxtaposed with that of the pig suddenly jolting. The final image, created by throwing the camera into the air, completes the series of juxtapositions by purposely combining speed with an unpredictable register of images to give the impression of collision. This sequence demonstrates Man Ray's interest in building visual thought and in structuring the audience's accumulation of visual details related not to narrative development, but to the representation of feeling or sensation. This form of montage can also be found in a later sequence in which the hands of a banjo player are juxtaposed with the legs of a woman dancing the Charleston. The alternation of the shots was conceived by Man Ray to be accompanied by a piece of music by Django Reinhardt, which compliments the gradual building of visual rhythm. This section of the film, like that of the earlier collision, makes use of the expressive possibilities of montage beyond the function of logically linking together narrative elements. The images themselves may be figurative but they are unrelated to any kind of logical progression and actually exclude narrative associations due to their 'abstraction' from context. The hands of the banjo player and the legs of the dancer are isolated from their bodies, and, as such, they reflect other repetitive movements in the film.

In his autobiography, Man Ray refers to *Emak Bakia* as 'purely optical, made only to appeal to the eyes', and 'the result of a way of thinking as well as seeing.'[78] Like the earlier comment about the film presenting a series of fragments, this statement points to the centrality of vision as the film's organising force. Taken together, these personal reflections allow us to consider *Emak Bakia* in terms of the interrelationship between human and cinematic vision since the earlier comment emphasises the expression of cinematic specificity, whilst the later one deals with the specificity of vision itself. From this we can deduce that Man Ray's intention was to create a form of cinematic vision that would reflect the eye in its pure state, in other words to unite the mechanical eye of the camera with that of the creator and, in the viewing process, the spectator. In the theoretical writings of the 1920s the inherent capacity of the cinema to create a form of vision freed from the *a priori* discourse of intellectual association was a common theme. It was understood by some theorists that the camera occupies a privileged position since it 'sees' and records reality from an objective perspective, a perspective that is denied to the human eye due to the thought processes that naturally accompany human vision. André Levinson, for example, states, 'peintre et poète, l'objectif de la *caméra* n'est pas un penseur.' [Painter and poet, the *camera's* lens does not think.][79] In contrast to this view, Man Ray does not exclude thought from his concept of vision. To speak of the film as purely visual and as a way of thinking initially seems paradoxical (and thus not altogether unusual given Man Ray's fondness for contradictory statements) until one considers the film from the logic of thinking visually. Indeed, this is one of the major concerns in *Le Retour*, where connections between images are made through their visual similarity or difference, transcending the everyday signification attached to the actual objects that create the images. The key to both achieving and understanding this process of visual thought lies within the realms of representation, and it is in this respect that *Emak Bakia* demonstrates a progression of ideas from Man Ray's first film.

Emak Bakia must therefore be understood from the perspective of a system of relations between images and their effect of the viewer. The key factor in this development of relations is that the images are generally dissociated from the figural relationships found in Surrealist film, where meaning

depends largely on establishing systems of metaphor and metonymy. In this sense it is important to consider the possibility of a purely visual narrative. Edward A. Aitken, in his reassessment of *Emak Bakia* draws attention to Tzvetan Todorov's notion that narrative 'is constituted in the tension of formal categories, difference and resemblance.'[80] Indeed, as the previous chapter illustrates, Man Ray's work demonstrates a clear interest in the use of similarity and difference as organising principles, which seem to represent what could be termed a 'narrative of images.' We can see this most clearly in the alternation of sequences featuring defined figurative images with sections that express an overriding sense of formlessness. The sequences that are usually considered as 'narrative fragments' generally give way to more formally complex moments. For example, the car journey sequence can be understood in terms of a metaphoric trajectory from figuration to abstraction. This is seen in the blurred impressions of the passing scenery and the random register of images during the collision.

Light and movement

As we have already noted in relation to the theme of cinematic vision, *Emak Bakia* represents Man Ray's interest in exploring the essentials of the film medium. The final observations of this chapter build on and develop these earlier arguments by examining the importance of movement and light. These are central elements of Man Ray's work in virtually all the arts in which he was involved, finding their ultimate expression in his films. *Emak Bakia*, however, is the work in which the qualities of light and movement are most fully explored. Steven Kovács, in relation to the development of these concerns, has stated:

> It seems that between the making of his first film and the second Man Ray discovered that film was more than just moving pictures, that although it was able to animate an object, it was above all a medium of light. Thus, he moved from animated photography to the film of light.[81]

Although I would agree that there is a clear progression of concerns from *Le Retour* to *Emak Bakia* – an aspect that the previous pages have unfolded – I would modify Kovács' view to suggest that light is brought into play *with* movement in *Emak Bakia*, and that movement, rather than being replaced by light as a key concern, is pushed into new territory and becomes an even stronger characteristic in the second film.

Different forms of movement in Emak Bakia

This view derives in part from the fact that a number of different types of movement can be detected in *Emak Bakia*. There is first of all the 'artificial' movement of the rayograph images, which appears disordered and chaotic, throwing the spectator into unknown territory. The inserted shot of daisies not only juxtaposes camera-based with camera-less but introduces the 'actual' movement of the camera. This type of movement represents a clear development from *Le Retour*, in which the camera rarely moves from a fixed position. We could therefore adapt the statement made by Kovács to argue that between the two films Man Ray also discovered the mobility of the camera and understood the possibility of creating a wider variety of kinetic effects. This discovery is no doubt related to his growing knowledge of film technology, along with the financial freedom he was given in making the film. The money provided by Arthur Wheeler allowed Man Ray to buy 'the finest professional camera available in France at the time.'[82] He had also 'acquired a small automatic hand camera for special takes.'[83] It was probably the mobility of the latter that prompted him to experiment with different forms of movement.

The freedom of movement is recognised and exploited by Man Ray in the travelling sequence (a similar sequence is found a few years later in *Les Mystères du Château du Dé*). In terms of the pure dynamism of this section of the film, and the attention it places on the dizzying perceptual effects created by speed and movement, it can be related to the proclamations about and the visual representations of movement, energy and conflict produced by the Futurists (although there is little evidence to show that Man Ray was in contact with any of the Futurist artists, it is likely that he was at least familiar with some of their declarations).

Aside from its development of associative montage, the collision demonstrates one of the key areas of Man Ray's growing awareness of the creative possibilities of movement. He states in relation to this section:

> One of the most interesting shots I made was while being driven by Rose Wheeler in her Mercedes racing car; I was using my hand camera while she was driving eighty or ninety miles an hour, being pretty badly shaken up, when we came upon a herd of sheep on the road. She braked to within a few feet of the animals. This gave me an idea – why not show a collision? I stepped out of the car, followed the herd while winding up the camera and set it in movement, then threw it thirty feet up into the air, catching it again.[84]

That he later refers to this shot in terms of the 'thrill' it provided again looks back to the Futurists' association of speed and movement with corresponding emotions of excitation and elation. The effect of disorientation to which this shot gives rise is repeated later on in the film when a rotation of the camera shows 'the sea revolving so that it [becomes] sky and the sky sea.'[85] This reference to the changing places of the sky and sea is crucial since it points to the way in which the movement of the camera allows Man Ray to develop the theme of inversion as an element of kinetic transformation. The effect created by the rotation of the camera clearly interested Man Ray as it reappears on a number of occasions in *Les Mystères du Château du Dé*. These moments constitute further examples of self-reflexivity in which attention is drawn to the physical presence of the camera and its ability not simply to record the action, but also to become part of it. Additionally, by inverting the image or throwing the camera into the air, Man Ray destabilises the fixed position of the viewer in order to both highlight and escape the illusionist nature of cinematic representations.

With *Emak Bakia*, Man Ray also discovered movement through animation, and a number of sequences are created using this technique. Animation was especially important as it once again allowed him to extend the creative possibilities of inversion, this time of animate and inanimate qualities. In one sequence, geometric blocks of different shapes and sizes gradually build themselves seemingly unaided by the human hand, whilst in another, disparate objects dance together within the frame like actors on a stage. At the end of this section of the film a drawing of a human figure

(based on the earlier *Homme d'affaires*) is brought to life as it jumps from one pre-defined stage of movement to the next. As the earlier outline of the film mentions, this is a clear reference to the work of the French nineteenth-century scientist Etienne Jules Marey, whose pioneering explorations into the analysis of movement had a significant impact on the development of the cinema.[86] During the 1880s, Marey developed a system for recording several phases of movement on one photographic surface (chronophotography), which displayed 'a single figure successively occupying a series of positions in space.'[87] This combination of movement and photography must have attracted Man Ray, considering that his own interest in the cinema derives partly from a desire to put photography into motion. The placement of this reference at the end of a series of animated sequences creates a link between Marey's work in chronophotography and the technique of animation, thus contributing to *Emak Bakia*'s status as a comment on the nature of cinematic representation and its mechanical basis. If Marey's chronophotography deconstructs movement, it also, by extension, deconstructs the cinema and reveals it to be but a series of static images, which, through mechanical intervention, create the illusion of movement. The emphasis on modern technology as a scientific tool in Marey's work relates particularly to Man Ray's fascination with mechanical intervention in art.

References to Marey and the mechanical foundations of the cinema resonate throughout *Emak Bakia*, particularly through the concentration on repetitive movement. In the film's most abstract sequences, the temporal development of the refractions, reflections and distortions is made possible through the use of a turntable. The rotation allows a continuous effect to be established, which itself refers to the mechanism of both the film camera and the projector, in the same way as the sequence of fairground lights and rotating objects in *Le Retour à la raison*. Repetition is a recurring feature in the films of Man Ray, demonstrating the way in which the machine aesthetic of Dada comes into play with a more general fascination with the temporal quality of the cinema found amongst the German abstract and French Impressionist filmmakers. The ability to manipulate reality through repetition rather than respect mimetic continuity reflects a revolutionary approach that focuses attention on the purely illusionist nature of film by highlighting its fundamental means of construction – editing.

Repetitive movement dominates *Emak Bakia* from shot no.28 to no.48. Following on from the collision sequence, we are presented with a shot of a woman's feet getting out of a car. Through the use of superimposition, Man Ray repeats the action several times – each time a different set of legs – to give the impression of an impossibly excessive amount of women having occupied the car (a witty allusion to the herd of sheep witnessed in the previous sequence?). This humorous use of excess as an artistic tool is characteristic of Man Ray's approach, and highlights one way in which his work can be seen to reflect a Dada sensibility. To take a similar sequence from *Ballet mécanique* – the repeated action of a washerwoman climbing stairs – we can see how the two films build on viewer expectations and the anticipation of narrative development. Of the washerwoman sequence, Léger states: 'We persist up to the point when the eye and the spirit of the spectator will no longer accept. We drain out of it every bit of its value as a spectacle up to the moment when it becomes insupportable.'[88] The reference to cinematic spectacle is crucial, again bringing us back to the link between pre-narrative cinema and the avant-garde outlined in Chapter 1.

What sets Man Ray's approach apart from that of Léger is his exploration of superimposition as a form of repetition. Although the multiplying feet can be understood as a Dada technique, emphasising the illusionist nature of the cinematic image, it also relates to the poetic use of superimposition by the Impressionist filmmakers, such as Dulac, Delluc and Epstein. The following section, however, is based wholly on the power of editing to create rhythm, again suggesting a link with *Ballet mécanique*. The alternation of a banjo player with dancing legs – a sequence to which I have already referred in relation to its use of associative montage – does indeed approach 'the point of exasperation'[89] towards which Léger drives, a view that is supported by Man Ray's comment that it 'might annoy certain spectators.'[90] However, even if the sequence may indeed have shocked audiences of the time – not simply because of its gratuitous repetition, but also because of the isolation of body parts from their respective whole –, the overall effect is one of unity and of the building of cinematic rhythm. Man Ray uses musical rhythm as a formal structure and the sequence was clearly conceived in the context of the accompanying jazz music. A sense of overall harmony is created by bringing together the individual elements

of image and music to create a rhythmic unity. One also finds examples of temporal expansion and condensation, further attesting to the film's complex structures in relation to time and movement. This is particularly noticeable in the next sequence in which a woman (Rose Wheeler) prepares herself in front of a dressing table. What is immediately noticeable about this section is the fact that each of these actions, such as brushing hair, applying lipstick and putting on pearls, is divided into separate, self-contained shots and expresses what would be seen in conventional cinema as a kind of narrative economy in presenting only the crucial details. This allows us to see the way in which a figurative/abstract dichotomy also involves notions of temporal representation. The 'objective' sequences have a defined sense of time whereas the more 'subjective' ones render time and space immeasurable, combining formlessness with a corresponding sense of timelessness.

Finally, there are, throughout the film, subtle movements of the face, again suggesting a link with sections of *Ballet mécanique*, in which we see Kiki's smiling lips.[91] Three separate shots show the faces of different women breaking into a smile, raising eyebrows or, in one example, muttering a few words to the camera. These shots relate directly to Man Ray's interest in photographic portraiture and from this perspective can be seen as a clear instance of what could be called 'kinetic photography' – that is, they demonstrate an attempt to put his photographic compositions into motion. Rather than freezing a facial expression in time, Man Ray exploits the temporal nature of film to show the development of that expression. Sophie Winqvist evokes another important issue in relation to the transference of photographic conventions to the medium of film when she states, 'One difference between still photography and film is that the model is expected to look straight at the camera in a still, while convention forbids the direct gaze in film.'[92] By approaching film simply in terms of moving photographs, Man Ray breaks one of the fundamental rules of narrative cinema designed to preserve the illusion of reality by not drawing attention to the camera as creator of that illusion. So by extension, this process of 'pointing to the film apparatus as an illusion-producing machine,'[93] associates *Emak Bakia* with a Dada approach to the cinema, whilst also pointing to the complex relationship between Man Ray the photographer and Man

Ray the filmmaker. This relationship is further evidenced in the role played by light, which is established, often in conjunction with movement, as one of the film's central aesthetic concerns.

Painting with light

In a speech made on 13 November 1924, Germaine Dulac proclaimed, 'Illusions! Sur l'écran jouent des ombres et des lumières: des images se forment, se déforment, se succèdent, s'effacent [...] ombre, lumière, illusions! C'est le cinéma.' [Illusions! On the screen lights and shadows flicker; images are formed and then transformed, they come, they go, they fade [...] shadow, light, illusions! This is cinema.][94] This comment, made two years before the release of *Emak Bakia*, seems to relate directly to the visual content of the film, almost as if Man Ray were answering Dulac's wishes for a cinema based on the elements of movement and light. The creative potential of light is one of the defining aspects of Man Ray's work as both a photographer and filmmaker. Techniques that were recognised as his trademark, particularly that of 'solarization', were achieved principally through the manipulation of light in a way that radically departed from conventional photographic processes.

The compositions found in many of Man Ray's photographs depend largely on the potential of certain objects and their arrangement in the frame to create complex geometrical effects through the casting of shadows. Indeed, as Francis Nauman has observed, the shadow and the reflected image become increasing concerns in his work from around 1916 onwards, even before he began working seriously in the field of photography.[95] This is seen particularly in *The Rope Dancer Accompanies Herself With Her Shadows* of 1916, a work made from coloured sheets of construction paper, depicting the shadows cast by the rope dancer as huge abstract forms that dominate the picture. *Ballet Silhouette*, an ink drawing of the same year, is similar to *The Rope Dancer* in the way the figures and the dark patches of shadow cast by them are given equal attention, creating an interesting interplay of juxtaposing elements. The photographs *Woman (Shadows)* (1918) and *Man* (1918) express the importance of the object in relation

to its shadow. The former depicts a constructed object of two metal light detectors and six clothes pegs attached to a plate of glass (see figure 14), whilst the latter simply features an eggbeater. In both images, it is not only the object itself that is of interest, but the extension of meaning created by the shadows that seem to merge the abstract with the concrete. In relation to these works, Man Ray confirmed, 'The shadow is as important as the real thing',[96] thus placing his relationship to the effects of light at the forefront of his aesthetic concerns. The rayographs that he produced extensively during the 1920s and 1930s represent a process of pure shadow creation, and, in light of this comment, must have seemed to Man Ray like the perfect form of photographic expression in which only the shadow of the object remains.

It is because of this interest in light and shadow that the majority of Man Ray's photography was carried out in the studio, an environment that provided him with the ideal conditions for his experiments with light. Although he did occasionally shoot in external locations, it is the more staged work that expresses his diverse yet characteristic style. Despite being known for his improvisational flair, making him particularly popular with the Dadaists, his working practice demanded control as much as it demonstrated spontaneity. Therefore, the ability to meticulously control the aesthetic effects of light and shadow was paramount to his working process, and it was often these effects that took precedence over the actual subject of the photograph. Naturally, then, his early films were also shot predominantly in the studio, and share many qualities with his still photographic work in relation to the composition of shots and the play of light and shadow. Here, as with the photographs, objects seem to have been chosen for their potential to interact with light in a specific way. For instance, the egg box divider in *Le Retour* and Man Ray's sculpture *Fisherman's Idol* in *Emak Bakia* are relatively inexpressive as actual objects, but when brought into play with their own shadows they become the site of the most interesting visual effects.

Aside from these studio-based shots, light also plays an important role in the external shots recorded at night time, where Man Ray capitalises on the numerous arrangements of artificial lights with which one is continually surrounded. In order to maximise their creative effect, these

sections are filmed naturally, drawing on the diminished sensibility of the camera lens in the absence of light, thus giving rise to a darkened background with only the lights themselves actually visible. The fairground lights in *Le Retour*, the scrolling announcement of *Emak Bakia* and the approaching car headlights that begin *Les Mystères du Château du Dé* all seem to relate to Man Ray's later photographs that feature artificial light, such as *La Ville* (*The City*, 1931) and *Montparnasse* (1961), two very similar images that present a collage of various neon signs in the centre of Paris, with the former featuring an illuminated Eiffel Tower. This concentration on various forms of artificial light represents a particular fascination with modern life that is commonly seen as a key feature of avant-garde works of the early twentieth century. That Man Ray produced, in 1931, a publicity pamphlet for the Compagnie Parisienne de Distribution d'Electricité – a collection of ten photographs entitled *Electricité* – aligns his interest in light with the concerns of modern living. It is only with the later *Les Mystères du Château du Dé*, a film that forced him out of the studio and into a specific location in the south of France, that Man Ray explored the creative potential of natural sunlight, presenting a kind of complement to the predominance of artificial light throughout his work in both film and photography.

The difference between the use of light and shadow in these two media is the element of movement, which allows Man Ray to further develop his photographic concerns. A noteworthy discussion of *Emak Bakia* in *Paris vu par le cinéma d'avant garde* places emphasis on Man Ray's experimentation with light and movement and describes a progression of concerns through the different sections of the film:

> Un jeu de lumières, créé, grâce à la rotation à vitesse variable d'un prisme de cristal qui se reflète et se multiplie dans plusieurs miroirs installés sur le fond à cette fin. C'est un mouvement de lumières, programmé avec exactitude, qui répartit sur l'écran une trame organique et en quelque sorte géométrique de faisceaux lumineux. Le jeu de lumières se poursuit au plan suivant, mais sa configuration est sensiblement différente: elle n'opère plus en se dépliant avec ordre, mais mélange chaotiquement des sources de lumières différentes qui tournent dans l'espace rendues floues par un filtre ou une modification intentionnelle de la mise au point.[97]

[An interplay of lights, created by a crystal prism rotating at varying speed is reflected and multiplied in many mirrors fixed to the base for this purpose. It is a movement of lights, programmed with precision, which spreads an organic and somehow geometric matrix of light beams across the screen. The interplay of lights continues in the next sequence but its configuration is quite different; it no longer operates in a predictable fixed order, but chaotically mixes different light sources rotating in space blurred by a filter or some intentional change to the arrangement.]

Crucially, this description draws attention to the 'movement of lights' and highlights the kinetic element of these sections by referring to the transformation of light effects through time. This 'interplay of lights' is understood as having been made possible by the rotation of objects and the use of varying speeds to diversify the resulting visual impressions. The brief discussion of the film is one of the few instances in which light and movement are singled out as the central creative forces and analysed in terms of the formal structures created by them. As the statement suggests, light seems to play the most significant role in the film's abstract sequences, that is, where the image breaks completely with any concrete basis in reality. The important factor here is the inherently abstract and intangible nature of light itself, an aspect I have discussed in relation to *Le Retour*, and to which subsequent chapters shall return. In much of Man Ray's work, the very formlessness of light is thus contrasted with the more defined contours of the shadow, which is, in any case, an abstract rendering of the object from which it emanates.

Clearly, the subject of light as an artistic tool raises important questions related to visual representation. In *Emak Bakia* these concerns are extensively developed; here light is not simply a tool for visual exploration, but becomes the subject of the image itself. Whereas light in *Le Retour* is subordinated to creating complex formations that both disturb and enhance our vision of the object, *Emak Bakia* reverses this process so that it is no longer the object in which we are interested, but the light impressions themselves. We can understand this process as painting with light, a term used also by Julien Levy in relation to Man Ray's photography, and which provides an alternative, but not altogether conflicting, view to that of Tzara.[98] What is important here is the use of light as material or matter and not simply as a means to facilitate perception. The prismatic lenses

and crystals used in *Emak Bakia* allow light to be reflected and creatively reformed into moving patterns that stimulate the eye through physiological responses. This represents one of the key ways in which the film can be distinguished from Surrealist concerns, despite Man Ray's attempt to align it with the principles of the movement.

Its historical, formal and thematic positioning within the movements of Dada and Surrealism make *Emak Bakia* Man Ray's most complex film. His work as an artist often seems to create a dialogue between the movements, seeming simultaneously to express different, even opposing concerns. It must be understood, however, that contradiction was a major impulse in Man Ray's life, and became a vital creative tool, characterising virtually every area of his artistic output. That *Emak Bakia* resists easy interpretation was undoubtedly Man Ray's intention, and it is the refusal to subscribe to any particular mode of expression that emerges as one of the strongest aspects of the film. It seems likely that rather than setting out to make a 'Dada film' or a 'Surrealist film', Man Ray allowed himself to be taken in whatever direction pleased him, drawing on his interests in Dada and Surrealist-related vision but ultimately exploring beyond the confines of either doctrine. Defining the film more than anything are its visual diversity and juxtaposition of techniques, freely moving from the figural to the abstract, from the highly constructed to the purely improvised, from spatial definition to spatial ambiguity and from temporal progression to a sense of timelessness. Some of these elements are already present in *Le Retour* and I have discussed in relation to that film Man Ray's interest in the creative possibilities of similarity and contrast. *Emak Bakia* develops these principles further and explores the extent to which they create their own sense of structure from chaos and meaning from the seemingly meaningless.

The filmmaker and the poet: *L'Etoile de mer*

(1928, 35mm, 15 mins, black and white, silent with musical accompaniment)

The history of avant-garde filmmaking is scattered with numerous examples of collaborative partnerships, often involving an interdisciplinary dialogue between film and other arts such as painting, photography and poetry. *Entr'acte* (1924) was the result of collaboration between the painter Francis Picabia and the filmmaker René Clair, just as *Un Chien andalou* (1929) came into being through the combined artist sensibilities of Salvador Dalí and Luis Buñuel. Germaine Dulac's *La Coquille et le Clergyman* (1927), although perhaps not such a harmonious collaboration, was made from a Surrealist scenario written by Antonin Artaud.[1] Man Ray's third film *L'Etoile de mer* represents a similar combination of personalities, and, in ways comparable to *La Coquille*, demonstrates the process by which literary ideas are developed through cinema. The film is commonly held to be an adaptation of a poem by the Surrealist poet Robert Desnos and, as such, symbolises a particular relationship between literary and visual Surrealism turning images of poetry into poetic cinematic images. As we shall see, the relationship between written poetry and visual poetry is one of the central concerns of *L'Etoile de mer*, particularly through its use of intertitles.

If *Emak Bakia* is considered by critics as representing the intermediary stage between Dada and Surrealist expression, with much confusion as to where it should be positioned, *L'Etoile de mer*, as a result of Desnos' influence on the film, is widely accepted as occupying more distinctly Surrealist terrain. It is often cited, along with the films of Buñuel, as well as Dulac's *La Coquille et le Clergyman*, as one of the few examples of early film Surrealism. The discussion of Man Ray's Dada sensibility that dominates accounts of his first two films is virtually replaced by a more thematic

concentration on the cinematic formulation of desire, which focuses on the extensive use of metaphoric association. The majority of analyses of *L'Etoile* therefore emphasise the relationships that are established by the imagery provided by Desnos, and end up providing an exclusively Surrealist reading of the film. Lauren Rabinovitz, for example, highlights the predominance of Freudian symbolism, privileging specific moments that support such an interpretation and leaving aside those which express other more visually determined concerns.[2] Allen Thiher relates much of the film's imagery to the themes of Eros and anti-Eros, whilst P. Adams Sitney draws attention to the centrality of the 'toothed vagina' and the castrating woman to the development of the action.[3] Whilst I would not wish to deny the importance of these accounts in understanding the content of the film (the following discussion will draw on some of these interpretations), the emphasis tends to rest largely on the content of the film and neglects questions of form. This chapter aims to reconcile these two areas by looking more closely into the conception of the film and the very unique collaboration between Man Ray and Robert Desnos. The purpose of such an investigation is ultimately to create a more in-depth understanding of the way *L'Etoile de mer* can be seen within the context of Man Ray's work as a filmmaker, but also to uncover some concerns that relate more generally to his interest in developing a uniquely cinematic form of vision, drawing on the inherent properties of the medium. Throughout the subsequent discussion, these concerns will be considered not in isolation from, but in close relation to, the Surrealist content of the film.

Of the four cinematic works by Man Ray, *L'Etoile* is the only film that did not emerge as the result of a request or commission, but one that was made, nonetheless, in response to an external stimulus. In *Self Portrait*, Man Ray describes the initial conception of the film during a dinner that was held to celebrate Desnos' departure on a journalistic mission to the West Indies. At the end of the meal, Desnos apparently began to recite various poems, one of which, written by him, had a significant impact on Man Ray. It was, remembers the latter, 'like a scenario for a film, consisting of fifteen or twenty lines, each line presenting a clear, detached image of a place or of a man or a woman. There was no dramatic action, yet all the elements for a possible action [...] My imagination may have been stimulated by the wine

during our dinner, but the poem moved me very much. I saw it clearly as a film – a Surrealist film.'[4] That very evening he promised to have a completed film by the time Desnos returned to Paris. Despite subsequently regretting his impulsive decision, he set to work on the project the following day and did indeed have a finished version in time for Desnos' return. The account offered by Man Ray presents the film in terms of an individual effort and makes no reference to the process by which the poem was transformed into a film. Importantly, this account restricts the role of Desnos to the recital of the poem and his cameo appearance in the final scene of the film, which was shot prior to his departure.

A number of critics have expressed their doubt in relation to the authenticity of Man Ray's claims. Allen Thiher, for instance, states that, 'the existence of such a poem in a finished form is doubtful. Man Ray's description of the poem in *Self Portrait* reads more like a résumé of his own film, and one might well suspect that, rather than a completed poem, Desnos gave him a certain number of themes, images and perhaps tropes that the photographer decided to transform into a film.'[5] In a similar vein, J.H. Matthews writes 'If Desnos' poem was indeed only fifteen or twenty lines long as Man Ray tells us, it must have been a masterpiece of compression. As he recalls it [in his autobiography], Man Ray evidently is evoking all it suggested to him.' Matthews also goes on to suggest, like Thiher, that Man Ray's description seems to be a 'summary of the content' of the finished film rather than a description of the poem itself.[6]

It would not be unusual for Man Ray, famous for his contempt for facts and details, to have distorted, either purposefully or not, the progression of events some thirty years after their having taken place. However, some recent discoveries shed light on the situation, and allow a deeper understanding of the way in which the project was conceived by both Desnos and Man Ray. Whilst there is no existing evidence of the poem to which Man Ray refers in his autobiography,[7] there are a number of original documents: a rough outline of the film held in the Bibliothèque littéraire Jacques Doucet in Paris and accompanying musical indications in the Bibliothèque du film,[8] as well as a more detailed scenario, which, as Inez Hedges points out, has been in the collection of the Museum of Modern Art since 1972.[9] The fact, noted by Hedges, that the existence of

these documents has gone largely unnoticed by previous commentators
goes some way to understanding the general acceptance of Desnos simply
providing Man Ray with a basic idea around which the latter structured
his film. From this perspective, *L'Etoile* could easily be worked into Man
Ray's statement that he worked alone on all of his films.[10]

Looking more deeply into the project reveals, however, that this was
not entirely the case. The detailed manuscript of the scenario, reproduced,
transcribed and translated in Kuenzli's *Dada and Surrealist Film*, corre-
sponds almost exactly with the finished film. It is divided into twenty-three
sections describing the succession of shots and intertitles, next to which
are added instructions for musical accompaniment. The most interest-
ing aspect of these documents is that they appear to have been written
not by Man Ray, but by Desnos.[11] Notations added in pencil to the later
manuscript have been established as in the hand of Man Ray. Rather than
developing the actual content of the scenario, these revisions focus pre-
dominantly on the order of the images and were likely to have been made
during the actual shooting of the film. This is suggested by the additional
diagonal pencil marks that appear across each of the sections, which were
probably made once a shot had been completed. As Hedges remarks in
her reassessment of the film from the perspective of the Man Ray–Desnos
relationship, any study of the scenario reveals that *L'Etoile* must be under-
stood in terms of a collaborative effort, with Robert Desnos contributing
to a much greater extent than has previously been acknowledged. His role
should therefore not be relegated to simply providing the basic ideas, but
must be recognised as contributing significantly to the nature of the film
in terms of both image and text.

Considering *L'Etoile* as a collaboration not only privileges the posi-
tion of Desnos, but also helps us to assess the film more accurately within
Man Ray's cinematic oeuvre. As this chapter will demonstrate, many of
the Surrealist themes and motifs that are developed throughout the film
seem to derive from concerns quite specific to Desnos, and can be seen as a
recurring element in his work. The predominant themes of love, sexuality
and violence form the basis of the majority of analyses of the film, yet they
are rarely ascribed to a particular origin, leaving open the question of how
these issues are supposed to relate to Man Ray's work more generally. In

contrast, many of the film's formal intricacies are overlooked, and, since it is through these qualities that Man Ray's artistic persona is most strongly evidenced, vital questions about the relationship between *L'Etoile* and Man Ray's development of specifically cinematic concerns are left unexplored. This chapter thus aims to provide a reassessment of the film that develops certain observations made by Hedges, to argue for the simultaneous presence of two distinct paths of expression: on the one hand the poetic Surrealist discourse of Desnos, and on the other the exploration of the plastic qualities of the cinematic image characteristic of Man Ray. In some areas of the film these paths diverge, whilst in others there seems to be an element of convergence where, although not necessarily expressed in the same way, the artistic sensibilities of the two men can be seen working side by side. The examination of *L'Etoile* from the perspective of the combined forces of Man Ray and Robert Desnos also allows us to consider one of the most important issues in the field of Surrealist theory: the relationship between word and image.

Man Ray and Robert Desnos: A fusion of sensibilities

As the previous chapter highlights, although Surrealism emerged out of literature and was initially expressed through the medium of poetry, the power of the image was a central element of the movement in its early stages.[12] The Surrealists seized upon the immediacy of the image and its seemingly direct link with the unconscious, and it was precisely in the realms of cinematic representation that image was seen to acquire magical poetic status. The world as portrayed in the movies held a certain fascination for the Surrealist writers and poets, and the influence of the cinema can be seen even before the movement was established. Many of them were avid cinemagoers (André Breton's account, in 'Comme dans un bois', of his random visits to the cinema with Jacques Vaché in 1917 is a perfect example of how film was used as a source of creative inspiration[13]), and several

Surrealist authors, such as Louis Aragon, Philippe Soupault and Robert
Desnos began to publish scenarios and articles on the cinema in the late
1910s and early 1920s.[14] The most famous of these include Jacques Vaché's
letter to André Breton in 1918, in which he proclaims, 'quel film je jouerai!
– Avec des automobiles folles, savez-vous bien, des points qui cédent, et des
mains majuscules qui rampent sur l'écran vers quel document!' [What a film
I'd make! – With crazy cars, d'you know, points that disappear, and enor-
mous hands creeping across the screen to heaven knows what document!][15]
The artistic fusion of Man Ray and Robert Desnos is thus significant in
this context since it represents an exchange or dialogue between two key
areas of Surrealist expression – the visual and the literary. It is interesting
therefore to briefly explore the nature of this exchange and to outline their
respective trajectories towards the making of *L'Etoile de mer*.

Man Ray and the written word

Although Man Ray was first and foremost a visual artist, his interest in
poetry and the creative power of words had a considerable effect on his
work. Much of his life was spent in the company of writers and poets,
beginning with the years during which he lived in the artists' commune
in Ridgefield, and continuing with his acquaintances in both New York
and Paris. He claims that during his early development as a painter, it was
not the vast collection of modernist works he saw at Alfred Steiglitz's
gallery '291' in New York that had the greatest impact on him, but rather
the creative energy and ideas of a literary kind, both past and contempo-
rary.[16] His first wife, the Belgian Adon Lacroix, was a writer, and provided
his initiation into the world of the French poets. He has on a number of
occasions expressed the direct influence that these poets, especially Lau-
tréamont and his use of juxtapositions, had on his artistic approach. *The
Enigma of Isidore Ducasse (The Riddle)* (1920), a photograph of an object,
or objects, covered by carpet and bound with string, is a direct reference
to this inspiration, and even constitutes the central theme of the work. As
Francis Naumann observes, 'Man Ray wanted the viewer to believe that
two rather commonplace objects were hidden under the carpet. The only

way a viewer could know what they were, though – and thus solve the riddle – was to have been familiar with the writings of the obscure, though extremely influential, French author Isidore Ducasse, whose pseudonym was Comte de Lautréamont.'[17]

Images produced by Man Ray have often been placed alongside works of a literary nature. These include journals such as *La Révolution surréaliste*, as well as collaborative publications such as *A Book of Divers Writings* with Lacroix, and *Les Mains Libres*, a collection of drawings with accompanying poems by Paul Eluard, published in 1937. Whilst living in Ridgefield, New Jersey, he established a journal entitled *The Ridgefield Gazook* and collaborated with the painter Samuel Halpert and poet Alfred Kreymborg on the publication of *The Glebe*, a home-grown magazine intended to rival the Chicago-based Imagist publication *Poetry*. In New York, he was also involved in the *Others* magazine, headed by the poet, art patron and collector Walter Arensberg,[18] as well as the unique issue of *New York Dada* in 1921.

Man Ray was particularly aware of the potentially powerful relationship between image and text, as the intricate interweaving of visual and literary references in *The Riddle* demonstrates. The Armory Show of 1913 and the scandal caused by Duchamp's *Nude Descending a Staircase* (1912) helped to shape his understanding of how the two artistic domains could collide in such a way as to alter the viewer's perspective and thus their interpretation of the work. He has argued that one of the most important aspects of Duchamp's painting is the title given to it, without which it would not have attracted so much attention. He states, 'L'incident m'avait ouvert les yeux et j'ai par la suite donné un titre à chacune de mes œuvres. Elles ne sont certes pas expliquées par les mots qui leur ajoutent cependant un "élément littéraire", pour ainsi dire, et agissent sur la pensée comme un stimulant.' [The incident opened my eyes and thereafter I gave a title to each of my works. They are certainly not explained by these additional words which, however, add a 'literary aspect', so to speak, and act as a stimulant to thought.][19] Thus, in many of his art works he uses the title to alter the meaning or to create a collision of signification. To return to *Self Portrait*, discussed in Chapter 2, the title of this work is of central importance since, contrary to what it suggests, the mixed media collage does not even feature

his face, but a hand print in the middle of an arrangement of elements designed to provoke the public. I have suggested in the previous chapter that by calling the work a self-portrait, Man Ray simultaneously challenges expectations whilst drawing attention to himself as the creator and thus the provoker. *The Rope Dancer Accompanies Herself With Her Shadows* of the same year is another example of text entering into a relationship with the image. The title gives figurative meaning to what would otherwise be seen as an abstract work.

Man Ray's literary interests are revealed on a number of levels in his films. Chapter 1 suggested a correlation between the visual relationships developed in *Le Retour à la raison* and the poetic structures found in the writings of the Dadaists and Surrealists, described by Eric Sellin as repetition and parallel, converse and contradictory pairings of images.[20] The similarities found by comparing the content of his early films with the syntactical structures of poets such as Breton, Tzara, Aragon, Arp, Soupault, Reverdy and, of course, Desnos, demonstrate an affinity with certain poetic methods in the creation of images through time. These structures are also a key characteristic of *Emak Bakia*, and reappear to a certain extent in *L'Etoile de Mer* and *Les Mystères du Château du Dé*. Man Ray thus establishes in his films a visual 'language', where relationships are developed on the level of the signifier, suppressing the traditional reliance on the signified for the development of structures of meaning. The titles of these films also reveal an interest in linguistic structures on a very basic level of alliteration, itself a form of repetition. The phrase 'le retour à la raison' works with elements of repetition and alternation, two salient features of the film's visual content. We could take this very simple observation slightly further to bring in Sellin's notion of the 'echoic',[21] in which repetition is altered slightly since the 'le re' of the first part of the title becomes 'la rai' in the latter, demonstrating a clear phonetic relationship. 'Emak Bakia' illustrates a similar process with the 'ak' being repeated in a different form from one word to the next.

Man Ray's desire to inject poetic structures into visual expression can also be seen in his decision to give *Emak Bakia* the subtitle 'ciné-poème', a feature that self-consciously points to the nature and arrangement of the images in terms of poetry. Indeed, Man Ray refers to the intended effect of his films in the light of emotional responses related to poetry. He imagines

the spectator might 'rush out and breathe the pure air of the outside, be a leading actor and solve his own dramatic problems. In that way he would realize a long cherished dream of becoming a poet, an artist himself, instead of being merely a spectator. Poets have declared that everyone should write poetry. All art is the writing of poetry and the painting of pictures.'[22] Carl I. Belz argues that Man Ray's films constitute a personal 'writing of poetry', stating that this element provides the common ground between them.[23] Interestingly, to demonstrate this idea, Belz draws on exactly the kinds of elements to which Sellin refers, without directly associating them with corresponding poetic structures. He emphasises, for example, features of similarity, alternation and the play of opposing elements that thread their way through all the films, particularly those of real/unreal and reality/fantasy, which, as we shall see, are crucial to the structure of *L'Etoile*. Poetry was also an inspiration for *Les Mystères du Château du Dé*, the film in which Man Ray most effectively demonstrates the interrelationship between modernist forms of literature and the cinema.

Perhaps the most interesting aspect of Man Ray's relationship with the written word is the predominance of word play and humorous punning within his works. Although his use of the pun can be seen as early as 1915 in his review *The Ridgefield Gazook*, it was again through his friendship with Duchamp that this area seems to have been developed. Duchamp's extensive exploration of the humorous possibilities of language and its ability to create a complex dialogue with the visual quality of the work began with the eponymous *L.H.O.O.Q.* of 1919, featuring a defaced *La Giaconda* (Leonardo da Vinci's renowned painting of 1503–5) wearing a beard and moustache. The title, which when read aloud sounds 'elle a chaud au cul', demonstrates the polyvalence of language and its creative potential for revealing hidden meanings.[24] This idea of interchange was further developed by Duchamp through his invented female alter-ego and pseudonym Rrose Sélavy (Eros, c'est la vie/sel à vie), in the name of whom many of his works and writings were produced, including *Anémic Cinéma*.[25] In this film, on which Man Ray collaborated, the graphic spirals producing the illusion of depth are interspersed with flat spiralling texts – a series of elaborate (frequently erotic) puns, 'producing an endless train of associations.'[26] Lines such as 'l'Aspirant habite javel et moi j'avais l'habite en spirale' and

'Esquivons les ecchymoses des esquimeaux aux mots esquis' not only play
with linguistic constructions, but also self-consciously refer to the content
and structure of the film itself.[27]

Duchamp's use of the homonym is reflected throughout Man Ray's
oeuvre. For example, as Robert Pincus-Witten, one of the few commen-
tators to concentrate exclusively on the role of Man Ray's punning titles,
states, a 1935 work entitled *Main Ray*, 'follows Duchamp's lead' in exploiting
'his own name as a source for art.'[28] Here, the actual image of a mannequin's
hand holding a ball is less important than the double meaning created
through the similarly sounding words, 'Man', the artist and 'main', mean-
ing hand. This process can also be seen in later works such as *Pain peint*
(1960), a baguette painted blue, and *Ballet français* (1957/71) a mounted
bronze broom ('balai' in French). In the latter, 'the linguistic correlatives
[...] connect the notion of sweeping gestures with a choreographic idea,
and conversely deflate balletic pretensions into something homely.'[29] Thus,
'much of the meaning of the works lies not in the objects themselves but
in the overlay between language and object that they embody.'[30] This dem-
onstrates how Man Ray, taking his lead from Duchamp's linguistic experi-
ments, developed the use of titles in his works to go beyond simple ruptures
between what is seen and what is read. The link between Man Ray, Duch-
amp and Desnos within the realms of language and word play is crucial in
understanding the role of literary and visual expression in *L'Etoile*, since
Desnos too would emulate Duchamp's use of homophony in a text entitled
Rrose Sélavy (1922–3), amongst others.[31]

Robert Desnos and the cinema

Desnos was one of the key members of the Surrealist group until growing
tensions between him and André Breton led to their eventual estrange-
ment at the end of the 1920s. He regularly participated in the Surrealists'
early experiments into automatism, during which the subject would go
into a dream-like trance and utter words and thoughts apparently released
from all logic and rationality. He was particularly gifted in this area, fall-
ing quickly into a kind of waking sleep and producing the most striking

results. Man Ray was clearly impressed by Desnos' personal embodiment of the Surrealist principles, stating in his autobiography:

> In his normal state he was unpredictable, one moment gentle and urbane, then again suddenly violent and vindictive towards some act of injustice or stupidity. He'd give free rein to his passions in public gatherings, exposing himself to a beating by some outraged neighbor. Often in my studio, he'd slump down in an armchair and doze peacefully for a half-hour. Opening his eyes, he continued an interrupted conversation as if there had been no time lapse. It was a perfect illustration of one of the Surrealist maxims: there was no dividing line between sleep and the state of being awake.[32]

It was clearly the powerful fusion of these two states that led to Desnos' interest in the cinema, which he referred to as 'un rêve éveillé'.[33] The final passage of the novel *Pénalties de l'enfer ou Nouvelles Hébrides* refers to the ambiguous boundary between cinema and reality. Here, Desnos' desire to go beyond the screen, to discover that which lies behind it, leads him to the scene of his friends Aragon and Baron's suicide, 'Je compris qu'eux aussi avaient voulu voir ce qui se passait derrière la toile et la toute beauté de leur suicide me fut révélée.' [I understood that they too had wanted to see what was going on behind the screen and all the beauty of their suicide was revealed to me.][34] As Haim Finkelstein observes, *Pénalties de l'enfer*, written in 1922, 'constitutes Desnos' first evocation of a cinema experience.'[35]

Between 1923 and 1930, Desnos wrote a series of articles on various aspects of the cinema for newspapers, magazines and journals such as *Paris-Journal, Le Soir* and *Journal Littéraire*. Although these texts clearly fit into the context of film criticism, he stated in 1923, 'Je me suis toujours efforcé de ne pas faire de critique.' [I always tried not to be a critic.][36] Interestingly, this proclamation seems to anticipate a very similar statement made retrospectively by Man Ray, and which I have already highlighted in the introductory chapter, 'J'ai résolu de ne jamais m'occuper du cinema.'[37] Both men draw attention to the desire to maintain a certain distance from film as a commercial undertaking and to not become actively involved in an art form that nonetheless fascinated them. Through his writings, however, Desnos expressed a wide-ranging interest in the cinema, and clearly valued its potential for Surrealist expression. He wrote a large number of film synopses and scenarios, which, taken together, establish a developed

understanding of cinematic expression.[38] His position can be defined in relation to the belief, shared by many artists and writers of the period and discussed in the previous chapter, that film is capable of recreating the dream experience through its characteristic ability to evoke both reality and illusion. Linda Williams highlights this aspect of his approach to cinema:

> A true Surrealist, Desnos refuses to consider the film as simply another art form, an object of contemplation endowed with aesthetic virtues [...] he prefers to model the film upon the dream's function of wish-fulfilment, as a mirror reflecting our desires rather than what is. For Desnos the heroes of film would ideally act out the spectator's own repressed desires, daring to commit the crimes they are too timid to commit themselves.[39]

During the 1920s and 1930s, a number of Surrealists turned their attention to film writing, producing a plethora of film poems, synopses and scenarios. As Richard Abel has noted, many of these 'hybrid textual forms' were un-filmable and never actually made it to the screen.[40] They did, however, develop an extremely diverse area of Surrealist expression that draws on the possibilities of cinematic expression through textual description. Along with Blaise Cendrars and Pierre Reverdy, Desnos was particularly prolific in this area, producing cinematic outlines in a range of formats. The most interesting of these in the context of the present discussion are the published scenarios dating from 1925 to 1933, which demonstrate his approach to writing for the cinema. If Desnos was interested in using the medium of film as a way of transmitting the dream experience, 'Minuit à quatorze heures' (1925), 'Les Récifs de l'amour' (1930) and 'Les Mystères du métropolitain' (1930) all reveal this concern to lie not within its form, but its content, focusing primarily on the expression of desire.

The principle point of convergence in the approaches of Man Ray and Robert Desnos towards the cinema would appear to lie in the use of iconography to build towards a specific idea or effect. As the previous chapter makes clear, *Emak Bakia* abounds with references to eyes, legs and water. Certain images reappear from one film to the next, such as the dice that provide the focal point in *Les Mystères du Château du Dé*, or, most obviously, the image of the starfish that is briefly referred to in the same film. In Desnos' scenario for 'Minuit à quatorze heures', the circular image, which appears in a variety of guises, gradually becomes a menacing force, finally

literally consuming the narrative and the characters within it.[41] Whilst this element of the scenario points, as Linda Williams has suggested, to an underlying interest in formal similarities typical of later Surrealist film (e.g., the eye–moon analogy in *Un Chien andalou*),[42] there is also something quite significant, almost symbolic, about Desnos' conception of the threatening, all-consuming form that ultimately destroys the narrative and the characters within it, bringing it to a violent and abrupt end. This becomes particularly relevant when we come to consider the interaction between Desnos and Man Ray in the making of a film that seems to be caught between thematic and formal concerns.

Collaboration on L'Etoile de mer

The exact nature of the collaboration between Man Ray and Desnos is unclear. As we have seen, Man Ray makes no reference to the scenario in his discussions of the film, and always considered his cinematic works in terms of an individual effort. This can be seen as part of a more general reluctance to put his work under more than one name. Man Ray often expressed his distaste for collaborative projects, giving this as one of the main reasons for his lack of interest in filmmaking on a larger scale. This attitude also characterises his relations with both the Dada and Surrealist groups with whom he was happy to be associated as long as he maintained his artistic independence. That the manuscript of the scenario can be traced to the hand of Desnos thus raises important questions related to authorship. Was the scenario worked out together by the two men or was it purely the work of Desnos, whose ideas were simply translated into images by Man Ray? On the subject of the film's conception, Desnos has stated:

Je possède une étoile de mer (issue de quel océan?) achetée chez un brocanteur juif de la rue de Rosiers et qui est l'incarnation même d'un amour perdu, bien perdu et dont, sans elle, je n'aurais peut être pas gardé le souvenir émouvant. C'est sous son influence que j'écrivis, sous la forme propice aux apparitions et aux fantômes d'un scénario, ce que Man Ray et moi reconnûmes comme un poème simple comme l'amour, simple comme le bonjour, simple et terrible comme l'adieu. Man Ray seul pouvait concevoir les spectres qui, surgissant du papier et de la pellicule, devaient incarner, sous les traits de mon cher André de la Rivière et de l'émouvante Kiki, l'action

spontanée et tragique d'une aventure née dans la réalité et poursuivie dans le rêve. Je confiai le manuscrit à Man et partis en voyage. Au retour, le film était terminé. Grâce aux opérations ténébreuses par quoi il a constitué une alchimie des apparences, à la faveur d'inventions qui doivent moins à la science qu'à l'inspiration, Man Ray avait construit un domaine qui n'appartenait plus à moi et pas tout à fait à lui.[43]

[I have a starfish (from which ocean did it originate?) purchased from a Jewish second hand shop in the Rue de Rosiers which is the epitome of a lost love, lost for all time but without which I would not have retained this moving memory. Under its influence I wrote, in a way that was appropriate to apparitions and ghosts in a screenplay; Man Ray and I recognised it as a simple love poem, as simple as saying hello, as simple and terrible as saying farewell. Man Ray alone was able to conceive that the spectra, rising up out of the paper and the film, should embody the features of my dear André de la Rivière and the affecting Kiki, and that the action should be both spontaneous and tragic, grounded in reality and passing into a dream. I gave the manuscript to Man and went travelling. On my return, the film was complete. Thanks to the shady means by which he had constructed some ghostly dream, thanks to inventions that owed less to science than to inspiration, Man Ray had created a world that no longer belonged to me and yet was not entirely his.]

The account by Desnos only adds to the ambiguity surrounding the film. It is almost impossible to discern whether the original idea was written in the form of a poem or a scenario and to what extent Desnos and Man Ray actually worked together on the details of the film. This is due to the simultaneously evocative and evasive language used by Desnos that, perhaps purposefully, creates an aura of mystery. Whilst he does not directly refer to the writing of a scenario, he does suggest that his literary expression evoked cinematic images and patterns. The line 'what Man Ray and I saw as a poem simple like love' neither confirms nor denies the presence of an actual poem since the sentence can be read from two different perspectives: that Man Ray and Desnos recognised a simplicity in the poem or that they saw a simple form of poetry in the written document (whatever form it may have taken).

We can make yet further observations about this comment. In describing the transformation of the film from page to screen, Desnos refers to 'ghosts' and 'spectres', bringing to mind a characteristic of the cinema to which he was particularly attracted. 'You die and yet your doubles captured in the fragility of the celluloid survive you and continue to carry out your

ephemeral actions', he states. 'The projection does not stop at the screen. It goes beyond it, and ever-increasing, continues to infinity like two mirrors reflecting each other.'[44] The paradoxical presence/absence phenomenon can also be detected in Man Ray's films. As I have already discussed, the rayograph technique that features in both *Le Retour à la raison* and *Emak Bakia* highlights this duality, as does the focus on light and shadow, an aspect that seems to form the basis of Man Ray's work in both cinema and photography more generally. In both *Emak Bakia* and *Les Mystères*, one comes across moments that seem to correspond with Desnos' observations about the relationship between cinema and reality. In the former, a sequence of numerous pairs of feet stepping out of a car uses the technique of superimposition to give an impression of ghostly traces. *Les Mystères*, as I will discuss in the next chapter, draws more directly on this theme, presenting it both visually and through written intertitles. Desnos' approach to the cinema in terms of its ghostly characteristics and his reference to the effect of the mirror can be linked also to an area of film theory that has had a significant impact on the understanding of Surrealism and the cinema – Christian Metz's notion of the 'imaginary signifier', i.e., that cinema presents us with an image of something that is not really there.[45] One final remark should be made about Desnos' account of the film – the way he presents it as existing in between the expressive domain of both himself and Man Ray but ultimately belonging to neither one of them. It is this aspect of the film that I shall now explore in detail, through an analysis of the relationship between the scenario and the film.

From page to screen

A close consideration of the scenario for *L'Etoile de Mer* reveals a number of important details that shed light on the collaborative relationship between Man Ray and Robert Desnos. The first and perhaps most important observation is that it contains very few technical references, focusing instead on a predominantly literary description of the film's action. The main detail

that signals Desnos as the principle author of the text lies in the laconic and elliptic style of writing. The text describes the content through a series of numbered tableaux, which present a simple action, image or location, and bears a striking resemblance to the four scenarios that Desnos published in the 1920s and 1930s, the images of which are also consecutively numbered. Placed alongside the scenario by Antonin Artaud for *La Coquille et le Clergyman* of the same period, the difference in style is remarkably evident. Artaud's scenario is written as a narrative and describes the progression of events in detail.[46] Although, like Artaud, Desnos does not specify elements such as framing and transition between the shots, there is nonetheless a particularly cinematic feel to the scenario for *L'Etoile de mer* that arises from the simplicity with which the images are described. The content is reduced to concise visual cues, which, importantly, are combined with a series of intertitles. Since much of this chapter's introductory discussion has focused on the role of language and written text in bringing together the personalities of Man Ray and Robert Desnos, it is useful to give a brief overview of their respective concerns regarding the use of intertitles and the relationship between text and image in the cinema.

Intertitles

The inclusion of intertitles in both the scenario and the finished film is extremely significant as it demonstrates the positioning of the film in opposition to the conventions of silent cinema, according to which the intertitle functions to supply the viewer with additional information or to comment on the visual action. In the context of traditional cinema, intertitles are subordinate to the images and work alongside them to create narrative consistency. However, as P. Adams Sitney has pointed out, the role of the intertitle became a key concern during the 1920s, when a number of filmmakers purposely omitted them.[47] A common view, particularly amongst the Impressionist filmmakers and theorists, was that the intertitle was fundamentally 'uncinematic', due to the way it emphasised the literary over the visual. Louis Delluc, for example, argued, 'Le texte, redisons-le, ne doit pas être là quand l'image peut le remplacer. On abuse du sous-titre. Cela

gêne le mouvement – et le spectateur.' [Let's say it once again, there is no need for the text when the image can replace it. Subtitles are all too often abused. They disconcert the flow – and the viewer.][48]

In 1923, Robert Desnos published an article on the subject, counter-arguing for the importance of the intertitle in film. Expressing a view that opposes the purist approach of the Impressionists, this article focuses on text as an integral part of cinematic expression and not simply a superficial addition, stating, 'C'est qu'en effet tout ce qui peut être projeté sur l'écran appartient au cinéma, les lettres comme les visages.' [The fact that anything that can be projected onto the screen belongs to cinema, words as well as faces.][49] However, he goes on to condemn their conventional use as simple literary adjuncts, separated from the visual expressivity of the film: 'Le principal est qu'ils restent du cinéma et qu'un imbécile désir de littérature ne les isole pas de l'action comme le commentaire d'un pion au bas d'un beau poème.' [The main thing is that they remain cinematic and that an idiotic desire for literature does not isolate them from the action like an intrusive comment at the bottom of a beautiful poem.][50] Indeed, this stance is reflected in a number of avant-garde films of the 1920s that experiment with the relationship between text and image.[51] Duchamp's *Anémic Cinéma* demonstrates a radical break with the conventional storytelling function of textual intertitles by bringing them into an abstract relationship with the images. The earlier *Ballet mécanique* also uses text as a basis for abstract visual exploration when a newspaper headline is broken up into its component parts and the letters dance freely across the screen.

When assessing the importance of the intertitle to Man Ray's filmmaking practice, we must again consider the more general status of text in his work. As I have already discussed, Man Ray often uses titles in his work to destabilise the viewing process, and to create a delicate interchange between different and often contrasting concepts and interpretations. This process can be seen in his first film *Le Retour à la raison*, where the title functions in a number of ways. Seen in terms of a Dada statement, it juxtaposes the promise of reason with its very opposite. Yet, as my discussion of this film emphasises, *Le Retour à la raison* is about much more than simple nega-tion, and, despite the spirit of anarchy that exists at its surface, the film expresses a strong creative urge through the development of purely visual

structures. According to Sitney, 'The "return to reason" of the title might be taken as a declaration that cinema is fundamentally a play of light on surface. After almost thirty years of cinema, here was a film that returned to the theoretical starting point of the medium, taking account of its possibility as an art.'[52]

Regardless of the position taken in relation to this film, it is clear that the title goes beyond that of accompaniment to, or description of, the material since it enters into a relationship with the images and forms part of the film's central message. Although *Emak Bakia* is the first film in which Man Ray makes use of the intertitle, attempts to incorporate text into the visual ensemble can already be seen in *Le Retour à la raison* through the almost imperceptible flashes of writing. The words, written directly onto the film strip and lasting only a number of frames, are emptied of any significance and turned into visual impressions, the period of time for which they remain on the screen being far less than would be required for the spectator to recognise the words and incorporate them into a linguistic understanding. Only one intertitle is used in *Emak Bakia* and it has almost the same function as the title *Le Retour à la raison*. The idea of reason and logic is evoked, only to be juxtaposed with a sequence that transcends any logical explanation, suggesting that behind the normal laws of rationality exists another world based on purely visual relationships. The placement of the intertitle just prior to this quasi-narrative sequence is also, of course, a reference to the conventional role of textual inserts and therefore an attempt at subverting the spectator's expectations. The intertitle has no narrative significance, and, unlike the textual information of the majority of silent films, does not help the viewer to understand the visual content of the film on a narrative level.

L'Etoile therefore expresses an overlap of interests between Man Ray and Desnos within the realms of text-image interaction. Turning now to an exploration of the relationship between the scenario and the finished film, what conclusions can be drawn from Man Ray's interpretation of Desnos' literary description, and, more importantly, how can we understand *L'Etoile* within the wider context of the former's distinctive cinematic voice? If Desnos was the author of the scenario, how much of his influence can be detected in its cinematic form? These questions will lead ultimately

to a better understanding not only of how the film relates to the Surrealist themes of Desnos, but also of the way in which Man Ray brings to the material his own aesthetic concerns.

From text to image: Man Ray's interpretation of the scenario

The film opens with the rotating image of a starfish, confirming the importance of the title 'L'Etoile de Mer' in establishing the central motif. The distorted quality of this shot demonstrates a clear link with sections of *Emak Bakia*, and it is likely that Man Ray employed the same visual technique in both films. The isolation of the object against a black background is also reminiscent of the visual studies that characterise the earlier film. In fact, the closing shot of *Emak Bakia*, in which the upside-down face of Kiki swings and rotates, is almost seamlessly continued in this opening section of *L'Etoile de mer*. This is an early indication that Man Ray, despite working from a Surrealist text, had not abandoned his own visual concerns, and was, crucially, still employing some of the techniques that he had developed in his previous film. The next shot introduces the Man Ray–Desnos partnership, exactly as it features in the scenario manuscript – 'L'etoile de mer, poëme [sic] de Robert Desnos tel que l'a vu Man Ray.' Unlike the initial presentation of the title, which appears in large anonymous typography, this text is handwritten and presented in very much the same format as in the scenario. This time, however, the text appears to have been written by Man Ray and not, as is the case with the original manuscript, by Desnos.

The juxtaposition between the two forms of textual presentation, that is, the standard typography of film titles and the handwritten text, continues throughout the film and represents one of the many examples of duality. The appearance of this introductory text in handwritten form creates a kind of authorial statement as it clearly suggests the hand of the artist ('main ray'), and can therefore be seen alongside the opening shot of *Emak Bakia*, in which Man Ray films himself operating his camera, as well as the sections of film in *Le Retour à la raison* onto which he wrote directly. However, this is rendered complex when, at the end of the film, Desnos, in

a cameo appearance, is seen leading Kiki out of the frame and away from
her lover. Viewed from this perspective, the question of authorship again
becomes an ambiguous one. However, the variation in the presentation of
text in the film – the lack of consistency in the presentation of different
styles and fonts, typed intertitles and handwritten ones – looks ahead to the
use of Stéphane Mallarmé's groundbreaking poem as inspiration for Man
Ray's next film, demonstrating his interest in the use of text not simply in
its symbolic signification, but also as a graphic visual element.

The entry into the story world of the film is visually suggested by a
panelled window that opens out towards the camera. A man and a woman
(André de la Rivière and Kiki) are presented in a long shot walking towards
the camera along what appears to be a country lane. As they approach, the
shot changes to show their legs in close-up, walking together in synchro-
nicity. This clearly demonstrates Man Ray's visualisation of Desnos' brief
explanations 'Marche' and 'leurs jambes'. Indeed, as I shall discuss later, the
staccato rhythm created by Desnos' literary style is effectively mirrored in
the visual rhythm that is fleetingly established through these transitions.
The image returns to a medium-shot of the couple as they stop in front
of the camera. The woman bends down and a dissolve reveals a shot of
her legs. The first intertitle states, 'Les dents des femmes sont des objets
si charmants ...' The same image returns and the woman lifts up her skirt
slightly to adjust her garter, kicking her leg forward in a playful, almost
sexual manner. The sentence ends, 'qu'on ne devrait les voir qu'en rêve ou à
l'instant de l'amour.' Thus the film begins with a powerful juxtaposition of
image and text, subverting the conventional use of intertitles as reinforcing
and complimenting what is presented visually. Instead of creating consist-
ency, the intertitle provides an incongruous comment on the previous scene.
The image of the leg corresponds to Desnos' indication in the scenario, 'on
voit sa jambe', but the added intertitle suggests another layer of meaning
that is not present at the corresponding stage in the scenario. The phrase
is a quotation from Desnos' *Deuil pour deuil*, which reads, 'Les dents des
femmes sont des objets si charmants qu'on ne devrait les voir qu'en rêve ou
à l'instant de l'amour.'[53] The intertitle thus plays on the homophony of the
words 'l'amour' and 'la mort', which, as Ramona Fotiade argues, 'indirectly
echoes Desnos' early exploration of language games [...] as well as hinting

at the more obvious interlocking of Eros and Thanatos that highlights a major Surrealist thematic strand running through the film.'[54]

What remains unclear is whether this reference to *Deuil pour deuil*, which is absent from the original scenario, was later suggested by Desnos or rather inserted by Man Ray in homage to the poet. Questions of influence and authorship as not as clear as they first seem since, although the phrase creates a clear link between the film and Desnos' poetry, the juxtaposition itself also suggests recurring elements of Man Ray's work. This can be seen if we look at his previous film *Emak Bakia*, which, in two key sequences, expresses an interest in women's legs detached from their bodies. In both sections, this focus on legs is accompanied by a subversion of cinematic conventions and the narrative expectations of the spectator. The feet that dismount the car do not lead the film towards narrative progression, but multiply into infinity, just as the dancing legs do not turn out to be a cutaway that is reconciled with the whole, but which, to quote from Man Ray's own comment about the film, 'remains a fragment.' Here we can see Man Ray delighting in the creative possibilities of subversion and the ability to reverse logical expectations. The same process can be seen in *L'Etoile*, and instead of referring to the beauty of women's legs, the intertitle subverts what would be a logical connection in favour of creating humorous discordance. Of course, this juxtaposition also reads as a more general comment on the relationship between text and image in the cinema. This concern is expressed at the end of *Emak Bakia*, where a single intertitle humorously suggests an explanation for the film's concentration on form.

In the following sequence, the man and woman are shown walking up a staircase and entering a bedroom. The woman undresses and lies down on the bed, after which the man inexplicably stands up, kisses her hand and leaves the building. This section follows closely the indications made in the scenario, except for an intertitle that is added just after the man leaves the room. The phrase 'Si belle! Cybèle?' again seems to belong to the series of verbal puns and homophonies that characterised Desnos' poetry during the 1920s, yet it also has a wider signification in relation to the rest of the film, to which this discussion will return. For the moment, I would like to explore another addition that Man Ray makes to the scenario – that is, the striking sense of formal organisation that underlies the sequence. The

entire section is structured through image pairings that create a perfectly symmetrical effect. It begins with the image of a door, which in itself is a repetition of the window that opens onto the action at the beginning of the film. This is mirrored by an identical shot at the end of the sequence of a closing door. The second image of the two characters climbing the stairs is likewise paired with the second-to-last shot in which the man walks *down* the stairs towards the door. Again the visual elements are almost exactly the same in terms of camera position, framing and duration. The third shot in which the man and woman enter the room from behind the camera is mirrored by an image of the man leaving as he disappears behind the camera. The framing here is that of a medium-long-shot; during the exchange between the two characters the framing changes to a medium-close-up of the man.

A gelatine filter that is used throughout the film, the main function of which is to distort the images, prevents us from reading any kind of significant facial expression or gesture, thus making the transition lack the usual narrative motivation that one would expect. This detail further supports the idea that Man Ray uses the alternation of shots not within the context of the traditional rules of continuity editing, but rather in a formal arrangement based on similarity and difference. The medium-close-up switches back to the medium-long-shot, only for the alternation to be repeated once more. In effect, this alternation of framings creates a tight triangular formation in the middle of the sequence, which can be illustrated as follows:

MLS

MCU MCU

MLS MLS

The mirrored pairings thus begin from the second medium-long-shot, in which the woman takes off the last of her clothes, representing the point of the triangle.

The overall effect of this formal schema is that it creates a sense of visual rhythm that is developed somewhat independently of thematic content, and

demonstrates one of the ways in which Man Ray's attention to the visual structure of the film goes beyond the concerns of the scenario. From this section one can see clearly how elements of the written description – the climbing of the stairs and the closing of the door – have been employed in a way that interprets the original idea, whilst building into the film a sense of sustained visual organisation. Another indication of this pairing of shots can be found in the repetition of the image of the concrete tower that appears at the beginning of the following sequence. The corresponding indication in the scenario simply states 'Dans la rue', whereas the shot in the film involves a vertical tilt of the camera from an empty street along the length of a concrete tower. Later in the film the same movement is made in reverse. Although a number of discussions have interpreted this image in terms of its phallic symbolism, it is clear from this perspective that its significance goes beyond the overriding concern with sexuality that is inscribed into the scenario.

The presence of paired structures can also be perceived on the level of language. As the man leaves the room, a further intertitle states, 'Nous sommes à jamais perdus dans le désert de l'éternèbre.' This phrase has no clear relationship with the preceding action, and, as Fotiade's invaluable analysis of the film points out, 'only manages to confuse matters further.'[55] Like the intertitle that appears moments later – 'Le soleil, un pied à l'étrier, niche un rossignol dans un voile de crêpe' – the text seems to represent an example of automatic writing, the principal technique of Surrealist poetry. However, the word combination 'éternèbre' – seemingly a conflation of 'éternel' and 'ténèbre' – looks ahead to the similar fusion of *piscine* and *cinéma* in the intertitle 'piscinéma' of *Les Mystères du Château du Dé*. Although the latter seems to emerge directly from the visual, context and therefore does not create the same irrational juxtaposition between image and text, there is a similar interest in bringing together two distinct levels of signification to create a new meaning from a single word. Interestingly, the idea of 'eternal darkness' to which this word give rise is an important element of the later film, which is expressed through subtle references to death and immortality in the intertitles. What links the two films therefore is the reference to light – Man Ray's lifelong interest – and its binary opposite – shadow, darkness, death. This brings us back to Man Ray's

homonymic transformation of Desnos' line from *Deuil pour deuil*, in which 'l'amour' becomes 'la mort'.

The next section of the film introduces the motif of the starfish into the action, thus beginning the series of syntagmatic associations between the woman and various other symbolic phenomena that appear in the film. In a medium-long-shot, the same woman is shown selling newspapers on the street to invisible passers-by. A medium-shot then shows her looking past the camera into the distance, followed by the intertitle, 'Qu'elle est belle' – the first that also features in the scenario. An upside down newspaper in close-up is lowered to reveal the woman's eyes, an iris-in heightening the emphasis. The earlier medium-long-shot returns and into which the man walks, leading the woman away to another part of the street. This section of the film is interesting as in the scenario it is the female character that leads the man away and gives him the jar containing the starfish. Here, a close-up of the jar and an iris-in onto the starfish is followed by a shot in which the woman picks up the jar and holds it out in front of her in order to examine the object it contains. The man takes it out of her hands and repeats the same gesture. A final highly stylised shot shows the two characters, the man holding the jar out in front of him with the woman, her back to the camera, resting on his shoulder. The sequence ends with another iris-in, further confirming the significance of the starfish.

A number of observations can be made in relation to this short but important sequence that reflect upon Man Ray's visual interpretation of the scenario. The first of these is the element of visual discontinuity that is brought into the series of images, and which does not feature in the original description of the film. The shot that is placed in between those of the woman selling newspapers seems to momentarily break the narrative flow since it clearly does not belong to the accumulation of visual information, which, despite the overriding ambiguity, follows the rules of continuity. This sense of what could be called 'abstraction' (relating it to one of the key characteristics of Man Ray's work) from the rest of the action is highlighted by the way the lower half of the woman's face is masked off by the newspaper. The nature of the shot recalls images of Kiki that appear in *Ballet mécanique*, where a similar masking reveals only parts of her face. The positioning of the newspaper contributes to this overall effect

of abstraction, in that it refuses the usual transmission of meaning with which a newspaper is normally associated. Here the process of signification is once again brought into question and the text, as in certain sections of *Le Retour à la raison*, is reduced to a purely plastic function.

Another example of this narrative interruption occurs at the moment in which the two characters are shown staring at the jar containing the starfish. This shot, despite containing all the elements that are present in the previous shots, represents a sort of visual shock as the stylised pose of the characters breaks with the continuity of the action and focuses heavily on visual composition within the frame. Although Man Ray creates the impression of continuity by providing a sense of narrative development, discontinuity can be detected in the subtle details of the shot, which, like the final sequence of *Emak Bakia*, display a number of ruptures in the overall visual organisation. In the preceding shot, the two characters occupy the left half of the frame, with the man standing to the right of the woman. The image in question then shows them in a medium-shot, again towards the left half of the frame, but in completely altered positions. Whereas in the previous image the man's gaze was directed towards the left-hand side of the frame, he now looks to the right. Even if we assume that this image represents an example of the 180° line having been crossed, the position of the woman does not correspond since, whilst the man's position has changed, she remains on the left-hand side of the frame. Discordance is also achieved by the sudden clarity of the image in comparison with the other shots that are created with the filter; yet Man Ray does not aim to shock the viewer with outright incongruity, but instead attempts to create an atmosphere in which reality is only slightly out of synch with the way it is traditionally presented in the cinema.

It is at this point in the film that Man Ray illustrates the chain of associations that link the starfish with the male and female characters. This aspect of the film opens up one of the most crucial debates in the field of visual and literary semantics. The process by which one image – the starfish for example – comes to stand in for another – the woman – relates to the Surrealist use of metaphor and the predominance of poetic structures in which comparative forms such as 'as' or 'like' play a decisive role. The Surrealists' admiration for the writings of poets such as

Lautréamont derives particularly from the ability to transform traditional perceptions of the world by viewing one thing in relation to another. Linguistic metaphors thus became the most precious tool for Surrealist expression, and can be found particularly in the writings of Desnos. As an extension, then, it would be natural to read the images in *L'Etoile* in terms of filmic metaphors, and therefore as an adaptation of the techniques of literary Surrealism in order to create cinematic Surrealism. As Fotiade rightly observes, '*L'Etoile de mer* raises an important number of questions regarding the passage from verbal to visual metaphor, and, more generally, the problematic status of any attempted transposition of automatic techniques to the screen.'[56] The repeated use of intertitles such as 'belle, belle comme une fleur de verre', 'belle comme une fleur de chair' and 'belle comme une fleur de feu' that feature in Desnos' original script seems to represent the clearest attempt to bring literary metaphors into a visual domain. Yet, as intertitles, they retain a literary characteristic, an aspect that Man Ray tries to overcome by presenting them as handwritten, rather than typed, phrases.

The issue of the film's use of the Surrealist metaphor is approached by Allan Thiher, who argues that it fails to reproduce the effect of the literary metaphor (an effect that he sees as the film's 'more profound ambition'), which would normally depend on some kind of syntactical structure to create a framework of meaning:

> *L'Etoile de mer* has virtually no narrative structure. It thus forces us to confront one of the limits of cinematic discourse insofar as it attempts to create a prolonged metaphorical discourse. In *L'Etoile de mer* Ray and Desnos have discarded the rational use of metaphor as a form of binary transference and have attempted to juxtapose the star image with all the images in the film in order to create what we see as a prolonged surrealist simile. The juxtaposition of the starfish with any other given image – woman, knife, book, and so forth – is, in effect, an attempt to dislocate normal associative relations and analogies, with the goal of revealing those new relations that defy restrictive forms of logical discourse and thus reveal the marvelous.[57]

The relevance of this observation becomes clear when we consider *L'Etoile* within the context of Man Ray's filmmaking, which, as the previous two chapters have demonstrated, revolves around the association between

images, and the process by which an image, or a series of images, is understood in terms of its similarity or contrast with another. In relation to this, perhaps the most interesting aspect of the film is the way Man Ray's interpretation of Desnos' scenario demonstrates the variety of techniques that can be used to visualise and bring to life what appear as rather banal associations in their literary form. This aspect of *L'Etoile* is largely overlooked by Thiher in his discussion of the film's 'prolonged metaphorical discourse', which could be more accurately described as an interaction between literary and visual forms of image association.

The first clue to identifying Man Ray's interpretation of Desnos' metaphoric associations can be found in the way that similarities are drawn between particular images in terms of their visual presentation on the screen. Since this sequence introduces the image of the starfish, it is crucial in the establishment of these associations. The shot of Kiki's face is the first non-distorted shot in the film – that is to say, without the gelatine filter. It is followed by the two shots featuring the starfish, which are similarly created without the filter. There is a clear progression of associations, linked not only through the comparative clarity of the image, but also through the iris-in technique, which has the effect of focusing attention on a particular element within the frame. In this way, the woman is associated with the newspaper, which is in turn associated with the starfish – the iris-in highlighting almost exactly the same point on the screen. In the third association, the man holds the jar containing the starfish, whilst the woman stands with her back to the camera. This implies transference since we no longer see the woman's face – she is literally 'replaced' by the image of the starfish. The final shot, in which the man appears alone with the starfish, completes this series of associations. Gradually the starfish symbolically cancels out the presence of the woman. Whilst the association is simply hinted at in the scenario, with very little indication of how this transference was to take place in visual terms, it is Man Ray's awareness of visual structures that allows such relationships to be established.

In perhaps a intentionally exaggerated reconfirmation of the importance of the starfish's relationship with the woman, the next shot features an extreme-close-up of the living creature – a shot that does not feature anywhere in the scenario. This image signals a noticeable change of direction

in the film and begins a considerably more formally dictated sequence, which I will analyse closely in the following section. The man is shown running after sheets of a newspaper as they are being blown along the street, finally catching one. In a similar shot to the one in the previous sequence, a newspaper appears on the screen, only this time it is seen the correct way up and in extreme-close-up, inviting the spectator's participation in reading the words. Yet, if the signification process initially seems to be reinstated through the presence of now identifiable signifiers, the spectator is nonetheless ultimately denied an overall meaning since, although the article in the newspaper is readable, the slightly diagonal framing renders understanding impossible and only the title 'L'entrevue' and the first sentence – 'Ier mars – Varsovie publie ce matin la réponse de M. ***' – are wholly visible.

Whilst highlighting the significance of the 'meeting' between the man and the woman, the text also has a wider significance within the context of Desnos' writing. In 1927, his *Journal d'un apparition* was published in *La Révolution surréaliste*.[58] This piece describes the mysterious visitations of an unknown woman who is constantly referred to by three asterisks or *étoiles*,[59] one of the many references to the star motif in Desnos' work of the period. The newspapers are thus metaphorically associated with the woman, who is presented as an elusive object, constantly slipping through the hands of the man. This chain of associations, like that involving the starfish in the earlier section, is already present in Desnos' scenario, but it is Man Ray's careful handling of the material that allows these ideas to be transmitted in a formally engaging way.

The next sequence begins with the image of a man lying down, with the woman (off-screen) stroking his hair. A series of images involving a train journey and shots of boats leaving a harbour follow. In the first version of the scenario, Desnos indicates the motivation for these shots in the sentence 'L'homme et la femme rêvent.' Thus, the images of the train and the boat are presented as the content of their (shared) dream. However, maybe because Desnos found this direct association too formulaic, the second version states, 'L'homme à genoux devant la femme et la tête sur les genoux', creating a more subtle and complex relationship between these images. This revision also places more emphasis on the male character's psyche and his relationship with the elusive woman, around which the scenario clearly revolves. Here, the train and boat, representing travel and a means of escape, can, like

the image of the newspapers, be understood as symbolically referring to the distant woman, who, despite her physical proximity to the male character, remains ultimately out of reach. One of the most interesting aspects of this sequence is exactly the way in which Man Ray turns what are presented in the scenario as symbolic or dream images tied to the male unconscious into more formally-determined explorations. The direct association that Desnos suggests between the image of the man and those of the boat and the train is greatly surpassed in the film, and the images take on a significance of their own, leaving behind any kind of symbolic or metaphorical anchoring. Indeed, Man Ray seems to momentarily abandon the narrative development at this point in order to concentrate on a number of visual elements that clearly do not belong to the film's diegesis.

A return to the world of the story is signalled by the appearance of a flower, slightly out of focus, and the intertitle 'si les fleurs étaient en verre.' In one of the most striking shots of the film, the screen is then divided into twelve separate segments. Multiplicity is demonstrated not in a series of shots that develop temporally, as in the previous sequence of travel, but in a collage of images that place emphasis on spatial arrangement and simultaneity. The same shot of the flower returns but is now focused so that the image appears clearly. The intertitle is also repeated, as it is in Desnos' script, and is followed by an image of the woman in underwear lying on the floor, a broken bottle in front of her. An iris-in onto the broken glass again focuses attention on the development of associations that are brought together in the following still life of a newspaper on which are placed a bottle of wine, a glass, the starfish and a half-eaten banana. The following section begins with a shot showing the woman stepping out of bed, her foot falling onto an open book with the barely visible starfish placed on top. In the following shot, an iris out begins on the book and reveals almost exactly the same image as before but without the distorting gelatine filter. This time the starfish appears on the floor next to the book (see figure 15), creating a subtle rearrangement of elements.

A temporal and spatial leap in the narrative occurs when the woman is next seen alone, walking along the same country lane as that featured at the beginning of the film. The framing and duration of the shot are almost exactly the same, making the absence of the male character all the more noticeable. An intertitle announces 'belle, belle comme une fleur de verre',

and is replaced through a dissolve by a close-up of the starfish against a black background. The next shot shows the man and woman facing each other in a medium-close-up, the woman wearing a mask over her eyes, which she pulls off as she smiles at the man. The innocence of the gesture contrasts starkly with the sinister quality of the subsequent shot of the mask in close-up, the eyes shining a bright unnatural white against a black background. The intertitle 'belle comme une fleur de chair' that momentarily overlaps with this shot further reinforces the symbolic interchange of qualities and draws attention to the use of duality: the idea of a 'flower of glass' contrasts starkly with that of a 'flower of flesh'. These transformations and dualities, developed linguistically by Desnos, are effectively mirrored in Man Ray's visual interpretation of the scenario, which attempts to establish visual oppositions and associations through a range of cinematic effects and subtly altered repetitions.

The earlier shot of the man alone with the jar containing the starfish is now repeated. As he stares at his hands, an iris-in once again focuses on the image of the starfish. A close-up of the hands reveals thick black lines drawn onto both palms, and a dissolve into an even closer framing shows one hand with a line across the wrist becoming more visible. In a gesture that emphasises formal relationships rather than thematic ones, Man Ray plays the two images against each other to create visual complexity. The first shows both hands with the fingers pointing downwards whilst the second features one hand with the fingers, now disappearing out of the frame, in the opposite direction. Clearly, the interest in similarity and contrast that so heavily characterises Man Ray's earlier films is not completely abandoned, despite the thematic concerns of the scenario. The focus on repetition also becomes a gradually more prominent concern in L'Etoile. The door that opens and closes earlier in the film and which frames the scene in which the woman undresses in front of the man now reappears, opening and closing within the same shot. The woman is seen climbing the stairs of the apartment, with a second shot taken from the top of the stairs more clearly showing her wearing a black gown and holding a knife. A shot of the starfish at the bottom of the stairs interrupts her approach towards the camera, which ends with a close-up of both her face and the knife, a juxtaposition that the absence of the gelatine filter renders all the more

striking. Again, by way of reinforcing syntagmatic associations, Man Ray inserts a stylised shot that does not feature in the scenario: a medium-close-up of the woman's arm, from which the starfish is suspended. As she moves her hand, which still holds the knife, the starfish also moves, emphasising symbolic association through a very blatant physical connection.

An image of a prison wall and the intertitle 'Les murs de la Santé' that precedes it, remain as ambiguous in Man Ray's film as in Desnos' scenario, and it is unclear as to whether the reference to isolation and insanity is made in relation to the male or the (castrating) female character. The only real change made by Man Ray to this section of the film is the pan from the wall to the sky, which allows him to make an almost seamless transition to Desnos' image of the 'ciel étoilé'. Here, the scenario makes an obvious visual link with the recurring motif of the starfish. The star-filled sky is followed by two shots that correspond to the indication in the scenario, 'La Seine … qui coule'. These shots of water are particularly interesting in the way Man Ray links them with the previous image of the sky at night in order to create a formal play of moonlight on the surface. They also relate to the emphasis on water in *Emak Bakia* and the swimming pool sequence of *Les Mystéres du Château du Dé* (not to mention the presence of the verb *couler* in the intertitles of that film – 'Les déités des eaux vives / Laissent couler leurs cheveux'). In the scenario, the indications featuring the night sky and the Seine are presented as separate elements, whereas in the film they become formally linked.

After the woman is seen behind the flames of a fire, another stylised image shows her in Phrygian costume, again drawing attention to the status of the image as a symbolic reference. It relates specifically to an earlier intertitle that states 'Si belle! Cybèle?', referring to the ancient Phrygian goddess, the worshipping rites of whom involved, crucially, self-castration, leading to trans-sexuality and androgyny. Although the Phrygian theme is present in Desnos' original outline of the film, the intertitle itself was added at a later stage and raises the important question of whether Man Ray sought to further emphasise this aspect of the scenario. Androgyny and the question of sexuality were recurring concerns in both Dada and Surrealism, and can be seen as one of the areas in which Man Ray's work seems to engage directly with these movements. Many of his photographs

deal with the ambiguity of sexuality, and explore the boundaries of gender by dressing the subject (sometimes himself) in clothes of the opposite sex. Gender, in many of these images, is seen as a transmutable entity related specifically to representation, itself a subject close to the artist's heart. Another shot of rising flames, this time with the woman absent, further emphasises this idea of alchemic transformation.

In the final sequence, the woman is seen from a distance lying half undressed on her bed, the gelatine filter creating only a vague impression of the image. We cut to a close-up of her sleeping face, and then return to the original shot, only to find her now completely naked. Although the filter has been removed, the focus is slightly blurred, simultaneously drawing the spectator into the intimacy of the scene whilst maintaining the required distance. An intertitle 'Vous ne rêvez pas' humorously draws attention to this momentary transgression. However, like much of the film, this phrase is striking in its multiple significance as the 'vous' could refer either to the viewer (working specifically within the context of the film/dream relationship of interest to the Surrealists) or the sleeping woman we see in the film. There is also a contrast in the film's mode of address – an earlier intertitle states 'et si *tu* trouves sur cette terre une femme à l'amour sincère.' This ambiguity turns attention to towards the viewing subject and their shifting position in relation to the film. This can be understood as representing yet another self-reflexive device that problematises the conventional film-spectator relationship and the role of intertitles in maintaining or, in this case, breaking with the narrational detachment characteristic of early cinema's approach to storytelling.

Spatial and temporal dislocation is reintroduced when the woman is seen walking along the same path as the opening sequence. This time the man walks into the right hand side of the frame from behind the camera (another repetition of action) and greets the woman. A third man (Robert Desnos) enters the frame and leads the woman off to the left. The first man's disappointment is shown in a close up as he turns his head to watch them leave, perhaps the first suggestion of emotion in the whole film. 'Qu'elle était belle' becomes 'qu'elle *est* belle' as he stares again at the contents of the jar, an iris-in and another close-up shot of the starfish completing the chain of associations. This last image of the male character relates directly

to Desnos' account, featured earlier in this chapter, of the starfish as a symbol of lost love. The screen flickers from white to black and then reveals a final image of the woman behind a pane of glass, on which is written the word 'belle'. The glass suddenly shatters in a self-reflexive reference to the breaking of cinematic illusion reminiscent of Man Ray's early films (see figure 16). The window that features at beginning of the film closes, concluding the action and providing an element of symmetry that has been a key characteristic throughout.

Form versus content

What should be clear from this detailed description of the film is the way Man Ray's formal interests develop beyond the demands of the scenario. One of the most generally overlooked aspects of *L'Etoile* is the extent to which it expresses visual concerns that are more easily related to Man Ray's idiosyncratic approach to cinematic representation than to Desnos' themes of love, desire and loss. Inez Hedges has argued, 'If any aspect of the film may be ascribed exclusively to Man Ray, it is the opposition between abstraction and allegorical narrative that threatens to pull the film in opposite directions. The progress of the story is continually threatened by stasis, by shots that appear as experiments in animating still photographs, and that recall his earlier films.'[60] Since, as I have argued in previous chapters, Man Ray's cinematic work is characterised by such a tension between abstraction and figuration, it is hardly surprising that this should be a central feature of *L'Etoile*, despite its concentration on thematic developments. Although Desnos was clearly interested in the power of cinematic imagery, it was primarily towards the ability of such images to replicate the dream experience that his attention was focused. He was not particularly interested in exploring the inherent plastic qualities of the medium, and, like many of the Surrealists, he abhorred the works of the early French Impressionist filmmakers, where a range of cinematic techniques were employed to

express the emotional states of the characters. In an open critique of this type of film, Desnos states:

> Un respect exagéré de l'art, une mystique de l'expression ont conduit tout un groupe de producteurs, d'acteurs et de spectateurs à la création du cinéma dit d'avant-garde, remarquable par la rapidité avec laquelle ses productions se démodent, son absence d'émotion humaine et le danger qu'il fait courir au cinéma tout entier.[61]

> [An exaggerated respect for art, a mystique surrounding a particular form of expression has led a group of producers, actors and spectators to the creation of so-called *avant-garde* cinema, remarkable for the rapidity with which its productions go out of style, its lack of human emotion and the danger it poses to cinema as a whole.]

He goes on to criticise the use of certain 'technical processes' unmotivated by the action, which can be assumed to include superimposition, split screen, rapid editing etc – in other words, those techniques that significantly alter the impression of reality.

It is specifically within this area that the singular aims of Man Ray and Desnos can be seen to emerge, for although the scenario points to the importance of narrative and the focus on the Surrealist themes of love, mystery, madness and desire, the visual interpretation of the scenario introduces a number of plastic concerns that distract attention away from content and towards form. Hedges is one of the few commentators to highlight the relationship between these sections of the film and the formal qualities of *Le Retour à la raison* and *Emak Bakia*, paving the way for a revised consideration of *L'Etoile* not simply as a Surrealist film but as Man Ray's formal interpretation of a Surrealist scenario. In order to facilitate a clearer understanding of this relationship, I will consider these sections of the film in detail, paying close attention to the way in which they affect a Surrealist reading.

Even in the introductory text, 'L'étoile de mer. Poème de Robert Desnos tel que l'a vu Man Ray', our attention is focused on the relationship between the two forms of expression around which film is structured – image and text – and on the way a poem is 'seen' through the eyes of Man Ray. Iannis Katsahnias draws attention to the formal interpretation of the scenario and highlights the important issue of authorship that characterises the film: 'Pour la première fois, Man Ray fait un film qui suit une

trame et des images proposées par quelqu'un d'autre. Cela ne l'empêche pas d'expérimenter pour autant.' [For the first time, Man Ray makes a film that has a plot with images suggested by someone else. This does not prevent him from experimenting just as much.][62] For although the genesis of the film can be traced to the poetic sensibility of Desnos and certain concerns related to Surrealism, many of its formal characteristics would seem to be in conflict with the poet's conception of cinematic expression. Whilst Desnos aims to create a hermetically sealed world, comparable to the structure of the dream, Man Ray constantly undermines this world by breaking with the illusion of reality and introducing a number of self-reflexive strategies. These processes of self-reflexivity relate not only to the material and technical basis of film, but also draw attention to the personality of the artist. This latter point is particularly relevant in the context of the making of the film since it represents Man Ray's attempt to stamp his identity on a piece of work that was not entirely his own.

Although the sections of the film were worked out carefully by Desnos and later rearranged slightly by Man Ray, it is in fact a formal device that provides the most striking organisational principle. As mentioned briefly above, a gelatine filter is placed intermittently over the lens, creating a blurred, distorted perception reminiscent of similar effects of distortion in *Emak Bakia*. This immediately works into the film an abstraction/figuration dichotomy that characterises the previous two films, and thus shifts the emphasis from a thematic to a formal structure. As Man Ray recounts, the filter was used as a direct response to the requirements of the scenario as a way to avoid censorship:

> There were one or two rather delicate points to consider: the portrayal of absolute nudes would never get by the censors. I would not resort to the usual devices of partial concealment in such cases as practiced by movie directors. There would be no soft-focus, nor artistic silhouette effects. I prepared some pieces of gelatine by soaking, obtaining a mottled or cathedral-glass effect through which the photography would look like sketchy drawing or painting.[63]

This seems to represent the first hurdle in turning the text into images, forcing Man Ray to consider and adapt to the restrictions of the industry. His second film *Emak Bakia* had already attempted to push the boundaries

of cinematic representation by introducing an element of eroticism detached from any narrative justification. The repeated shots of women's legs, like the nude torso in *Le Retour à la raison*, were, as Norman Gambill suggests, 'a radical and historically unprecedented departure.'[64] Whilst these earlier films approach the body within the context of aesthetic contemplation and therefore partly direct attention away from its sexual connotations, the sexual emphasis is integral to Desnos' scenario.

What is interesting in Man Ray's treatment of the material is precisely the way the visual restrictions of the scenario give rise to formal experimentation. His refusal to conform to popular cinematic vocabulary has the effect of turning attention back to the plastic concerns so prevalent in his earlier films. The process by which Man Ray channels the conditions – either freedoms or restrictions – of a particular cinematic project into technical and formal experimentation is a recurring element in his filmmaking. I have discussed this already in relation to *Emak Bakia*, but it is also a key characteristic of *Les Mystères du Château du Dé*, as the next chapter will demonstrate.

What conclusions can be drawn from the use of the gelatine filter? It is clear that its significance extends beyond the practical function ascribed to it since it also creates a sense of visual duality that continues throughout the film. As Katsahanias points out, 'Ce plan est à l'image de tout le film: un effort pour créer une hallucination vraie.'[65] This emphasis on the way the filter facilitates the co-existence of reality and unreality clearly highlights the importance of subjective vision that was of crucial importance to the Surrealists. Katsahanias' notion of a real or true hallucination also seems to reflect on the nature of the cinema itself, echoing the Surrealists' fascination with the resemblance of the film with the dream. Yet, although this aspect of the film is sometimes interpreted in terms of its attempt to establish the different levels of reality corresponding to the states of dream and wakefulness,[66] its overriding emphasis on form blocks any kind of identification with the characters and the world occupied by them. Furthermore, whilst Surrealism aims towards the unification of the two states, *L'Etoile* treats them as separate entities, i.e., as having a significantly different visual appearance.

The alternation between the two forms of vision also breaks the emphasis on narrative that dominates the scenario. In his discussion of the film, Sitney points to the self-reflexive characteristic of the gelatine filter: 'The alternation of lenses points first of all to the very fact that films are shot through lenses. *L'Etoile de mer* is a film about seeing the world through layers of glass. The camera always protects its sensitive film surface from the exterior world with a wall of glass. The implication here is that the so-called normal lens is as artificial as the stippled one.'[67] This move away from the consideration of the distorted lens as an attempt to create Surrealism towards an understanding of the way it reflects on the nature of cinematic vision realigns the film with concerns specific to Man Ray. As I have argued in Chapter 2, the emphasis on the camera lens and the idea of a cinematically mediated reality is a key feature of *Emak Bakia*, stated from the very outset in the opening shot, in which the camera lens is juxtaposed with the superimposed eye. Distorted lenses are also used in that film to problematise the notion of objective vision.

In one of the final shots of the film, in which Kiki is seen behind a pane of glass with the word 'belle', Man Ray further draws attention to the cinematic lens or screen through which the world is perceived. The writing renders that which is normally invisible visible, setting up a layer that is seen rather than seen *through*. The smashing of the glass consolidates this idea, taking the perception of the glass layer to the final stage of concrete realisation. From this perspective, the last shots of the film can be read in terms of a progressive destruction of the illusion of reality. In both *Emak Bakia* and *L'Etoile de mer*, the emphasis on glass goes beyond references to the camera lens and exists at various levels of content. In the former, it appears in the form of reflecting crystals and prisms but is also suggested in the sequence in which fish appear to swim in front of the camera. We are again faced with the absence/presence phenomenon since, in a reversal of the 'belle' image, the execution of the shot hides the glass container that holds the fish, whilst it is the very presence of the glass that makes the shot possible. The same awareness of absence and presence is inscribed into *L'Etoile* through the alternation of lenses. The presence of the gelatine filter represents absence of vision, whilst the presence of vision in the normally filmed sequences is marked by the absence of distortion.

A close look at the structure of the film reveals that the gelatine filter is used in the majority of the scenes that feature the characters, leading A.L. Rees to state that it 'refuses the authority of "the look."'[68] Indeed, one of the main effects of the filter is that it prevents the viewer from connecting with the characters on an emotional level, as their actions and facial expressions are always shrouded in mystery. This is evident at the beginning of the film where the woman undresses in front of the man, who promptly gets up and leaves. The mixture of responses to this scene is no doubt due to the fact that the use of the filter increases the ambiguity surrounding the characters' motives and emotional responses. Thus, Man Ray transfers to the characters the very qualities that define his visual expression. In other words, objects and actors are submitted to the same defamiliarisation processes. The refusal of the look to which Rees refers is part of a larger refusal of representational objectivity and a move towards abstraction. A similar process can be seen in *Les Mystères du Château du Dé*, where the 'actors' all wear stockings over their faces to hide their identity but also as a method of depersonalisation that allows them to be turned into objects of formal contemplation.

This interpretation challenges the view expressed by a number of commentators who argue that the filter in *L'Etoile* is employed randomly, with no clear motivation for either type of vision. I would argue that, on the contrary, a pattern is developed that emphasises a concentration on form and abstraction. The filter is present throughout the whole first sequence of the film in which the two characters meet and finally separate. It is interrupted by a normally filmed shot in which the camera tilts down the length of a tower building to reveal an empty street. Whatever interpretation is made of this shot on a thematic level, e.g., the tower as a phallic symbol that relates to the quasi-sexual exchange that has just taken place, it cannot be ignored that the first shot of the film without the distorted lens concentrates on geometric composition. The vertical movement of the camera corresponds to the structure of the tower and ends where the tower meets the street, creating a satisfyingly precise angle. Thus, besides functioning as a metaphor within the framework of the film's narrative, it also concentrates on formal composition within the frame. The absence of the filter allows this quality to be fully absorbed. The alternation also facilitates the

understanding of syntagmatic associations since the majority of the shots without the filter develop the relationship between the male and female characters and a range of motifs, such as the starfish, newspapers, fire, water, etc. These are usually brought together by the use of the iris-in.

Beyond these conclusions about the employment of different lenses, a concentration on the plastic qualities of the cinematic image can be seen in various parts of the film. The first of these occurs just after the characters are presented. They are shown walking together towards the camera and then, in a seemingly unmotivated transition, we see a shot of their feet moving in synchronicity. For a fleeting moment, Man Ray indulges in the plastic qualities of this movement, and, as if to further emphasise the effect, slows down the action slightly. This is a key example of what Hedges calls a moment of 'stasis', in which the content of the film momentarily escapes from the narrative flow and develops not along the horizontal axis of story development, but on a vertical axis of visual exploration. The brief spectacle is brutally disrupted with an abrupt movement away from the feet, creating a blurred effect similar to that of the thrown camera in the collision sequence of *Emak Bakia*. The juxtaposition of the feet in slow motion with the very rapid sweeping movement of the camera creates a visual shock whilst also functioning to underline the nature of cinematic movement.

It is useful to compare this section of the film with the instructions provided in the scenario, which simply state, 'Marche. Leurs jambes.' Whilst the written description focuses on the effect of repetition (the word 'jambe' appears three times in the description of the first set of images), juxtaposing the banal action of walking with the highly sexual connotation of the legs, Man Ray's interpretation of the text foregrounds the formal beauty of the image over its thematic function. The fragmentation of the body for the purpose of formal exploitation are key characteristics of Man Ray's work, and can be found operating on a number of levels in his films. The shot mentioned above can be compared to other sections of *Emak Bakia* that express related concerns, notably the superimposed feet dismounting the car and the disembodied legs dancing the Charleston.

The concern with form is demonstrated most effectively in a series of images that begins about a third of the way through the film. After a

predominantly narrative-based development focusing on the exchanges between the male and female characters, the film changes direction and begins to present a number of self-contained moments of visual contemplation. This is initiated with an extreme close-up of the starfish that naturally follows the preceding shots in which the animal gradually becomes the focus of attention of both characters. The very close framing is partly justified by the level of concentrated fascination expressed by the man as he studies the contents of the jar by the light of a lamp. However, the link between the man and the starfish is gradually made tenuous through the prolonged duration of the shot; at forty-five seconds it is the longest in the film. The slow writhing of the sea creature's body creates a hypnotising study of form and movement that has strong links with the equally long sequence of goldfish in *Emak Bakia*. Carl Belz, referring to this section of the film, has argued that the 'blatant and obscene image of the starfish with its wreathing tentacles, scaly surface, and ugly, devouring mouth' provides a counterpoint to scenes of eroticism and as such represents 'Desnos's use of abrupt and sensuous contrasts.'[69] Although the image of the starfish clearly originates with the poet, its visual representation in the film must also be considered from the perspective of Man Ray's own formal concerns. It should be noted in relation to this point that this particular image does not feature in the original scenario, and was probably added by Man Ray during the filming, throwing into question the idea put forward by Belz that the more sinister qualities of the starfish can be worked into what he ultimately considers as a Surrealist dichotomy of attraction and repulsion. In fact, the slow, delicate movements of the starfish, accentuated by the framing, can be read as having a subtly erotic and sensual nature that further challenges this interpretation.

A closer consideration of this shot allows us to see the difference between Man Ray and Desnos' relationship to cinematic imagery. In the scenario, the role of the starfish is reduced to its symbolic properties. Desnos relies heavily on the powers of metaphoric association common to Surrealist poetry, and which are demonstrated throughout the film's intertitles, 'belle comme une fleur de verre', 'belle comme une fleur de chair', 'belle comme une fleur de feu'. The association of the woman with these image juxtapositions builds a gradual understanding of the nature of the male

character's feelings towards her. The repeated presence of the starfish aims to achieve a similar effect through image association, reducing it to a mere symbolic motif. The artificiality of this process is mirrored in the lifeless object that stands in for the actual living creature, and which is simply placed alongside other elements within the frame in order to create the repetitive associative exchange referred to by Thiher.

In contrast to this artificiality, the shot added by Man Ray brings the animal to life and explores it beyond the reductive position to which it is condemned in the scenario. The idea of the emancipation of the starfish from its static symbolic role is very strongly suggested in this image, showing the animal moving freely without the constrictions of the glass jar through which it is perceived in the preceding shots. The duration of the shot further emphasises this hypothesis as it functions as a temporal correlative to the spatial development. In other words, whilst the viewer is forced into a contemplation of the starfish through its physical abstraction from the rest of the film, the length of time for which the image stays on the screen produces a halt in the narrative, severing the previous system of association that requires a much more rapid presentation of images.

In the following sequence, ten consecutive shots of newspapers being blown along the street by the wind are rapidly edited together. Along with the movement of the camera that frantically tries to keep up with the sheets as they tumble and turn in all directions, the staccato rhythm produced by the editing creates a temporal counterpoint to the slow and gradual movement of the starfish, represented in a continuous static shot. The distortion to which the movement of the papers, coupled with that of the camera, gives rise can be compared with the kinetic explorations found in *Le Retour à la raison* and *Emak Bakia*. This sequence also bears a strong resemblance to sections of Hans Richter's *Vormittagsspuk* (*Ghosts Before Breakfast*, 1927), in which, as Richter describes,

> four bowler hats, some coffeecups and neckties 'have enough' (are fed-up) and revolt from 11.50 to 12 a.m. Then they take up their routine again. The chase of the rebellious 'Untertanen' (objects are also people) threads the story. It is interrupted by strange interludes of pursuit which exploit the ability of the camera to overcome gravity, to use space and time completely freed from natural laws. The impossible becomes reality and reality, as we know, is only one of the possible forms of the universe.[70]

The free, liberated movement of the sheets of newspaper represents a similar revolt against the world of logic and order to which they traditionally belong. The impression of spontaneity felt in this section of the film contrasts with the stylised nature of the previous sequences, in which gesture and motif take on increasing importance. We can compare this series of shots of newspapers with the final sequence of *Emak Bakia*, where shirt collars are wrenched from their everyday function and enter into a world of purely visual relationships. Richter's statement is interesting in this context as it seems to express aspects of both Dada and Surrealism that are also central features of Man Ray's films.

One of the most visually significant moments *L'Etoile* occurs about half way through the film, in a series of images related to the theme of travel. In the scenario, this section is described in only two shots: 'Un train qui passe' and 'Un bâteau'. Man Ray's interpretation of these two indications transforms a relatively banal and fleeting reference into a play of visual elements. The reference to the train is clearly used as an opportunity to explore cinematic movement since rather than viewing the speed of the train from the detached and objective position suggested by the scenario, Man Ray invites the viewer to experience and become involved in the movement through the subjective position of a passenger. An image of rails disappearing off the screen is followed by a number of shots of the passing landscape. The attempt to recreate the perceptual experience is represented in the repetition of the same image, which flickers almost imperceptibly across the screen five times. The emphasis on subjective vision is also a key element in the following series of images involving views from a boat. This time, as if in an ironic reference to the rudimentary description in a scenario, the flat silhouette of a boat slides across the frame, its artificial nature creating a counterpoint to the realism of the previous images. Indeed, it is the documentary-like quality of this short section of images that sets it apart from the rest of the film.

The preceding chapter discussed the importance of repetition as a formal device in *Emak Bakia*. Although *L'Etoile* initially seems to represent a departure from Man Ray's previous concerns, it is through an analysis of formal similarities that we gain a clearer understanding of the relationship between the two films, and the way in which these visual qualities are worked into the framework provided by Desnos. A consideration of

repetition allows us to detect a convergence between the scenario and the film, and an overlapping of the individual concerns of Desnos and Man Ray. Allen Thiher, as I have discussed above, has described *L'Etoile* in terms of the creation of filmic figures, through which a sense of thematic coherence emerges. He notes that the film is structured predominantly through the appearance of specific motifs, which function by means of association with other images in the film:

> These motifs are created by the repetition of images, and one can say that in this type of film, much as in surrealist poetry, the initial level of meaning is generated almost exclusively by recurrence. The most obvious example is the star-starfish motif that the film presents as its opening images. This image occurs most frequently in the film and dominates the thematic modulations. A description of the film also shows that in spite of the great diversity of images, a rather small number of motifs are generated in it.[71]

Indeed, it is not difficult to identify these motifs, which are presented both on a visual level and through the insertion of text. There is, for instance, the very clear motif of sexual desire, presented in the repetition of the word 'belle' in relation to the female character, but also, through association, to the image of the starfish, which comes to stand in for the woman. The flower, itself a symbol of female sexuality, is another recurring element, as is the image of glass, which appears in many different forms, and to which I have already briefly referred. However, whilst Thiher's observation about the role of repetition in *L'Etoile* makes a useful comparison between poetic structures and corresponding strategies in filmic images, it does not take into account the formal repetitions that are not tied to the thematic concerns emerging from the scenario, but which relate more specifically to Man Ray's sense of formal organisation. These repetitions, rather than contributing to the narrative development, represent further examples of stasis, where the image breaks away from thematic connections.

A careful consideration of both the scenario and the film reveals some of the ways in which Man Ray's interpretation establishes formal patterns that build on Desnos' concentration on repetition. The image of the opening and closing window at the beginning and end of the film adds another layer of repetition to that found in the scenario, in which the initial image of the man and woman walking down the street is repeated towards the end

of the film and culminates with the woman leaving with a different man. This detail has been discussed from the perspective of Surrealism since it represents a symbolic entry into another world, locating the action 'beyond our daily realm of ordinary time and causality.'[72] Yet as I have stated earlier, it is precisely this separation of the two states of waking and dreaming, or consciousness and unconsciousness that leads to the weakening of the film's Surrealist effect. In this sense, it can be compared to Antonin Artaud's disapproval of the presentation of *La Coquille et le Clergyman* as a dream. 'I shall not try to excuse the apparent inconsistency by the facile subterfuge of dreams',[73] Artaud stated, clearly arguing, as did Breton, for the fusion of dream and reality through the language of film. Man Ray's addition of the framing device in *L'Etoile* betrays an overriding interest in formal organisation that seems somewhat at odds with the aims of Surrealism.

Musical accompaniment

Like Desnos, Man Ray was not a purist when it came to the exploration of cinematic representation through the addition of external elements. In his discussions with Pierre Bourgeade, he speaks about colour and three-dimensional images, and even goes as far as to conceive of a kind of expanded cinema, where the experience of watching a film would involve other atmosphere-inducing elements such as odours. Although *Le Retour à la raison* was projected as a silent film, *Emak Bakia* incorporated the use of predominantly popular jazz music, which, as I have mentioned in the previous chapter, contributes significantly to the building sense of rhythm in that film. Similarly, music plays a key role in *L'Etoile de mer* and deserves to be considered in some detail. I mentioned at the beginning of this chapter that, along with a short outline of the film, Desnos also wrote a plan for the film's musical accompaniment, which can be found in the Bibliothèque du film in Paris. These musical indications are incorporated into the later version of the scenario, specifying at exactly which moment in the film a certain piece of music was to feature. Inez Hedges has, with the help of

Francis Naumann, traced these annotations to the hand of Man Ray, a detail that has nonetheless been questioned by Bouhours and De Haas.[74] Irrespective of whether or not these annotations were *written* by Man Ray, they were clearly conceived by Desnos within the context of his Surrealist vision of the film and relate almost exactly to those contained in the original document. That the initial musical choices were uniquely those of Desnos is supported by the fact that Man Ray's own later instructions for the musical accompaniment do not correspond to those found in the scenario.

The difference between the two men's approach to the way the music would interact with and complement the images on the screen further testifies to a fundamental duality at the heart of the film, that sees Man Ray adapting the Surrealist concerns of Desnos to his own conception of cinematic expression. As Bouhours and De Haas argue, Desnos' original outline for the music foregrounds the element of discordance, and also, crucially, makes use of sound not simply as an accompaniment to the images, but as an independent creative force in the film:

> Le premier accompagnement sonore prévu par le poète comporte, outre des indications musicales, des incrustations de bruitages de cris humains, ainsi que la reproduction de *L'internationale* 'jouée faux'. Si ce 'détail' avait été conservé, il eût peut-être aidé André Breton à se réconcilier avec le film, dont la première fut un événement trop mondain à son goût [...] Le rendez-vous du surréalisme avec le cinéma sonore a bien failli se jouer ici. La version ultérieure de ce scénario laissera de côté ces aspects iconoclastes de la bande sonore pour un accompagnement strictement musical, moins directement articulé aux images.[75]

> [The first musical accompaniment planned by the poet has, in addition to a purely musical part, the sounds of human cries and a recording of *The Internationale* 'played out of tune'. If this 'detail' had been retained, it might have helped André Breton to be reconciled to the film, the premier of which was an event too urbane for his taste [...] The conjunction of surrealism with sound cinema came close to falling apart. The later version of this screenplay left aside these iconoclastic aspects of the soundtrack for a strictly musical accompaniment, less directly linked with the images.]

Desnos' conception of discordance in the way sound relates to image bears a striking similarity with the idea of contrapuntal sound, developed in 1928 by the Russian filmmakers Sergei Eisenstein, Vsevolod Pudovkin and Grigori Alexandrov, where the soundtrack is used to question and undermine

the meaning transmitted by the image. 'The first experimental work with sound', they wrote, 'must be directed along the line of its distinct nonsynchronization with the visual images. And only such an attack will give the necessary palpability which will lead to the creation of an orchestral counterpoint of visual and aural images.'[76] Importantly, this method of contrasting sound or music with the image rather than using it as a harmonious accompaniment challenges the illusionist fluidity of conventional cinematic representations. The clash between image and sound would seem to be the perfect means by which the Surrealist filmmaker could effectuate a 'derailment of the senses', and it is indeed for this reason that Bouhours and De Haas consider *L'Etoile de mer* in terms of a missed opportunity to create a potentially powerful example of Surrealist cinematic expression that would undoubtedly have appealed to Breton.

It is important to observe the series of changes made to the musical accompaniment between the original outline made by Desnos and the indications left by Man Ray that now feature as part of the film. As Bouhours and De Haas point out, the initial idea that the section of the film featuring the train and the boat should be accompanied by silence and then indistinct cries of 'ah! ah!' does not appear in the later version of the scenario. This is noteworthy since, as we have already seen, the first draft of the scenario firmly relates these images to the dreaming characters, whilst the revised one replaces 'L'homme et la femme rêvent' with the more visually conceived 'L'homme à genoux devant la femme et la tête sur les genoux'. Thus, the act of dreaming is suggested rather than stated, with much stronger sexual overtones. To accompany this change, Desnos included 'le tambourin de Rameau', which was subsequently replaced with 'O sole mio'. The original suggestions are replaced with a much more conventional notion of musical accompaniment. Furthermore, the idea to include 'L'Internationale' played with false notes during the sections featuring the deserted street and the woman in Phrygian costume is similarly abandoned in the second version of the scenario. Despite these initial changes – which make the second scenario seem slightly less subversive than the first – the role played by music in Desnos' conception of the film is clearly an important one, and his choices demonstrate a depth of musical knowledge as well as an interest in the way image and music can enter into a creative dialogue. However,

the interrelationship conceived by Desnos differs greatly to that created by Man Ray in *Emak Bakia*, for example, where musical rhythms combine with visual ones. Desnos is interested less in the use of music as a support to the visual component than in the creation of an independent unit of expression that comes into play with the images on an equal level. In this sense, music is used in the same way as intertitles, making film more than just moving images.

Desnos uses music to add another layer to the film comparable to the use of intertitles since a number of his suggested pieces were chosen because of the signification of the lyrics. 'Plaisir d'amour', for example, was written by the poet Jean Pierre Claris de Florian during the eighteenth century and expresses the theme of lost love and deception that features regularly in Desnos' own work. It recounts the story of a dejected lover who loses the woman for whom he has given up everything to another man, and focuses on the double-sidedness of love and the callousness of women. The first two lines of the song, 'Plaisir d'amour ne dure qu'un moment' and 'Chagrin d'amour dure toute la vie' are singled out to begin and end the film, further demonstrating the emotional signification of the lyrics. This is similarly the case with the use of 'O sole mio', clearly highlighting the notion of loneliness and desolation that is found in some of the film's imagery such as the empty street and the prison walls.

Other pieces of music chosen by Desnos include 'Dernier tango' and 'Le Beau Danube Bleu', a waltz by Johann Strauss, both significant in the way they evoke dance, and thus the male-female interaction, which develops intricately through time by way of a number of discrete actions and interchanges between the couple. Finally, perhaps the most interesting detail of the original musical outline is the inclusion of 'La carmagnole' and 'L'Internationale', equating the relationship between man and woman with revolutionary struggle and social reform, concerns very dear to the Surrealist project. Along with the inclusion of the then popular waltz and tango pieces and, as Desnos states in the first version of the scenario, 'quelque chose de très connu dans l'oeuvre de Bach', which by the second revision had become 'L'aria', these musical details attest to a desire on the part of the poet to use film as both a creative and revolutionary tool that would speak to the spectator through direct metaphoric and cultural references.

There is little available information concerning the exact musical accompaniment for the first public screenings of the film in Paris, Brussels, Berlin and New York, making it unclear whether or not the musical indications by Desnos were followed. Man Ray refers to only one event in his autobiography, where the film was screened before Josef von Sternberg's *The Blue Angel* (1931). He states simply that the theatre owner allowed him to 'coach' the trio of musicians.[77] Neil Baldwin, confusing this second run of the film with the première, which was held at the same venue, notes that 'Man Ray chose recordings of Cuban dance music to accompany the film at the last moment, discarding his elaborately plotted orchestral scenario in favour of a more disruptive and violent background.'[78] In any case, Man Ray would later revise and change the music, and it is possible that, for at least a certain period of time, it was shown with a diverse accompaniment depending on the theatre, orchestra and the country in which it happened to be screening. The film is nowadays accompanied by the five pieces of music chosen by Man Ray during the 1940s and left in a box containing disks to be played with all of his films (with the exception of *Le Retour à la raison*, which remains without musical accompaniment). Interestingly, the majority of these songs are from popular films of the 1930s, including the opening track, 'C'est lui' performed by Josephine Baker, which was composed for the film *Zouzou* (Marc Allégret, 1934). There is also 'Los Piconeros' from *Carmen, la de Triana* (Florian Rey, 1938) and 'Au fond de tes yeux' sung by Mistinguett for the film *Rigolboche* (Christian-Jaque, 1936). The two other musical pieces to be played with the film are 'Saetas' by the Spanish flamenco singer 'La Niña de los peines' (The Woman with the Spanish Combs) and 'Sigonomi sou zito'.

Thus, the focus on classical music that is represented by Desnos' indications is rejected for a more contemporary atmosphere, a detail that is emphasised by the fact that Man Ray further revised the music to be played with all of his films during the 1960s, choosing more recent, and perhaps therefore more culturally relevant, pieces.[79] Furthermore, the initial effect of discordance that was originally conceived by Desnos does not seem to be a concern of Man Ray's in his selection of accompanying music, which tends towards complementing the images with a seamless flow from one song to the next rather than the exploration of sound as an individual creative

element. Another important detail is that all the songs in Man Ray's selection of music are sung by female vocalists, reversing Desnos' focus on the male psyche and the understanding of the woman from this perspective. Following Man Ray's instructions, the film begins with a song in which a woman sings about a man, stating 'c'est lui'. This contrasts somewhat with the opening music detailed in the scenario, which more directly highlights the central themes of the film itself. Although Desnos seems to have left aside some of the more Surrealist elements in his revisions, Man Ray's choices take the film even further from these goals, opting instead for a less conspicuous accompaniment that gives full attention to the expressive power of the images.

L'Etoile de mer clearly illustrates the artistic personalities of both Man Ray and Robert Desnos, and, as such, represents an important exchange between visual and literary Surrealism. However, while the film has its origins in the Surrealist scenario, it develops visual ideas outside the realms of Surrealism, many of which can be seen to have a very direct relationship with Man Ray's work in other areas, as well as expressing a distinctly formal cinematic approach. It therefore demonstrates to some extent the distance between Man Ray and the official Surrealist movement, despite his association with the group. In his autobiography, Man Ray describes Desnos' reaction to his list of invitations to the film's premier screening: 'When Breton and the Surrealists were mentioned, a wild look came into his eyes; he began a violent tirade against the former. There had been a bitter falling out between them, of which I wasn't aware, as it was a period in which I hadn't been frequenting the group.'[80] The fact that the making of *L'Etoile de mer* coincides with this seemingly individualist episode in Man Ray's career only serves to support the notion that he was interested less in the official Surrealist practices and doctrines laid out by Breton than in the paths of his own independent artistic development.

Film, poetry and architecture:
Les Mystères du Château du Dé

(1929, 35mm, 25 mins, black and white, silent with musical accompaniment)

Les Mystères du Château du Dé is the least discussed of Man Ray's cinematic oeuvre. Unlike *Le Retour à la raison*, *Emak Bakia* and *L'Etoile de mer*, which are often deemed the most important avant-garde works of the period, there exist very few in-depth analyses of *Les Mystères du Château du Dé*, leading to its placement on the margins of Man Ray's involvement with the moving image and of experimental film practice more generally. As the introduction points out, many descriptions and short surveys of Man Ray's cinematic period only mention his first three films, reducing the status of *Les Mystères* to that of a forgotten finale, a seriously undervalued conclusion to a unified body of works. Despite their resistance to straightforward categorisation – an aspect to which the previous chapters have drawn attention – these earlier films are often viewed within the theoretical frameworks of Dada and Surrealism. *Les Mystères*, on the other hand, demonstrates a rather more problematic positioning, one that seems to have cut it off from the rest of his cinematic work. However, as this chapter attempts to outline, this is a rather false perception that stems from the over-reliance on Dada and Surrealism as guiding factors in the interpretation of Man Ray's filmmaking. This final film in fact brings together a number of formal concerns found throughout the previous works, whilst also demonstrating, more than any of his films, Man Ray's characteristic interdisciplinary approach.

As well as being the one that attracts the least attention, *Les Mystères* is also the most misunderstood of Man Ray's films, undoubtedly a result of its extremely hybrid nature and the diverse range of concerns. Barbara Rose, for example, refers to it as 'Man Ray's most preposterous and pretentious film',

claiming it to be 'full of heavy references to Mallarmé's line, "A throw of the dice can never abolish chance."' She further states, 'Essentially a sophisticated home movie made for the amusement of the idle rich, the Château de Dé suggests the malingering ennui of Axel's Castle with its "shall-we-go?," "shall-we-stay?," and "what-difference-does-it-make-anyhow-since-life-is-just-a-game?" dialogue.'[1] Commissioned by the Vicomte de Noailles to document his recently constructed modernist villa in the south of France, *Les Mystères* partly functions as an architectural record, one that, in contrast to the earlier films, was never meant to be screened publicly. It is perhaps the clearly discernable trace of the commission that has led to such critical ambivalence. Although his earlier film *Emak Bakia* had been the result of a commission by Arthur Wheeler, the artist was given complete freedom in terms of both subject and formal approach. Except for certain scenes that were created voluntarily in and around the Wheelers' home in Biarritz, there are few clues to its financial origins and the film functions rather as a highly personal piece of cinematic expression. Likewise, the two later films that Noailles was to subsidise – Luis Buñuel and Salvador Dalí's *L'Age d'or* (1930) and Jean Cocteau's *Le Sang d'un poète* (1930) – were entirely open projects with none of the constraints that characterise the project undertaken by Man Ray at the villa.

Les Mystères was made specifically *for* and *about* the Noailles. It was intended to be their own personal showcase, showing their newly constructed house, the collection of art works, as well as themselves and their guests. Charles de Noailles was a patron of the arts and therefore would have expected an original and creative interpretation of his request (hence his choice of Man Ray), yet the fact remains that the film was intended as a kind of home-movie. When J.H. Matthews states that, 'all in all, in this film, his last, Man Ray failed to take full advantage of Noailles' generosity', he clearly neglects to take the conditions of the commission into consideration.[2] Therefore, if *Les Mystères* initially appears to depart from the concerns expressed in Man Ray's earlier works, it is specifically due to the conditions of the commission and the pre-defined subject of the villa. Even so, *Les Mystères* is much more than a home-movie or an architectural document.[3] It is Man Ray's interpretation – his visualisation – of the modernist material, to which he brought his own concerns, motifs and, most importantly, his

unique artistic vision. It blurs the boundaries between documentary and fiction, reality and fantasy, objective and subjective vision, whilst blending concerns related to film, architecture and literature in a truly modernist fashion. In perhaps the most detailed and sustained discussion of *Les Mystères*, Helmut Wiehsmann perfectly describes it as 'a film poem about architecture',[4] drawing attention to the delicate interweaving of different modes of expression.

This final film represents a crucial stage in Man Ray's filmmaking period, not simply because it can, in some ways, be seen as a conclusion to his professional explorations into the medium (although, as the following chapter will discuss, he did not entirely abandon film after this, but rather continued to make more personal works not meant for public release), but also because it brings together a number of elements from his previous films. There is, once again, the acceptance of a commission, allowing comparisons to be made with *Emak Bakia*, in the sense that the circumstances of the filming provided Man Ray with a relatively defined context from which he developed a range of visual concerns. The key element here is the interplay of pre-planning and spontaneity, a situation he seemed to particularly relish. Both commissions involved a journey from Paris to the south of France, which Man Ray uses to imbue the films with a sense of 'otherness'. *Emak Bakia* is characterised by an aura of Mediterranean exoticism, whilst *Les Mystères* centres on the attempt to create an element of mystery that is directly related to the modernist location around which the film is based. In its extensive use of intertitles, *Les Mystères* also involves text-image interactions, continuing an interest already established in *L'Etoile de mer*. Whilst the earlier film creates a link with Surrealist poetry through the use of a script by Robert Desnos, the later work draws on the work of the Symbolist poet Stéphane Mallarmé. The title *Les Mystères du Château du Dé*, along with a number of its textual inserts, functions as a direct reference to Mallarmé's poem *Un coup de dés jamais n'abolira le hasard* (1897).

The previous chapter discusses at length Man Ray's interest in literature, and the important relationship between word and image in *L'Etoile de mer*. These concerns continue into *Les Mystères*, despite the significantly different circumstances in which it was made. His experience of

the collaboration with Robert Desnos, along with his new awareness of the possibilities for the use of text within visual representation, clearly affected his approach to a film that was originally conceived as a kind of documentary. It is within these realms that the extremely hybrid form of *Les Mystères* is most strongly felt since the poetic nature of the textual inserts contributes to the reality/fantasy dichotomy that characterises the film. The interrelationship between text and image can be seen in Man Ray's early conception of the film. In a letter to Charles de Noailles, accepting the terms of the commission, he writes 'I should begin by getting one of my literary friends to prepare a scenario taking into account the location and ap[p]roximate number of people involved. This scenario need not be a coherent story but offer a field for original plastic or optical effects'.[5] It is highly probable that Man Ray was thinking specifically of Desnos and the way in which his previous film had been structured around the poet's written indications. Thus, this section of the letter to Noailles also serves to corroborate the argument made in the chapter on *L'Etoile de mer*, that Desnos' Surrealist scenario did indeed serve as a basis for Man Ray's visual explorations. The reference to the use of a literary scenario, not as a clear narrative outline, but as a framework facilitating visual experimentation, reflects the collaborative process involved in the making of that particular film. A similar coexistence of literary and visual concerns was clearly envisaged for *Les Mystères*, attesting to the development of Man Ray's interest in this area.

Whether or not Man Ray did approach Desnos, or indeed any other of his Surrealist friends remains uncertain. What we do know, however, is that the film followed some kind of written outline that was sent to all those involved before the shooting commenced, and which Noailles described in a letter to the Duchesse of Ayen as seeming 'un peu abracadabrant'.[6] In his autobiography, Man Ray refers to the travelling sequence at the beginning of the film, stating, 'Although mostly improvised it fitted in with the script. After the start, not knowing what I was heading for, it seemed to me that I had successfully created an air of mystery'.[7] Unlike the existing documents that allow us to look further into the making of *L'Etoile de mer*, no such scenario remains for *Les Mystères*, and it must be assumed, from the comments by Noailles and Man Ray, that it was little more than a shooting

script, woven together by a rough narrative outline. It seems likely then that the intertitles that appear throughout the film and which provide it with a very literary flavour were added after the filming took place, suggesting a process quite different to the one that characterises *L'Etoile de mer*. However, the similarity between the two films in this respect lies in the fact that the intertitles go beyond narrative description and frequently take on a poetic quality of their own, and whilst occasionally commenting on the 'action' or visual information, are in no way restricted to this function. Although some of the text in *Les Mystères* has a descriptive purpose, it nonetheless retains a lyrical quality.

This chapter explores the relationship between Man Ray's film and Mallarmé's poem by emphasising correspondences in structure, rhythm and movement. It examines the way *Les Mystères* brings together literary and cinematic expression through the medium of architecture, focusing particularly on their shared emphasis on space. By comparing certain formal characteristics of Mallarmé's poem with those of Man Ray's film, I will argue that the building of spatial awareness and the concretisation of space constitutes the key point of convergence. Mallet-Stevens' architecture, with its emphasis on frames and windows, allowing one space to spill into another, in many ways mirrors the process of cinematic representation, where the containment space is of similar concern. Man Ray's complex geometric compositions within the frame, which stem from the architectural intricacies of the Villa de Noailles, in turn mirror Mallarmé's typographical compositions on the page, in an attempt to interact with and overcome the invisible, intangible nature of space. The film's focus on the atemporality of space and the possibilities it creates for a simultaneous rendering of past and present will also be explored briefly in relation to the villa's fusion of old and new. Of crucial importance in relation to these themes is the representation of the body, which, as we shall see, is brought into play with the characteristics of the villa and incorporated into its formal design.

With *Les Mystères*, Man Ray moves completely out of the studio and fully explores the possibilities of natural space. Whilst sections of *Emak Bakia* were shot on location and can be seen to exploit the formal possibilities of the Mediterranean surroundings, they are ultimately anchored by,

and juxtaposed with, the studio-based images. Similarly, although a large majority of *L'Etoile de mer* also involves non-studio shooting, Man Ray rarely concentrates on the qualities of spatial depth and perspective that so characterise *Les Mystères*, and which demonstrate a new awareness of the medium. The gelatine filter that is used for the majority of the shots in the earlier film represent an attempt to render spatial perception problematic, a process that also seems to be at work in both *Le Retour à la raison* and *Emak Bakia*. Man Ray's last film is therefore a turning point in the development of his cinematic ideas in the realms of space. It is also in this film that the camera is given greater freedom of movement, breaking away from the predominantly static position of the previous films. Although, as Chapter 2 discusses, *Emak Bakia* already sees Man Ray experimenting with different forms of movement, camera mobility is explored much more extensively in *Les Mystères*. Furthermore, if *Le Retour à la raison*, *Emak Bakia* and *L'Etoile de mer* concentrate to a large extent on the destruction of spatial perspective through techniques of abstraction and distortion, Man Ray's last film involves an investigation of the whole spectrum of cinematic space through camera movement, framing and positioning in non-studio-based surroundings.

From architecture to film: The villa and the commission

Although each of Man Ray's four films emerged from specific circumstances that contribute to the nature of the final product, the number of external elements that entered into the conception and construction of *Les Mystères* make it a particularly complex work and perhaps the most interesting example of Man Ray's trans-artistic sensibility. For this reason, it is necessary to give a brief outline of the project and the personalities involved before discussing the formal qualities of the film in detail.

A Modernist Project

In 1923, wealthy aristocrats Charles and Marie-Laure de Noailles commissioned the architect Robert Mallet-Stevens to design a winter house, which would be built in Hyères on the Mediterranean coast. As Noailles remembers in a letter to Mallet-Stevens some years later, the request specified 'une maison infiniment pratique et simple où chaque chose serait combinée au seul point de vue de l'utilité.' [An extremely practical and simple house where everything should be chosen with utility as the sole aim.][8] The expansive villa, constructed in stages and completed in 1927, was a testimony to the modernist spirit in architecture, bringing together the most recent tendencies in the arts. It is perhaps for this reason that Noailles was eager to commit the building to film, providing a documentary record of the grounds whilst at the same time adding another artistic dimension to what was already an impressive creative achievement. He first approached Marcel L'Herbier's production company, which led to a film by Jacques Manuel entitled *Biceps et bijoux* (1928). This short piece, with a 'vague fil narratif',[9] was centred primarily in and around the swimming pool situated on the ground floor of the villa. Unconvinced by the artistic merits of Manuel's film, Noailles approached Man Ray at the beginning of 1929 with an offer to join him and a number of other guests for a few weeks at the villa that coming winter. The offer came with the condition that he would bring his movie camera and shoot some scenes of the villa and its guests.

Despite Man Ray's reluctance to involve himself in any more filmmaking projects, having already decided to give up working with the medium, he was attracted by the loose conditions of the commission and the opportunity that it provided for a holiday in the south of France. Man Ray was reassured by the fact that the film was to be the private property of the Vicomte and would not be screened publicly. He was already beginning to resent the fact he was now being considered as having turned his interests to movie making and no doubt felt a certain liberty in making a film for which there would be no artistic expectations. However, as he points out in his autobiography, although he had planned to approach the film in terms of a straightforward documentary, an 'easy, mechanical job' that

'required no inventiveness', a photograph of the grounds given to him by Noailles before his departure stimulated his imagination and altered his perception of the project:

> Before leaving for the south to open up his château, Noailles gave me a photograph of it – a conglomeration of gray cement cubes built on the ruins of an old monastery on the top of a hill overlooking the town and the sea. Designed by a well-known architect of the day, Mallet-Stevens, it was severe and unobtrusive as if trying to hide the opulence that was housed in it. In spite of myself, my mind began to work, imagining various approaches to the subject; after all, it would be best to make some sort of plan if only not to waste effort. The cubic forms of the château brought to mind the title of a poem by Mallarmé: 'A Throw of the Dice Can Never Do Away With Chance.' This would be the theme of the film, and its title: *The Mystery of the Château of the Dice.*[10]

Architecture thus provided the principle creative stimulus and the main theme on which the film would pivot. As we shall see, the formal properties of the villa and its contradictory connotations highlighted here by Man Ray dictate to a large extent the overall approach to the project. The filming began at the beginning of January 1929 and lasted for about two weeks. Noailles was delighted with the finished film and a private screening was organised at their home in Paris for 1 May of the same year. Another private showing, organised by the Surrealists, took place at the Studio des Ursulines on 12 June, along with Luis Buñuel and Salvador Dalí's *Un Chien andalou*, and was followed by a number of public projections throughout the year.[11] Noailles' enthusiasm for the film, as well as the high esteem in which he held Man Ray's artistic talent, led to an offer of financial backing for a feature-length film with no restrictions. Man Ray declined. To go from making short films, on which he worked almost independently, to enter into the arena of professional filmmaking seemed to him a massive leap, which would, above all, require him to collaborate with any number of industry specialists. However, *Les Mystères* demonstrates collaboration on a number of levels, principally in the bringing together of different personalities and creative approaches. If the commission involved a direct liaison between Man Ray and Charles de Noailles, it is also characterised, as demonstrated by the above quote, by a more indirect relationship between Man Ray and Mallet-Stevens.

Man Ray and Mallet-Stevens

Chapter 3 discusses the connection between Man Ray and the poet Robert Desnos, with whom he collaborated on the making of *L'Etoile de mer*, and outlines the way in which their respective interests in the arts of poetry and film provided the perfect conditions for an interdisciplinary exploration. A similar exchange can be seen at work in *Les Mystères* since, even if Man Ray and Mallet-Stevens did not officially collaborate in the making of the film, they nonetheless shared certain preoccupations within the realms of both cinema and architecture, contributing to a fusion of ideas that clearly influenced the shape taken by the finished piece. Although there would appear to be little in Man Ray's work to link him with the field of architecture, his early passion and aptitude for mechanical drawing whilst at high school earned him a scholarship in architecture at Columbia University, which he declined in order to pursue his more passionate interest in painting. A number of drawings from this period demonstrate a studied composition of line and perspective. In later years, influenced by developments in Cubism, he began to focus attention instead on the flat surface of the canvas. In a pamphlet produced in 1916, entitled *A Primer of the New Art of Two Dimensions*, Man Ray developed a theory of two-dimensional art in which he brought together painting, sculpture, architecture, music, literature and dance by demonstrating their common 'potential for reduction on a flat surface.'[12] In this treatise he stated, 'All architecture is based on the principle of proportion or scale, a purely plastic element adaptable to the flat plane and fully expressive of the architectural sense of the mind.'[13] As we will see later in this chapter, *Les Mystères* draws on this plastic element of architecture by concentrating on the way depth and perspective is expressed on the flat surface of the cinema screen, pushing the notion of filmic space to the foreground of his visual explorations. The Cubist forms of Mallet-Stevens' architectural design thus seem to project Man Ray back to his earlier pictorial concerns, allowing him to finally expand these ideas into the medium of cinema, the only art form to which *A Primer* does not refer.

Robert Mallet-Stevens was more directly involved in the cinema than Man Ray was involved in architecture, and, as such, his work expresses a

much more profound interrelationship between the two arts. He was a member of the ciné-club founded in 1921 by Ricciotto Canudo, *Le Club des Amis du Septième Art*, which included many of the key avant-garde figures of the period, such as Louis Delluc, Jean Epstein, Blaise Cendrars, Jean Cocteau and Fernand Léger.[14] As Donald Albrecht notes, he also wrote the first book on the subject of modern architecture in the cinema, *Le décor moderne au cinéma*.[15] In some ways echoing Delluc's notion of 'la photogénie',[16] Mallet-Stevens argued for the inherent suitability of modern architecture as a cinematic subject: 'L'architecture moderne est essentielle-ment photogénique: grands plans, lignes droites, sobriéte d'ornements, sur-faces unies, opposition nette d'ombre et de lumière.' [Modern architecture is essentially photogenic: large spaces, straight lines, sober ornamentation, plain surfaces, clear opposition of light and shadow.][17] It is particularly this awareness of the cinematic possibilities of modern architecture's emphasis on light and shadow that links the artistic concerns of Mallet-Stevens to those of Man Ray.

Like many architects of the period, Mallet-Stevens worked as a set-designer for a number of films, and was therefore aware of the practical, as well as theoretical, implications in bringing together the two forms of expression. In 1925 he wrote, 'It is undeniable that the cinema has a marked influence on modern architecture; in turn, modern architecture brings its artistic side to the cinema. Modern architecture does not only serve the cinematographic set (*décor*), but imprints its stamp on the staging (mise-en-scène), it breaks out of its frame; architecture "plays."'[18] These ideas are clearly expressed in the exterior décor that was created for Marcel L'Herbier's film *L'Inhumaine* (1924),[19] and which bears a striking resem-blance to the Villa Saint Bernard that Mallet-Stevens designed for the Noailles. The notion of architecture as taking on a role rather than simply providing a background for the action is a key characteristic of *Les Mystères*, perhaps the first film to be made in which architecture becomes the central 'actor' through an intimate camera-subject relationship that is traditionally reserved for the filming of characters and the expression of emotion. Thus, Man Ray's film both demonstrates and expands Mallet-Stevens' view by bringing architecture to centre-stage, not as a means to emphasise charac-ter emotion of the kind found in *L'Inhumaine*, but rather in *becoming* the

character itself. As we will see later in this chapter, *Les Mystères* actually reverses the conventional relationship between characters and their surroundings through a process of de-familiarisation that contrasts starkly with the techniques of Expressionism (a major influence on the making of *L'Inhumaine*), in which the set takes on an expressive quality but still remains subservient to the communication of human emotion. In drawing out geometric patterns within the villa through camera movement and composition within the frame, Man Ray fuses his own visual concerns with those found in the architectural design of Mallet-Stevens, and, in doing so, brings out the purely formal qualities of the modernist space.

The film begins with the introductory text, 'Comment deux voyageurs arrivèrent a Saint Bernard, et ce qu'ils virent dans les ruines d'un vieux Château, au-dessus desquelles s'élève un autre château de notre époque', followed by a series of images that form the basis of a prologue. A set of car headlights emerge out of darkness, followed by a succession of images of the villa and the surrounding area coming closer into view through a series of dissolves (see figure 17). A pair of wooden hands, presented in close-up, play with a set of dice, creating a strong visual reference to the title of Mallarmé's poem. An inter-title 'Loin de là, à Paris' serves to locate the subsequent action, whilst simultaneously setting up a dichotomy between Paris and the 'elsewhere' (otherness) of the previous image. The following sequence shows two men (Man Ray and his assistant Jacques-André Boiffard) in a bar rolling dice in order to decide whether or not to leave. They wear stockings over their heads, making their faces, and thus their expressions, imperceptible to the viewer. The decision to leave prompted by the result of the dice roll is followed by a series of exterior shots showing them getting into a car and driving away. In narrative terms, an attempt is made at imbuing the journey with a sense of mystery, represented in the two textual inserts 'Où allons-nous?' and 'Les portes de Paris s'ouvrent sur l'inconnu.'

What follows is a relatively lengthy sequence representing their journey, filmed entirely from the moving car and consisting of a total of twenty-one separate shots. Although movement is a key element here, it is certainly not the only point of interest since a number of important visual concerns are developed, notably the play of light and shadow and the oscillation between

abstraction and figuration. This section of *Les Mystères* strongly resembles Man Ray's earlier films in its collage-like construction of individual shots that each concentrate on a particular formal detail. The cement cubes that line the edge of the road at the beginning of the journey seem to look back to the animated geometric shapes of *Emak Bakia* whilst anticipating the focus on geometric compositions in later sequences of the villa. The strangely truncated trees draw attention to the underlying element of abstraction in concrete reality, which, as a comparison with one of Man Ray's documentary photographs from 1930 demonstrates, clearly fascinated Man Ray. In this untitled image, a tree-lined Paris boulevard recedes into the background, each of the trees stripped bare of its foliage. What strikes us about the photograph is the way it expresses the geometrical regularity into which nature is forced, a concern that is also found in *Les Mystères*. Another interesting formal detail in this sequence of the film is the shot of a fence through which sunlight streams, creating a strobe-like effect as the car travels past it. The vertical lines of the fence as they move across the screen create an almost identical effect to that of the sequence of distortions in *Emak Bakia* in which similar black and white lines rapidly move from one side of the frame to the other.

The end of the journey and the arrival of the two men at a place of interest are signalled by a series of shots of a sculpture by Jacques Lipchitz – *J'aime le mouvement qui déplace les formes* – that is situated in the villa's 'triangular garden'. Man Ray interprets the title of the statue by creating an impression of movement, again bringing to mind the earlier films and their concentration on sculptures or constructed objects in motion (we are also reminded here of the 1920 photograph *Moving Sculpture*). The subsequent sequence represents, in terms of the commission, the most important aspect of the film since it constitutes the documentary record of the villa itself, beginning outside with the camera meticulously picking out the unusual structures and angles of the building. Unlike the representation of the journey, which is heavily edited to provide a series of rapidly changing visual impressions, this section is characterised by the presence of a sequence of longer shots that builds a gradual awareness of the architectural intricacies of the villa. This is followed by a similar exploration of the interiors. Here, the filming is less objective and the presence of the camera is felt more

clearly, being positioned at different levels and carrying out more diverse and erratic movements. A number of intertitles suggest a search for signs of life, insisting on the emptiness of the place. Particular details are singled out and become the focus of individual sequences: a stained glass window, a sink fitted with removable cover, various sculptures and racks of paintings (with only the reverse side of the pictures visible to the viewer).

After these sections of exterior and interior exploration, another set of 'characters' are introduced, this time the inhabitants of the villa. However, their role as characters in the traditional sense is suspect from the outset, not only because, like the two travellers seen at the beginning, their faces are obscured by stockings, but also due to the way the subtitles introduce them as a kind of strange, unknown species occupying a 'hidden corner' of the castle's grounds and playing, childlike, with a pair of oversized dice (which also function to highlight their impishness). The camera then follows them engaging in various sporting activities, dominated by a sequence that takes place in the swimming pool, clearly designed to demonstrate the aquatic skills of Noailles and his wife Marie-Laure, whom Man Ray describes in his autobiography as 'expert swimmers'. It is at this point in the film that the role of the textual insert takes on greater significance, not simply commenting on the action, but rather becoming significant in its own right, giving rise to particular moments where the text seems to have only a tenuous relationship with the image. Then, as the actions of the characters (played variously by Charles and Marie-Laure de Noailles, Eveline Orlowska, Bernard Deshoulières and Alice de Montgomery, Marcel Raval and the count and countess of Ursel) become gradually more choreographed and formally composed, the intertitles simultaneously become less frequent, with the focus again becoming that of the purely visual.

After the second temporal reference announcing the second day, another pair of travellers, this time a man and woman (Comte Etienne de Beaumont and Lily Pastré), arrive by chance at the castle. Upon finding the abandoned dice, the couple, like the other characters before them, put their destiny in the hands of chance and let the dice decide whether or not they should stay. Thus, the 'On part? On ne part pas?' dilemma of the two travellers who begin the film is mirrored by the 'On reste? On ne reste pas' of those featured here. They climb to the summit of the castle,

undress and begin to dance, whereupon they become frozen in time as statues. Man Ray transfers the image from positive to negative, making their bodies appear white against a black background. The wooden hands seen at the very beginning reappear to conclude the film.

For the purposes of analysis *Les Mystères* can be divided into four relatively distinct sections: first of all there is the journey that the two travellers make from Paris, which provides the motivation for the subsequent series of more or less self-contained formal exercises. Secondly, there is the documentary-like exploration of the castle, which again provides Man Ray with a pretext to develop and experiment with different styles of filming. The third section concentrates on the activities of the guests, whilst the fourth, albeit shorter and less individually succinct, ends the film with the arrival and immortalisation of the second set of travellers.

Situating *Les Mystères du Château du Dé*

Before discussing the main concerns of *Les Mystères* in detail, I shall first outline the historical and discursive context that has significantly affected its reception and its situation within avant-garde film studies. This will be useful in understanding the very limited parameters to which analyses of the film are often restricted. As is the case with all of Man Ray's cinematic works, the main problem that arises in existing discussions of *Les Mystères* is how and where to place it within the context of avant-garde activity of the period. Despite being considered by the Surrealists with a certain amount of scepticism at the time of their release (and, as I have argued in previous chapters, continue to raise an element of doubt in terms of categorisation), the earlier films *Emak Bakia* and *L'Etoile de mer* ultimately found their way into André Breton and Philippe Soupault's *Dictionnaire abrégé du mouvement surréaliste*,[20] although, as Robert Short has suggested, these inclusions were probably made to compensate for the dearth of truly 'Surrealist' productions, by 'bumping up the roster.'[21] In 1951, Breton would express his regret at the ultimate failure of the cinema – the medium that

had seemed to offer the most potential – to realise the Surrealist hopes of a revolutionary form of visual expression:

> For my part it would be to gainsay myself, to disavow what conditions me in my own eyes, what appears to affect me beyond measure, to disown, as is customary, the disappointments wrought by the cinema, that form of expression one has been able to believe in to a degree greater than any other called upon to promote 'real life.'[22]

This disappointment, which must have already been felt as early as the 1930s, along with Man Ray's continued loyalty through the most testing years of Surrealism, during which many of the group's members were thrown out for political or artistic treachery, undoubtedly led Breton to reconsider his earlier severity as to what constituted Surrealist expression in the cinema.[23] However, his later revisions did not stretch as far as the inclusion of *Les Mystères*, an omission that seems to have relegated the film to an inferior position, The circumstances out of which the film emerged and its close connection with the modernist architectural project of Mallet-Stevens, as well as earlier avant-garde filmmaking practices against which Surrealism was positioned, are clearly significant in understanding this ambiguous status. It is not only a film that defies genre classification (i.e., documentary, fiction, home-movie), but also one which, more importantly given its historical positioning, seems to evade stylistic definition.

The first screenings of *Les Mystères* were accompanied by *Un Chien andalou*, Buñuel and Dalí's short piece produced the same year. In *Histoire du mouvement surréaliste*, Gérard Durozoi evokes the effect of this film on the reception of Man Ray's cinematic work:

> À la fin de l'été 1929, une projection privée du film de Dalí et Buñuel *Un Chien andalou* est organisée chez les Noailles, à laquelle assistent Breton et d'autres membres du Groupe. Ils en sont enthousiasmés: jamais le cinéma n'a atteint une violence ou une cruauté comparable, et par rapport au film de Buñuel, les essais de Man Ray paraissent eux-mêmes bien timides.[24]

> [In the late summer of 1929, a private screening of Dalí and Buñuel's film *Un Chien andalou* is organised at the Noailles' house, attended by Breton and other members of the Group. They are excited; the cinema has never achieved such comparable violence or cruelty and, compared with Buñuel's film, Man Ray's experiments seem very timid.]

Jean-Michel Bouhours echoes this perspective, with a more direct reference to the impact on the way *Les Mystères* itself was perceived: 'sorti au même moment qu'*Un Chien andalou, Les Mystères* [...] dont les images photogéniques de Man Ray sont empreintes d'une poésie légère, fait parfois pâle figure devant la puissance des images de Buñuel et Dalí.' [Released at the same time *Un chien andalou, Les Mystères* [...] in which Man Ray's photogenic images are marked by a delicate poetry, sometimes pales before the power of Dalí and Buñuel's images.][25] From these two comments we begin to understand the way in which the viewing of Man Ray's film was (and still is) affected by the concurrent release of Buñuel and Dalí's now infamous first film. Their second cinematic collaboration, *L'Age d'or*, as well as Jean Cocteau's *Le Sang d'un poète*, both also funded by the Vicomte de Noailles, appeared the following year. The films by Buñuel in particular signalled a new kind of avant-garde filmmaking, one that outwardly rejected the formal aestheticism of the previous wave of artist/filmmakers. These films suggested new possibilities for Surrealist creation whilst simultaneously opening up previously undiscovered avenues of cinematic construction that did not consist in the outright rejection of traditional codes and conventions, but precisely in exploiting these conventions to create a psychological, rather than, formal effect.

Jacques B. Brunius has referred to this period as the dissolution of the cinematic avant-garde, 'the fourth and last period [...] that saw both the culmination and disintegration of this spirit of adventure.'[26] Drawing attention to the difference between the previous concerns of the avant-garde film and those of the new mode of expression represented primarily by *Un Chien andalou*, Brunius observes that the latter 'reasserted the importance of the anecdote, and discarded all virtuosity that added nothing to the subject. The whole effort of Dalí and Buñuel bore on the *content* of the film, and they loaded it with all their obsessions, all the images of their personal mythology, deliberately made it violent and harrowing. As for the container, Buñuel gave it the simplest possible form.'[27] From this perspective, the Surrealist films of this period signalled once and for all the abandon of concerns related to medium-specificity developed by the first wave of abstract and Impressionist filmmakers and still present to some extent in the later Dada-related films of Fernand Léger, René Clair and,

of course, Man Ray. However, in relation to the comment by Brunius, we must question whether the separation of form and content to which he refers is at all possible since the two are inextricably linked even in the least formally concerned films. This issue has been raised by Linda Williams in her discussion of Surrealist film, which highlights the misconception that the Surrealists' approach to film necessarily involved a rejection of form in favour of content.[28]

The consequences of this misconception can be seen in Brunius' statement that, '*Un Chien andalou* came just in time to shake the blind confidence in the lens, the cameraman, and laboratory tricks, which had fostered the habit of forgetting to endow scenes with any meaning at all.'[29] The argument thus becomes clearer: formally determined explorations and self-reflexive strategies that focus attention towards the nature of vision and cinematic representation, Brunius seems to suggest, are without meaning, since meaning exists exclusively on the level of content. This is indeed a view expressed by Léon Moussinac, who at the time of the film's release wrote:

> C'est l'aspect plastique des images, l'expression intime de celles-ci qui intéresse tout spécialement Man Ray, admirable photographe. Rien de ce qui fait une composition cinématographique, de ce qui commande au rythme d'un film, rien des rapports mathématiques des images entre elles ne semble le retenir. C'est une architecture 'au jugé', qui garde le charme de son incertitude, mais qui ne manque pas, souvent, d'être un peu lassante, et nous apparaît comme un divertissement inutile. Seule la séduction agit sur l'aspect plastique des images, la volonté et l'esprit qui s'y relèvent, mais ça n'est pas suffisant en cinématographie.[30]

> [It is the plastic aspect of the images, their intimate expression that is of particular interest to Man Ray, that wonderful photographer. He is not held by anything to do with cinematic composition, with what drives the rhythm of a film, nor the mathematical relationships between the images. It is a 'judgmental' architecture which maintains the charm of his uncertainty, but often becomes a little boring, and seems to us to be an unnecessary diversion. We are enthralled by the plastic aspect of the images, and by the will and the mind behind them, but that is not enough to make it cinema.]

What Moussinac seems to find most dubious about Man Ray's approach in *Les Mystères* is the kind of formal introspection that characterised abstract, Impressionist and Dada cinema, and against which Surrealism was positioned. Moussinac had been an early supporter of French Impressionism and a friend of Louis Delluc, who, throughout the 1920s, became gradually more aligned with the theories of the Russian Soviet filmmakers Sergei Eisenstein and Dziga Vertov. By 1929, he was criticising the films of the French avant-garde for their lack of structure and excessive concentration on pictorial values, claiming in 1933 that, 'because it envisioned the problem according to the point of view of aesthetics only, because it wanted to ignore the economic laws which determined it, the avant-garde is dead.'[31] For Moussinac, simply pushing the limits of cinematic conventions for purely aesthetic purposes did not amount to an advancement of the medium but rather stunted its creative possibilities. Although he praises the aesthetic beauty of Man Ray's images, he suggests that what are admirable and pleasing effects in a photograph are not powerful enough in cinematography. Of course, this final statement must surely depend on what is understood by 'cinematography'.

It seems clear that by 1929 a new approach to cinematic expression was establishing itself through a number of French critics who, like Moussinac, were becoming aware of the revolutionary potential of film. The increasing popularity of the Soviet theories of montage, as well as the new direction of Surrealist film signalled by the collaborative efforts of Buñuel and Dalí, focused attention away from the formal experiments of the previous years. Man Ray was aware of the critical position in relation to his films and, years later, would attempt to counter Moussinac's statement, arguing 'il ne m'intéresse pas de faire de la "belle photo" au cinema.'[32] Although he does not explicitly refer to the criticisms of his overly aesthetic cinematic approach, they are nonetheless implicitly suggested.

If the kind of expression found in Man Ray's film does indeed seem far from the revolutionary fervour of the Russian experiments in montage or the violent images of *Un Chien andalou*, it does not necessarily equate to the empty formalism referred to by both Brunius and Moussinac. *Les Mystères* is not an attempt at a Surrealist film, even though it contains numerous elements that express a Surrealist sensibility. As I have already

highlighted, it bears more of a resemblance to Man Ray's early works in the sense that it, as Inez Hedges points out, 'returns to the abstract study of shapes and moving forms, despite a rudimentary story line.' Hedges argues that, 'perhaps because of the absence of Desnos as collaborator, one can find few Surrealist elements.'[33] It is, nevertheless, these very elements to which descriptions and definitions of the film tend to point, attesting to a particular quality that deserves attention. Mario Verdone, for example, has referred to *Les Mystères* as a 'typico film surrealista, con elementi immaginari e reali',[34] whilst Sheldon Renan employs the term, 'surrealist mystery film',[35] to evoke the aura or atmosphere of Surrealism, without necessarily relating it to the psychological violence of other forms of Surrealist expression. What these statements seem to highlight is the inadequacy of the term 'Surrealist' to describe a film that approaches, but ultimately evades, the fundamental aims of the movement. Verdone's generalisation of the film's fusion of real and imaginary elements as constituting a typical example of Surrealism, and Renon's attempt to open up the category by relating it to vague notions of mystery and strangeness underline the phenomenon of taking a part for the whole that would seem to be a common problem in the use of Surrealism as a critical tool. Just as Man Ray's film involves more than a fusion of reality with imagination, the notion of Surrealism also goes beyond such a simplified process.

Man Ray was clearly inspired by his contacts with the Surrealist movement, but *Les Mystères*, like most areas of his work, sees him bringing Surrealist elements into a fusion with other formal concerns. As a result, Surrealism exists as only one of a number of preoccupations, and any attempt to fix the film to such a singular interpretation is inevitably met with frustration. The way the film initiates a subtle transformation of reality is, in other accounts, described in terms of the fantastic, which crucially avoids the strict alignment of the film with the processes of Surrealism. This is the path taken by Peter Weiss, who states, 'Man Ray fait subir à la réalité quelques métamorphoses. Il nous montre, par exemple, des membres de la haute société, couchés sur le plancher, et sur lesquels jouent des ombres fantastiques.' [Man Ray subjected reality to some transformations. He shows us, for example, members of high society, lying on the floor, and upon whom fantastic shadows glide.][36] Iannis Katsahnias highlights similar qualities

when he refers to 'des reflets et des ombres qui touchent au fantastique.'[37]
The important factor here is the way the 'fantastic' and the merging of reality
with fantasy are related specifically to the film's formal characteristics, such
as the play of light, rather than any particular narrative content. This is a
feature of Ado Kyrou's summary of the film, in which certain details such
as the covered faces of the characters and the Cubist décor are described
as producing 'des effets éminemment insolites.' [highly unusual effects.][38]
Similarly, A.L. Rees refers to the 'repeated empty rooms' of *Les Mystères*
in terms of Man Ray's 'cinema of refusal', suggesting the important link
between the film and the architecture of the villa.[39] It is here that the extent
of the need to consider the film as situated *between* the forces of modernist
formalism and Surrealism becomes evident as Man Ray draws out both the
formal and psychological impact of Mallet-Stevens' architecture.

Thus, although the following pages focus largely on a formalist reading
of *Les Mystères*, it must be highlighted that this approach does not deny the
existence of links between the content of the film and certain elements of
Surrealist thought. Indeed, it is within the representation of space and its
inevitable evocation of time (past, present and future) that this relation-
ship is most visible. In the first Manifesto of Surrealism, Breton evokes an
imaginary space, a metaphor with multiple functions that he uses to outline
the dynamics of the movement and its members in relation to the wider
context of society within and against which it operates.

> For today I think of a *castle*, half of which is not necessarily in ruins; this castle
> belongs to me, I picture it in a rustic setting, not far from Paris. The outbuildings
> are too numerous to mention, and, as for the interior, it has been frightfully restored
> in such a manner as to leave nothing to be desired from the viewpoint of comfort.
> Automobiles are parked before the door, concealed by the shade of trees. A few of
> my friends are living here as permanent guests.[40]

What is interesting about this description is the extent to which Breton's
space resembles that represented some years later in *Les Mystères*, evoking
exactly the same kind of juxtaposition between the old and new that so
fascinated Man Ray, and to a large extent defined his approach to the film.[41]
The space created by Breton brings together past and present, the ruins of
the castle contrasting with its modernist transformation. The scepticism

with which this 'frightful' restoration is approached is also reflected in *Les Mystères*, where the formally detached architecture and empty rooms give rise to a sense of malaise and foreboding. Against this background, human presence is represented as depersonalised, becoming gradually absorbed into and overtaken by the architectural surroundings.

This aspect of the film has been related to the Surrealist spaces of Giorgio de Chirico,[42] where the anonymous human figure wanders through an interminable spaces populated by statues – immortal incarnations representing mythical gods and goddesses. As we shall see, juxtapositions of living beings with statues and references to immortality are key aspects of *Les Mystères*. It is perhaps the repeated emphasis on spatial framings (windows and arcades) in De Chirico's metaphysical paintings that provides the most interesting link with Man Ray's film. As Alexander Gorlin observes, 'one of the themes of de Chirico's metaphysical interiors and his series of empty plazas is the exploration of the ambiguous relationship between interior and exterior space.'[43] Gorlin describes the painting *Man Seated Before a Window*, with its different levels of spatial reference, as 'a series of frames within frames.'[44] These are precisely the themes I will explore in relation to *Les Mystères* and its representation of space. However, the discussion will emphasise the predominantly formal direction taken by Man Ray in his exploration of space, which, in contrast to De Chirico's distorted perspective and multiple viewpoints, represents a more pragmatic physical rendering of space. The correspondences between *Les Mystères* and painters such as De Chirico and René Magritte – whose work also deals with the framing of space through windows and mirrors – are nonetheless noteworthy, and, whilst outwith the focus and scope of the present study, would no doubt bring to light valuable observations about the relationship between cinematic and painterly conceptions of space.

Un coup de dés ...

In many ways, the most evident connection with Surrealism can be found in Man Ray's use of Mallarmé's modernist poem *Un coup de dés jamais n'abolira le hasard* as a key source of inspiration. The Symbolist work was a favourite amongst the Surrealist group, along with others by Apollinaire, Lautréamont and Rimbaud. Most important in the context of this discussion is the way this text demonstrates a link between Surrealism and formalism. In a lecture delivered in Prague in 1935, André Breton praises Mallarmé for having created a poem 'in which visual elements take their place between the words without ever duplicating them.'[45] He refers to systems of poetic construction employed by Mallarmé and by Apollinaire in his *Calligrammes* in terms of a 'systematic derangement of all the senses', exactly the kind of derangement that was vital to the Surrealist project. Indeed, one of the most striking effects of Mallarmé's poem is the formal arrangement of the text on the page and the breaking up of traditional poetic structure (the twelve-syllable alexandrine). The various word groupings, spread seemingly randomly across the poem's twenty-four pages and presented in contrasting sizes and typeface, express purely formal relationships. Normal processes of signification are rendered problematic since words and phrases often do not flow naturally from one section to another, producing the 'derangement' of which Breton speaks so highly. As in Apollinaire's *Calligrammes*, the words are freed from conventional systems of signification and become autonomous visual elements within a loose structure known as 'pure poetry'.[46] As we shall see, certain moments of *Les Mystères* can be associated to a similar derangement of the senses by altering the way in which we experience external reality. As I have argued in Chapter 2, this is a crucial aspect of Man Ray's expression that occasionally seems to overlap with Surrealist practice, whilst ultimately treading a formally determined path.

... jamais n'abolira le hasard

Through the central role played by the title within the text of the film, the formal structure of the poem is related to the notion of chance, that aspect of creative production so dear to the Surrealists. The random appearance of the poem and its insistence on unconventional groupings of words seem to represent an early example of what Breton and his followers would later develop as automatic writing. Yet, Mallarmé was only interested in the paradoxical nature of chance and the extent to which it enters into a relationship with, and reveals patterns of, logic and reason. This is clearly evident in the perplexing double nature of the title, which even suggests the cancelling out of chance. As Dee Reynolds explains:

> The poem's semantics clearly invite a questioning between order and chance. The use of the verb 'n'abolira' in the title phrase suggests an opposition between 'un coup de dés' and 'le hasard' [...] whereas in fact the two are etymologically equivalent, 'hasard' being derived from the Arabic 'az-zahr', meaning 'le dé' [...] The emphasis on the theme of 'le nombre' suggests that the numerical structure of 'le vers' is itself caught up in the paradoxically interchangability of order and disorder, which illustrates the interconnectedness of all phenomena, where chance can throw up its own order.[47]

As the earlier chapter on *Le Retour à la raison* demonstrates, Man Ray's work expresses the complex and contradictory nature of chance. As an artist, he was fully aware of the possibilities offered by submitting oneself to the laws of chance, but, like Mallarmé, he also understood the way that chance was inseparable from patterns of order.

The contradictory title of Mallarmé's poem was undoubtedly the key source of attraction for Man Ray, whose own personality was characterised by a strong sense of contradiction. This is evidenced in the reproduction of the title within the film, the presentation of which mirrors the formal structure of the poem:

Un coup de dés ...

<div style="text-align:center">... jamais n'abolira</div>

<div style="text-align:right">... LE HASARD</div>

Appearing in three separate intertitles to the left, middle and right of the screen, the title demonstrates Man Ray's attempt to create a cinematic interpretation of the poem. The intertitles are alternated with shots of the castle's inhabitants throwing dice, further establishing the concentration on chance. Yet the incorporation of the reference to Mallarmé and the theme of chance into the 'narrative' of the film are not without a certain element of irony, an aspect that has gone unnoticed by many critics. The physical presence of the oversized dice serves not only to create a strange sense of proportion that makes the actors appear impish, but also bestows upon the scene an absurd or burlesque quality, undermining the seriousness of the act of throwing dice to determine a sequence of events. Indeed, an element of humour is glimpsed briefly as one of the dice is raised into the air as if to strike the head of the adjacent person, the intertitle 'Un coup de dés' playing on the dual significance of the French expression 'un coup' as either a throw or a blow. Given Man Ray's penchant for the *double entendre*, the irony of the scene is not difficult to spot.

In *Les Mystères*, as with *Le Retour à la raison* and *Emak Bakia*, Man Ray brings chance into play with order and logic. That each set of characters roll dice to decide on what to do next introduces an element of predictability through repetition. In considering this aspect of the film, we are reminded of Man Ray's comment, referred to in Chapter 1, that, 'quand on répète une chose, ce n'est plus le hasard.' Therefore, the contradictory nature of chance is already introduced on the level of narrative. Furthermore, after rolling the dice, the activities of the villa's guests that make up the middle section of the film take on a gradually more organised and regular quality that fits in, as we shall see, with the geometric explorations of the building's architecture. The body is shown not as independent of the laws of its surroundings, but rather subject to them, ultimately giving rise to a fusion between animate and inanimate.

The interplay between chance and order can be detected on the level of the film's construction. In an approach that to a large extent characterises his earlier films, Man Ray allowed the forces of chance to dictate the visual quality of *Les Mystères*. The sequence of the journey made from Paris to the south of France, in which the camera captures the passing landscape and the fortuitous patterns of light and shadow, expresses, on the

one hand, the spirit of spontaneity with which it was filmed. Yet, looking at it from another perspective, this section of the film also demonstrates a sense of order and precision in the geometric regularity of both natural and man-made surroundings. These fleeting impressions thus both contrast with and prefigure the subsequent explorations of the villa, in which choreographed movements and framing create complex geometrical compositions. The carefully traced path of the camera as it slowly and meticulously records the structural details of the building counterbalances the quickly paced and improvised nature of the preceding section. Man Ray thus seems to offset the creative effects of chance with those of a more ordered approach, a process that forges a strong link with both *Le Retour à la raison* and *Emak Bakia*.

It is clear then that the role of chance in the film goes beyond straightforward references to Mallarmé's poem in the intertitles and the presence of dice, and develops a number of strategies to render chance both complex and questionable. However, although this is perhaps the most obvious link between the poem and the film, it is certainly not the only perspective from which to understand the relationship between them. Man Ray may have been greatly influenced by Mallarmé's conception of chance and his interest in contradiction and duality, factors that are reflected in the structure of *Les Mystères*, but a comparison of the two works takes us much deeper into the fabric of Man Ray's film and enables us to understand it as one of his most complex interdisciplinary works. It is therefore in the analysis of the way the film reflects certain formal tendencies of the poem that the intricate weaving of artistic influences can be found.

Rhythm and movement

The most obvious correspondence between *Les Mystères* and *Un coup de dés* is on the level of structure. It has already been noted that the film can be divided into four main sections, which provide it with clear stages of progression. The same can be said of *Un coup de dés*, which revolves around the four segments of the title, presented in the poem in large capital letters of the same size and font: UN COUP DE DÉS / JAMAIS / N'ABOLIRA

/ LE HASARD. Indeed, one of the key features of the poem is the way it expresses rhythm and movement through the formal presentation of the text. As Virginia A. La Charité has noted, 'when upper-case and lower-case letters are mixed, the effect on the reader is one of contrastive movement: the lowercase letters tend to reflect stability, while the upper-case ones indicate dynamism or instability.'[48] On some pages the text flows smoothly downwards in a diagonal movement from one corner of the page to another, whereas on others there is a jagged left-to-right movement. The use of italics enhances the sensation of rhythm by creating an impression of lightness and speed.[49] These qualities are demonstrated most effectively on pages 16 and 17 of the poem. The minimalist content of the left page and the sweeping downward movement that it traces from right to left and then right again contrasts with the abundance of information and lack of direction found in the right page, thus demonstrating a concern with pace and rhythm. Here the eye of the reader is given the most freedom since there are very few organisational cues, except for the 'LE HASARD' in large uppercase letters. This phrase functions as the focus point and the eye moves directly to it by virtue of its dominating presence on the page. Around it, various words and groupings of words of different sizes and typeface produce an overriding sense of chaos and fragmentation that thwarts any attempt at straightforward comprehension. The staccato rhythms of the top half of the page, in which the thick grouping of the text is dominated by the repetitive punctuation (again split into four sections), 'EXISTÂT-IL', 'COMMENÇÂT-IL ET CESSÂT-IL', 'SE CHIFFRÂT-IL' and 'ILLUMINÂT-IL', contrasts with the lower half, which expresses a more free-flowing movement. The latter effect of rhythmic continuity and weightlessness as opposed to the earlier heavy pulsations is symbolically reflected in the words themselves: 'Choit / la plume / rythmique suspens du sinistre.'[50]

This dynamism and changing rhythm of *Un coup de dés* is to a large extent reflected in the tempo of *Les Mystères*, demonstrated most effectively during the travel sequence. The piece of music that was chosen by Man Ray to accompany this section of the film – 'Samba Tembo' by Thurston Knudson – serves to highlight its rhythmic qualities by providing a corresponding beat.[51] The continuous rhythm of the music reminds one of

the repetitive sounds made by a moving train, foregrounding the themes of movement and energy that are central qualities of the poem, whilst making a subtle reference to the train journey in *L'Etoile de mer*. The sequence consists of a series of short self-contained views of the surrounding landscape, with each shot providing a new development and thrusting the film forward in a way that mirrors the speed and progression of the actual journey. During these moments, the feeling of being effortlessly carried forward by an invisible force (the car itself is almost completely absent from the image during the journey) is comparable to the kinetic qualities of *Un coup de dés*. Furthermore, this feeling of movement and speed, which corresponds with the italics of the poem, is abruptly punctuated by the solid forms and oppressive presence of the sculpture that signals the end of the journey. Shot in a series of close-ups, the sculpture can be seen as echoing the larger typeface of the poem; and just as this section of the text is characterised by repetition, a quality that further breaks with the earlier lighter rhythms, so too do the successive shots of the slowly rotating statue in the film contrast with the rapid kinetic sensations of the previous sequence. This sequence of the journey in *Les Mystères*, which functions as the first main focal point of the film, can be seen to demonstrate the impression of chaos and fragmentation that characterises the overall structure of the poem. Each shot represents a different view, often with a changed camera position, and there is often little thematic consistency from one flash of imagery to the next. Any connection that could be made exists on the level of form, in much the same way as the poem itself.

Another formal aspect of the Mallarmé text, highlighted by La Charité, relates to the poet's stay in Brittany in 1873. La Charité argues that this extends beyond the nautical references to incorporate actual physical similarities: 'Resembling the serrated, jagged appearance of the coastline of Brittany, the layout of *Un Coup de dés* is one of displacement, loss of equilibrium, abrupt obstacles and an uneven rising and falling motion.'[52] A similar process can be evidenced in the visual representation of the villa in *Les Mystères* and the continual juxtaposition of vertical, horizontal and diagonal camera movements, giving rise to a sense of fragmentation and disorientation. The arrival in the film of the two travellers at the villa is signalled by a series of camera movements that alternate between vertical

and horizontal, reflecting the regularity of the architectural structures of the building and the way they contrast with the irregularity of its natural surroundings. The camera first follows a jagged wall that traces a climbing diagonal trajectory until it reaches the straight vertical lines of a castle tower, where it whips horizontally past a row of trees. Another brief vertical movement is made towards the sky, which is followed by a horizontal pan along another wall – this time of the villa itself – ending on the vertically upright sculpture discussed earlier. In a series of individual shots, the formal intricacies of the sculpture are explored, first from a distance and then gradually moving closer to the object. The subsequent sequence describes the exterior grounds of the villa, beginning with a panning shot lasting over fifty seconds. The slow horizontal movement recalls a similar pan of the sea in *Emak Bakia*, in which the camera traces the line made by the waves on the sand, bringing us back to the nautical theme of *Un coup de dés*. Just as the formal layout of Mallarmé's poem can be seen to have its roots in physical reality, Man Ray's use of the camera likewise follows the formal peculiarities of the villa.

Further observations can be made in relation to the correspondences between literary practices and the art of filmmaking. Susan McCabe has recently explored the relationship between modernist poetry and film, arguing that there is a similarity between the poetry of Gertrude Stein and the kind of visual expression found in *Emak Bakia*.[53] The main thrust of her argument centres on the notion that Stein's use of fragmentation and the juxtaposition of words can be seen as synonymous with the loose structure and the questioning of objective reality found in Man Ray's film. The correspondences that can be found between the formal concerns of *Un coup de dés* and those of *Les Mystères* demonstrate a reverse process, which sees Man Ray mirroring, cinematically, Mallarmé's unique and revolutionary poetic style. It could be argued, however, that the kinetic (and therefore cinematic) qualities of the poem lend themselves easily to such a comparison. Yet the overriding sense of fragmentation that characterises the poem is a continually recurring aspect of the film. Although *Les Mystères* was commissioned partly as an architectural document, very few sections aim to create an overall, objective view of the villa and focus instead on individual parts that stand for the whole.[54] Jean-Michel Bouhours has

referred to the exploration of the castle from the perspective of a 'caméra objective',[55] which would suggest an element of detachment, yet there are many subjective or self-reflexive instances that seem to throw such a view into question. Once inside the building, the camera movements become gradually less objective and on a number of occasions rapid pans suggest the spontaneous movements of the human eye. The theme of searching becomes gradually more pronounced and thus effaces any objectivity that may have been present in the preceding exterior sequence. Also important here is the increasing use of intertitles, which simultaneously signals a departure from traditional documentary approaches and suggests a further link with poetic forms of expression.

Word and image

As stated earlier in this chapter, *Les Mystères*, like Man Ray's previous film *L'Etoile de mer*, interweaves both the visual and the literary in a way that goes beyond the conventional use of text as mere accompaniment to the images. However, unlike the earlier work, which was based largely on Desnos' poem/scenario, with the images interpreting the text, *Les Mystères* represents a different relationship whereby the visual subject – the villa – gives rise to poetic associations. This is visible in Man Ray's initial conception of the film and his description, quoted above, of how the Cubist architecture brought to mind Mallarmé's poem. Initially descriptive, the text informs the viewer of the journey and the simultaneous presence of past and present, which the castle, their destination, embodies. This emphasis is crucial in establishing the duality on which later textual inserts will centre. The castle is not the only example of duality, and Man Ray seems to use the idea of one thing and its opposite as a structuring principle in the sequences that follow.

One curious aspect of the textual inserts in *Les Mystères* is the combination of humorous and serious tones that at times threatens the unity of the film and goes some way to explaining the relative lack of critical attention it has received. As Chapter 3 outlines, Man Ray was famous for his interest in word play and the 'direct and unsubtle'[56] punning of works

such as *Main Ray* and *Ballet français*. In one section of the film, the effect of sunlight reflected off the swimming pool and onto the surrounding walls gives birth to the word 'piscinéma'. This play on words emphasises the mise-en-abyme structure of a projection-within-a-projection, thus allowing a delicate interchange of the visual and the literary. Man Ray's works often demonstrate a humorous discrepancy between the image and its title, as seen in the tube containing ball-bearings and the photograph of an emptied ashtray, both of which were called *New York* (1917 and 1920 respectively). In *Les Mystères*, Man Ray uses textual inserts to communicate with his audience, self-consciously subverting their expectations. For instance, during the moment at which Noailles' vast collection of paintings is to be presented to the viewer, an intertitle promises to provide an insight into 'Les secrets de la peinture'. The images that follow, however, reveal this statement to be not a subtle (and conventional) rumination on the wonder and mystery of the sacred art itself, but a direct and provocative reference to what we don't see. When Man Ray shows us the backs of the paintings, what was initially a metaphorical notion of 'secret' becomes a very literal one. Presence, from this perspective, is formulated through absence. Other textual inserts, although relating to the theme of bringing life to inanimate phenomena, a theme I shall turn to later in this discussion, similarly function to subvert viewer expectations and to undermine the purely descriptive function of text in relation to images. 'L'intrus' turns out to be nothing more than a sink cover and the declaration of 'personne' is followed by two (albeit lifeless) faces staring back at the camera. Like the titles of many of Man Ray's works, the text injects an element of irony into the images and alters the way they are perceived. Meaning can thus be said to arise from what Pincus-Witten describes as the 'overlay' between image and language.[57]

As the film progresses, however, the intertitles begin to express wider concerns that mark a return to the past/present theme of the opening text. If earlier sequences aim to create a sense of mystery through subtle references to 'l'inconnu' and 'un étrange destin', the first sign of human presence in 'un coin oublié' signals a concentration on the ghostly, a recurring theme in Man Ray's films. The four characters play with a pair of dice then stand up, drop their robes and run out of the frame, the camera lingering on the

abandoned dice and clothing. An intertitle asks, 'Existe-t-il des fantômes d'action? ... des fantômes de nos actions passées? Les minutes vécues ne laissent-elles pas des traces concrètes dans l'air et sur la terre?' Man Ray clearly seems to have been inspired by the castle's overlapping of epochs and the ability of architecture to evoke and embody absence. This idea is reflected in two later intertitles:

> Passe il faut que tu suives
> Cette belle ombre que tu veux
>
> O Sommeil, O Soleil, ma vie sera,
> Soumise à tes lois
> Et je fermerai les yeux
> Quand tu disparaitras
>
> [Pass on – you must follow
> That beautiful shadow that you want]
>
> [O Sleep, O Sun, my life shall be,
> Subject to your laws
> And I will close my eyes
> When you disappear]

Although 'belle ombre' can be seen as a reference to the play of light and shadow that follows this text, there is also an evocation of the ephemeral, the passing of time and the intermingling of past and present. The setting of the sun, and the sleep that follows it, functions as a metaphor for death and the transience of human existence. In this context, the 'il faut' of the text highlights the inevitability of death, whilst the word 'passe' literally signifies the passage to another world, symbolically evoked in the image of the shadow – the opposite of light.

The continual reference to statues and gods and goddesses incorporates a fantasy of immortality into the film that is visualised in the final moments where two travellers arrive at the villa and decide whether or not to give themselves over to its timeless grasp. There is a dark and ambiguous

subtext to this sequence that associates immortality with suicide, a theme that obsessed Man Ray[58] and which can be seen in the photographic *Self Portrait* of 1932, where the artist portrays himself in an absurd multiple suicide scenario involving pills, alcohol, a rope around his neck and a gun to his temple. The subject of suicide was present in Man Ray's work as early as 1917, in an aerograph painting bearing the same title, and continues through the photographic works also entitled *Suicide* from 1926 and 1930.[59]

In *Les Mystères*, the travellers can only achieve immortality by transforming themselves into statues, forever remaining part of the place that enchants them; they must give up their living bodies in what is presented as a kind of self-sacrificial ceremony. The film's last intertitle '... QUI RES-TERENT', therefore expresses a sense of finality that goes beyond its surface meaning as a relatively banal 'shall-we-stay-or-shall-we-go' decision described by Barbara Rose. The capital letters add further significance to the text, giving it the dynamic impact of Mallarmé's typography in *Un Coup de dés*.

Spatial relations

The concentration on space in *Les Mystères* effectuates an overlapping relationship between film, poetry and architecture, posing questions about how ideas related to space are formulated and interpreted through different forms of expression. It is within the realms of spatial exploration that *Un Coup de dés* and *Les Mystères* can be understood as expressing similar concerns, even if these concerns are related specifically to the media in which they are created. If Man Ray's film demonstrates an interest in cinematic space, Mallarmé's poem focuses attention on textual space and visual layout. *Un Coup de dés* is characterised largely by the arrangement of text on the page and the way different word groupings dictate the freely moving gaze of the reader. This is not restricted to an awareness of the page itself as an overall physical spatial entity, but is also broken down to include the smaller units of space between the words and groupings of words. When

the poem was first published in the magazine *Cosmopolis* in 1897, Mallarmé wrote a preface, in which he attempted to orientate the reader, stating, 'Les "blancs" en effet, assument l'importance, frappent d'abord.'[60] His comment is therefore an instruction to the public to 'read' the spaces as an integral part of the text. La Charité has argued that space in fact constitutes the poem's fundamental driving force:

> Because space is the primary element of the text, it is by, in, with, and through space that the reader must pursue relationships and seek to establish points of contact which confer meaning upon the units of the text. Space is the authorial controlling factor which directs the reader and orders the accumulation of data which may be read and interpreted [...] To read *Un Coup de dés* demands a reading of the space which supplies its order and confers on the text its ultimate form.[61]

Charité's account is invaluable in highlighting a strong formal characteristic of the poem that in many ways relates to Man Ray's own visual concerns in both photography and film. Mallarmé's notion of space assuming a key role in the act of reading can be understood in terms of Man Ray's assertion, discussed in Chapter 2, that the shadow cast by a person or object is as important as its physical referent. The shadow is fundamentally a projection *into* space and involves an awareness of one thing in relation to its opposite. So, if Mallarmé seems to argue that the configurations into which words can be arranged are as infinite as the space that surrounds them, so too does Man Ray develop a similar hypothesis in relation to objects and the physical space they inhabit. The infinite number of visual configurations provided by the raw material of external reality certainly seems to be a key feature of *Emak Bakia*. But precisely how can Mallarmé's concentration on space be related to the content of *Les Mystères* and the use of architecture as its subject matter?

Space and the cinema

In order to understand Man Ray's interest in space as a creative element it is useful first of all to consider the different perspectives from which space can be perceived and conceptualised. Fundamentally ambiguous and

virtually impossible to grasp theoretically, space evades straightforward categorisation. However, I would like to hinge this discussion on the definition provided by La Charité in relation to Mallarmé's poem. 'Space', she states, 'is the abstract which cannot be explained, the pure which cannot be experienced, the authentic which cannot be derived: it is formless, not enclosed [...] sterile, unlimited, original and complete within itself [...] Space has no direction; it is anti-linear and open or free.'[62] The combination of so many unknowns provides the perfect context for an artist such as Man Ray, whose work constantly leans towards ambiguity, mystery and the elusive. The contradictory nature of space (it forms the basis of concrete reality, yet it is, at the same time, a purely abstract phenomenon) is one of the central concerns of Man Ray's art. As highlighted in earlier chapters, his photographic work was carried out principally in a studio setting, allowing him to create striking visual effects through the manipulation of light. Yet, such a manipulation of light also assumes a transformation of space since light can only be perceived *through* space. Within the realms of the cinema, *Emak Bakia* already demonstrates to a large extent his growing interest in the creation of an undefined space. In the distortions he created through light and movement, the object not only occupies the space but morphs into it, taking on its formless and infinite features. Form and ground can no longer be distinguished as separate entities and instead become one single phenomenon.

The abstract nature of space is illustrated in the opening shot of car headlights in *Les Mystères*, featuring white lights against a black background and the gradual expansion of what initially appear as two circular forms to describe depth and distance. Drawing on earlier experiments with the filming of artificial lights at night, this introductory shot perfectly illustrates the representational/non-representational dichotomy through the exploration of screen space. Seen as simple white forms slowly growing in size, the shot highlights the flatness and surface of the screen by privileging what appears to be a two-dimensional image. We are reminded of the circular forms of *Le Retour à la raison* and *Emak Bakia*, in the sequences of rayographs, but also in sections of the latter film, where artificial light, mirrors, crystals and the rotational movement of the turntable are used to create circular and oblong forms that seem to float in the dark. As the

car reaches its closest point to the camera, the representational properties become more clearly evident, switching attention from the dimensions of the flat screen to an awareness of depth and space within the frame.

A similar process can be detected in other sections of the film, which demonstrate the way depth and perspective give rise to abstract geometric compositions. On a number of occasions during the travelling sequence, for example, the camera points straight ahead towards the space that the car traverses. In one shot, whilst the car drives along a country lane, the receding vertical line of the road stretching out in front of the viewer gives rise to a triangular form reaching from the bottom to the middle of the frame. The composition is mirrored in the top half of the shot, with the road and sky creating tonal inversion, again reminiscent of the formal relationships found in *Le Retour à la raison*. The shot of the bridge provides a more complex example of these geometric arrangements, bringing into play the additional effects of shadow. A number of visual elements can be seen at work here that will become greater concerns later on in the film. The first of these is the very clear emphasis on line, and the juxtaposition between the horizontal and the vertical, elements that also feature strongly in the typographical layout of Mallarmé's poem. The other is the framing of space as a way of overcoming its abstract and elusive qualities and giving it tangible presence. This not only facilitates the visual perception of a discrete unit of space, but also allows it to be entered or passed through. The arches of the bridge through which the car drives anticipate the arched passages of the villa and the repeated square forms cut out of the wall that surrounds it. *Les Mystères* can thus be seen in terms of an attempt to comprehend space through the creation of geometric compositions and framings.

Architectural space

Les Mystères represents a fusion of architectural and cinematic space, with Man Ray interacting with Mallet-Stevens' design of the villa in order to capture the abstraction contained within it. In Moussinac's statement quoted earlier, 'mathematic relations between the images' are associated with a form of cinematic architecture. This seemingly unconscious connection between

the main concerns of *Les Mystères* – that is, formal patterns derived from the architecture of the villa – provides us with a starting point from which to understand the visual shape of the film. Both film and architecture are defined through their relationship to space, the framing of the camera lens reflecting the framing created by walls, windows and doors. Karl Sierek, in a discussion of architecture and film, highlights the very specific nature of space in the cinema, stating

> The cinematic space is anything but closed. With openings here and there it is inter-sected by vectors; it points outwards instead. Every cut, every movement of the camera questions that notion of completeness, wholeness and unity, which we would also like to attribute to our own bodies. They reveal what was previously invisible, but only for an instant, followed closely by the next act in this game between inside and outside, presence and absence.[63]

The dichotomous relationships to which Sierek refers are crucial to Man Ray's film in relation to its architectural content, specifically in the interplay between internal and external spaces. Through the nature of the filming and the organisation of sequences, particular attention is given to the way in which the modernist architecture of Mallet-Stevens brings about a conflation of internal and external space. Shortly after the arrival of the travellers at the villa, the camera embarks on an exploration of the garden and grounds that surround the main building. An initial 180° pan allows both the villa and the landscape in the distance to occupy the shot, whilst describing a number of oppositions: vertical/horizontal, light/shadow, nature/civilisation. Of crucial importance, however, is the way this shot both begins and ends on the framing of space. The walls that surround the villa are constructed as a series of windows that look out on the surrounding area (see figure 18), and the camera is positioned precisely on the inside (which is in fact outside) looking out into the distant landscape. External space therefore gives rise to a sense of internal space, a feature to which the uninterrupted camera movement draws attention. Man Ray's film does indeed play a 'game between inside and outside' that is both architectural and cinematic.

In order to further draw attention to the way the villa evokes a dialogue between internal and external space, Man Ray executes a smooth

transition from the grounds outside to the rooms inside. Shooting from behind a window, the camera focuses on a suspended sculpture in the form of a star, slowly moving upwards to bring the object into the frame. Aside from this practical function (facilitating the movement from outside to inside and conjoining the two spatial entities in a single shot), the star also acts as an intertextual motif, referring to the suspended objects of *Le Retour* and the central metaphor in *L'Étoile de mer*. The viewer is given a linguistic clue to this connection in the inter-title 'Etoile de jour'. The use of the star in bringing together interior and exterior space highlights the function of the window as facilitating a crossover between the two domains. The star is important in this relationship since it is something that is seen *through* the window, demanding that the space be traversed, therefore rendering it physical. In the same way as Mallarmé's 'blancs', space in Man Ray's film becomes something to be perceived, negotiated and understood not simply as that which exists between things, but as an element in its own right. The backwards movement of the camera in this shot also contributes to an awareness of depth by creating layers of visual information, the space of the room, the space outside the window and that which exists in between it, that is, the window itself.

The next image is an expansion of this idea, again creating a juxtaposition of internal and external space and further emphasising the importance of the frame. The shot begins on a vertical upwards movement of the camera, revealing another window from the inside with the exterior grounds of the villa clearly visible through it. The horizontal and vertical divisions of the window, creating a very simple geometric composition, dominate the foreground. To this arrangement are added the horizontal lines of the shutters just visible to the centre-right of the frame. In the middle ground can be seen the horizontal lines of steps leading up to a sculpture. The upward movement of the steps leads our attention to the vertical line of the sculpture, creating a sense of formal harmony. As the camera moves upwards along the window, the individual rectangular planes provide a frame for the sculpture, which slides from one adjacent space to another. The composition is now one of a frame-within-a-frame-within-a-frame! As the camera reaches the top of the window the glass in the final pane slightly distorts the image and provides a faint echo of the

distortions of objects and light reflections found in *Emak Bakia*, which were themselves created with glass prisms and mirrors. This allusion is not without significance since, as I have noted in the previous chapter, glass appears in different forms throughout Man Ray's films and weaves a clear line between them. Although there is clearly an attraction to glass as a substance with immense aesthetic possibilities, windows and doors also appear to a large extent in *L'Etoile de mer* and *Les Mystères* as framing devices. Interestingly, this also draws attention to the act of looking, which plays an important role in the way the images are presented from the perspective of the two travellers.

Camera mobility continues into the next section, only here the sense of suspension that characterises the previous two shots is replaced by the impression of forward movement, mirroring the car journey at the beginning of the film. The camera, placed at ground level and mounted on a trolley of some sort, fluidly moves through a section of the villa, inviting an awareness of space by physically traversing it. Man Ray uses the walls on either side to create a frame-within-a-frame structure and to emphasise depth. The viewer is again presented with a sense of abstraction, and it is only in coming closer to the objects and in their shift from the background to the foreground of the frame that we are able to identify them as the lower section of a table and chairs. Thus the actual movement through space is also a metaphor for the transition from abstraction to figuration created by it. Through camera positioning and the arrangement of the furniture, our attention is drawn to the abstract geometric qualities of the shot, which simultaneously express receding depth and three-dimensionality and the basic patterns of lines on a flat plane. The household furniture is reabsorbed by its abstract qualities and attention is focused away from its utilitarian function towards formal composition and the structuring of space. This dual approach to cinematic space and the simultaneous presence of abstraction and figuration within the same image mirrors the opening shot of car headlights.

One of the most interesting moments of the film in relation to this theme of spatial perception and framing occurs at the end of the above sequence. It is signalled by an intertitle, 'Les secrets de la peinture', which, as I have already mentioned, plays with audience expectations and humorously

comments on the hidden content of the canvases of which only the backs are shown. The shot begins with an image of a metal rack that fills the screen and divides it into tiny squares. Behind this can be seen the back of a painting, the wooden frame providing further divisions. The rack moves to the right revealing a similar image behind it, this time with a different arrangement of picture frames of various sizes. The action is repeated twelve times, each movement giving rise to the perception of space behind it, until the back of the room is finally revealed. It is here that the formal intricacies of the shot become evident, establishing compositional concerns that are increasingly more pronounced in later sections of the film. The handles of the racks are visible to the right of the frame and recede from the foreground to the background, clearly emphasising the spatial depth of the shot. A mirror at the back of the room further contributes to this process by incorporating the space that exists behind the camera itself, rendering, in Sierek's words, the invisible visible. The mirror is positioned so that a line where the wall meets the floor divides it in two. The horizontal is again juxtaposed with the vertical in a complex geometrical rendering of screen space.

A number of other observations can be made about this particular shot. First of all it clearly represents Man Ray's interest in repetition and echoes other repetitive actions in the film such as the slow dissolves in the opening sequence and the rolling of dice by each set of characters. As I will discuss below, this concentration on repetition contributes to a sense of visual rhythm that characterises *Les Mystères* and forges an important link with *Emak Bakia*, in which repetition also plays a key role. Another point relates to a more direct relationship with *Un Coup de dés*. A number of critics have highlighted the focus on 'le nombre' in Mallarmé's poem, some even arguing that it displays an underlying mathematical structure. Roger Pearson, for example, has observed that, 'it becomes impossible not to acknowledge, in this poem about a hypothetical throw of at least two dice, that the "profond calcul" governing the text is based on the number twelve.'[64] The total number of racks in this sequence is also twelve, attesting either to pure coincidence or to the presence in *Les Mystères* of more correspondences with Mallarmé than have been previously acknowledged. My attempts in previous chapters to underline strong formal patterns and structures in Man Ray's films should provide a context into which the latter

opinion can be easily assimilated. The strong sense of geometrical composition in many of the shots – much more than in any of the films – gives further credence to the possibility that Mallarmé's mathematical structuring principle influenced both the form and content of *Les Mystères*.[65]

After this documentary-like introduction, the focus of the film changes slightly to involve the activities of the guests. However, rather than moving into narrative terrain as one would expect from such a switch of emphasis, the following sequences attempt to incorporate the body into the exploration of space established up to this point. The film thus turns into a kind of choreographed performance in which bodily movements interact with the surrounding space by reacting and drawing attention to its physical attributes. Crucially, this goes beyond the simple everyday notion of bodies 'occupying' a particular space, with the surroundings acting as a backdrop, and moves towards an examination of the way the human body can enter into a dialogue with that space. The activities that follow are thus to a large extent insignificant beyond the formal relationships they develop and the manner in which they contribute to the perception of space.

Space and the body

Recent comparisons of Mallarmé's poem with certain modernist and avant-garde forms of art have opened up the spectrum of references and have allowed its revolutionary qualities to be understood from a variety of new perspectives. In particular, the examination made by Dee Reynolds of Mallarmé's influence on the choreographer Merce Cunningham represents one of the most interesting developments in this field. Reynolds highlights the kinetic qualities of Mallarmé's writing, already referred to in the previous section, in order to establish the relationship between poetry and dance. The reference to choreography is vital to the present discussion since *Les Mystères*, by virtue of its relationship with the poem, can be seen as making one of the earliest connections between *Un coup de dés* and the art of dance. The choreographed movements of the actors in the film are brought into play with the modernist architecture of the villa, which itself functions as a stage, both dictating and complementing the synchronised actions of

the bodies. The movements carried out by the main characters in the film are virtually devoid of narrative significance and contribute principally to a stylised representation of the way in which the body occupies a modernist space. From this perspective, *Les Mystères* appears to approach the concerns explored through modern dance, where particular movements are understood specifically in the context of the relationship between the human body and its surroundings. The connection between the body and the modernist architectural space is further reflected in the use of intertitles and their emphasis on the mortal/immortal theme inherent in the body/environment dichotomy.

One of the most the most significant observations to be made about Man Ray's treatment of the body is precisely the way it points towards a collective or universal, rather than individual, form of expression. Virtually every aspect of the representation of people in the film emphasizes the process of depersonalisation. First of all, an overriding sense of anonymity characterises the film through the actors' stocking-covered faces, making it difficult to distinguish one from the other. This unusual choice, made apparently to quell the insecurities of the guests about appearing in front of the camera, conveniently shifts attention from the face to the body and from a sense of the individual to that of the mass. Indeed, the actions carried out by the 'inhabitants' of the castle are choreographed and synchronised in such a way that their presence becomes increasingly defined by a sense of uniformity. This is emphasised by the fact that they wear identical clothing in every section of the film. Whilst in conventional narrative cinema the clothes of a character correspond in varying extents to his or her psychological traits, the costume in *Les Mystères* contributes exclusively to the emphasis on formal, geometric relationships, preventing any kind of spectator identification on a psychological level. Instead, the horizontal stripes on the t-shirts worn by Noailles and his guests both reflect, and are brought into play with, the geometric structures of the villa. The actors thus become part of the architecture, facilitating a delicate interchange of animate and inanimate qualities, as well as creating complex visual compositions.

In one shot that takes place in the gymnasium, the viewer is presented with a laddered wall. The four characters run into the frame from behind

the camera and arrange themselves in various positions on the ladder. The effect is that the patterns of the characters' t-shirts correspond exactly with the lines of the ladder structure. Our attention is clearly directed to this formal arrangement, and the movements of the characters are significant only in the way they contribute to the bringing together of the human form with the characteristics of the building. In a similar sequence, another empty shot of a shadow-covered floor is gradually filled as the characters roll into frame, one against the other, their positions alternating in a head to toe arrangement. Once all four characters are in place, a geometric harmony is revealed through the symmetry of the black and white alternations created by their clothes. Both this and the previously mentioned shot end with the sudden disappearance of the bodies, leaving the original geometrically defined 'empty' space. The body is characterised by a constant state of flux and impermanence compared with the stability and longevity of its surroundings. Later in the film these qualities are reversed when the body takes on the inanimate characteristics of a statue. The first illustration of this occurs during the sequence of activities on the terrace, the point at which the movements become more and more choreographed and the focus more formally determined. A panning shot shows the four characters standing on stools against the outer wall of the swimming pool. Their alignment in relation to the building and the identical pose adopted by each – arms thrust above the head – makes them instantly appear de-humanised and transformed into the surrounding décor. The second example appears at the very end of the film when the second of travellers find themselves within the grounds of the villa and decide (with the help of the dice) to stay, their decision symbolised in the literal freezing of their movement. The inversion of the image into negative strengthens the effect by making their bodies appear white in resemblance to the statue next to which they are placed. This transference of formal qualities is a strong feature of *Le Retour à la raison*, the film to which the positive-negative inversion subtly refers.

The main section of this gymnastic part of the film takes place in the swimming pool. Natural light pours in from the large windows situated along the side of the pool, creating a bright, open space. For the majority of the sequence, the shooting is carried out from a high-angle position looking down onto the water. This creates the best perspective of the building

and allows movements to be captured in a general manner that does not distract attention away from the spatial context. At the top of the frame is a mirror, which, in the same way as the earlier 'secrets de la peinture' shot, creates another dimension of screen space that is not within the camera's field of vision. As the guests swim, dive and climb up ropes suspended above the pool, the camera executes a series of corresponding vertical and horizontal movements, constantly allying their activities with the space in which it is carried out. At times, certain elements seem to occupy the shot for reasons of compositional tension – the mirror for instance, and a swing made out of rope that moves in and out of the frame. One of the women (Marie-Laure de Noailles) performs a series of underwater tricks, juggling, brushing hair, skipping and weightlifting. Beyond their role as mere personal performances, designed to amuse and entertain the private audience to which the film would be shown, these individual actions play with spatial expectations since the novelty arises precisely from the reversal of normal relations. The sea-sky reversal of *Emak Bakia* is once again evoked and a context is created for the increasing use of camera rotations. These suggestions of underwater space, signalled by the intertitle 'Eve sous-marine', draw attention to Man Ray's interest in this cinematically inaccessible realm. Again in *Emak Bakia*, an attempt at simulating underwater filming can be seen in the multiple exposures of swimming goldfish shot in close-up so that the water fills the screen and creates a sense of expansive space. In *Les Mystères*, the reflections of water on the walls surrounding the swimming pool can be read from a similar perspective, creating both an eerie sense of *dépaysement* and a site of formal 'attraction'.

The aquatic section is followed by a number of sequences in which the guests become more actively involved with the architectural structures of the villa, creating further more intricate geometrical relations. At one point, a static shot shows them emerging out of the water and walking along the edge of the pool. The camera is positioned directly in front of them on the poolside so that they walk from background to foreground, the path receding to the back wall. As with previous shots, Man Ray positions the camera in order to most effectively create a sense of depth and spatial awareness, the large windows on the right-hand side providing the vertical reference points. Everything in the frame seems to highlight the

juxtaposition of vertical, horizontal and diagonal lines and geometrically aligned shapes. The windows, poolside and the radiator in the background all stress vertical harmony, whilst the sunlight that streams into the room creates a diagonal tension, simultaneously drawing the eye to the various square forms in the other half of the frame. The bodies disappear one-by-one past the camera and out of the shot, once again leaving behind an overriding sense of absence and the gradual passing of time.

During a later sequence, the group sit cross-legged in the gymnasium. They are positioned in such a way that they are facing each other, with the two figures furthest away from the camera being 'framed' on either side by the other two. In the background, the wooden climbing frame is visible and again provides the very definite geometric lines with which the rest of the shot comes into play. A gauze or mesh is placed over the camera lens and creates contrasting vertical lines in the foreground. Kinetic elements are added to the formal composition when the group begin to throw a ball to each other, an action which has the dual effect of both establishing a horizontal line and indicating depth in the centre. Throughout the duration of this shot, the mesh moves from side to side, constantly bringing the eye to the surface of the screen. This shot is perhaps the most complex of the film, and it is the one that involves the most spatial and geometric relations. In order to go beyond simply describing space through the mimetic qualities of the cinema, Man Ray creates layers of geometrically defined images in order to render perception more complex, dividing the space into different planes that interact with each other to create both harmony and contrast. The eye is forced to move back and forth between the three points of interest: the wooden frame in the background, the mesh in the foreground and the action that takes place in the middle ground.

This is taken further in the next shot, which rearranges the elements to make the relationship even more disorientating. The position of the camera is altered so that the outer windows of the swimming pool are visible to the left of the frame. This allows a juxtaposition of both interior and exterior and increases the amount of visual detail within the shot. The camera itself is also tilted slightly to the right so that our perspective on the scene is somewhat confused; what were previously horizontal and vertical lines now become diagonals, clashing with the clean and straight angles of the

frame. An extra person is added to the group, and the arrangement of their bodies creates an even more complex formal composition. Two figures in the foreground take up acrobatic stances arching their bodies backwards with feet and hands on the ground. Behind them, the remaining three rotate a giant ball in the air above them (see figure 19). This shot, with its stylised bodily movements and choreographed actions, is perhaps the most demonstrative of the film's relationship to modern dance. Although the poses taken up by the Noailles and their guests were likely to have been suggested by them and not Man Ray, what interests us is the way these bodily positions are incorporated into the cinematography and the overall formal composition of the film.

(In) animate transformations

The integration of the human form into Man Ray's explorations of space and composition draws attention to one of the central themes of his work: the exchange of qualities between animate and inanimate phenomena. This is explored to a great extent throughout his films, where he frequently capitalises on the possibilities of the medium to reverse the laws of everyday reality, whilst maintaining the semblance of mimesis through photographic realism. *Emak Bakia* outwardly exploits this quality by employing a range of techniques such as animation, montage editing and double exposure, whilst *L'Etoile de mer* more subtly explores cinema's potential for the development of syntagmatic associations between animate and inanimate objects. *Les Mystères*, as the previous section demonstrates, takes these investigations further by bringing the body into a more complex relationship with its surroundings, giving rise to a mysterious interchange where the body is depersonalised and inanimate phenomena take on expressive qualities. This interchange can be related to a self-reflexive awareness of the mechanical basis of the cinema and its ability to rearrange our perception of reality, once again bringing us back to the concerns of Man Ray's earlier films.

Les Mystères, like *Le Retour à la raison* and *Emak Bakia*, exploits the human form for its plastic expressivity. It is from this perspective that the film effectively demonstrates the extent of Man Ray's disinterest in the dramatic possibilities of film since, although there is the vague suggestion of a narrative, the characters are never really explored within this vein, their psychological drives being reduced to simple, almost mechanical either/or decisions that they themselves do not make, but which are made for them by a throw of dice. The human condition is thus represented as a series of choices that give rise to particular situations. Despite the recurrence of this existentialist perspective, it is clearly not the focus of the film as Man Ray's interests are directed towards the purely cinematic representation of the body. The dive executed by Noailles that appears in reverse gives the impression of a highly mechanical movement that is imbued with a self-conscious reference to technique. A similar effect is repeated later in the film when one of the guests (possibly Noailles again) runs towards the camera and then, as the action reverses, appears to run backwards from where he came. This relationship between film as machine and body as machine can also be seen in the famous washerwoman sequence of *Ballet mécanique*, where the repetition of a single movement through editing creates an analogy with the previous sequences of machine parts in motion. The way the mechanical basis of cinema is self-consciously referred to in the film represents one of the major challenges to Surrealism's simulacrum of reality. By drawing attention to the *difference* between reality and its cinematic representation, Man Ray bypasses the Surrealist desire to use the illusionist nature of the cinema and its capacity for *dépaysement* to represent the workings of the unconscious mind and to produce psychological shocks in the spectator. These sections of *Les Mystères* rather lead to a re-questioning of the relationship between avant-garde cinema and early forms of pre-narrative or 'primitive' cinema, discussed earlier.[66]

The use of reverse motion in *Les Mystères* very closely resembles one of the earliest illustrations of the technique in Auguste and Louis Lumière's *Démolition d'un mur* (1895), in which a wall is knocked down and then subsequently rebuilds itself. This reference to the element of spectacle (and, of course, humour) of early cinema demonstrates a kind of homage to, and nostalgia for, a non-codified, non-illusionist form of filmmaking, where

a fascination with technique was still very dominant. Furthermore, the re-appropriation of these early concerns in the avant-garde cinema of the 1920s reveals a desire – found particularly within Dadaism – to overcome the fixed relationship between the body and its surroundings. The link between Dada-related cinema – the destruction of illusion and the drawing attention to the technical and thus artificial nature of the medium – and early pre-narrative cinema has been repeatedly highlighted and provides a useful perspective on the movement's conflation of positive and negative tendencies.[67] This relationship thus highlights the difficult positioning of *Les Mystères* – and indeed Man Ray's oeuvre more generally – between the discourses of Dada and Surrealism.

The depersonalised representation of the human body and its incorporation into the modernist architecture of the villa gives way, in other sections of the film, to a contrasting process in which objects are brought to life and our ordinary perception of the world is subtly altered, allowing the expression not necessarily of what *is*, but of what *could be*. The animation of inert objects is present from the very beginning of the film, in which wooden hands roll a pair of dice. The same hands appear at the end, functioning as a kind of framing device and a reiteration of one of the main themes of the film. The paradoxical nature of hands made of wood – fusing the animate with the inanimate – draws attention to the idea of contradiction and duality that runs throughout Man Ray's films. The themes of immobilisation and the transformation of humans into statues or sculptures, referred to above, contrast with the visual presentation of the Lipschitz's statue at the beginning of the film. Here the focus is that of making an inert object appear mobile, which, as I have stated earlier, relates directly to the title of the work itself (*J'aime le mouvement qui déplace les formes*) and the obvious reference to the creative possibilities of movement. The object is filmed in such a way as to give the impression that the sculpture is rotating in front of the camera, breathing life into an otherwise lifeless entity. In his description of the film, Man Ray refers to this interchange of qualities, evoking the same kind of impression as that of the 'epileptic dance' of the pins and the 'lone', 'desperate thumbtack' in *Le Retour*:[68] 'Inanimate objects, hoops, dumbbells and medicine balls have a little spree of their own rolling back and forth on the terrace.'[69] The

first signs of this bringing to life of inanimate objects are found in the exploration of the interiors of the castle. An intertitle, 'An intruder' has the effect not only of suggesting human presence, but also of highlighting a conventional narrative device: the disruption of normality that will give rise to a series of actions and create narrative flow. When the subsequent shot shows a cover rolling itself back to reveal a sink, the surprise that is created is a dual one: the viewer's narrative expectations are subverted, but the lack of human presence also underlines the animate characteristics of the sink. A similar process occurs moments later when the search becomes more pronounced. The third declaration of 'personne' is followed by a shot of a statue of two African figures staring back at the camera. This humorous moment of self-reflexivity echoes the shots of women's faces in *Emak Bakia*, in which the viewer's gaze is returned and the act of looking becomes a central issue in the destruction of cinematic illusion. That Man Ray overtly restricts the 'look' in other sections of the film by making the actors wear stockings over their faces makes this personification of the inanimate figures all the more significant.

The transformation and refiguration of the inherent properties of natural phenomena is a central characteristic of Man Ray's work and is particularly pronounced in his photography. The photographic medium, with its intrinsic insistence on reality and representation, is equipped with the very tools with which to convincingly reshape this reality and reorganise our vision of the world. As Rosalind Krauss has observed, one of the characteristics of Man Ray's photography is the de-familiarisation of the human body, 'redrafting the map of what we would have thought the most familiar of terrains.'[70] This process relates equally to the treatment of objects, particularly those that have the most banal or defined everyday functions. The personfication of inanimate phenomena can be found in the two previously discussed objects of 1918: *Man* and *Woman (Shadows)*. This is also seen in the rayographs with which Man Ray worked extensively during the 1920s and which very often feature mechanical objects and kitchen utensils, such as cogs, funnels, springs and cutlery. A comment by Sarane Alexandrian in relation to these images allows us to contextualise the animate/inanimate exchange in *Les Mystères*. He states, 'Les rayographies sont des *nus d'objets*,'[71] evoking an interchange of qualities, a kind of

anthropomorphising of objects that heavily occupies certain sections of the film. These observations establish a clear framework for understanding *Les Mystères* as a crucial element in Man Ray's artistic and cinematic oeuvre since the film seems to express many of his characteristic concerns despite the restraints of the commission. In light of the above observations, we can see it clearly within the context of Man Ray's comment that his films were, as much as anything, an attempt to put into motion the effects he created in photography.

Although *Les Mystères du Château du Dé* is often overlooked in the context of Man Ray's work, it offers a number of interesting perspectives from which to view his development as a filmmaker. One of the most important observations here is the way it reflects formal concerns characteristic of the earlier films, attesting to its crucial position *within*, and not, as some critics have approached it, on the margins of his cinematic oeuvre. Although the circumstances that surrounded the making of the film initially suggested that it would stand apart from the rest of Man Ray's films, it nonetheless found a certain success as an avant-garde work due to the spirit of innovation and experimentation with which it was approached. If, as Inez Hedges notes, *Les Mystères* returns to the concerns with abstraction that characterise Man Ray's first film *Le Retour à la raison*, it also reflects structural patterns found in *L'Etoile de mer*.[72] Both films make use of a prologue and epilogue that serve to 'frame' the content. In *L'Etoile* this is the opening and closing door and the reappearance of the characters in the same locale at the end as in the beginning. The framing in *Les Mystères* is provided by the image of the wooden hands and another mirrored action: whilst the characters at the beginning of the film decide to leave, those at the end decide to stay. This shared characteristic of the framing device is further emphasised by Man Ray's instructions for the musical accompaniment since both films begin and end with one piece of music – 'C'est lui' by Josephine Baker in *L'Etoile* and Erik Satie's 'Gymnopédie' in *Les Mystères*.[73] That *Le Retour* is often considered as his most improvised work, whilst *L'Etoile*, with its basis in the scenario written by Desnos, is clearly the one that displays the most pre-planning and organisation of scenes, demonstrates the extent to which *Les Mystères* brings together elements from different stages in his career.

The most important conclusions, however, emerge from an assessment of the way Man Ray weaves the expressive qualities of poetry and architecture into the fabric of the film. The inspiration drawn from Mallarmé leads to another example of the way the text works alongside the images to create a poetic interplay of ideas. As in *L'Etoile de mer*, the intertitles do not simply provide a commentary on the images, but rather take on their own expressive significance. Word and image thus interact to provide different levels of meaning. This chapter has also drawn attention to the film's concentration on space; Man Ray's exploration of the cinematic space and the way it impacts on, and is affected by, architectural space mirrors the exploration of space in Mallarmé's poem *Un coup de dés*. The similarity between the two works, I have argued, rests on the way both artists' attempt to build an awareness of space by focusing on the basic formal qualities of their media. The architectural subject of *Les Mystères* provides Man Ray with a solid formal basis from which to carry out his examination of actual space and its cinematic representation. The modernist backdrop also allows for the development of themes such as the relationship between body and its surroundings and the notion of an overlapping past and present. Although some of these themes can be related to the concerns of the Surrealists, this chapter has illustrated the way Man Ray's approach leans towards predominantly plastic, rather than psychological, explorations.

CHAPTER 5

Collaborations, experiments and home movies

> My reaction to the hectic Twenties began in 1929. My excursions into
> the film world had done me more harm than good. People were saying
> that I had given up photography for the movies, few sitters presented
> themselves for portraits. The magazines shunned me [...] It was time
> for a complete change in my life ... I sold my professional movie camera
> and my swank car which I had been a slave to for six years. These things
> no longer had the romantic appeal for me as in the beginning; they
> appeared just as prosaic to me as a sewing machine.[1]

This description of the period following the making of *Les Mystères du
Château du Dé* raises important issues about Man Ray's perception of
himself as an artist, where his filmmaking pursuits are perceived as being
detrimental to more serious professional activities, such as painting and
photography. Whereas Man Ray had, in the early days, embraced film
as a new form of artistic expression to be explored and conquered, this
enthusiasm seems to have waned significantly by the end of the 1920s. The
critical success of Buñuel and Dalí's Surrealist film *Un Chien andalou*, as
well as the relatively unfavourable responses to *Les Mystères*, such as that
by Léon Moussinac, may well have dealt serious blows to Man Ray's ego. If
this were the case, it seems only natural that he would reject the cinematic
medium and use it as a scapegoat for the growing lack of interest in his
work as a photographer. A public statement was required, retrospectives
of his photography were organised, but as Patrick de Haas has perfectly
understood, Man Ray the filmmaker does not disappear at this point – he
simply goes into hiding.[2] The present chapter considers this position from
a number of perspectives: the switch from the public to the private sphere

in his use of the moving image, the continuing problem of collaboration, and the impact of Hollywood on the development of his ideas about cinematic representation.

Despite being criticised for not having taken up the offer of making a feature-length picture funded by the Comte de Noailles (an opportunity that Buñuel and Cocteau eagerly accepted and which subsequently launched their careers as Surrealist filmmakers), Man Ray's services as a cameraman continued to be sought after. In his autobiography, he relates that he was approached to shoot footage of General Kerensky's headquarters in Paris after his defeat by the Bolsheviks. Not wanting to get 'mixed up in politics', he sent an assistant to shoot the film anonymously.[3] Another offer with political implications came in the form of a request from Max Eastman – a socialist writer whom Man Ray had met in New Jersey – to film the exiled Leon Trotsky on the Turkish island of Büküyada. Again reluctant to get involved in the world of politics ('I wasn't interested in politicians any more than they were interested in me'[4]) – which, above all else, seemed to Man Ray potentially detrimental to his reputation as an artist – another of his protégés was sent on the mission. These two instances demonstrate Man Ray at his most diplomatic, balancing professional interests with creative integrity in a characteristically astute awareness of his public image. However, he describes how, before 'disposing' of his professional filmmaking equipment, he had embarked on a final project with Jacques Prévert, a Surrealist poet who would later become famous for his scenarios for films such as Marcel Carné's *Le Jour se lève* (1939) and *Les Enfants du paradis* (1945).[5] This collaborative effort between Man Ray and Prévert seems to have been carried out in the same semi-improvised manner as Man Ray's early films, with the latter referring to it as 'a sightseeing, or slumming operation'.[6] The work appears to have taken the form of a quasi-documentary, delving into the shady underworld of Parisian dance halls and brothels populated by strange and unsavoury characters. The exploration of forgotten, marginalised and working-class quarters of the city from an almost voyeuristic standpoint reflects a major interest in Surrealist activity of the late 1920s and early 1930s, in the realms of both literature and photography.[7] Unfortunately, little is known about Man Ray and Prévert's project, although it seems likely that a film found in the

archives of the Cinémathèque française in 1958, bearing the title 'Souvenir de Paris', scenes from which were later incorporated into Prévert's *Paris la belle* (1960), corresponds to this description.

As De Haas has pointed out, Man Ray's apparent abandon of the cinema and the end of his 'official' filmmaking career – that is, the period beginning with *Le Retour à la raison* in 1923 and culminating in 1929 with the release of *Les Mystères du Château du Dé* – roughly coincides with the major transition from silent cinema to the 'talkies'.[8] Speaking in 1936, Man Ray referred to this as arising more from the increasingly industrial nature of filmmaking than from any artistic preference:

> Since the advent of the sound-film, I have not touched the cinema, not because of aesthetic convictions; I have always believed in the necessity of sound accompaniment ... My abstinence has simply come from the realisation that the cinema is primarily a banking operation these days, and I hate collaboration in any movement which requires the co-operation of more than one person.[9]

However, when asked in an earlier interview, published in 1929, whether he would make a talking picture, Man Ray's reply was slightly different, placing considerably more emphasis on the aesthetic connotations of synchronised sound than his later comment. His position is based on the idea that, at the end of the 1920s, the transition was premature, that the medium was not yet ready for such a development, and that filmmakers were still to fully explore the possibilities of the silent film. 'Voyez où nous en sommes: on abandonne le cinéma muet au moment où il devient intéressant de travailler avec lui. Il y a encore tant à faire!' [Look where what we're at: we are discarding silent film just when it is becoming interesting to work with. There is still so much to do!][10] From the perspective of this earlier statement, we can in fact see Man Ray's antipathy for the talking picture within the context of a more general rejection of synchronised sound in contemporaneous film theory and criticism. Alexandre Arnoux, for example, stated, 'I love the cinema deeply. Its interplay of black and white, its silence, its linked rhythms of images, its relegation of speech, that old human bondage, to the background, seem to me the promise of a wonderful art. And now the savage invention has come along to destroy everything.'[11] Although Marcel L'Herbier was one of the first to make a sound film in France, he remembers

his initial response as being more than dubious: 'When the cinématographe said to us all of a sudden: "Look here, I, too am going to talk," I said to myself, "So the catastrophe is coming."'[12] Germaine Dulac was also characteristically against the talking picture from the perspective of the cinema's growth as an independent art form: 'Quant au film parlant, j'estime qu'au point de vue art le cinéma étant une musique visuelle, la parole ne pourrait que l'amoindrir.' [As for sound film, I think that from an artistic point view cinema is visual music, and words can only diminish it.][13] Man Ray's position therefore reflects some of the arguments of the period and, most importantly, demonstrates his divergence from the Surrealists' embracing of sound as a contrapuntal device. As we have seen, Man Ray's use of musical accompaniment in *L'Etoile de mer* rejects Robert Desnos' original suggestion that the soundtrack be used in a revolutionary way by creating a series of clashes between what is seen and what is heard. This contrapuntal technique was employed by Luis Buñuel and Salvador Dalí in their second collaborative work *L'Age d'or*, and was visually suggested in their earlier Surrealist film *Un Chien andalou*, in which the shot of a hand ringing a doorbell is juxtaposed with an image of a cocktail shaker. In contrast, the musical accompaniment in Man Ray's films often demonstrates a more conservative approach, one which ultimately supported the expressive qualities of the images rather than undermining them.

The second reason for Man Ray's public rupture with the cinema, according to De Haas, relates to his long-standing desire to be recognised first and foremost as a painter, painting being for him the only true serious art form, but which was frequently overshadowed by the critical attention paid to his work in photography and film.[14] But, again, there are more conclusions to be drawn from this detail. Just as Man Ray withdrew from filmmaking as an artistic pursuit with the coming of sound (at least publicly if not privately, as the subsequent discussion will illustrate), he also returned to painting as his principle activity at about the same time as colour photography was becoming increasingly popular during the 1930s. Although it is important not to overplay the element of purism in Man Ray's artistic approach (he would often state that he was not a purist as far as film aesthetics were concerned), it is possible to detect a tendency towards artistic simplicity and the rejection of technological sophistication in his

choice of materials. This relates particularly to the relationship between the art work and its representation of reality, which, in terms of synchronised sound and colour photography, achieves a level of authenticity and perfection that Man Ray, in what Robert Pincus-Witten refers to as his 'brute' simplicity in relation to the materials of artistic production[15], seems to resist. Painting was thus a way of retaining a level of representational freedom in the face of such technological advances.

Although the problem of sound and the return to painting were major factors in Man Ray's turn away from filmmaking as a professional activity, they only partly extinguished a curiosity that seems to have continued for some time following what he refers to as the 'complete change' in his life after 1929. An underlying interest in the art of the moving image can be detected throughout the 1930s and even into the 1940s, through a range of personal essays, home movies and collaborations. If the four films discussed in the preceding chapters present a critical challenge through their immensely diverse and muli-layered nature, those that complete the portrait of Man Ray the filmmaker only serve to render this challenge more intense. Yet, delving into this vastly unexplored area is an extremely rewarding experience, revealing a surprising amount of links and overlaps with his more recognised cinematic oeuvre and enriching our insight into the context from which it arises. The continuation of Man Ray's filmmaking is divided here into two main areas: the Surrealist collaborations, crucial, as I shall argue, in the way they demonstrate a shift in Man Ray's attitude towards cinema as a public activity, and the disparate group of personal essays and memorabilia, frequently referred to as 'home movies'.

Collaborative projects

The problem of collaboration reappears constantly in Man Ray's comments about filmmaking and partly explains his ambivalence towards the medium. What was important to him, above all else, was the feeling of artistic freedom of uncompromised creative experimentation. The more

people that were involved in a project, the less direct control he would be able to exert and the less personal the final work would be. Even when the films did involve collaborations, such as *L'Etoile de mer* and *Les Mystères du Château du Dé*, Man Ray seems to have been reluctant to discuss them in such terms, stating instead that he always worked alone.[16] The two main cinematic projects in which he was involved in the 1930s and 1940s – *Essai de simulation du délire cinématographique* and *Dreams That Money Can Buy* – are defined primarily by this contradictory approach to collaboration. There is, on the one hand, the ever-curious innovator, eager to experiment with new ideas and creative modes, and, on the other, the individualist and loner who refuses to let his own artistic vision be subsumed by that of others. For his last major cinematic project with Hans Richter in the 1940s, Man Ray found the perfect solution to this dilemma in the form of a passive collaboration, which, as we shall see, epitomises his love for contradiction. In the case of *Essai de simulation*, however, this resistance to collaboration gives the project a double and contrasting identity – an incomplete film and a self-contained photo-essay – bestowing on it an altogether different artistic status.

These two cinematic ventures, both of which are related in some way to Surrealism, have rarely been discussed in the context of Man Ray's cinematic activity and his relationship with the Surrealist movement. What is most interesting about them is their demonstration of Man Ray's desire, to which I have frequently drawn attention in this study, to remain at a distance from official manifestations of the movement, despite contributing significantly to its artistic output. Whilst the first – a group project based on an outline by André Breton and Paul Eluard – did not make it to completion, due in part to Man Ray's reluctance to continue ('my heart wasn't in it'[17]), the second saw him presenting his own scenario for Hans Richter's collective Surrealist film, 'telling [Richter] to do it himself as I was loath to involve myself in movie making.'[18] Whilst it is not specifically the Surrealist subject that seems to have put him off in this case, the idea of a collaborative effort and of his own artistic ideas existing alongside those of others would clearly have been an issue for this 'independent journeyman'.

Essai de simulation du délire cinématographique

As we have seen, Man Ray was approached on numerous occasions with propositions for film projects, which he systematically refused. However, he clearly found it difficult to turn his back on Breton and Eluard's proposal in the summer of 1935. Breton, Eluard, their wives and Man Ray were guests at the country house of writer and Surrealist muse Lise Deharme in Landes, south of France – 'a rambling affair, filled with strange objects and old rococo furniture.'[19] Man Ray had taken along a small camera in order to film some of the group's activities during their stay, much in the same way, one presumes, as he had done whilst on holiday in La Garoupe with Picasso, the Eluards and the Penroses around the same period. This fact is crucial in demonstrating Man Ray's interest throughout the 1930s in the use of film for the creation of personal documents. It was suggested that the group put the camera to better use in making a Surrealist film, for which Breton and Eluard hastily wrote a scenario. Man Ray initially appears to have been enthusiastic about the project: 'Here was a chance to do something in close co-operation with the Surrealists, whom I had not consulted in my previous efforts', he remembers. 'It was an opportunity to retrieve myself.'[20] However, he also recalls that the shooting was fraught with problems, including Breton's bad acting and short temper, as well as the continual jamming of the camera.[21] Only a few stills could be retrieved, seven of which were subsequently published in a 1935 issue of *Cahiers d'art* (see figure 20). Apart from the title – 'Essai de simulation du délire cinématographique' – and the accompanying details – 'scénario d'André Breton et Paul Eluard. Réalisation de Man Ray' – there is little that distinguishes the piece as a film project.[22]

Using the *Cahiers d'art* piece as publicity for the film, Breton and Eluard suggested that shooting should recommence, but, sensitive to failure and falling again into his reluctance to be associated with the world of filmmaking, Man Ray refused their offer and the film remained unfinished. What emerges from these fragments of details is Man Ray's increasingly ambiguous and ambivalent attitude towards the medium of film. Although it is difficult to gain an objective perspective (the most in-depth account of the *Essai de simulation* is his own), it is clear that Man Ray's desire to 'retrieve'

himself in the eyes of the Surrealists was quickly replaced by a reluctance to become too involved in a project that was ultimately not entirely within his control. This is most clearly demonstrated in the title of the film, which directly refers to Breton and Eluard's earlier experiments into the simulation of various pathological states in an attempt to channel them into the process of poetic expression. The texts that were written to correspond to these mental disorders were published under the chapter heading 'Possessions' in *The Immaculate Conception*, as simulations of mental debility (*la débilité mentale*), acute mania (*la manie aigüe*), cerebral paralysis (*la paralyse cérébrale*), interpretative delirium (*le délire d'interprétation*) and premature dementia (*la démence précoce*). These variations of automatic writing were described by the authors as proving 'that the mind of a normal person when *poetically* primed is capable of reproducing the main features of the most paradoxical and eccentric verbal expressions.'[23] The attempt to align the film with a particular area of Surrealist literary activity raises a crucial issue that Man Ray leaves out from his description of the film and to which Bouhours and De Haas in their account of the project refer only briefly.[24]

The extent to which Breton and Eluard intended to transfer this practice of writing to the process of filmmaking is unclear, and there is little obvious link between the poetic imagery of the 'Possessions' chapter and photographs taken from the film itself. What does seem interesting about the film's genesis is the way the title corresponds to 'le délire d'interpretation', precisely the area of psychiatry that most inspired the Surrealists and which Salvador Dalí developed as 'paranoia criticism' (*la method paranoïaque-critique*). Interpretive delirium, or 'delusional thinking', refers to a state in which the subject's interpretation of reality is distorted without the presence of hallucinations. 'Aussi loin que possible de l'influence des phénomènes sensoriels auxquels l'hallucination peut se considerer comme plus ou moins liée', explains Dalí, 'l'activité paranoïaque se sert toujours de matériaux contrôlables et reconnaissables.' [Paranoid activity, which lies as far as possible from the influence of the sensory phenomena to which hallucination can be considered as more or less related, always uses recognisable and controllable materials.][25] The title given to the project undertaken by Breton, Eluard and Man Ray thus extends this interest into the medium of film and points specifically to the delusional effect inherent in the cinema,

i.e., mistaking one 'reality' for another, which does not require an actual hallucination on the part of the subject/spectator. The cinema thus creates the possibility to illustrate the workings of paranoia criticism, whilst itself existing as a form of delusional thinking. Undoubtedly inspired by the possibilities that Buñuel and Dalí's films *Un Chien andalou* and *L'Age d'or* had opened up for the interpretation of Surrealist themes in the cinema, it seems entirely plausible that Breton saw here the opportunity to make his own explorations into the medium. Yet, we can also assume that if such a framework did indeed exist in the minds of Breton and Eluard, it could well have appeared overly abstruse to the pragmatic Man Ray who tended to distance himself from Surrealism's more doctrinal practices.

Some of the stills that were published in *Cahiers d'art* – Breton by the window, Lise Deharme wearing a black dress covered with silver stars and with what appears to be a bird's nest resting on her head, a black horse with its rider completely dressed in white – directly correspond to Man Ray's description of the film's content:

> There were sequences of the women, strangely attired, wandering through the house and in the garden. A farmer's daughter nearby, whom we'd seen galloping across the country on a white horse without a saddle, was persuaded to repeat the ride before my camera [...] In one scene, Breton sits at a window reading, a large dragonfly poised on his forehead.[26]

The random nature of these sections points to a rather general commitment to the Surrealist principles of chance and irrationality, and one cannot help but wonder how the sequences described by Man Ray and the images that remain relate to the original scenario. The text that accompanies the stills in *Cahiers d'art* bears little resemblance to even the loosest of film outlines and it is highly probable that it was added afterwards by either Breton or Eluard. With each line corresponding to one of the seven images, the text reads:

> Rien dans le puits du Nord
> Tu me retrouverais toujours, dit le sphinx
> Et il signa ...
> Eteignez tout!

A la suite d'une vision sinistre, don Juan ...
L'homme du crépuscule
Ils s'étaient rencontrés pour la première fois.

[Nothing in the wells of the North
You will always find me, says the sphinx
And he signed...
Extinguish everything!
Following a sinister vision, don Juan ...
The man of twilight
They had met for the first time.]

The ambiguous relationship between the images, along with the oneiric style of the text itself, make this an interesting example of a Surrealist photo-essay, involving an irrational juxtaposition of text and image characteristic of the movement. *L'Essai de simulation* is therefore not insignificant within the context of Man Ray's filmmaking career since his last two films, *L'Etoile de mer* and *Les Mystères*, both emphasise such combinations of text and image. The mysterious trance-like atmosphere of the latter is also echoed in the *Cahiers d'art* piece, as well as in Man Ray's description of the film, where characters wander through Lise Deharme's house and garden in the same way as the anonymous bodies that inhabit the grounds of the Villa de Noailles. The reference to light ('Eteignez-tout') and the transition from day to night ('L'homme du crépuscule') are also key features of *Les Mystères*, as demonstrated in one of the intertitles of that film – 'O Sommeil, O! Soleil, ma vie sera / soumise à tes lois / Et je fermerai les yeux / quand tu disparaîtras'.[27] The connection with the Surrealists – their celebration of the night as a privileged moment of dreams and the unleashing of the unconscious – is evident here, especially in the day/night, conscious/unconscious, rational/irrational dichotomy to which this transitional moment gives rise. However, we are also reminded of Man Ray's interest in the dichotomy of light and shadow. The idea of a gradually fading light is significant in this context, as it suggests an all-encompassing shadow, obscuring vision and rendering problematic our perceptual understanding of the world.

This can be directly associated with the content of some of the images featured in the piece since a number of them point precisely to Man Ray's characteristic compositional flair and creative use of light and shadow, suggesting that the presence of Breton and Eluard's written outline, whatever form it may have taken, did not prevent him from pursuing his own visual interests. The first still, featuring Nusch Eluard, is particularly demonstrative of this. She is seen at the bottom of the frame, holding onto the lower branch of a tree, whilst a large piece of lace material that hangs from above casts shadows onto her face in profile. The composition brings to mind a number of Man Ray's photographic works that use the female face or body as a site of formal experimentation, as seen in the photograph *La résille* (1931) or the striped torso in the final moments of *Le Retour à la raison*. Two other stills, placed at the centre of the page, are yet further demonstrative of Man Ray's style and are perhaps the most interesting within the context of his work. The 'strange objects' to which Man Ray refers, and for which he clearly held a certain amount of fascination, play a central role here. In the first image, a woman's head (Jacqueline Breton), masked off from the rest of her body by a sheet of darkness, lies next to an unusually shaped round object, recalling similar juxtapositions of animate and inanimate elements that appear throughout Man Ray's oeuvre. The delicate interchange of qualities brought about by such a juxtaposition is enhanced by the almost identical shadows cast by both the head and the round object. A chair or table leg enters the frame, pointing towards them, its own shadow mingling with that of another object that remains out of sight. This extremely atmospheric arrangement of elements within the frame bears a striking resemblance to a photograph of 1937, *L'Aurore des objets* (see figure 21), which also juxtaposes various objects with the seemingly lifeless head of Lee Miller. This studied emphasis on objects is a recurring element of Man Ray's work, particularly his photography. At around the same time as the making of *Essai de simulation*, Max Ernst had taken Man Ray to the Institut Henri Poincaré in Paris to show him some of the mathematical objects that were on display there. Not understanding the algebraic formulations they were supposed to represent, but fascinated by their unusual shape, Man Ray made a series of photographs of them, which were published in *Cahiers d'art* in 1936, accompanied by an essay by

Christian Zervos entitled 'Mathématiques et art abstrait'.[28] A number of these photographs demonstrate a similar approach to the objects filmed a year earlier at Lise Deharme's house, suggesting an overlapping relationship between Man Ray's photographic and cinematic sensibilities.

Although, it is extremely unfortunate that the film itself never made it to completion, what remains of *Essai de simulation* is a highly evocative and mysterious photo-essay that carries with it its own myth of conception. It draws attention, above all, to the Surrealist hopes for cinematic expression, and the technological barriers that would prevent their realisation, whilst at the same expressing Man Ray's characteristic attention to form. If few successful films came out of the movement despite the belief of many Surrealists in the immense poetic potential of the cinema, it is undoubtedly due to the lack of spontaneity that is inherently part of its practical construction. Man Ray, for all his initial enthusiasm for making a Surrealist film in collaboration with Breton and Eluard, was undoubtedly aware of this contradiction and probably felt that what had come out of the project was the most authentic record of the experience. In his next collaboration, Man Ray would be significantly less involved in the practical process of filmmaking, for the first time allowing his ideas to be put into images by someone other than himself.

Ruth, Roses and Revolvers

In 1940, fearful of his own safety in occupied France, Man Ray fled Paris and returned to the United States, settling not in New York, the city he had left behind when he had initially sailed to France in 1921, but the very centre of the commercial film world: Hollywood, California. As Neil Baldwin has pointed out, for someone who lived so close to the throbbing heart of cinema, Man Ray had surprisingly little to do with it. Indeed, this proximity is seen by Baldwin as exacerbating his ambivalent feelings towards the medium.[29] The German artist and filmmaker Hans Richter was also living in America during the 1940s and contacted Man Ray with a filmmaking proposal. Richter had conceived of a Surrealist film that would consist of individual episodes made by different artists. Not wanting to be

involved in the filming itself, Man Ray sent Richter a scenario, which he had adapted from his own story 'Ruth, Roses and Revolvers', published in the American magazine *View* in 1944. The central narrative of Richter's film, entitled *Dreams That Money Can Buy*, centres on a male protagonist who, on discovering his ability to create dreams, embarks on a money-making project selling them to the public. Each of the seven short self-contained episodes, created by Max Ernst, Fernand Léger, Marcel Duchamp, Alexander Calder and Hans Richter, represents one of these dreams, whilst largely corresponding to the artistic approach of its author (Duchamp's contribution for example features the spiralling disks of his 1926 film *Anémic Cinéma*).

Ruth, *Roses and Revolvers* is the third dream in the film, which begins with a couple reading a book of the same title. The writing on the front of the book is recognisably that of Man Ray, a detail that serves to incorporate a personal stamp despite his not being involved in the actual filming. In fact, Richter continually pays homage to Man Ray, possibly in an attempt to make up for his absence in the production process. The space that serves as Joe's office or consultation room is dominated by a cropped version of one of Man Ray's photographic self portraits. Interestingly, this closely resembles another photograph that Man Ray took of himself after shaving off half his beard around the same period. As discussed below, the same image comes to play an even more important role within the *Ruth, Roses and Revolvers* section, again asserting Man Ray as the author of the work. So whilst, as the previous chapters illustrate, the earlier films see the artist inscribing his own presence into the filmmaking process, *Dreams That Money Can Buy* represents Richter's attempt to both capitalise on, and pay homage to, Man Ray's artistic persona. The story on which the film is based is characteristically self-reflexive and constitutes one of Man Ray's most important statements about the medium of cinema and his own position in relation to it. If the earlier analysis of *L'Etoile de mer* largely involved examining Man Ray's visualisation of Robert Desnos' scenario, the discussion of *Ruth, Roses and Revolvers* requires precisely a reversal of this process. It is unclear to what extent the scenario that Man Ray sent to Richter diverges from the text printed in *View* since no record of the former remains. Nonetheless, the original story is close enough to the final film

to assume that little of the content was changed in the rewriting process. Although it would be misleading to discuss the final film in terms of Man Ray's own cinematic expression, the story itself offers us sufficient material from which to analyse the development of his ideas in this area.

In the original story, Man Ray walks along a residential street with Juliet early one evening carrying a heavy yellow book. They come across a red brick house with all the blinds closed except those on the ground floor. Juliet proceeds ahead, whilst Man Ray leaves the book next to a tree. As he does this, the title 'SADE' appears on the cover. On entering the building, the couple find themselves amongst a group of people gathered together to watch a film. In her introduction, the leader of the group, Ruth, tells the audience that what they are about to see is one of the most original films ever made, that what it lacks in colour and sound will be compensated for through their own conversations and by looking at her. She then goes on to explain that the success of the film depends upon the extent to which the audience actively collaborate with it. Finally, she adds that the main character will be well-known to the audience, that they trust him, as well as the meaning of his gestures. However, in order to make sense of the gestures, the audience must imitate them throughout the duration of the film, which then begins with a series of landscapes – cloud-filled skies, mountains, lakes – and other conventionally 'beautiful' images. A man appears in a room that is empty except for a prie-Dieu. Initially lost in his thoughts, he subsequently begins to carry out a range of actions, beginning by standing on his chair, looking out into the distance, kneeling to pray and then finally leaving the room. The spectators, following Ruth's instructions, obediently imitate these actions, but Man Ray resists and becomes gradually more irritated until finally, when the actor kneels, he calls out for the audience to come to their senses. Receiving only their disapproving looks, he returns to his seat and indulges in the image onscreen, which, with the rest of the audience out of the way, he now sees with perfect clarity. He leaves the cinema after the others and, accompanied by Ruth and Juliet, retrieves his book from under the tree. Next to it lies a pile of excrement with a dead rose, making Juliet cry out with laughter, 'all we need now is a revolver!'

In fitting with the theme of *Dreams That Money Can Buy*, Richter's interpretation of Man Ray's story respects its dreamlike quality, but necessarily dispenses with its personal voice. In its original form, *Ruth, Roses and Revolvers* is narrated in the first person, from the perspective of the writer himself, whereas the film has a more distanced, anonymous quality. However, there is a clear attempt to compensate for this lack of subjective authority through the continually glimpsed images of, and references to, the artist. Apart from those seen in the consultation room, there are numerous other examples within the dream segment itself. In the film projection sequence, the same picture of Man Ray hangs behind the actor whose gestures the audience must imitate. At the end of the film, when the abandoned book is retrieved, the male character flips it over to reveal once again this same portrait. The voice on the soundtrack states, 'You see, it's like this book. People look at one side of this for details that are more prosaic: title, subject matter, country of origin, language. But look carefully at the other side and you will see the real significance, including the exact date of the writing.' This piece of dialogue, which does not feature in the original story, can again be interpreted within the context of Richter's continued homage to Man Ray and the affirmation of him as the real author of the work. In this sense, the book functions as a metaphor for the film itself: looking at it from one side reveals only the basic details – the action on a descriptive level – whereas the other side reveals its true identity and creative origin, that is, Man Ray. This meaning was clearly recognised and appreciated by its author, whose enthusiastic response to the film was printed in the programme notes:

> Since the movies are a projection, it amused me to carry the idea to a consistent end, and see an interpretation of it realized by others, so that I could get the same surprise out of it that any other spectator would have. The result has justified my anticipations, and I enjoyed the combined role of entertainer and entertained. To wear a beard and not wear one at the same time is indeed an achievement.[30]

The beard incident thus becomes a central intertextual reference, whilst also functioning as a metaphor for Man Ray's divided self (a theme to which this chapter will later return).

Ruth, Roses and Revolvers functions partly as a critique of Hollywood illusionism and the rising appeal of stardom amongst cinema audiences. Living in the vicinity of some of the main film studios, Man Ray was well-situated to launch this kind of attack, his own repertory of films already existing on the margins of commercial cinema. In the story, Ruth's introduction to the character of the film that is about to be projected is particularly telling. She draws attention to the fact that the audience know him well, referring to the process of character identification and the false impression of familiarity created through the star system and enhanced through celebrity gossip columns of newspapers and magazines. Here Man Ray highlights the public veneration of movie stars, their status as icons and the ability of film to bestow on the simplest of gestures a sense of majestic significance. The audience, he seems to suggest, in their hypnotised state accept these cinematic representations and personalities as authentic and imitate them unquestioningly. At the same time, Man Ray presents an active process of film viewing that challenges traditional passive modes of reception, rendering the critique itself complex and contradictory. This aspect of the story can also be understood in terms of collaboration, not between filmmakers themselves, but rather between the filmmaker and spectator, adding yet another layer of significance that relates to the author's own experiences. Interestingly, Man Ray is the only member of the audience who does not wish to collaborate, preferring to follow his own desires.

The critical emphasis is retained in Richter's interpretation of the scenario, yet, as the description in the programme notes demonstrates, it is subtly reoriented away from Hollywood as the central target and towards the cinema audience more specifically – i.e., the film/stars are not to blame, but the inherent gullibility of human nature:

> From an original story by Man Ray. In it the artist ridicules the readiness with which most people accept what other people impress upon them. A movie theatre offers an adequate setting.[31]

As Man Ray states, the 'satirical nature' of the story is given 'a psychological twist in keeping with the rest of the film.'[32] Although, aside from this, he was relatively happy with Richter's interpretation of his scenario, Man Ray's contribution to *Dreams That Money Can Buy* would be the final example

of his involvement in the cinema. Four years after its release, he returned to Paris, leaving Hollywood, and its artifice and contradictions far behind. *Ruth, Roses and Revolvers* was his parting statement, and a valuable comment on the industry he resented so much.

Home movies and cinematic essays

The works discussed so far – the four films made during the 1920s as well as the collaborations with Breton, Eluard and Richter – were all viewed and judged by a public audience, albeit a minority one and, in the case of *Simulation du délire*, through a medium other than that of film. The same cannot be said for the films only recently discovered, which testify to the important role played by the moving image in Man Ray's private life.[33] Here, experimentation into the art of filmmaking continues but seemingly without the pressure of commercial exhibition and critical assessment. Writing about these films, then, feels almost like a betrayal of the artist's intentions, an intrusion into his private sphere, and, most importantly, a critical undertaking that goes against the nature of the works themselves. Patrick de Haas raises some of these issues in his discussion of Man Ray's 'films inconnus'. 'La difficulté', he states, 'réside dans la nécessité de ne pas traiter comme oeuvre d'art ce qui ne l'était pas pour l'artiste, et simultanément dans l'impossibilité pour le regardeur de ne pas voir l'artiste qui se cache derrière sa pratique d'amateur.' [The difficulty lies in the need not to treat as a work of art something that the artist did not consider as such, and, at the same time, in the impossibility for the viewer of not seeing the artist hiding behind his amateur practice.][34] It is precisely for these reasons that the films offer an illuminating case for analysis, expressing a more intimate relationship with the camera, whilst at the same time demonstrating some of the key characteristics of Man Ray's art. They therefore seem to exist at the threshold between Man Ray's public and private persona, in front of and behind the camera.

When asked, in 1936, about his relationship with the cinema, Man Ray was characteristically resolute: 'I look at the cinema now merely as a spectator.'[35] These short cinematic essays, experiments and personal documents testify to the fact that, even if he had publicly withdrawn from the cinema and was no longer making films for theatrical projection, his interest nonetheless continued to be stimulated by the medium in a number of forms. Although some of the films clearly fit into the category of the home movie, to put them all under this banner would be to ignore their experimental vigour. As well as blurring the boundary between professional and amateur filmmaking, these films also, through the recurring presence of Man Ray as both subject and creator, prefigure the emergence of the autobiographical subgenre in avant-garde cinema, epitomised by the films of Maya Deren amongst others. Despite adding significantly to our knowledge of Man Ray's relationship to film, and their valuable depiction of the artist in front of the camera, little has so far been written about them. The only existing accounts are those by Patrick de Haas in *Man Ray: directeur du mauvais movies* and *Le je filmé*,[36] both only brief descriptions of the films and their ambiguous position in relation to Man Ray's 'official' cinematic oeuvre. The former nonetheless remains an invaluable resource to which I am indebted in my own analysis of the films.

Although the works are often intricately related, I will deal with each one chronologically, except for *Corrida* and *La Course landaise*, which involve the same subject of the bullfight. This separation is mainly to create ease of reference but also respects the chronological development of Man Ray's 'amateur' filmmaking. Since these films have a more direct link with the artist's personal life, I have also tried to emphasise certain corresponding events that shed light on the direction taken by the works themselves. Dates and technical details are taken from the information provided by Jean-Michel Bouhours and Patrick de Haas in *Man Ray: directeur du mauvais movies*.

Rue Campagne-Première (circa 1923-9, 35mm, 1 min, black and white, silent)

One of the earliest of these films, shot in and around the rue Campagne-Première apartment where Man Ray lived during the 1920s, perfectly illustrates his characteristic experimental approach to the medium, and points to some of the techniques that would find their way into his main body of films. It is the only one of the cinematic essays discussed here to be shot on 35mm film, the same professional format as the four later films. The film opens with a static shot of a street corner. Although we see passers-by in the background, the framing gives special attention to the building itself, particularly the shop front and the street sign that serves to place it geographically. There is a hint here of Man Ray's street photography, in which he dabbled briefly during the 1930s, and which also often features shop fronts and building façades. Yet just as many of Man Ray's urban photographs undermine the sense of everyday reality through unusual framings, the conventional documentary-like image that begins the film is abruptly replaced by a disorientating perspective that contrasts starkly with the realism of the previous shot. The camera is now turned 90-degree and the street is filmed through an oval shaped window. All sense of depth is removed, and it is initially difficult to even distinguish interior from exterior, let alone identify what is presented on screen. It is only when a figure moves from the top to bottom of one edge of this oval that we become aware of the perspective and camera positioning. What is interesting about this shot is its similarity to a composition that appears towards the end of *Emak Bakia*, where Man Ray films a building from an unusually low angle, again turning the camera 90-degree so that the height of the building stretches out lengthways to the right of the frame. A number of comparisons can be drawn between the two films despite their differing status within Man Ray's oeuvre. Both examples of experimentation with perspective are preceded by a relatively 'realistic' depiction of space – the street scene in Rue Campagne-Première and the sequence in *Emak Bakia* where a car is seen arriving in front of a building. In the latter, the transition from a traditional representation of cinematic depth and perspective to a more abstract depiction of reality is made through an interior shot that shows the man entering the building from outside. Here the glass-panelled door

sets up a multi-framed space within the single frame of the cinema screen. This idea of a frame-within-a-frame is also one of the central themes of *Les Mystères du Château du Dé*. Thus the oval window within the rectangular frame in *Rue Campagne-Première* therefore seems to be part of a much wider concern in Man Ray's work with the framing of space.

Another important similarity is the use of the clue to reorient the spectator within the distorted reality of the cinematic image. In both films, this is a figure that walks through an extremity of the frame – from top to bottom-right in *Rue Campagne-Première* and, in a reversal of direction, from bottom to top-left in *Emak Bakia*. Although it is difficult to ascertain the exact relationship between the two films, it is highly likely that these correspondences were not accidental and that the composition in the earlier work served as a study for the final section of *Emak Bakia*. The recurring central theme in these films is the undermining of conventional modes of perception by literally presenting reality from a new angle, giving rise to Breton's notion of *dépaysement*.

A similar technique can be found in the striking visual composition of the untitled photograph taken at 229 Boulevard Raspail, where the unusually low angle and disorientating framing gives the eerie impression of a looming building façade detached from its surroundings. Generally discussed in terms of Surrealism, this image is remarkable for the way it creates, in Jane Livingston's words, 'a feeling of improbably vertiginous perspective that elicits sensations of almost claustrophobic distortion.'[37] It also demonstrates how the controlled environment of the studio, in which everyday reality could be manipulated and transformed to create new visual experiences, informed Man Ray's approach to the urban exterior. This brief cinematic experiment thus highlights a crucial link between cinema and photography in his explorations of reality and its representation.

Corrida (1929, 9.5mm, 4 mins 50, black and white, silent)
Course landaise (circa 1937, 16mm, Kodachrome, 9 mins, colour, silent)

During his discussions with Pierre Bourgeade in 1972, Man Ray evoked the element of boredom that he found to be an inherent part of movie-going. As outlined in Chapter 2, this was a recurring theme in his thoughts about the cinema, which, on occasions, stimulated him to create purely formal patterns from the figurative material presented on the screen. What is significant about his comments to Bourgeade, however, is the analogy he makes between the cinema and spectator sports such as the bullfight:

> j'allais au cinéma, mais c'était plutôt par politesse, si on peut dire: je savais d'avance que la plupart des films allait m'ennuyer énormément, comme quand j'allais voir des spectacles plus sportifs [...] une corrida, par exemple [...] Pour trois heures, il y a peut-être une minute ou deux minutes passionnantes![38]

> [I went to the cinema, but it was more out of politeness, as it were; I knew in advance that most films would be a real bore, just like when I go to sporting events [...] a bullfight, for example [...] in three hours there may be one or two minutes of excitement!]

That he singles out the bullfight to illustrate his point seems particularly curious given that two of the films found in his collection are personal documents of this very sport. Furthermore, an article published in *Voilà* in 1934, entitled 'Mort dans l'après-midi', seems to suggest that, contrary to his statement, he held a certain fascination for the bullfight.[39] Are we to assume then that the ambivalent attitude he maintained in relation to the cinema informed his response to other activities? Or was boredom itself a source of inspiration for Man Ray – something to be explored and overcome? Perhaps the act of filming distracted from the boredom of the event and transformed it into something more engaging. Importantly, this would see Man Ray actively interacting with the spectacle rather than passively absorbing it, a gesture that, as we have seen, demonstrates the key way in which boredom is dissipated in his film viewing. Just as the images on screen are transformed by viewing them through semi-transparent cloth, distorting glasses or the spaces between his fingers, so too is the actual experience of

watching a bullfight mediated and rendered visually more interesting by the presence of the film camera. Another important factor here is the element of time since the film necessarily shortens the actual duration of the event, emphasising those 'exciting moments' to which he refers. 'Moi, j'ai toujours voulu tout racourcir!'[40] Placed behind the camera, Man Ray was thus liberated from the boredom he found so unbearable and allowed him to actively manipulate the reality of the scene played out before him.

The first of these filmed bullfights, labelled simply 'Corrida' and dating from 1929, raises some crucial questions about authorship. Despite being found in Man Ray's collection amongst other films that were clearly made by him, there is little in terms of either form or content in this piece that would suggest his presence behind the camera. At around this time, Man Ray had lent his small 9.5mm camera to the writer Ernest Hemingway, who wanted to film his first corrida in Pampelune. Although it cannot be said for sure, it seems quite possible that *Corrida* was shot by Hemingway, explaining its rather anonymous feel and distinct lack of any qualities that would trace it back to Man Ray.

This issue of authorship becomes even more marked when compared with a later film, *Course landaise*, shot around 1937. Here the same subject of a bullfight is treated in a noticeably different manner, giving more concern to style and visual detail. The first panning shot of the film begins on a loudspeaker pole, passes over the crowd and ends on an architectural detail of the ancient amphitheatre. There is a more personal feel here, signalled by an image of Ady smiling at the camera and more direct close-ups shots of the crowd. This is also demonstrated in the depiction of the fight itself, which, unlike the distanced perspective of the earlier film where the camera takes up the position of spectator, creates an intimate sense of participation. The excitement of the fight is translated through the use of close-ups showing the frantic rapid movements of the bull and the matadors that interact with it. Shorter shot length also contributes to this feeling of excitement and immediacy, and at various points in the film attention is focused on the repetition of the same action (e.g. the matador on horseback circling the bull with his arm raised ready to strike). The most important feature of *Course landaise*, one that sets it apart from *Corrida*, is the sudden switch to colour film towards the end. Although Man Ray's experiments with colour

photography did not come until much later, around the beginning of the 1950s, he seems to have been eager to explore the effects of colour in the moving image. The bullfight provides the perfect context for this, given the predominance of the red blood of the injured bulls, which stands out against the black and white section of *Course landaise*.

Autoportrait ou Ce qui manque à nous tous
(circa 1930, 9.5mm, 10 mins 50, black and white, silent)

Earlier chapters have shown how Man Ray used the moving image to extend his artistic practice and to further explore ideas that had been developed in a range of other media such as painting, photography and sculpture. Likewise, aspects of the films have been channelled back into other areas of Man Ray's work, in some cases through simple intertextual references, as in the photograph *Le Retour à la raison* (1931), the painting *Piscinéma* (1965) or the mixed media construction *Etoile de verre* (1965). That the medium of film played an important role in Man Ray's investigations of the kinetic possibilities of his works is particularly evident in the experiment shot around 1930 – again in 9.5mm format – featuring himself and Lee Miller. Here, it is one of Man Ray's sculptures *Ce qui manque à nous tous* that provides the focus of the film. Created in 1927, the object consists of a clay pipe onto which the title of the piece is painted, a glass ball attached to one end. In the film, Man Ray has devised a system whereby the glass ball is replaced by a bubble blown at the end of the pipe, which then fills with smoke; when the bubble's capacity is reached, it either explodes voluntarily or is burst, leaving behind a suspended trail of smoke. The experiment is carried out a number of times, each one giving rise to a slightly different visual effect. As with Man Ray's first two films, the action is staged in a tightly controlled studio context, with the black background and special lighting effects creating an isolated site of visual contemplation characteristic also of his photographic work.

Man Ray's interests in the kinetic properties of smoke were already being expressed in *Le Retour à la raison*, where smoke is blown in front of the work *Danger/Dancer* in order to suggest movement. *Autoportrait* illustrates

the development of this interest and crucially points to the influence of Etienne-Jules Marey, to whom Man Ray had already paid homage in *Emak Bakia*. Between 1899 and 1902, Marey experimented with smoke trails, building a series of machines that could produce threads of smoke, which were then dispersed by placing differently shaped objects in their path, creating varied and complex patterns. The results were photographed by setting up the machines in a darkened room and using the light of the flash to capture the wisps of smoke. Despite its more rudimentary form, the experiment carried out by Man Ray and Lee Miller in *Autoportrait* mirrors the work of Marey in a number of key ways. First of all, the staging, as I have already mentioned, consists of a darkly lit background against which the smoke is made visible, giving rise to a sense of dislocation and abstraction from external surroundings. Secondly, there is an underlying element of unpredictability or chance in the use of smoke, which was recognised by both Marey and Man Ray, and over which they both attempted to exert some kind of control by employing specific instruments. The difference is, of course, that Man Ray's focus is purely aesthetic, and revolves primarily around the use of an existing work of art to produce another, allowing the medium of sculpture to feed seamlessly into that of film.

Another important link between Marey the scientist and Man Ray the artist is their mutual interest in intangible phenomena. In Man Ray's work this is demonstrated most effectively in his manipulations of light and in the exploration of absence and presence through the interplay of light and shadow. Light often becomes the 'object' of attention in his photographs and films, focusing on the insurmountable paradox of immateriality. It is precisely this issue that appears to occupy Marey in his extended investigations into smoke patterns, which are, in part, an attempt control that which ultimately escapes the realms of physicality. It seems logical, then, that Man Ray should also be attracted to such an undertaking for artistic purposes. In his earlier studies of human and animal movement, Marey also tried to seize that which escapes human perception: the precise positions involved in the act of motion. As the *Homme d'affaires* sequence of *Emak Bakia* suggests, Man Ray held a certain amount of esteem for the emphasis Marey placed on this area of perception, which corresponded to his own extended investigations into movement in that film. However, whilst Marey was interested primarily in analysing movement through the

arrested moment, Man Ray here uses film to capture precisely the temporal *development* of movement, an element that seems to relate back to his work with Duchamp.

Although the beginning of *Autoportrait* resembles *Le Retour* and *Emak Bakia* in the sense that the formal experiments unfold without showing the physical intervention of the artist, the film gradually becomes a more intimate portrayal of both Man Ray and Lee Miller. This symbolises a key shift in Man Ray's use of the moving image, from its incorporation into, and extension of, his work as a visual artist, addressing similar formal problems as those which occupied him in other media, to the more informal role it occupied within his personal life. Here the shift is signalled by the movement of the camera, which shows the face of Man Ray. This is the first of many moments in the films discussed here, where the artist appears in front of rather than behind the camera, positioning himself as the object of the gaze. It is not insignificant that the majority of these intimate portrayals were carried out with the collaboration of Man Ray's female companions – Lee Miller, Meret Oppenheim, Ady Fidelin and Juliet Browner.

In *Autoportrait*, as in subsequent films, the gaze is alternated by showing the same action carried out by both 'players' – in one shot Miller peeks through the opening of a door and in the next Man Ray does the same, demonstrating a delicate interchange between them. The film ends with one of the most intimate insights into Man Ray's private persona. Wearing a nightdress, he acts out a number of humorous gestures for the camera, revealing his genitals, dancing in an exaggerated manner, and scratching his backside. Thus, the subtle humour of his official cinematic works gives way to an overtly provocative play of physical burlesque that demonstrates an entirely different side to Man Ray's relationship with the camera.

Poison (circa 1933–5, 16mm, 2 mins 40, black and white, silent)

This intentionally exaggerated acting was given further expression in a film made around 1933 with Meret Oppenheim, a young Surrealist muse who featured in a number of Man Ray's photographs of the period. Oppenheim would later become one of the most important female voices in Surrealism, shooting to instant recognition with her now infamous work

of 1936, *Breakfast in Fur*.[41] The first moments of the film reveal Man Ray's fascination with Oppenheim as a photographic subject, as well as the latter's self-conscious awareness of herself as object of the (male) gaze. Moving her head from one profile to another, she looks at the camera operator (presumably Man Ray) and then directly at the camera, involving the spectator in the intimate exchange between viewer and viewed. In a playfully improvised moment, she places her arms across her face, hiding her eyes and mouth, then lowers them and again looks directly at the camera. These images are somewhat reminiscent of those found in *Emak Bakia*, where the female subjects return the gaze of the spectator, breaking the illusionist distance between them. Here, however, the camera takes on a different role, one more associated with the home movie aesthetic with which Man Ray clearly plays. This is seen particularly in the following section in which Man Ray appears, bringing his face towards the lens. There is a cut to black, which is then followed by a shot of Oppenheim moving away from the lens, attempting to light a cigarette, and then another image of Man Ray in exactly the same framing. Aside from its emphasis on the continued desire for cinematic experimentation, this part of the film can be read as symbolising Man Ray's divided persona, as well as expressing the very intense nature of the relationships he had with his female muses. One could also associate the male-female interchangability found throughout these private works with an interest in sexual ambiguity, a theme to which I have already referred in the discussion of *L'Etoile de mer*, but which can also be found to some extent in the de-sexualised bodies of *Les Mystères du Château du Dé*.

From this point in the film, attention is focused on the perception of drinking and smoking as degenerate and potentially poisonous activities, a view that is ridiculed by the caricatured acting of Man Ray, which shows him going through the states of sobriety, drunken animation, illness and then, finally, death. It is difficult not to see *Poison* as a comment on America's prohibition law, which banned the consumption of alcohol until 1933, roughly the time at which this sketch was made. Frequently critical of his homeland, and living in France since 1921, it is highly likely that Man Ray saw much absurdity in this aspect of American society.

L'Atelier du Val-de-Grâce (circa 1935, 16mm, Kodachrome, 1 min. 50, colour, silent)

At the end of the 1920s, in order to separate his professional activity of photography from what he considered his more artistic pursuits, Man Ray acquired a studio in the quiet street of the rue du Val-de-Grâce in the latin quarter of Paris. Here he would devote his time to painting, away from the distractions of customers calling on him for portraits at the rue Campagne-Première studio, at which he continued to work in the afternoons.[42] This short colour film of less than two minutes-long and dating from around the middle of the 1930s shows the interior of the studio and its contents, including the famous large canvas, *A l'Heure de l'Observatoire – les amoureux* (1933–4). The camera pans around the walls picking out various works, particularly a pencil drawing of a naked woman, on which it lingers repeatedly. This documentary-like film gives a brief glimpse into Man Ray's personal work space and allows us to see assembled together some of his works of the period. It is a clear illustration of the importance Man Ray placed on the activity of painting, to which he had vigorously returned during the 1930s. Here, the medium of film is thus used simply as a way of preserving and giving value to this area of his creative output, and experimentation is virtually absent.

La Garoupe (circa 1937, 16mm, 9 mins 10, black and white, colour, silent)

During the 1920s and 1930s, Man Ray regularly spent periods of time in the south of France, holidaying with various friends, many of them members of the Surrealist movement. The film that he shot around 1937 during one such holiday in La Garoupe, Antibes, is the only 'home movie' that he mentions in his autobiography. Featuring Picasso, Paul, Nusch and Cécile Eluard, Emily Davies and Roland and Valentine Penrose, it is one of the most interesting of his private works, expressing the very close relationship between Man Ray and other key literary and artistic figures of the period (see figure 22). As well as intimate depictions of various members of the group relaxing, reading, eating and sleeping, the film also includes a number of sketches consciously acted out in front of the camera, mirroring

similar moments in some of the other works discussed here. In one of these sketches, Man Ray pretends to make advances towards the indifferent Nusch in a café, ending with a physical retort, and, finally, laughter. In another, Eluard walks about in a strangely distorted fashion, a large leaf covering his face in a Surrealist re-arrragement of reality. At one particularly humorous section of the film, a shot of the group walking together around a pole is cleverly juxtaposed with an image of chickens rotating on a spit. Although it is sometimes difficult to identify who is operating the camera, some moments clearly point to Man Ray's distinctive visual interests, such as the shots of quaint shop fronts and rows of trees that recall his documentary photography of the early 1930s.

As Man Ray recounts in *Self Portrait*, Kodak had just begun to produce a new colour film and had provided him with a camera and a supply of stock in order to test the product. Over-sensitive to the contrasts in colour and the pasty white skin of the majority of his friends, Man Ray placed an orange filter over the lens. When the print came back from the laboratory, it was accompanied by a note informing Man Ray that he had forgotten to remove the filter and that the pictures were ruined. As with his other photographic experiments and accidents, the unusual effects were received enthusiastically by this unconventional artist, who saw the 'problem' to lie rather with the limited imagination of the lab technicians and their restrictive definition of what constitutes a realistic or successful representation:

> Upon projecting the film I was astonished and delighted at the result; the sky was green, the sea was brown, and everyone looked like a redskin or at least as having been exposed a month to the sun. I sent the camera back, disgusted with the technicians; they had probably never heard of Gauguin and Tahiti. And I never wanted to hear of moving pictures again, at least never handle a camera.[43]

This characteristically antagonistic reaction to the medium of film is understandable given that it would have followed quite closely the aborted Surrealist project with Breton and Eluard in 1936. Although, as is usually the case with Man Ray, this string of technological failures – jamming cameras, 'forgotten' filters – gave rise to something creatively original – a mysterious photo-essay and an experiment in colour respectively – the frustration was clearly too much to bear. A few short film essays were made after this but,

as the collaboration on *Dreams That Money Can Buy* suggests, Man Ray now shied away from any kind of commercial cinematic undertaking.

Ady (1938, 16mm, 53 seconds, black and white, silent)

The break up with Lee Miller, previously his assistant, left severe emotional scars on Man Ray and he resolved to remain unattached for some time. However, as he recounts in *Self Portrait*, his encounter with Adrienne Fidelin, a young dancer from Guadeloupe, had an enormous impact on him, and she became his partner during the latter part of the 1930s. The relationship with Ady lasted until his departure to the United States just prior to the occupation of Paris. After a gruelling unsuccessful attempt to leave France together by car, Ady decided to remain in Paris and Man Ray finally fled the country alone. This very short film of 1938 takes place in the Val-de-Grâce studio and shows Man Ray at his most relaxed. Wearing only a short wrap-around skirt, he smokes and paints, whilst Ady sits in the background. The placement of the camera suggests a desire to capture the idyllic domestic scene and the feeling of calm that was a key element of his relationship with Ady and to which he refers frequently in his memoirs. The intimacy with which Man Ray films himself and his surroundings is characteristic of his use of film toward the end of the 1930s, moving gradually away from the spirit of visual experimentation that one finds in the earlier works.

Dance (1938, 8mm, 7 mins 33, black and white, silent)

In all of the films discussed so far in this section, the people featured have been close friends of Man Ray – identifiable figures from the world of art and literature, as well as lovers and muses. In contrast, the piece entitled *Dance*, also of 1938, has a more anonymous feel; the dancer does not appear in any of Man Ray's other work, as is usually the case with the women in his films – Kiki, Lee Miller, Meret Oppenheim, Nusch Eluard, Ady, Juliet and even Marie-Laure de Noailles. Also, unlike the rest of his cinematic essays

and home movies, the dancer's body is objectified and sexualised, the framing frequently excluding the head from the shot. However, there are obvious links here with *Le Retour à la raison* and *Emak Bakia*, in which Man Ray isolates body parts such as the torso, legs and face, creating, to quote his description of *Emak Bakia* 'a whole that still remains a fragment.'[44] Although it expresses a similar fascination with the female form, *Dance* lacks the aesthetic stylisation of these early films and of Man Ray's photography in general. Indeed, the straightforward documentary style of the film – admittedly a characteristic of most of these more amateur 16mm works – makes it feel like a filmed audition. The woman, probably a professional dancer, performs her routine in front of the static camera, occasionally moving backwards to reveal her face as she looks directly at the lens. It is the dance itself that takes precedence, with the camera simply acting as a mediator and documentor of the spectacle. Nonetheless, *Dance* emphasises a recurring theme in Man Ray's work, one which is ultimately related to the expressive power of rhythm and movement, bringing us back to his pre-cinematic works *Moving Sculpture*, *The Rope Dancer Accompanies Herself With Her Shadows* and *Danger/Dancer*.

The rest of the film seems to bear no relation to this dance sequence and was evidently carried out as a separate piece. This time it features Man Ray, again acting out a number of sketches, but without the humour of some of the earlier pieces. In a series of shots, we see him walking into the frame, sitting down, making phone calls and writing on a sheet of paper (which at one point he picks up and kisses). Although there is little of aesthetic interest in these disparate scenes, it is interesting to note this is the first and only time that Man Ray presents himself alone in front of the camera, providing a fleeting autobiographical insight.

Juliet (circa 1940, 8mm, 3 mins 43, black and white, silent)

Shortly after arriving in California at the beginning of the 1940s, Man Ray was introduced to Juliet Browner, the woman with whom he returned to Paris and in whose company he would remain until his death in 1976. The important role played by Juliet in the latter half of Man Ray's career is demonstrated in the number of photographic works devoted to her image

throughout the 1940s and 1950s.[45] This short 8mm film, the only one to have been shot in Hollywood, is the last in a series of intimate portraits and cinematic experiments involving the key women in Man Ray's life. It is particularly reminiscent of the playfulness of the earlier films with Lee Miller and Meret Oppenheim, and involves the same interchange of roles. Juliet is first seen through a glass door out of which she subsequently emerges. The same action is repeated by Man Ray, who runs jokingly towards the camera and then proceeds to self-consciously act up in the same farcical manner as in *Autoportrait* and *Poison*. There is a sequence of Juliet dancing, but, unlike the earlier film, *Dance*, where the female form is provocatively sexual and sexual*ised*, these images maintain a respectful distance. Filmed in a long shot, Juliet's body is presented as a whole, moving away from the fragmentation of previous films.

Two Women (undated, 16mm, 4 mins 12, black and white, silent)

The final film in the discussion of Man Ray's short cinematic essays and experiments has been impossible to date, and a question mark still remains over its authorship. Despite the presence of female subjects, there is little in terms of its visual approach to link it with the artist. This issue is raised by Patrick de Haas in his account of this relatively unknown area of Man Ray's cinematic output:

> Malgré l'absence de générique, la quasi-totalité des films retrouvés attestent par la présence d'objets, de peintures ou d'amis, qu'ils ont bien, selon toute vraisemblance, été entièrement tournés par Man Ray. Un doute subsiste cependant pour le film intitulé 'Two Women'.[46]

> [Despite the absence of credits, almost all the films that have been found indicate, by the presence of objects, paintings and friends that they have, in all likelihood, been entirely shot by Man Ray. Some doubt remains, however, for the film entitled 'Two Women'.]

Although this statement is somewhat over-generalised, considering the similarly uncertain status of *Corrida* and the close collaborative nature of films such as *Autoportrait* and *Poison*, it does signal the danger of attributing

particular works to Man Ray simply because they are found in his personal collection. Indeed, points out De Haas, it seems more likely that *Two Women* was kept by Man Ray precisely in his role as collector and not as author of the work.

It centres on the sexual interaction between two women, also unknown from the rest of Man Ray's cinematic and photographic work. In a series of ten different shots, the film illustrates a variety of lesbian activities, which, through the deadpan, almost clinical manner in which they are approached, seem to aim more at demystification than titillation. Although the theme of lesbianism is suggested in a number of photographs, such as *Nusch et Ady* (1937), the direct, un-stylised and sexually explicit nature of the film contrasts with the subtle, delicate beauty of these works, and of Man Ray's depiction of the female form more generally. The situation is rendered ambiguous, however, when we consider Man Ray's photographic contribution to Benjamin Péret and Louis Aragon's collection of pornographic poems, *1929*.[47] The first of the four images, representing the section entitled 'Printemps', is almost identical to the first shot of *Two Women*, the tight framing on the sexual act immediately establishing the confrontational visual style common to the pornographic genre. Despite their explicit nature, the three remaining photographs, display Man Ray's compositional awareness and attention to line and form, giving the images an aesthetic interest that goes beyond their pornographic content. Like many of his works, soft focus creates visual ambiguity, and planes seem to merge, approaching a level of abstraction. It is, in the end, these observations that make the direct approach of *Two Women* incompatible with Man Ray's distinct pictorial style. That this film was found in his collection demonstrates that even if it was not his own work, it was nonetheless one that he undoubtedly admired for its daring and provocative representation of a subject that interested him immensely.

The films discussed in this chapter are extremely varied in terms of both their content and the spirit in which they were made. Not only do they cover a range of subjects, techniques and approaches, and involve numerous collaborations of various kinds, they also span more than twenty years of Man Ray's career. For this reason, it is impossible to approach them as anything other than an extremely disparate body of works existing on the margins of the four accepted examples of his cinematic production. Whilst

it would be unhelpful to try to incorporate these works fully into Man Ray's repertoire as a filmmaker, they should nonetheless be recognised as constituting an important part of his explorations into the medium and as significantly developing his ideas in this area. As I have tried to demonstrate in the above discussion, a surprising amount of observations can be drawn from them, which contribute to our knowledge of Man Ray's relationship with the cinema and the formal problems it poses. Along with the early collaborations with Duchamp and Léger, these films are, above all, a testimony to the complex role of the moving image in Man Ray's life and work.

Conclusion

Despite Man Ray's reticence and scepticism towards the cinema, his fascination with its creative potential cannot be overlooked. Indeed, this fascination is demonstrated in a number of works from his pre-cinematic period and is still evident beyond 1929 in the form of diverse collaborations, short cinematic essays and home movies, which also experiment with a range of formats, including the newly introduced 16mm and 8mm film. Like a number of his contemporaries (Fernand Léger, Marcel Duchamp, Hans Richter), he was curious to see how film could be used as an extension of emerging new ideas and techniques in painting and photography. The four films made by Man Ray during the 1920s reveal many of the hallmarks of modernism: a radical turn away from previous modes and means of expression, a rejection of 'objective' reality, and, most importantly, an exploration of form, structure and medium-specificity. In terms of independent, experimental forms of cinema, they are amongst the most historically significant, representing the first sustained example of an alternative mode of filmmaking or 'artists' film' as it would later become known. *Le Retour à la raison*, for example, is remarkable in the extent of its unconventionality, transgressing the norms of pre-planned construction, exhibition, spectatorship, and even, crucially, the traditional mechanical requirements of film production. *Emak Bakia*, a showcase of various cinematic techniques and optical effects, pushes these explorations further by pitching abstraction against figuration, objectivity against subjectivity, live action against animation and light against shadow, turning the film into a series of binary oppositions that challenge the norms of cinematic structure. The later films, *L'Etoile de mer* and *Les Mystères du Château du Dé*, build on the cinematic use of text, finding new ways to bring poetry into a relationship with both figurative and abstract images.

But it is as cinematic manifestations of Dada and Surrealism that Man Ray's films have gained notoriety, not surprisingly since these two

movements dominated artistic expression and subsequent critical discourse around avant-garde film. Man Ray played a key role in both Dada and Surrealism but also kept himself at a distance from aesthetic dogmas and the staunch political views of the Surrealists, demonstrating one of the most enlightening examples of simultaneous affinity and marginality. The fundamental differences between Dada and Surrealism – the undefined and impulsive nature of the former, with its declarations of nothingness and desire for destruction, contrasting with the academic, frequently doctrinal approach of the latter – often seem to disappear in Man Ray's work. Although he is positioned at the crossroads of Dada and Surrealism, making his art difficult to assess from any one standpoint, he also tests the creative boundaries of the movements themselves. Rather than fully adhere to the collective aims set out in various declarations and manifestos, the principles were incorporated into his own personal artistic program, often presenting an interpretation of the Dada and Surrealist approach from an entirely new angle.

Man Ray's pronounced aestheticism and his preoccupation with form aligns him with the purist tendencies of early twentieth century modernism, against which Dada and Surrealism were positioned. Both movements opposed the bourgeois introspection of modern art, with its insistence on form and its 'art for art's sake' leanings and pursued a more socially engaged, in Peter Bürger's words, 'integration of art into the praxis of life.'[1] What is most interesting about Man Ray is the way he allows these forces to co-exist within a single work. This study has therefore used this ambiguous position between the movements of Dada and Surrealism as a starting point for the discussion of Man Ray's films, which are regularly defined in relation to either or both discourses. The main focus has therefore been to understand Dada and Surrealism as overlapping tendencies within a sustained interest in film aesthetics, particularly as a form of moving photography. To define this approach more clearly, Man Ray's engagement with techniques associated with Dada and Surrealism derive specifically from a desire to explore the possibilities of film and not, as some have tended to argue, from a desire to explore the possibilities of Dada and Surrealism themselves.

As a result of this reassessment, emphasis has been shifted onto two main areas that have, up to now, received relatively little attention: the first

involves an understanding of the films as expressing fundamental aspects of Man Ray's artistic approach, allowing them to be viewed alongside his work in other media; the second is a consideration of how the films relate to each other, revealing recurring patterns and concerns that lead us to an awareness of an evolving cinematic sensibility. These two poles of enquiry – contextualising Man Ray's films within his work as an artist and exploring the way in which he develops a specifically cinematic 'voice' – have demonstrated a fluid interaction between his artistic and cinematic activity, reflected in the title of this book. It is precisely the way Man Ray uses film as an extension of painting, photography and sculpture, whilst at the same time delving into its inherent qualities, that makes the study of his cinematic period both a fascinating and indispensable undertaking.

What emerges as the most interesting and innovative aspect of Man Ray's filmmaking is the way his trans-artistic vision – perfectly highlighted in Neil Baldwin's comment quoted in the introductory chapter – facilitates an unprecedented dialogue between film and the other arts. This is best understood in the context of Man Ray's relationship with photography, an art form he became involved with, it should be mentioned, only in order to produce reproductions of his paintings. Thus, from very early in his career, one medium is defined in relation to another. The beginning of this book discusses Man Ray's use of industrial mechanical processes in his paintings and the removal of the mechanical apparatus associated with photography, thus reversing the traditional relationship between the artist and his materials. Man Ray's pioneering of the rayograph and aerograph techniques is perhaps one of the best examples of his artistic cross-fertilisation (as the introductory chapter highlights, Man Ray was delighted with the photographic quality of his airbrush paintings). Interdisciplinarity can also be detected in Man Ray's use of photography to provide documents of his objects and sculptures, posing the crucial question of exactly which medium we are dealing with when faced with such works – is it the object or the photograph of the object that constitutes the 'work' itself? Man Ray was aware of this paradoxical issue, once stating that he liked the reproductions of certain of his works so much that he would often destroy the original (sculpture) and keep the (photographic) document.

When Man Ray claimed that his original interest in the cinema was to put his photographic compositions into motion, he was suggesting not simply a two-way interrelationship between photography and the cinema, but also, in the case of *Le Retour à la raison* and *Emak Bakia*, a three-way fusion of photography, film and sculpture/collage. In these two films, the moving rayographs and light compositions are accompanied by a number of kinetic objects and drawings, some of which were created for the film and later became works in their own right, such as *Homme d'affaires*, *Fisherman's Idol* or *Emak Bakia*, or already existed before the making of the film, such as *Danger/Dancer*. In other cases – the paper spiral or the moving poem in *Le Retour à la raison* for example – an object in the film mimics a previous construction or recurring theme. In all of these areas, the principle concern lies in the merging of the qualities inherent to film with those of another medium, notably sculpture.

This artistic overlapping can be found on many levels, from Man Ray's 'painting with light' in *Emak Bakia* to his bringing together of cinema and architecture through the medium of poetry in *Les Mystères du Château du Dé*. The theme of dance, suggested by the choreographed movements of the characters and objects in that film can be threaded back to what Man Ray described as the 'epileptic dance' of drawing pins in *Le Retour à la raison*, the 'dance' of the shirt collars in *Emak Bakia*, not to mention the very literal reference to dance in the Charleston sequence of the same film. It is therefore possible to see how Man Ray creates an analogy between the art of dance and the kinds of movement the cinema is capable of creating, especially since his films are based largely on the principle of repetition interspersed with variation. As with the film on which he collaborated, *Ballet mécanique*, it is the ability of cinema to bring inanimate phenomena to life that seems to create the crucial link with dance.

Analysis of these films reveals a striking number of similarities on both a formal and thematic level, presenting the most important challenge to many previous studies in which they are separated along the lines of Dada and Surrealism. One finds a repetition of formal compositions, light patterns and iconography that sees Man Ray trying out the same ideas in different ways and in altered circumstances. Light is a key feature of *Le Retour à la raison* and *Emak Bakia*, but with *Les Mystères du Château du*

Dé Man Ray takes this interest further, moving from studio-based effects to natural light. Yet the visual outcome is consistent, with reflection and shadow remaining central components despite being brought into a dialogue with other concerns such as the exploration of cinematic space. Movement plays an important role in all the films, as does the binary image; both are also elements that characterise Man Ray's work in other areas, particularly photography. Often the films make direct references to each other, either verbally ('Etoile du jour' in *Les Mystères du Château du Dé*) or in the re-appearance of certain motifs and optical effects (the anamorphic lens that begins both *Emak Bakia* and *L'Etoile de mer*).

The films of Man Ray represent above all an exploration into vision, linking his practice with a dominant strand of avant-garde film theory of the 1920s (frequently referred to as Impressionism). However, his approach is unique in the sense that his starting point is the alteration of the way the world is perceived and understood. His primary means for achieving this is the interaction between abstraction and figuration, through which a path is created between the figural and the formless. The cinema was the perfect medium for this kind of exploration as it allowed Man Ray to make these transformations through time, allowing the image to oscillate between one mode of representation and another, such as the car headlights in *Les Mystères du Château du Dé*, the rotating objects in *Le Retour à la raison* or the sequences of light reflections and distortions in *Emak Bakia*, where the identity of the object constantly remains just out of reach. The repeated use of superimposition extends his explorations into vision since the technique is rarely used in his photography. Again, his interest clearly lay in the way superimpositions could be made through time, gradually transforming and developing visual perception, as is the case with the egg crate in *Le Retour à la raison*, the multiple feet dismounting a car and the swimming fish in *Emak Bakia*, and the opening shots of the villa in *Les Mystères du Château du Dé*.

The emphasis on vision is therefore intricately tied to an investigation into the mechanics and materiality of the cinema. Throughout his films Man Ray draws attention to the process of filmmaking and its ability to transform vision, giving rise to the notion of reality as a construct. This 'reality', as it is seen in these films, far from being fixed and determined, is

rather in a constant state of flux, giving rise to a new experience with every camera angle, movement, change of focus, framing, light effect or other technical manipulation. The inherent qualities of the cinema open up a field of possibilities for Man Ray's fascination with reality and its representation. This sensibility does not equate, however, to a straightforward veneration of the cinema and its technical possibilities, and in his discussions about art he commented on a number of occasions that the artist must feel a 'certain contempt' for the material that he chooses for the expression of an idea.[2] His first film *Le Retour à la raison* seems to express such a position and challenges the conventional forms of vision offered by the cinema, introducing an approach to reality that radically departs from previously accepted notions of representation. As with photography, the rejection of the camera – the mechanical basis of the medium – mirrors the way in which artists of the early twentieth century moved away from the reliance on the traditional materials of visual representation such as paint and paintbrushes in order to expand the parameters of creative expression. It is from this perspective that Man Ray's approach can be understood in terms of injecting a Dada sensibility into a purist conception of the cinema, a relationship to which this book has attempted to draw attention.

Man Ray's critical view of the cinema was based largely on its dependence on narrative, a position that can be related to similar criticisms of film's subservience to literary modes of storytelling by the some of the Impressionist filmmakers, most notably Germaine Dulac. Nonetheless, another fundamental difference between him and these early filmmakers can be found within his general disinterest in theory. It has already been mentioned that Man Ray was a pragmatist and reacted to things as they affected him directly. He did not seek consistency in his approach to art and life but rather concentrated his interest on the expression of immediate thoughts and feelings. To this end, he has stated that what he most abhors in narrative film is the repetition, the banality and, above all, the length. He refers to being bored, constructing distorting glasses that transform the image into something magical and stimulating; yet he denied that his relationship to the cinema resembled anything like a purist approach and did not, unlike the first wave of avant-garde filmmakers, pursue the medium as an independent art form. Although his films explore certain medium-specific

qualities such as movement and rhythm, he once spoke of his ideal form of cinematic expression as involving elements not strictly associated with the cinema itself, but with a more general notion of verisimilitude:

> Dans les années 20, j'ai fait des films en noir et blanc, non pas parce que j'étais puriste, mais parce que la couleur n'existait pas. Je ne suis pas un puriste. Si je faisais un film maintenant je ferais un film en couleurs et en trois dimensions, qui remplacerait le théâtre lui-même. En trois dimensions! Il faudrait que le film donne les odeurs, en même temps que le son, et puis le chaud et le froid, évidemment.[3]

> In the 1920s, I made films in black and white, not because I was a purist, but because colour did not exist. I am not a purist. If I made a movie now I would make a film in colour and 3D, which would replace the theatre itself. In three dimensions! The film should also create smells, along with the sound, and make heat and cold, clearly.

So whilst we can compare certain aspects of his cinematic sensibility to contemporaneous avant-garde film theory, it ultimately remains idiosyncratic in its ambiguity, not to mention its tendency towards contradiction. Although his statement seems intentionally controversial, it nonetheless highlights his fascination with reality and its representation, an element that threads throughout his films, where the line of resemblance between an object and its pictorial representation is frequently blurred.

The year 1929 was, for Man Ray, the final stage of his status as a professional filmmaker, even it by no means represented the end of his involvement with the medium. In his autobiography, he explains his increasing ambivalence towards the cinema as an art form and his final reluctance to continue his explorations into this area following the making of Richter's *Dreams That Money Can Buy*:

> A book, a painting, a sculpture, a drawing, a photograph, and any other concrete object are always at one's disposition, to be appreciated or ignored, whereas a spectacle before an assemblage insists on the general attention, limited to the period of its presentation. Whatever appreciating and stimulation may result in the latter case is influenced by the mood of the moment and of the gathering. I prefer the permanent immobility of a static work which allows me to make my deductions at my leisure, without being distracted by attending circumstances.[4]

Tracing a line from the first references to the cinema and movement in his early works, through his initial experiments with kinetic rayography and rotating objects, to the final turn away from film, the paradoxical connotations of this comment become clear. If the temporal quality of the cinema provided the initial stimulus for Man Ray's explorations into the medium, allowing him to set his photographic compositions in motion, it was also precisely this characteristic that prevented him from further incorporating it into his artistic repertoire.

It would be difficult to overestimate the impact of Man Ray's cinematic work on subsequent generations of avant-garde film artists. His explorations into movement, light and form, as well as his fascination with the medium's mechanical apparatus and material substrate, have made him one of the most influential figures in the history of experimental filmmaking. In an era that regularly predicts the death of film in the face of new digital technologies, these early works continue to serve as a model for artists working within celluloid-based expression, particularly in the camera-less films of contemporary filmmakers such as David Gatten and Jeanne Liotta. Here, the hand of the artist – the 'main' or Man – leaves its indelible trace.

Notes

Introduction

1 In J.-M. Bouhours and P. De Haas (eds), *Man Ray: directeur du mauvais movies*, Paris: Centre Pompidou, 1997, p. 7.

2 Man Ray's relationship with photography was complex. Although it was the medium through which he earned a living and gained artistic credibility, he regretted the fact that his painting did not attract equal attention. He particularly resented being labelled a photographer and frequently made pejorative remarks about the medium. In a small book entitled *La photographie n'est pas l'art* (*Photography is Not Art*), published in 1937 with André Breton he outlines some of the major issues related to the medium, arguing for its inherent artificiality. At other times, he attempted to highlight the artistic merits of photography by placing it on equal terms with painting: 'The problem of similarity between painting and photography has never worried me. As far as I am concerned there is no problem, since photography, like drawing or engraving, is part of the art of painting; only the tools differ.' Quoted in A. Schwarz, *Man Ray: The Rigour of Imagination*, London: Thames and Hudson, 1977, p. 228.

3 For an overview of how Man Ray's films are discussed in the context of the avant-garde, see, for example: J.B. Brunius, *En marge du cinéma français*, Lausanne: Editions L'Age d'Homme, 1987; D. Curtis, *Experimental Cinema: A Fifty Year Evolution*, London: Studio Vista, 1971; S. Dwoskin, *Film is ... The International Free Cinema*, London: Owen, 1975; R.E. Kuenzli (ed.), *Dada and Surrealist Film*, Cambridge, MA: MIT Press, 1996; S. Lawder. *The Cubist Film*, New York: New York University Press, 1975; B. Lindemann, *Experimental Film*, Hildesheim: Georg Olms, 1977; R. Manvell, *Experiment in the Film*, London: Grey Walls, 1949; M. O'Pray, *Avant-Garde Film: Forms, Themes and Passions*, London and New York: Wallflower Press, 2003; P. Adams Sitney, *The Avant-Garde Film: A Reader of Theory and Criticism*, New York: New York University Press, 1978.

4 N. Baldwin, *Man Ray: American Artist*, Cambridge, MA: Da Capo Press: 1988, p. xiii.

5 In P. Bourgeade, *Bonsoir Man Ray*, Paris: Maeght éditeur, 2002, p. 49.

6 Bouhours and De Haas (eds), *Man Ray: directeur du mauvais movies*, p. 13.

7 The aerograph technique (or 'airbrush painting'), with which Man Ray experimented during the period 1916–19, is the adaptation of an industrial process for the quick application of paint over a large surface using a spray gun connected to a compressed tank. Used in painting, airbrushing gives the picture a smooth perfection and eradicates any sign of the artist's hand, a detail that appealed particularly to Man Ray's unconventional artistic approach.

8 See for example the section on 'Suspensions in time and space' in Chapter 1.

9 This is especially the case in the field of avant-garde developments. Edward A. Aitken, in an article on Dada and the cinema, refers to the presence of cinematic references in the works of Dada poets such as Tristan Tzara. 'Reflections on Dada and the Cinema', *Postscript: Essays in Film and the Humanities*, 3, 2 (1984), p. 5. The Dada leader's interest in the poetic potential of film can be seen in the circumstances surrounding the making of Man Ray's first film, *Le Retour à la raison* in 1923.

10 The use of colour to suggest movement was a dominant tendency in early modern art and can be seen in the work of a number of painters, such as Frank Kupka, Robert and Sonia Delaunay. See F. Popper, *L'Art cinétique*, Paris: Gauthier-Villars, 1967.

11 Roland Barthes effectively theorises the notion of photographic reality in *Camera Lucida: Reflections on Photography*, trans. Richard Howard, London: Flamingo, 1984. For more discussion on the nature of photographic representation see also S. Sontag, *On Photography*, New York: Farrar, Straus and Giroux, 1977.

12 For this latter work, Man Ray provided 'do-it-yourself' instructions, enabling anyone to reproduce the same piece of work. This is significant in the way it draws attention to the process of creation and repudiates the idea of a 'unique' work of art. It also highlights the use of common household items as basic material and a simple, 'non-artistic', method of construction. Like Duchamp's readymades, Man Ray's work in this area came to represent one of the defining characteristics of Dada.

13 Baldwin, *Man Ray: American Artist*, p. 96.

14 A. Schwarz, *Marcel Duchamp*, New York: Abrams, 1975, p. xxx.

15 Man Ray, *Self Portrait*, Boston: Bullfinch Press, 1998, p. 62.

16 An interesting element of circularity can be detected here since the musical accompaniment to Man Ray's third film, *L'Etoile de mer*, includes a piece that was originally recorded for the film *Zouzou*, made by Allégret in 1934. See the section entitled 'Musical accompaniment' in Chapter 3.

17 Judi Freeman offers an overview of this situation in 'Bridging Purism and Surrealism: The Origins and Production of Fernand Léger's *Ballet Mécanique*',

in R.E. Kuenzli (ed.), *Dada and Surrealist Film*, pp. 28–45. See also W. Moritz, 'Americans in Paris: Man Ray and Dudley Murphy', in J.C. Horak (ed.), *Lovers of Cinema: The First American Film Avant-garde, 1919–1945*, Madison, WI: University of Wisconsin Press, 1995, pp. 118–36.

18 This seems to be backed up by Man Ray in his autobiography. Although he plays down his involvement in the project, he does describe making a number of shots with Dudley Murphy before the latter entered into collaboration with Léger, who had agreed to finance the film. It is likely that these shots found their way into the final film. Man Ray, *Self Portrait*, p. 218.

19 Man Ray, 'Témoignages', in *Surrréalisme et cinéma*, special issue of *Etudes Cinématographiques*, 38–9 (1965), p. 43.

20 F.M. Neüsuss, 'From Beyond Vision: Photograms by Christian Schad, Man Ray, László Moholy-Nagy, Raoul Hausmann', in F.M. Neüsuss, T. Barrow and C. Hagen, *Experimental Vision: The Evolution of the Photogram Since 1919*, Denver Art Museum, Colorado: Roberts Rhinehart Publishers, 1994, p. 10.

21 R. Fotiade, 'Spectres of Dada: From Man Ray to Marker and Godard.' Paper delivered at the International Dada Conference, 'Eggs laid by Tigers': Dada and Beyond, Swansea University, 5–8 July 2006.

22 Man Ray in an interview with Arturo Schwarz, 'This is not for America', *Arts Magazine*, 51 (May 1977), p. 117.

23 In Bourgeade, *Bonsoir Man Ray*, p. 123.

24 J.H. Matthews, *Surrealism and Film*, Ann Arbor: The University of Michigan Press, 1971, p. 84.

25 Some of Léger's comments about film are published in F. Léger, *Functions of Painting*, trans. Alexandra Anderson and ed. Edward. F. Fry, New York: The Viking Press, 1973. See also his articles, 'Dada and the Film', in W. Verkauf (ed.), *Dada: Monograph of a Movement*, Teufen, Switzerland: Arthur Niggli, 1957, pp. 39–43, 'The Badly Trained Soul' and 'Film as an Independent Art Form', in W. Schobert (ed.), *The German Avant-Garde Film of the 1920s*, Munich: Goethe-Institute, 1989, pp. 106–14.

26 Quoted in Elizabeth Hutton Turner, 'Transatlantic', in M. Foresta (ed.), *Perpetual Motif: The Art of Man Ray*, New York: Abbeville Press, 1988, p. 161.

27 In Schwarz's *Man Ray: Rigour of the Imagination*, for example, the chapter on filmmaking is little more than a series of quotes from the autobiography, with very little additional analysis.

28 J. Livingston, 'Man Ray and Surrealist Photography', in R. Krauss and J. Livingston (eds), *L'Amour fou: Photography and Surrealism*, New York and London: Abbeville Press, 1985, p. 120.

29 Schwarz, *Man Ray: The Rigour of Imagination*, p. 286.

30 Aitken, 'Reflections on Dada and the Cinema', p. 13.

31 Accounts of Dada and Surrealism tend to treat the two movements in terms of an
 unproblematic progression from one to the other, with Dada being understood
 as the natural precursor of Surrealism. Hans Richter, for example, states: 'Neither
 Dada nor Surrealism is an isolated phenomenon. They cannot be separated; they
 are necessary conditions of one another – as a beginning must have an end, and
 an end a beginning. They are basically a single coherent experience reaching
 like a great arch from 1916 until about the middle of the Second World War.'
 Richter, *Dada: Art and Anti-art*, London: Thames and Hudson, 2001, p. 165.
 However, as some critics have pointed out, this perspective is misleading since
 it privileges the Dada-Surrealism connection over other directions taken by a
 number of artists associated with Dada. See, for example, D. Hopkins, *Dada and
 Surrealism: A Very Short Introduction*, Oxford: Oxford University Press, 2004,
 pp. 26–8; J. Elderrfield, 'On the Dada-Constructivist Axis', *Dada/Surrealism*,
 13 (1984), p. 5.

32 For example, Frank Manchel's wide survey of film history, *Film Study: An
 Analytical Biography Volume 3* refers to Man Ray's first three films as demon-
 strating 'intriguing cubist imagery.' There is no mention at all of *Les Mystères
 du Château du Dé* despite the fact that the film demonstrates similar visual
 characteristics. London and Toronto: Associated University Presses, 1990.

33 H. Weihsmann, *Cinetecture: Film, Architektur, Moderne*, Vienna: PVS Verleger,
 1995, p. 85.

34 I. Hedges, 'Constellated Visions: Robert Desnos's and Man Ray's *L'Etoile de
 mer*', in Kuenzli (ed.), *Dada and Surrealist Film*, p. 107.

35 In P. Hill and T. Cooper, 'Camera-Interview', *Camera*, 54 (February 1975),
 p. 24.

Chapter 1

1 Beginning with Francis Picabia's public denoucement of Dada in the special issue
 of his journal *391*, entitled *Pilhaou-Thibaou*, the year 1921 saw a series of public
 attacks and counter-attacks between Picabia, Tzara and Breton. M. Sanouillet,
 Dada à Paris, Paris: CNRS Editions, 2005, pp. 250–9.

2 Ibid., p. 260.

3 Man Ray, *Self Portrait*, Boston: Bullfinch Press, 1998, p. 96.

4 Ibid., pp. 212–13.

5 M. Dachy, *Journal du Mouvement Dada 1915–1923*, Geneva: Albert Skira, 1989, p. 154.

6 T. Elsaesser, 'Dada/Cinema?', in R.E. Kuenzli (ed.), *Dada and Surrealist Film*, Cambridge, MA: MIT Press, 1996, p. 15.

7 D. Dusinberre, '*Le Retour à la raison*: Hidden Meanings', in B. Posner (ed.), *Unseen Cinema: Early American Avant-Garde Film 1893–1941*, New York: Anthology Film Archives, 2001, p. 65.

8 Quoted in A. Schwarz, *Man Ray: The Rigour of Imagination*, London: Thames and Hudson, 1977, p. 291.

9 P. Weiss, *Cinéma d'avant-garde*, trans. Catherine de Seynes, Paris: L'Arche Editeur, 1989, p. 23.

10 Kuenzli (ed.), *Dada and Surrealist Film*, p. 3.

11 A. Thiher, *The Cinematic Muse: Critical Studies in the History of French Cinema*, Columbia: University of Missouri Press, 1979, p. 38.

12 B. Rose, 'Kinetic Solutions to Pictorial Problems: The Films of Man Ray and Moholy-Nagy', *Artforum* (September 1971), p. 70.

13 Ibid., p. 70.

14 N. Gambill, 'The Movies of Man Ray', in *Man Ray: Photographs and Objects*, Birmingham, AL: Birmingham Museum of Art, 1980, p. 30.

15 A. Kyrou, *Le Surréalisme au cinéma*, Paris: Le Terrain Vague, 1963, pp. 174–5.

16 C. Lebrat, 'Attention danger! Le Retour à la raison, ou la leçon de Man Ray', in N. Brenez and C. Lebrat (eds), *Jeune, Dure et Pure! Une Histoire du Cinéma d'Avant-garde et Expérimental en France*, Paris: Cinémathèque française, 2001, p. 91.

17 R. Huelsenbeck, *Memoirs of Dada Drummer*, trans. Joachim Neugroschel, Berkeley: H.J. Kleinschmidt, 1991, p. 137.

18 H. Ball, *Flight Out of Time: A Dada Diary*, trans. Ann Raimes and ed. John Elderfield, New York: Viking Press, 1974, p. 58.

19 Although Tzara did not enter into correspondance with Francis Picabia and André Breton until 1919, he had been exchanging letters with the poet Guillaume Apollinaire since the end of 1916. M. Dachy, *Journal du Mouvement Dada*, p. 127.

20 Hans Richter, *Dada: Art and Anti-art*, London: Thames and Hudson, 2001, p. 171.

21 Ibid.

22 R.E. Kuenzli (ed.), *New York Dada*, New York: Willis, Locker and Owens, 1986, p. 1.

23 Ibid.

24 Picabia, quoted in Kuenzli (ed.), *New York Dada*, p. 3.

25 Kuenzli (ed.), *New York Dada*, p. 4.

26 Letter from Tristan Tzara reprinted in the journal *New York Dada* (April 1921), p. 2. This reference to God is not insignificant given Tzara's megalomaniacal character and the powerful influence he exerted over the direction taken by Dada in Paris.

27 Letter from Man Ray to Tristan Tzara, reproduced in Bouhours and De Haas (eds), *Man Ray: directeur du mauvais movies*, Paris: Centre Pompidou, 1997, pp. 8–9. Man Ray's comment that 'all New York is dada' is echoed in Kenneth Burke's 1925 article, in which he states, 'America is Dada in its actual mode of life, and has produced popular artists to express this Dada. The French Dadas express rather a reaction against their old, well-ordered system and look to the chaotic conditions in America with relief.' First published in *Aesthete* (February 1925) and reprinted in Kuenzli (ed.), *New York Dada*, p. 124.

28 Man Ray had used the same signature in Francis Picabia's guest book canvas *L'oeil cacodylate* (1921). 'I had added prophetically, Director of Bad Films – written in bad French – as a Dada gesture. Or was it in memory of my recent abortive experience with Duchamp in New York?' Man Ray, *Self Portrait*, p. 213.

29 In Man Ray's brief account of this film, he refers simply to 'a nude model.' Ibid.

30 The fundamental incompatibility of Dada with America is a theme to which Man Ray would return throughout his life. In an interview with Arturo Schwarz he stated: 'You see, the idea of scandal and provoking people, which is one of the principles of Dada, was entirely foreign to the American spirit. That's why I said Dada and Surrealism do not belong here.' In A. Schwarz, 'This is Not for America', *Arts Magazine*, 51 (May 1977), pp. 117–18.

31 Man Ray, *Self Portrait*, p. 213.

32 Ibid., pp. 86–7.

33 T. Elsaesser, 'Dada/Cinema?' in Kuenzli (ed.), *Dada and Surrealist Film*, pp. 13–14.

34 J. Elderfield, 'On the Dada-Constructivist Axis', *Dada/Surrealism*, 13 (1984), p. 9.

35 For an overview of the emergence of video and performance art see D. Bloch, *Art et Vidéo 1960/1980–2*, Locarno, Switzerland: Edizioni Flaviana, 1982; M. Rush, *New Media in Art*, London: Thames and Hudson, 2004.

36 For a discussion of the links between Dada and Fluxus in the realms of performance art see M. Kirby, 'Happenings: An Introduction', in M.R. Sandford (ed.), *Happenings and Other Acts*, London: Routledge, 1995, pp. 1–28.

37 Elsaesser, 'Dada/Cinema?', p. 19.

38 This aspect of Dada film has gone largely unnoticed in previous studies.
 M. Gordon's edited volume, *Dada Performance*, New York: PAJ Publications,
 1987, for example, completely overlooks the status of film within the context of
 the Dada performance, despite references to the 'Soirée du Coeur à barbe' and
 Francis Picabia's Swedish Ballet, *Relâche*, which took place on 4 December 1924
 and for which René Clair's film *Entr'acte* was made.

39 Man Ray, *Self Portrait*, p. 213. However, most accounts of the soirée do not men-
 tion Man Ray's film as the source of the outbreak of disputes in the theatre, but
 underline the volatile relationships between various members of the group as
 giving rise to the violence with which it is forever associated. Hans Richter, for
 instance, quotes Georges Hugnet's recollections of the evening: 'When the time
 came for the performance of *Le Coeur à gaz*, the actors [...] were suddenly inter-
 rupted by violent protests from the stalls. Then an unexpected interlude: Breton
 hoisted himself on to the stage and started to belabour the actors [...] Hardly had
 order been restored when Eluard climbed on to the stage in his turn. This action
 seemed surprising in one who was a friend of Tzara. But the members of the
 audience were not concerned with such subtleties and the author of *Répétitions*
 was at once leapt on by a group of spectators inflamed by the preceding rough
 and tumble.' Richter, *Dada: Art and Anti-art*, p. 190. See also M. Sanouillet,
 Dada à Paris, pp. 337–8.

40 P. Bürger, *Theory of the Avant-Garde*, trans. Michael Shaw, Minneapolis:
 University of Minnesota Press, 1984, p. 49.

41 Man Ray, *Self Portrait*, p. 79.

42 F. Léger, 'Speaking of Cinema', in *Functions of Painting*, trans. Alexandra Anderson
 and ed. Edward F. Fry, New York: The Viking Press, 1973, p. 103.

43 A number of more recent writings on avant-garde film theory have challenged
 these categories, arguing that they present too restricted a view on the diversity
 of perspectives and practices. P. Adams Sitney, for example, believes that they
 'perpetuate a distorted picture of this period.' *Modernist Montage: The Obscurity
 of Vision in Cinema and Literature*, New York: New York University Press, 1978,
 p. 101. See also R. Abel's problematisation of the terms 'First Avant-Garde' and
 'Impressionist Cinema', in *French Cinema: The First Wave, 1915–1929*, Princeton,
 NJ: Princeton University Press, 1984, pp. 279–86. Further discussion can also
 be found in his edited volume, *French Film Theory and Criticism, 1907–1939*.
 Volume 1 1907–29, Princeton, NJ: Princeton University Press, 1988.

44 Louis Feuillade, quoted in Abel, *French Film Theory and Criticism*, p. 200.

45 Abel, *French Film Theory and Criticism*, p. 202.

46 Ibid.

47 Quoted in Abel, *French Film Theory and Criticism*, p. 206.

48 J. Epstein, 'De quelques conditions de la photogénie', *Cinéa-ciné pour tous*, 19 (15 August 1924). Reprinted in Abel, *French Film Theory and Criticism*, p. 314.

49 G. Dulac, 'L'Essence du cinéma: l'idée visuelle', *Les Cahiers du mois*, 16/17 (1925), pp. 57–66. Translated by Robert Lamberton and reprinted as 'The Essence of Cinema: The Visual Idea', in P. Adams Sitney (ed.), *The Avant-Garde Film: A Reader of Theory and Criticism*, New York: New York University Press, 1978, pp. 36–42.

50 René Clair, whilst evoking the contradiction between the notion of 'pure cinema' and the material concerns and industrial organisation required to make a film, states that, 'a film fragment becomes pure cinema as soon as a sensation is aroused in the viewer by purely visual means.' R. Clair, 'Cinéma pur et cinéma commercial', *Cahiers du mois*, 16/17 (1925), pp. 89–90. Translated by Stanley Appelbaum and reprinted as 'Pure Cinema and Commercial Cinema', in Abel (ed.) *French Film Theory and Criticism*, pp. 370–1.

51 The use of accelerating montage became such a frequent quality of films of the period that Jean Epstein complained about its over-use in his article 'For a New Avant-Garde', stating 'Nineteen twenty-four has already begun, and in a month four films using breakneck editing have already been shown. It's too late; it's no longer interesting; it's a little ridiculous.' Originally published in *Cinéa-ciné pour tous*, 29 (15 January 1925). Reprinted in Abel, *French Film Theory and Criticism*, p. 349.

52 Kuenzli (ed.), *Dada and Surrealist Film*, p. 10.

53 Both the Dadaists and Surrealists were influenced by early silent comedy, particularly Charlie Chaplin, Buster Keaton and the slapstick chase films of Mack Sennett. Chaplin in particular was highly praised by the Surrealists (as well as proponents of Impressionist cinema, such as Delluc and Epstein) and frequently featured in the writings of Robert Desnos and André Breton amongst others.

54 Although this term seems to centre on American filmmaking, it refers to a wider international tendency of pre-war filmmaking. See K. Thompson and D. Bordwell, *Film History: An Introduction*, New York: McGraw-Hill, 1994, p. 39.

55 N. Ghali, *L'avant-garde cinématographique en France dans les années vingt: idées, conceptions, théories*, Paris: Editions Paris Expérimental, 1995, p. 258.

56 M.A. Foresta, 'Listening to Light', in Man Ray, *Man Ray*, London: Thames and Hudson, 1989, p. 8.

57 T. Gunning, 'The Cinema of Attractions: Early Film, Its Spectator and the Avant-Garde', in T. Elsaesser (ed.), *Early Film: Space, Frame, Narrative*, London: BFI, 1990, p. 57.

58 Ibid., p. 58.

59 S. Eisenstein, 'Montage of Attractions' in *Film Sense*, trans. and ed. Jay Leyda, London: Faber and Faber, 1968, p. 181.

60 Elza Adamowicz refers to this as one of the most important aspects of Dada and Surrealist film, in which the filmmaker, in cinematically cutting up the female body, plays the role of magician. E. Adamowicz, 'Bodies Cut and Dissolved: Dada and Surrealist Film', in J. Williams and A. Hughes (eds), *Gender and French Film*, Oxford: Berg, 2002, p. 22.

61 Christian Metz has argued that the history of narrative cinema has given rise to a conditioned state of mind in the viewing subject. He refers to this as the 'mental machinery' of cinema, which 'adapts [the audience] to the consumption of film.' *The Imaginary Signifier: Psychoanalysis and the Cinema*, trans. Celia Britton et al., Bloomington: Indiana Press, 1982, p. 7.

62 D. Macrae, 'Painterly Concepts and Filmic Objects', in D. Scheunemann (ed.), *European Avant-Garde: New Perspectives*, Amsterdam and Atlanta, GA: Rodopi, 2000, pp. 152–3.

63 T. Gunning, 'An Aesthetic of Astonishment: Early Film and the (In)credulous Spectator', in L. Braudy and M. Coen (eds), *Film Theory and Criticism: Introductory Readings* (5th edn), New York and Oxford: Oxford University Press, 1999, p. 825.

64 Surrealist automatism was largely inspired by André Breton's readings of Sigmund Freud and Pierre Janet, both of whom had written about the therapeutic effects of free association in which the hypnotised patient speaks in a 'stream-of-consciousness'-like dialogue. Chapter 2 discusses the Surrealists' creative use of automatism in more detail.

65 T. Tzara, 'Dada Manifesto 1918' in *Seven Dada Manifestos and Lampisteries*, trans. Barbara Wright, London: Calder, 1992, p. 3.

66 Man Ray, *Self Portrait*, p. 60.

67 Tzara, *Seven Dada Manifestos and Lampisteries*, p. 39.

68 Man Ray, *Champs délicieux*, Paris: Société Générale d'Imprimerie et d'Edition, 1922.

69 A. Breton and P. Soupault, *Les Champs magnétiques*, Paris: Au Sans Pareil, 1920.

70 Man Ray, *Self Portrait*, p. 106.

71 J. Svenungsson, 'The Making of Man Ray', in *Man Ray*, Stockholm: Moderna Museet, 2004, p. 31. See also E. De l'Ecotais, 'Man Ray: An American in Paris', in S. Levy (ed.), *A Transatlantic Avant-Garde: American Artists in Paris, 1918–1939*, Berkeley: University of California Press, 2003, pp. 139–41.

72 Karel Teige, for example, referred to one of Man Ray's Rayographies as 'un poème de lumière parfait.' K. Tiege, 'Le Cas Man Ray', *Zivot*, 2 (1922). Reprinted in E. De l'Ecotais, *Man Ray: Rayographies*, Paris: Editions Leo Scheer, 2002, p. 169.

73 Man Ray, *Self Portrait*, p. 212.

74 Interestingly, the Austrian filmmaker Peter Kubelka would later bring together the arts of film and cookery through an equal interest and committment to them both in his writings. See C. Lebrat, *Peter Kubelka*, Paris: Editions Paris Expérimental, 1990.

75 Solarization, or the 'Sabatier Effect', refers to a technique whereby the photographic plate is briefly exposed to light during the developing process, creating a reversal of tones so that part of the negative image appears as positive. In Man Ray's solarized photographs, the image appears with a dark black outline around the edges, giving rise to a kind of halo-effect.

76 Man Ray in a televised interview, *Man Ray, photographe*, directed by Claude Fayard and produced by Michel Tournier for the series 'Chambre noire', 1961.

77 Man Ray, *Self Portrait*, p. 211.

78 M. O'Pray, *Avant-Garde Film: Forms, Themes and Passions*, London and New York: Wallflower Press, 2003, p. 19.

79 Schwarz, *Man Ray: The Rigour of Imagination*, p. 288.

80 A. Breton, *Les Vases communicants*, Paris: Gallimard, 1955, p. 65. Translation from P. Waldberg, *Surrealism*, London: Thames and Hudson, 1965, p. 21.

81 Man Ray, 'Témoignages', in *Surréalisme et cinéma*, special issue of *Etudes Cinématographiques*, 38–9 (1965), p. 43.

82 J. Livingston, 'Man Ray and Surrealist Photography', in R. Krauss and J. Livingston (eds), *L'Amour fou: Photography and Surrealism*, New York and London: Abbeville Press, 1985, p. 128.

83 Elderfield, 'On the Dada-Constructivist Axis', p. 6.

84 This tendency is most expressed in German Dada, especially in the abstract work of Jean Arp and the Hanover-based Kurt Schwitters, as well as Richter. In September 1922 Richter, Hausmann, Tzara, Arp and Schwitters attended the 'Dada-Constructivist Congress' in Dusseldorf, where they made contacts with Constructivist artists, Theo van Doesburg, László Moholy-Nagy and El Lissitsky. Elderfield, 'On the Dada-Constructivist Axis', p. 12.

85 E. Sellin. '"Le chapelet du hazard": Ideas of Order in Dada-Surrealist Imagery', *L'Esprit Créateur*, 2, 4 (Summer 1980), p. 25.

86 Ibid., p. 23.

87 T. Tzara, 'Dada Manifesto 1918', p. 7.

88 The skin-screen metaphor is the focus of Haim Finkelstein's *The Screen in Surrealist Art and Thought*, Aldershot: Ashgate, 2007. The relation of the cinema to the

body more generally is a characteristic of a number of recent contributions to the field of film theory: M. Beugnet, *Cinema and Sensation: French Film and the Art of Transgression*, Edinburgh: Edinburgh University Press, 2007; S. Shaviro, *The Cinematic Body*, Minneapolis: University of Minnesota Press, 1993. Although there is not space here to fully consider such questions in relation to Man Ray's filmmaking, it should be noted that all four films draw attention to the cinematic body.

89 In Bourgeade, *Bonsoir Man Ray*, p. 99.

90 Man Ray probably constructed the sculpture whilst staying with Arthur Wheeler during the filming of *Emak Bakia*. It features in the same film and is discussed in Chapter 2.

91 The difference between the artistic approaches of Man Ray and Marcel Duchamp is rarely explored in detail. The two artists are often seen as expressing similar concerns through more or less the same means. Barbara Rose, for instance, has argued that, 'it is impossible to disengage Man Ray's career from Duchamp's.' B. Rose, 'Kinetic Solutions to Pictorial Problems: The Films of Man Ray and Moholy-Nagy', p. 69. For an in-depth account of the differing ways in which language is used in their work see R. Pincus-Witten, 'Man Ray: The Homonymic Pun and American Vernacular', *Artforum* (April 1975), pp. 54–8.

92 Man Ray, 'Answer to a Questionnaire', *Film Art*, 3, 7 (1936), p. 9.

93 In Bourgeade, *Bonsoir Man Ray*, p. 70.

94 G. Lukács, quoted in Elsaesser, 'Dada/Cinema?', p. 21.

95 D. Dusinberre, 'Sens et non-sens', in Bouhours and De Haas (eds), *Man Ray: directeur du mauvais movies*, p. 32.

96 This privately published 'manifesto' can be seen in terms of an attempt to create a synthesis between the arts based on the principles of painting. Neil Baldwin has argued that it also represents 'Man Ray's defense of his experiments with a variety of artistic modes.' *Man Ray: American Artist*, Cambridge, MA: Da Capo Press, 1988, p. 56. The pamphlet is reproduced in F.M. Naumann, *Conversion to Modernism: The Early Work of Man Ray*, New Brunswick, NJ and London: Rutgers University Press, 2003, p. 147.

97 Naumann, *Conversion to Modernism: The Early Work of Man Ray*, p. 148.

98 S. Kovács, *From Enchantment to Rage: The Story of Surrealist Cinema*, London: Associated University Presses, 1980, p. 78.

99 Sarane Alexandrian, 'Rayographies', in *Man Ray*, Paris: Editions Fillipachi, 1973, p. 26.

100 M. Le Grice, *Abstract Film and Beyond*, London: Studio Vista, 1977, p. 34.

101 Kovács, *From Enchantment to Rage: The Story of Surrealist Cinema*, p. 122.

102 Quoted in Elsaesser, 'Dada/Cinema?', p. 23.

103 This point is further emphasised by the fact that the writing in one part of the film is actually Man Ray's own name. This will become important in later films where processes of self-reflexivity become much more pronounced.

Chapter 2

1 Man Ray, *Self Portrait*, Boston: Bullfinch Press, 1998, p. 219.
2 J.-M. Bouhours and P. De Haas (eds), *Man Ray: directeur du mauvais movies*, Paris: Centre Pompidou, 1997, p. 41.
3 As I have mentioned in the introduction, Man Ray was involved to some extent in virtually all of these films, making him perhaps the most important figure in French avant-garde filmmaking of this period. This perspective challenges the notion, held by a number of critics and expressed to a certain extent by Man Ray himself, that he was never particularly interested in the medium of film. For instance J.H. Matthews argues that 'Man Ray's experiments with film were never intended to do anything more than express dissatisfaction with the cinema as an art form and curiosity to see how difficult it might be to resist the influence of art on movies.' Matthews, *Surrealism and Film*, Ann Arbor: The University of Michigan Press, 1971. Barbara Rose has also stated that 'Man Ray was not interested in film as independent art.' 'Kinetic Solutions to Pictorial Problems: The Films of Man Ray and Moholy-Nagy', *Artforum* (September 1971), p. 71.
4 Man Ray's extensive use of a record turntable in *Emak Bakia* to create the repetitive rotational movement that characterises a large number of the film's sequences can be related to Duchamp's explorations into optical illusion, such as *Rotary Glass Plates (Precision Optics)*, *Rotary Demisphere (Precision Optics)*, as well as the later *Rotoreliefs (Optical Disks)* (1935). Although these experiments differed in in terms of the desired result, they all employed rotational movement as a means to achieve these results.
5 Most accounts of the film focus solely on this initial interpretation, ignoring the way the content of the text might express wider themes. See for example, M. White, 'Two French Dada Films: *Entr'acte* and *Emak Bakia*', *Dada/Surrealism*, 13 (1984), p. 43 and L. Rabinovitz, 'Independent Journeyman: Man Ray, Dada and Surrealist Film-Maker', *Southwest Review*, 64 (Autumn 1979), p. 367.
6 N. Gambill, 'The Movies of Man Ray', in *Man Ray: Photographs and Objects*, Birmingham, AL: Birmingham Museum of Art, 1980, p. 31.
7 Ibid., p. 31.

8 The interplay of presence and absence, which I have already briefly discussed and to which I shall return a number of times in the following pages, is a recurring concern in Man Ray's films. It can be understood here as a self-reflexive comment on the ghostly nature of cinematic representations, which is itself woven into the formal fabric of the film.

9 Man Ray, *Self Portrait*, p. 49.

10 S. Kovács, *From Enchantment to Rage: The Story of Surrealist Cinema*, London: Associated University Presses, 1980, pp. 127–8.

11 Man Ray, *Self Portrait*, p. 221.

12 Ibid., p. 220.

13 S. Kovács, *From Enchantment to Rage: The Story of Surrealist Cinema*, p. 132.

14 Bouhours and De Haas (eds), *Man Ray: directeur du mauvais movies*, p. 42.

15 Man Ray, *Self Portrait*, p. 223.

16 Ibid., p. 223.

17 I. Christie, 'French Avant-Garde in the Twenties: From Specificity to Surrealism', in Phillip Drummond et al. (eds), *Film as Film: Formal Experiment in Film 1910–1975*, London: Arts Council of Great Britain, 1979, p. 42.

18 R.E. Kuenzli (ed.), *Dada and Surrealist Film*, Cambridge, MA: MIT Press, 1996, p. 10.

19 Elsaesser states that 'if one takes a generous view' the chronology of Dada film would include the early films by Hans Richter and Viking Eggeling, *Le Retour à la raison, Entr'acte, Ballet mécanique, Filmstudie, Emak Bakia, Anémic Cinéma, Ghosts Before Breakfast, Two-Penny Magic* and *L'Etoile de mer*. However, he concludes that no chronology of the movement itself stretches that far, suggesting that there is a discrepancy between the films that can be seen to express Dada characteristics and the corresponding historical context. T. Elsaesser, 'Dada/Cinema?', in R.E. Kuenzli (ed.), *Dada and Surrealist Film*, p. 15.

20 R. Passeron, *Surrealism*, Paris: Editions Pierre Terrail, 2001, p. 25.

21 A. Breton and P. Soupault, *Les Champs magnétiques*, Paris: Au Sans Pareil, 1920.

22 H. Richer, *Dada: Art and Anti-art*, London: Thames and Hudson, 2001, p. 167.

23 A. Breton, 'Manifesto of Surrealism', in *Manifestoes of Surrealism*, trans. Richard Seaver and Helen R. Lane, Ann Arbor: The University of Michigan Press, 1972, p. 26.

24 P. Waldberg, *Surrealism*, London: Thames and Hudson, 1965, p. 16.

25 A. Breton, 'Manifesto of Surrealism', pp. 21–2. In an accompanying footnote, Breton acknowledges the power of the image, admitting that his attempt to translate it into words derives simply from his own literary inclinations: 'Were

I a painter, this visual depiction would doubtless have become more important for me than the other. It was most certainly my previous predispositions which decided the matter.'

26 In his 1928 novel *Nadja*, Breton stated: 'Beauty will be convulsive or will not be at all.' Paris: Gallimard, 1972. The notion of convulsive beauty can also be found in Breton's 1937 publication *L'Amour fou*, Paris: Gallimard, 1966.

27 Quoted in Breton, *Manifestoes of Surrealism*, p. 20.

28 Breton, *Manifestoes of Surrealism*, p. 22.

29 Quoted in D. Bate, *Photography and Surrealism: Sexuality, Colonialism and Social Dissent*, London and New York: I.B. Tauris, 2004, pp. 73–4.

30 A. Breton, *Le Surréalisme et la peinture*, Paris: Gallimard, 1928. The other artists included in the book are: Giorgio de Chirico, Francis Picabia, Max Ernst, Man Ray, André Masson, Joan Miró, Yves Tanguy and Jean Arp.

31 L. Williams, *Figures of Desire: A Theory and Analysis of Surrealist Film*, Berkeley: University of California Press, 1981, p. 12.

32 J.H. Matthews quotes Georges Sadoul as saying: 'However doctrinaire we were, in many areas, we were far from being in agreement when it came to the cinema' and 'surrealism did not have, properly speaking, a cinematographic doctrine.' Matthews, *Surrealism and Film*, p. 11.

33 For a detailed account of the Surrealists' relation to commercial cinema, see Matthews, *Surrealism and Film*, pp. 11–50.

34 R.E. Kuenzli in his introduction to *Dada and Surrealist Film*, p. 8.

35 A. Breton, 'Comme dans un bois', *L'Âge du cinéma*, 4–5 (August–November, 1951). Translated and reprinted as 'As in wood', in P. Hammond (ed.), *The Shadow and Its Shadow: Surrealist Writings on the Cinema* (3rd edn), San Francisco: City Lights Books, 2001, p. 73.

36 Man Ray, 'Témoignages', in *Surréalisme et cinéma*, special issue of *Etudes Cinématographiques*, 38–9 (1965), p. 45.

37 Ibid., p. 45.

38 Man Ray, 'Cinemage', in Hammond (ed.), *The Shadow and Its Shadow: Surrealist Writings on the Cinema*, p. 133.

39 In P. Bourgeade, *Bonsoir Man Ray*, Paris: Maeght éditeur, 2002, p. 50.

40 Man Ray, *Self Portrait*, p. 222.

41 A. Kyrou, 'The Film and I', in Hammond (ed.), *The Shadow and Its Shadow*, p. 131.

42 Breton used Lautréamont's phrase 'Beautiful as the unexpected meeting on a dissecting table of a sewing machine and an umbrella.' See Chapter 1.

43 Quoted in Kuenzli (ed.), *Dada and Surrealist Film*, p. 58.

44 J. Goudal, 'Surréalisme et cinéma', *La Revue hebdomadaire* (February 1925). Translated and reprinted as 'Surrealism and Cinema', in Hammond (ed.), *The Shadow and Its Shadow*, p. 89.

45 Quoted in H. Finkelstein, *The Screen in Surrealist Art and Thought*, Aldershot: Ashgate, 2006, p. 1.

46 Kuenzli (ed.), *Dada and Surrealist Film*, p. 9.

47 R. Fotiade, 'The Slit Eye, the Scorpion and the Sign of the Cross: Surrealist Film Theory and Practice Revisited', *Screen*, 39, 2 (Summer 1998), p. 117.

48 Man Ray, 'Témoignages', p. 43.

49 Man Ray, *Self Portrait*, p. 222.

50 R. Short, *The Age of Gold: Surrealist Cinema*, London: Creation Books, 2002, p. 27.

51 White, 'Two French Dada Films: *Entr'acte* and *Emak Bakia*', p. 43.

52 Kovács, *From Enchantment to Rage: The Story of Surrealist Cinema*, p. 123.

53 Ibid., p. 124.

54 Ibid.

55 Man Ray, 'Emak Bakia', *Close up*, 1, 2 (August 1927), p. 40.

56 R. Fotiade, 'The Untamed Eye: Surrealism and Film Theory', *Screen*, 36, 4 (Winter 1995), p. 400.

57 P. Weiss, *Cinéma d'avant-garde*, trans. Catherine de Seynes, Paris: L'Arche Editeur, 1989, p. 33.

58 White, 'Two French Dada Films: *Entr'acte* and *Emak Bakia*', p. 43.

59 'Le cinéma art de vision, comme la musique est art de l'ouïe ne devait-il pas … nous mener vers l'idée visuelle faite de mouvement et de vie, vers la conception d'un art de l'oeil fait d'une inspiration sensible évoluant dans sa continuité et atteignant aussi bien que la musique la pensée et la sensibilité.' G. Dulac, 'L'essence du cinéma – l'idée visuelle', in *Écrits sur le cinéma (1919–1937)*, Paris: Editions Paris Expérimental, 1994, p. 66.

60 W.C. Wees, *Light Moving in Time: Studies in the Visual Aesthetics of Avant-Garde Film*, Berkeley: University of California Press, 1992, p. 3.

61 G. Ribemont-Dessaignes, 'History of Dada', in R. Motherwell (ed.), *The Dada Painters and Poets: An Anthology* (2nd edn), London: Belknap Press, 2005, p. 105.

62 Man Ray, *Self Portrait*, p. 219.

63 My use of this term should immediately be distinguished from the 'I' of psychoanalytical study and Freud's notion of the ego. Rather, it is used here to delineate a form of expression in which the artist highlights his own presence within the work, whilst also drawing attention to the human eye/mechanical eye dichotomy.

64 Kovács, *From Enchantment to Rage: The Story of Surrealist Cinema*, p. 124.

65 'A ma sortie de l'école, comme je pensais à mon avenir, j'en suis arrivé à une
 conclusion: *faire ce que l'on n'attendait pas de moi*.' In P. Hill and T. Cooper,
 'Camera-Interview', *Camera*, 54 (Februrary 1975), p. 37.

66 Quoted in N. Ghali, *L'avant-garde cinématographique en France dans les années
 vingt: idées, conceptions, théories*, Paris: Editions Paris Expérimental, 1995,
 p. 87.

67 This position is summarised by Ghali: 'Notre oeil est ainsi, par rapport à l'objectif
 de la caméra, impuissant à percevoir les beautés et les drames qui se déroulent
 devant lui. L'objectif enregistre sans sélection d'aucune sorte tout ce qui se présente
 à lui, car il n'est pas doué de pensée. À la différence de notre oeil qui est relié au
 cerveau grâce au nerf optique; lequel cerveau nous oblige à "traiter" et à inter-
 préter ce que nous voyons. L'objectif, lui, est incapable de penser; son sort est
 lié à la mécanique et à l'optique et l'image qu'il perçoit est ensuite révélée grâce
 aux procédés chimiques.' Ghali, p. 87.

68 Quoted in Ghali, p. 86.

69 D. Vertov, *Kino-Eye: The Writings of Dziga Vertov*, trans. Kevin O'Brian and ed.
 Annette Michelson, Berkeley: The University of California Press, 1984, p. 17.

70 M. O'Pray, *Avant-Garde Film: Forms, Themes and Passions*, London and New
 York: Wallflower Press, 2003, p. 34.

71 T. Tzara, 'La photographie à l'envers', in Man Ray, *Champs délicieux*, Paris: Société
 Générale d'Imprimerie et d'Edition, 1922.

72 J. Cocteau, 'Lettre ouverte à Man Ray, photographe américain', *Les Feuilles libres*,
 26 (April/May 1922), p. 134.

73 W. Ruttman, 'Painting with the Medium of Time', in W. Schobert, *The German
 Avant-Garde Film of the 1920s*, Munich: Goethe Institut, 1989, pp. 102–3.

74 Rose, 'Kinetic Solutions to Pictorial Problems: The Films of Man Ray and
 Moholy-Nagy', p. 70.

75 Carl I. Belz states: 'As Ray says, the film consists of a number of fragments. The
 relationships among them, however, are not of a progressive nature. No story
 is presented, nor is there a visual or purely artistic conclusion.' Belz, 'The Film
 Poetry of Man Ray', *Criticism*, 7 (1965), p. 121.

76 White, 'Two French Dada Films: *Entr'acte* and *Emak Bakia*', p. 44.

77 I am referring here particularly to the two films of Luis Buñuel and Salvador
 Dalí, *Un Chien andalou* (1929) and *L'Age d'or* (1930).

78 Man Ray, *Self Portrait*, p. 219.

79 Quoted in Ghali, *L'avant-garde cinématographique en France dans les années
 vingt: idées, conceptions, théories*, p. 87.

80 Quoted in E.A. Aitken, '"Emak Bakia" Reconsidered', *Art Journal*, 43, 3 (Fall 1983), p. 241.

81 Kovács, *From Enchantment to Rage: The Story of Surrealist Cinema*, p. 124.

82 Man Ray, *Self Portrait*, p. 219.

83 Ibid., p. 220.

84 Ibid.

85 Ibid.

86 As Mary Ann Doane has stated, Marey is 'frequently isolated as a primary scientific precursor of the cinema.' *The Emergence of Cinematic Time: Modernity, Contingency, The Archive*, Cambridge, MA and London: Harvard University Press, 2002, p. 46.

87 M. Braun, *Picturing Time: The Work of Etienne-Jules Marey (1830–1904)*, Chicago: Chicago University Press, 1992, p. 66.

88 Quoted in Judi Freeman, 'Bridging Purism and Surrealism: The Origins and Production of Fernand Léger's *Ballet Mécanique*', in Kuenzli (ed.) *Dada and Surrealist Film*, p. 39.

89 F. Léger, *Functions of Painting*, trans. Alexandra Anderson and ed. Edward F. Fry, New York: The Viking Press, 1973, p. 51.

90 Man Ray, *Self Portrait*, p. 220.

91 Although there are obvious similarities between the two films and their inclusion of women smiling directly at the camara, the main difference lies in the fact that *Ballet mécanique* focuses entirely on the fragmented face, whereas *Emak Bakia* presents more conventional representations in portraiture style.

92 S. Winqvist, 'A MAN? – Thoughts on Man Ray's Sexual Identity', in *Man Ray*, Stockholm: Moderna Museet, 2004, p. 39.

93 Kuenzli (ed.), *Dada and Surrealist Film*, p. 7.

94 G. Dulac, 'Images et Rythmes', in *Écrits sur le cinéma (1919–1937)*, p. 45.

95 F. Naumann, 'Man Ray, 1908–1921: From an Art in Two Dimensions to the Higher Dimension of Ideas', in M. Foresta (ed.), *Perpetual Motif: The Art of Man Ray*, New York: Abbeville Press, 1988, p. 77.

96 Quoted in Naumann, 'Man Ray, 1908–1921: From an Art in Two Dimensions to the Higher Dimension of Ideas', p. 77.

97 P. Hillairet, C. Lebrat, P. Rollet, *Paris vu par le cinéma d'avant-garde*, Paris: Editions Paris Expérimental, 1985, p. 39.

98 J. Levy, *Surrealism*, New York: The Black Sun Press, 1936, p. 22.

Chapter 3

1 The collaboration between Dulac and Artaud caused much controversy, with Artaud stating that Dulac had gravely misunderstood his scenario in making a film that claimed to recount the content of a dream rather than representing its structure. In 1928 he wrote: 'It is to show how far the scenario can resemble and ally itself with the mechanics of a dream without really being a dream itself, for example. It is to show how far the mind, left to itself and the images, infinitely sensitised, determined to lose nothing of the inspirations of subtle thought, is all prepared to return to its original functions, its antannae pointed towards the invisible, to begin another resurrection from death.' A. Artaud, *Collected Works Volume 3: Scenarios; On the Cinema; Interviews; Letters*, trans. Alistair Hamilton, London: Calder and Boyars, 1972. During the premiere screening of the film, the Surrealists protested by personally insulting Dulac and throwing objects at the screen. For a comprehensive discussion of the complex circumstances of this collaboration see A. and O. Virmaux, *Les Surréalistes et le cinéma*, Paris: Seghers, 1976 and *Artaud-Dulac: La coquille et le clergyman: essai d'élucidation d'une querelle mythique*, Paris: Éditions Paris Expérimental, 2000.

2 L. Rabinovitz, 'Independent Journeyman: Man Ray, Dada and Surrealist Film-Maker', *Southwest Review*, 64 (Autumn 1979).

3 A. Thiher, *The Cinematic Muse: Critical Studies in the History of French Cinema*, Columbia: University of Missouri Press, 1979; P. Adams Sitney, *Modernist Montage: The Obscurity of Vision in Cinema and Literature*, New York: Columbia University Press, 1990.

4 Man Ray, *Self Portrait*, Boston: Bullfinch Press, 1998, pp. 223–4.

5 Thiher, *The Cinematic Muse*, p. 38.

6 J.H. Matthews, *Surrealism and Film*, Ann Arbor: The University of Michigan Press, 1971, p. 82.

7 Links have previously been made between *L'Etoile de mer* and *La Place de l'étoile*, written by Desnos in 1927 as a play in nine parts, later to be re-edited as an 'antipoem'. Mary Ann Caws for example goes as far as to suggest that this text was the direct inspiration for the film, despite the very few resemblances between them. M.A. Caws, *The Surrealist Voice of Robert Desnos*, Amherst: University of Massachusetts Press, 1977, p. 28.

8 Both reproduced with short commentaries in J.-M. Bouhours and P. De Haas (eds), *Man Ray: directeur du mauvais movies*, Paris: Centre Pompidou, 1997, pp. 62–3.

9 I. Hedges, 'Constellated Visions: Robert Desnos's and Man Ray's *L'Etoile de Mer*', in R.E. Kuenzli (ed.), *Dada and Surrealist Film*, Cambridge, MA: MIT Press, 1996, p. 101.

10 Man Ray, 'Témoignages', in *Surrréalisme et cinéma*, special issue of *Etudes Cinématographiques*, 38–9 (1965), p. 46.

11 Inez Hedges explains that this recent discovery was made by comparing the writing with another manuscript by Robert Desnos from the same period, *The Night of the Loveless Nights*, also held at the Museum of Modern Art. Hedges, 'Constellated Visions', p. 207.

12 The importance of the mental image, for example, can be seen in Breton's development of the concept of automatism in his first Surrealist Manifesto. Here he describes being struck by a phrase, which he remembers as being something like 'a man is cut in two by a window.' The impact of this phrase is virtually inseparable from the striking mental image to which it gives rise and to which Breton himself draws attention.

13 See the section on Surrealist film in Chapter 2.

14 For a detailed account of this area of Surrealist activity see J.H. Matthews, *Surrealism and Film*; L. Williams, *Figures of Desire: A Theory and Analysis of Surrealist Film*, Berkeley: University of California Press, 1981; R. Abel, 'Exploring the Discursive Field of the Surrealist Scenario Text', in Kuenzli (ed.), *Dada and Surrealist Film*.

15 J. Vaché, 'Lettre de guerre', in A. and O. Virmaux, *Les Surréalistes et le cinéma*, p. 105.

16 For Man Ray's comments on the influence of writers on his artistic development see A. Schwarz, 'This is Not for America', *Arts Magazine*, 51 (May 1997), pp. 116–17.

17 F. Naumann, 'Man Ray, 1908–1921: From an Art in Two Dimensions to the Higher Dimension of Ideas', in M. Foresta (ed.), *Perpetual Motif: The Art of Man Ray*, New York: Abbeville Press, 1988, pp. 80–1.

18 N. Baldwin, *Man Ray: American Artist*, London: Hamish Hamilton, 1989, pp. 32–46.

19 In P. Hill and T. Cooper, 'Camera-Interview', *Camera*, 54 (February 1975), p. 37.

20 See E. Sellin, '"Le chapelet du hazard": Ideas of Order in Dada-Surrealist Imagery', *L'Esprit Créateur*, 2, 4 (Summer 1980) and the section entitled 'Patterns of duality' in Chapter 1 of this book.

21 Ibid., p. 29.

22 Quoted in C.I. Belz, 'The Film Poetry of Man Ray', *Criticism*, 7 (Spring 1965), p. 119.

23 Ibid., p. 119.
24 For a more detailed account of Duchamp's play with language, see D. Antin, 'Duchamp and Language', in A. d'Harnoncourt and K. McShine (eds), *Marcel Duchamp*, Philadelphia: Philadelphia Museum of Art, 1973, pp. 95–115.
25 Katrina Martin addresses the subject of language in the film in 'Marcel Duchamp's "Anemic Cinéma"', *Studio International*, 189, 973 (January–February 1975), pp. 53–60.
26 D. Judovitz, 'Anemic Vision in Duchamp's Cinema as Readymade', in Kuenzli (ed.), *Dada and Surrealist Film*, p. 53.
27 Further examples of Duchamp's punning word games can be found in M. Duchamp, *Marchand du sel, écrits de Marcel Duchamp*, Paris: Terrain Vague, 1958, under the section 'Rrose Sélavy', pp. 99–105.
28 R. Pincus-Witten, 'Man Ray: The Homonymic Pun and American Vernacular', *Artforum* (April 1975), p. 57.
29 Ibid.
30 Ibid.
31 This text was published in 1930 in *Corps et biens*. R. Desnos, *Œuvres*, Paris: Quarto, Gallimard, 1999, pp. 502–12. Other examples of Desnos's interest in language games can be found in *L'Aumonyme* (published in 1923 in *Littérature*) and *Langage cuit* (also published in *Corps et biens*). See *Œuvres* pp. 513–37 and pp. 176–7.
32 Man Ray, *Self Portrait*, p. 223.
33 R. Desnos, 'Les Mystères de New York', *Le Merle* (1929), reprinted in A. and O. Virmaux, *Les Surréalistes et le cinéma*, p. 130.
34 R. Desnos, *Nouvelles Hébrides et autres textes 1922–1930*, Paris: Gallimard, 1978, p. 100.
35 H. Finkelstein, *The Screen in Surrealist Art and Thought*, Aldershot: Ashgate, 2007, p. 16.
36 Desnos, 'La Morale du Cinéma', first published in *Paris-Journal* (13 May 1923) and reprinted in R. Desnos, *Cinéma*, Paris: Gallimard, 1966, p. 110.
37 In P. Bourgeade, *Bonsoir Man Ray*, Paris: Editions Pierre Belfond, 1972, p. 67.
38 Only four of these scenarios were published by Desnos – 'Minuit à quatorze heures', *Les Cahiers du mois*, 12 (1925); 'Les Récifs de l'amour', *La Revue du cinéma* (1 July 1930); 'Les Mystères du métropolitain', *Variétés*, 15 (April 1930); 'Y a des punaises dans le roti de porc', *Les Cahiers jaunes*, 4 (1933). Eleven other synopses and scenarios are published in Desnos, *Cinema*, pp. 57–91.
39 Williams, *Figures of Desire: A Theory and Analysis of Surrealist Film*, pp. 23–4.
40 R. Abel, 'Exploring the Discursive Field of the Surrealist Scenario Text', in Kuenzli (ed.), *Dada and Surrealist Film*, p. 67.

41 A similar circular form – 'un disque lumineux' – is the catalyst for Desnos's search beyond the screen in the cinema passage of *Pénalités de l'enfer ou Nouvelles Hébrides*.

42 Williams, *Figures of Desire: A Theory and Analysis of Surrealist Film*, p. 27.

43 Desnos, *Œuvres*, p. 426.

44 Quoted in Williams, *Figures of Desire: A Theory and Analysis of Surrealist Film*, p. 23.

45 C. Metz, *The Imaginary Signifier: Psychoanalysis and the Cinema*, trans. Celia Britton et al., Bloomington: Indiana Press, 1982.

46 See Artaud, *Collected Works Volume 3: Scenarios; On the Cinema; Interviews; Letters*, pp. 19–25.

47 P. Adams Sitney, *Modernist Montage: The Obscurity of Vision in Cinema and Literature*, New York: Columbia University Press, 1990, p. 21.

48 Quoted in N. Ghali, *L'avant-garde cinématographique en France dans les années vingt: idées, conceptions, théories*, Paris: Editions Paris Expérimental, 1995, p. 195.

49 R. Desnos, 'Musique et sous-titres', first published in *Paris Journal* (13 April 1923) and reproduced in *Cinéma*, p. 98.

50 Ibid., p. 99.

51 Scott MacDonald has noted that the subversion of the conventional use of intertitles and the introduction of creative forms of text-image relations in the cinema was present as early as 1907, in Edwin S. Porter's *College Chums*. However, it was not until Charles Sheeler and Paul Strand's *Manhatta* in 1921 that a more developed form of 'text/image ciné-poetry' was evident. S. MacDonald, *Screen Writings: Scripts and Texts by Independent Filmmakers*, Berkeley: University of California Press, 1995, pp. 1–4.

52 Sitney, *Modernist Montage*, p. 21.

53 R. Desnos, *Deuil pour deuil*, in Desnos, *Œuvres*, p. 215.

54 R. Fotiade, 'Automatism and the Moving Image: From Visual to Verbal Metaphor in *L'Étoile de mer*', in M.C. Barnet, E. Robertson and N. Saint (eds), *Robert Desnos: Surrealism in the Twenty-First Century*, Oxford and New York: Peter Lang, 2006, p. 267.

55 Ibid., p. 271.

56 Ibid., p. 263.

57 Thiher, *The Cinematic Muse*, p. 45.

58 R. Desnos, 'Journal d'une apparition', first published in *La Révolution surréaliste*, 9–10 (1 October 1927), and reprinted in Desnos, *Œuvres*, pp. 395–400.

59 Fotiade, 'Automatism and the Moving Image', p. 274.

60 Hedges, 'Constelled Visions: Robert Desnos's and Man Ray's *L'Etoile de Mer*', p. 107.

61 Desnos, 'Cinéma d'avant-garde', in *Cinéma*, p. 189.
62 I. Katsahnias, 'Le Chasseur de Lumière', *Cahiers du Cinéma*, 390 (December 1986), p. 47.
63 Man Ray, *Self Portrait*, p. 225.
64 N. Gambill, 'The Movies of Man Ray', in *Man Ray: Photographs and Objects*, Birmingham, AL: Birmingham Museum of Art, 1980, p. 33.
65 Katsahnias, 'Le Chasseur de Lumière', p. 47.
66 Rabinovitz, 'Independent Journeyman: Man Ray, Dada and Surrealist Film-Maker', p. 371.
67 Sitney, *Modernist Montage*, p. 29.
68 A.L. Rees, *A History of Experimental Film and Video: From the Canonical Avant-Garde to Contemporary British Practice*, London: BFI, 1999, p. 43.
69 Belz, 'The Film Poetry of Man Ray', p. 124.
70 H. Richter, 'Dada and the Film', in W. Verkauf (ed.), *Dada: Monograph of a Movement*, Teufen, Switzerland: Arthur Niggli, 1957, p. 70.
71 Thiher, *The Cinematic Muse*, p. 39.
72 Ibid., p. 39.
73 Artaud, *Collected Works Volume 3: Scenarios; On the Cinema; Interviews; Letters*, p. 20.
74 Bouhours and De Haas (eds), *Man Ray: directeur du mauvais movies*, p. 63.
75 Ibid., p. 63.
76 S. Eisenstein, V. Pudovkin and G. Alexandrov, 'Statement on Sound', in R. Taylor and I. Christie (eds), *The Film Factory: Russian and Soviet Cinema in Documents, 1896–1939*, Cambridge, MA: Harvard University Press, 1988, p. 235.
77 Man Ray, *Self Portrait*, p. 225.
78 Baldwin, *Man Ray: American Artist*, p. 143.
79 Bouhours and De Haas (eds), *Man Ray: directeur du mauvais movies*, p. 42.
80 Man Ray, *Self Portrait*, p. 225.

Chapter 4

1 B. Rose, 'Kinetic Solutions to Pictorial Problems: The Films of Man Ray and Moholy-Nagy', *Artforum* (September 1971), p. 71.
2 J.H. Matthews, *Surrealism and Film*, Ann Arbor: The University of Michigan Press, 1971, p. 83.

3 It is useful at this point to briefly consider Alexandr Hackenschmied's *Na Pražském hradě* (*Prague Castle*), made in 1931. This 11-minute film focuses exclusively on the cinematic rendering of the St Vitus Cathedral in Prague. Through a series of different and often striking framings, Hackenschmied explores the complex architectural details of the building. However, unlike Man Ray's approach in *Les Mystères*, Hackenschmied seems more interested in a photographic rather than cinematic rendering. Indeed, whilst the former brings architecture and cinema together through an exploration of space, the latter uses film simply as a temporal tool for exploring the relationship between architecture and music: 'I have tried in my experimental film of *Prague Castle* (now entitled *Music of Architecture*) to find the relationship between architectural form and music.' A. Hackenschmied, 'Film and Music'. First published in *Film Quarterly*, 1 (1933). Sourced: www.logosjournal.com/hammid_1htm, accessed June 2008. Despite their differences, however, the two films demonstrate a shared interest in artistic cross-fertilization that can be found throughout the 1920s and 1930s.

4 H. Weihsmann, 'Ein "Filmgedicht"', in *Cinetecture: Film, Architektur, Moderne*, Vienna: PVS Verleger, 1995, p. 85.

5 Letter from Man Ray to Charles de Noailles in J.-M. Bouhours and P. De Haas (eds), *Man Ray: directeur du mauvais movies*, Paris: Centre Pompidou, 1997, p. 103.

6 Charles de Noailles in a letter to the Duchesse of Ayen, in Bouhours and De Haas (eds), *Man Ray: directeur du mauvais movies*, p. 109.

7 Man Ray, *Self Portrait*, Boston: Bullfinch Press, 1998, p. 226.

8 Letter from Charles de Noailles to Robert Mallet-Stevens, 19 April 1925, quoted in C. Briolle, A. Fuzibet and G. Monnier, *Mallet-Stevens: La Villa Noailles*, Marseille: Editions Parenthèses, 1990, p. 11.

9 J.-M. Bouhours, 'La légende du château du dé', in Bouhours and De Haas (eds), *Man Ray: directeur du mauvais movies*, p. 88.

10 Man Ray, *Self Portrait*, p. 226.

11 Bouhours and De Haas (eds), *Man Ray: directeur du mauvais movies*, p. 85.

12 F.M. Naumann, *Conversion to Modernism: The Early Work of Man Ray*, New Brunswick, NJ, and London: Rutgers University Press, 2003, p. 150.

13 Man Ray, 'A Primer of the New Art of Two Dimensions' (1916), reproduced in F.M. Naumann, *Conversion to Modernism: The Early Work of Man Ray*, p. 225.

14 *Le Club des Amis du Septième Art* provided an interdisciplinary forum for the discussion of ideas relating to the seventh art. Made up of filmmakers, actors, writers, artists, architects, musicians and critics, it was central to the development of avant-garde cinema in France. Writings by various members were published in the journal *Gazette des Sept Arts* and the club was active in the organisation

of public screenings, exhibitions and conferences aimed at the promotion of cinema as art. N. Ghali, *L'avant-garde cinématographique en France dans les années vingt: idées, conceptions, théories*, Paris: Editions Paris Expérimental, 1995, pp. 55–7. See also R. Abel, *French Cinema: The First Wave, 1915–1929*, Princeton, NJ: Princeton University Press, 1984.

15 D. Albrecht, *Designing Dreams: Modern Architecture in the Movies*, London: Thames and Hudson, 1986, p. 44.

16 The term 'photogénie', used for the first time by Louis Delluc in 1917, refers to the process in which an object takes on new expressive qualities when it becomes a cinematic image. It illustrates the ability of film to alter everyday perception through certain technical interventions such as lighting, focus, framing etc.

17 Quoted in Ghali, *L'avant-garde cinématographique en France dans les années vingt: idées, conceptions, théories*, p. 136.

18 Quoted in A. Vidler, 'The Explosion of Space: Architecture and the Filmic Imaginary', in D. Neumann (ed.), *Film Architecture: set designs from 'Metropolis' to 'Blade Runner'*, Munich and New York: Prestel, 1997, p. 14.

19 *L'Inhumaine* was the first film to use modern architecture in its setting and represents, according to Albrecht, 'a striking instance of the ability of vanguard French artists to move with relative ease between the "high" and the popular arts.' D. Albrecht, *Designing Dreams: Modern Architecture in the Movies*, p. 45.

20 A. Breton and P. Soupault, *Dictionnaire abrégé du mouvement surréaliste*, Paris: José Corti, 1938.

21 R. Short, *The Age of Gold: Surrealist Cinema*, New York: Creation Books, 2002, p. 20.

22 A. Breton, 'Comme dans un bois', *L'Age du cinéma*, 4–5 (August–November 1951). Translated and reprinted as 'As in wood', in P. Hammond (ed.), *The Shadow and Its Shadow: Surrealist Writings on the Cinema* (3rd edn), San Francisco: City Lights Books, 2001, p. 72.

23 The rarely discussed relationship between Man Ray and André Breton is a complex and intricate affair that seems to have been characterised by mutual respect. Although Man Ray was a key member of the Surrealist group, he maintained a high level of artistic independence, sparing him Breton's ritualistic condemnation that befell many of the members such as Robert Desnos, Philippe Soupault, Antonin Artaud, Georges Ribemont-Dessaignes, André Masson and Salvador Dalí.

24 G. Durozoi. *Histoire du mouvement surréaliste*, Paris: Editions Hazan, 1997, p. 187.

25 J.-M. Bouhours, 'La légend du château du dé', p. 90.

26 J.B. Brunius, 'Experimental Film in France', in R. Manvell (ed.), *Experiment in the Film*, London: Grey Walls Press, 1949, p. 98.

27 Ibid., p. 99.
28 L. Williams, *Figures of Desire: A Theory and Analysis of Surrealist Film*, Berkeley: University of California Press, 1981, p. 25.
29 Ibid., pp. 99–100.
30 Quoted in Bouhours, 'La légende du château du dé', pp. 90–1.
31 Quoted in Abel, *French Cinema: The First Wave, 1915–1929*, p. 274.
32 Man Ray, 'Témoignages', in *Surrréalisme et cinéma*, special issue of *Etudes Cinématographiques*, 38–9 (1965), p. 43.
33 I. Hedges, 'Constellated Visions: Robert Desnos's and Man Ray's *L'Etoile de mer*', in R.E. Kuenzli (ed.), *Dada and Surrealist Film*, Cambridge, MA: MIT Press, 1996, pp. 107–8.
34 M. Verdone, *Le avanguardie storiche del cinema*, Turin: Società Editrice Internazionale, 1977, p. 45.
35 S. Renan, *The Underground Film*, London: Studio Vista, 1967, p. 64.
36 P. Weiss, *Cinéma d'avant-garde*, trans. Catherine de Seynes, Paris: L'Arche Editeur: 1989, p. 37.
37 I. Katsahnias, 'Le Chasseur de Lumière', *Cahiers du Cinéma*, 390 (December 1986), p. 47.
38 A. Kyrou, *Le Surréalisme au cinéma*, Paris: Le Terrain Vague, 1963, p. 176.
39 A.L. Rees, *A History of Experimental Film and Video: From the Canonical Avant-Garde to Contemporary British Practice*, London: BFI, 2000, p. 43.
40 A. Breton, 'Manifesto of Surrealism', in *Manifestoes of Surrealism*, translated by Richard Seaver and Helen R. Lane, Ann Arbor: The University of Michigan Press, 1972, pp. 16–17.
41 Breton most strongly represents the Surrealist nostalgia for the past through his praise for the outmoded. This can be seen particularly in his descriptions in both *Nadja* and *L'Amour fou* of his weekly visits to the flea markets on the outskirts of Paris. Although, as Ian Walker has observed, none of the other members of the Surrealist group wrote about flea markets, an examination of Surrealist-related photography of the period reveals a large amount of images focusing on precisely this subject. I. Walker, *City Gorged with Dreams: Surrealism and Documentary Photography in Interwar Paris*, Manchester and New York: Manchester University Press, 2002, p. 124.
42 See H. Weihsmann, 'Ein "Filmgedicht"'.
43 A. Gorlin, 'The Ghost in the Machine', in T. Mical (ed.), *Surrealism and Architecture*, London and New York: Routledge, 2005, p. 104.
44 Ibid.
45 A. Breton, 'Surrealist Situation of the Object', in *Manifestoes of Surrealism*, p. 263.

46 The idea of 'pure poetry' originates with Edgar Allan Poe and was taken up
 enthusiastically by the French Symbolist poets. It turns away from the expression
 of meaning and celebrates the visual and musical components of poetry.

47 D. Reynolds, 'The Kinesthetics of Chance: Mallarmé's *Un Coup de Dés* and
 Avant-Garde Choreography', in P. McGuinness (ed.), *Symbolism, Decadence and
 the Fin de Siècle: French and European Perspectives*, Exeter: University of Exeter
 Press, 2000, p. 96.

48 V.A. La Charité, *The Dynamics of Space: Mallarmé's* Un coup de dés jamais
 n'abolira le hasard, Lexington, KY: French Forum Publishers, 1987, p. 40.

49 Reynolds, 'The Kinesthetics of Chance: Mallarmé's *Un Coup de Dés* and Avant-
 Garde Choreography', p. 103.

50 S. Mallarmé, *Œuvres complètes*, ed. Bertrand Marchal, Paris: Gallimard, 1998,
 pp. 382–3.

51 Man Ray's musical indications for the film include four other pieces: 'Gymnopédie
 no. 1' written by Erik Satie and interpreted by Leopold Stokowski, José Morand's
 'Batucada' and 'Shu-Shu', and 'Swinga-Dilla Street' by Fats Waller.

52 La Charité, *The Dynamics of Space: Mallarmé's* Un coup de dés jamais n'abolira
 le hasard, p. 126.

53 S. McCabe, *Cinematic Modernism: Modernist Poetry and Film*, Cambridge:
 Cambridge University Press, 2005, p. 65.

54 We are reminded here of Man Ray's comment about *Emak Bakia*, in which he
 describes the film as a 'series of fragments.' Man Ray, 'Emak Bakia', *Close up*, 1, 2
 (August 1927), p. 40.

55 Bouhours, 'La légende du château du dé', p. 89.

56 R. Pincus-Witten. 'Man Ray: The Homonymic Pun and American Vernacular',
 Artforum (April 1975), p. 57.

57 Ibid., p. 57.

58 See Man Ray's *Self Portrait*, p. 199. Suicide was a frequent topic of debate amongst
 the Surrealists. The second issue of *La Révolution surréaliste* included a survey
 entitled 'Le suicide est-il une solution?'.

59 All three photographs mentioned here can be found in *Man Ray Photographs*,
 translated by Carolyn Breakspear, London: Thames and Hudson, 1982.

60 Mallarmé, *OC*, p. 391.

61 La Charité, *The Dynamics of Space: Mallarmé's* Un coup de dés jamais n'abolira
 le hasard, p. 44.

62 Ibid., p. 13.

63 K. Sierek, 'Architecture and film in the work of Corbusier, Mies, Mallet.' Lecture
 delivered at the Frije Universiteit Amsterdam, 27 April 2001. www2.uni-jena.de/
 philosophie/medien/Vortraege/Amsterdam/architecture_and_film.ht, accessed
 February 2006.

64 R. Pearson, *Unfolding Mallarmé: The Development of a Poetic Art*, Oxford: Clarendon Press, 1996, p. 247.

65 It must be noted here that, although my analysis of this sequence concentrates exclusively on formal patterns within the frame, other factors related to what Man Ray called his 'Dada instinct' are at work here. The humourous reference to the 'secrets of painting' and the subsequent series of canvases seen from the reverse side constitutes the most effective anti-art statement, in which the relationship between the art work and its audience is severely thrown into question. This gesture of negation nonetheless provides Man Ray with the opportunity to explore other, more abstract, ideas more in keeping with the formal concerns of the film.

66 The term 'primitive' cinema is developed and discussed in D. Bordwell, J. Staiger and K. Thompson, *The Classical Hollywood Cinema: Film Style and Mode of Production to 1960*, New York: Routledge & Kegan Paul, 1985. See also Noël Burch, 'A Primitive Mode of Representation?', in T. Elsaesser (ed.), *Early Cinema: Space, Frame, Narrative*, London: BFI: 1990, pp. 220–7; T. Gunning, '"Primitive Cinema" A Frame-up? or The Trick's on Us', *Cinema Journal*, 28, 2 (Winter, 1989), pp. 3–12. See Chapter 1 for a more detailed discussion of early cinema and the 'cinema of attractions' theory.

67 See, for instance, E. Adamowicz, 'Bodies Cut And Dissolved: Dada and Surrealist Film', in J. Williams and A. Hughes (eds), *Gender and French Film*, Oxford: Berg, 2002, pp. 21–2.

68 Man Ray, *Self Portrait*, p. 212.

69 Ibid., pp. 228–9.

70 R. Krauss, 'Corpus Delecti', in R. Krauss and J. Livingston (eds), *L'Amour fou: Photography and Surrealism*, New York: Abbeville Press: 1985, p. 60.

71 Sarane Alexandrian, 'Rayographies', in *Man Ray*, Paris: Editions Fillipachi, 1973, p. 26.

72 I. Hedges, 'Constellated Visions: Robert Desnos's and Man Ray's *L'Etoile de mer*', p. 107.

73 Man Ray's instructions for the musical accompaniment to *L'Etoile de mer* actually list 'Sigonomi sou zito' as the final piece, yet the additional comment 'If film *Star of the Sea* ends before record E, replay record A' suggests the cyclical structure that is already developed within the film. Bouhours and De Haas (eds), *Man Ray: directeur du mauvais movies*, p. 60.

Chapter 5

1 Man Ray, *Self Portrait*, Boston: Bullfinch Press, 1998, p. 235. This analogy with
 the sewing machine is particularly interesting in its (perhaps unconscious) ref-
 erence to Lautréamont's phrase 'beautiful as the chance encounter between an
 umbrella and a sewing machine on a dissecting table', which was used by Breton
 as the Surrealist definition of beauty. See Chapter 2 for a discussion of Man Ray's
 relationship with Surrealism.

2 P. De Haas, 'À propos de quelque films inconnus', in J.-M. Bouhours and P. De
 Haas (eds), *Man Ray: directeur du mauvais movies*, Paris: Centre Pompidou,
 1997, p. 143.

3 Man Ray, *Self Portrait*, p. 230.

4 Ibid.

5 Ibid.

6 Ibid.

7 This is reflected particularly in Breton's fascination for the flea markets and the
 more general interest of the Surrealists in derelict areas such as the Zone – the
 space between the Parisian fortifications and the suburbs. Ian Walker describes
 this attraction in terms of a reaction against 'Haussmann's effort to rationalise
 the city'. I. Walker, *City Gorged with Dreams: Surrealism and Documentary
 Photography Interwar Paris*, Manchester and New York: Manchester University
 Press, 2002, p. 118.

8 De Haas, 'À propos de quelques films inconnus', p. 143. The first use of synchro-
 nised speech appeared in Warner Brother production, *The Jazz Singer* (Alan
 Crosland, 1927). Released in France on 26 January 1929, this film was a major
 success and played at the Aubert-Palace theatre in Paris for almost a year. R. Abel,
 French Cinema: The First Wave, 1915–1929, Princeton, NJ: Princeton University
 Press, 1984, p. 61.

9 Man Ray, 'Answer to a Questionnaire', *Film Art*, 3, 7 (1936), p. 10.

10 Man Ray in A. Gain, 'Un Entretien avec Man Ray', *Cinéa-ciné pour tous*, 144 (15
 November 1929), p. 27.

11 A. Arnoux, 'L'Expression de la peur' first published in *Pour Vous*, 25 (2 May 1929).
 Reprinted in R. Clair, *Cinema Yesterday and Today*, trans. Stanley Appelbaum,
 New York: Dover, 1970, p. 129.

12 Quoted in Abel, *French Cinema: The First Wave, 1915–1929*, p. 65.

13 G. Dulac, 'Film parlant ... film en couleur', first published in *Paris-Midi* (17
 August 1928). Reprinted in *Écrits sur le cinéma (1919–1937)*, Paris: Editions Paris
 Expérimental, 1994, p. 122.

14 De Haas, 'À propos de quelques films inconnus', p. 143.

15 R. Pincus-Witten, 'Man Ray: The Homonymic Pun and American Vernacular', *Artforum* (April 1975), p. 58.

16 Man Ray 'Témoignages', *Surrréalisme et cinéma*, special issue of *Etudes Cinématographiques*, 38–9 (1965), p. 43.

17 Man Ray, *Self Portrait*, p. 232.

18 Ibid., p. 285.

19 Ibid., p. 230.

20 Ibid., p. 232.

21 Ibid.

22 *Cahiers d'art*, 1–4 (1935), p. 106.

23 A. Breton and P. Eluard, *The Immaculate Conception*, trans. J. Graham, London: Atlas Press, 1990, p. 47.

24 'Essai de simulation du délire cinématographique', in Bouhours and De Haas (eds), *Man Ray: directeur du mauvais movies*, pp. 127–9.

25 S. Dalí, 'L'âne pourri', *Le Surréalisme au service de la révolution*, 1 (June 1930), pp. 9–10.

26 Man Ray, *Self Portrait*, p. 232.

27 See Chapter 4.

28 *Cahiers d'art*, 1–2 (1936), pp. 4–20.

29 N. Baldwin, *Man Ray: American Artist*, Cambridge, MA: Da Capo Press, 1988, p. 249.

30 Film programme notes, reprinted in Bouhours and De Haas (eds), *Man Ray: directeur du mauvais movies*, pp. 130–1.

31 Ibid.

32 Man Ray, *Self Portrait*, p. 286.

33 According to De Haas, *La Garoupe, Corrida* and *Ce qui nous manque à tous* were found in Man Ray's rue Férou studio in 1985, whilst the others were discovered around the same time by Lucien Treillard in Ady Fidelin's archives. De Haas, 'À propos de quelques films inconnus', p. 151.

34 De Haas, 'À propos de quelques films inconnus', p. 145.

35 Man Ray, 'Answer to a Questionaire', p. 10.

36 De Haas, 'À propos de quelques films inconnus', pp. 143–51; 'Les home movies de Man Ray', in Y. Beauvais and J.-M. Bouhours (eds), *Le je filmé*, Paris: Centre Pompidou, 1995, pp. 57–9.

37 J. Livingston, 'Man Ray and Surrealist Photography', in R. Krauss and J. Livingston (eds), *L'Amour fou: Photography and Surrealism*, New York, London: Abbeville Press, 1985, p. 133.

38 In P. Bourgeade, *Bonsoir Man Ray*, Paris: Maeght éditeur, 2002, pp. 49–50.

39 Man Ray, 'Mort dans l'après-midi', *Voilà*, 192, 24 (November), 1934.
40 Ibid., p. 50.
41 This object, the creation of which was apparently influenced by a conversation with Picasso, features a fur-covered cup and saucer.
42 Baldwin, *Man Ray: American Artist*, p. 148.
43 Man Ray, *Self Portrait*, p. 238.
44 Man Ray, 'Emak Bakia', *Close up*, 1, 2 (August 1927), p. 40.
45 See for example, *50 visages de Juliet*, a series of photographs, encompassing a range of styles, formats and techniques, produced between 1941 and 1955.
46 De Haas, 'À propos de quelques films inconnus', p. 151.
47 B. Péret, L. Aragon, Man Ray, *1929*, Paris: Allia, 1993.

Conclusion

1 P. Bürger, *Theory of the Avant-Garde*, trans. Michael Shaw, Minneapolis: University of Minnesota Press, 1984, p. 49.
2 'Un certain mépris pour le moyen physique d'exprimer une idée est indispensable pour la réaliser au mieux.' Man Ray, 'L'Age de la lumière', *Minotaure*, 3–4 (1933), p. 1. Elsewhere he states: 'Si l'on est en pleine possession d'un médium, force nous est de le mépriser un peu.' P. Hill and T. Cooper, 'Camera-Interview', *Camera*, 54 (February 1975), p. 23.
3 In P. Bourgeade, *Bonsoir Man Ray*, Paris: Maeght éditeur, 2002, p. 50.
4 Man Ray, *Self Portrait*, p. 232.

Bibliography

R. Abel, 'Exploring the Discursive Field of the Surrealist Scenario Text', in R.E. Kuenzli (ed.), *Dada and Surrealist Film*, Cambridge, MA: MIT Press, 1996, pp. 58–71.

——, *French Cinema: The First Wave, 1915–1929*, Princeton, NJ: Princeton University Press, 1984.

——, *French Film Theory and Criticism, 1907–1939*. Volume 1 1907–29, Princeton, NJ: Princeton University Press, 1988.

E. Adamowicz, 'Bodies Cut And Dissolved: Dada and Surrealist Film', in A. Hughes and J.S. Williams (eds), *Gender and French Film*, Oxford: Berg, 2002, pp. 19–33.

E.A. Aitken, '"Emak Bakia" Reconsidered', *Art Journal*, 43, 3 (Fall 1983), pp. 240–6.

——, 'Reflections on Dada and the Cinema', *Postscript: Essays in Film and the Humanities*, 3, 2 (1984), 5–19.

F. Albera, *L'Avant-garde au cinéma*, Lassay-les-Châteaux: Armand Colin, 2005.

D. Albrecht, *Designing Dreams: Modern Architecture in the Movies*, London: Thames and Hudson, 1986.

S. Alexandrian, *Man Ray*, Paris: Editions Filipacchi, 1973.

D. Antin, 'Duchamp and Language', in A. d'Harnoncourt and K. McShine (eds), *Marcel Duchamp*, Philadelphia: Philadelphia Museum of Art, 1973, pp. 95–115.

A. Artaud, *Collected Works Volume 3: Scenarios; On the Cinema; Interviews; Letters*, trans. Alastair Hamilton, London: Calder and Boyars, 1972.

N. Baldwin, *Man Ray: American Artist*, Cambridge, MA: Da Capo Press, 1988.

H. Ball, *Flight Out of Time: A Dada Diary*, trans. Ann Raimes and ed. John Elderfield, New York: Viking Press, 1974.

M.C. Barnet, E. Robertson and N. Saint (eds), *Robert Desnos: Surrealism in the Twenty-First Century*, Oxford and New York: Peter Lang, 2006.

R. Barthes, *Camera Lucida: Reflections on Photography*, trans. Richard Howard, London: Flamingo, 1984.

D. Bate, *Photography and Surrealism: Sexuality, Colonialism and Social Dissent*, London and New York: I.B. Tauris, 2004.

Y. Beauvais and J.-M. Bouhours (eds), *Le je filmé*, Paris: Centre Pompidou, 1995.

C.I. Belz, 'The Film Poetry of Man Ray', *Criticism*, 7 (1965), pp. 117–30.

M. Beugnet, *Cinema and Sensation: French Film and the Art of Transgression*, Edinburgh: Edinburgh University Press, 2007.

D. Bloch, *Art et Vidéo 1960/1980–2*, Locarno, Switzerland: Edizioni Flaviana, 1982.

D. Bordwell, J. Staiger and K. Thompson, *The Classical Hollywood Cinema: Film Style and Mode of Production to 1960*, New York: Routledge & Kegan Paul, 1985.

P. Bourgeade, *Bonsoir Man Ray*, Paris: Maeght éditeur, 2002.

J.-M. Bouhours and P. De Haas (eds), *Man Ray: directeur du mauvais movies*, Paris: Centre Pompidou, 1997.

L. Braudy and M. Coen (eds), *Film Theory and Criticism: Introductory Readings* (5th edn), New York and Oxford: Oxford University Press, 1999.

M. Braun, *Picturing Time: The Work of Etienne-Jules Marey (1830–1904)*, Chicago: Chicago University Press, 1992.

N. Brenez and C. Lebrat, *Jeune, Dure et Pure! Une Histoire du Cinéma d'Avant-garde et Expérimental en France*, Paris: Cinémathèque française, 2001.

A. Breton, *L'Amour fou*, Paris: Gallimard, 1937.

——, *Le Surréalisme et la peinture*, Paris: Gallimard, 1928.

——, *Manifestoes of Surrealism*, trans. and ed. Richard Seaver and Helen R. Lane, Ann Arbor: The University of Michigan Press, 1972.

——, *Nadja*, Paris: Gallimard, 1972.

——, *Les Vases communicants*, Paris: Gallimard, 1955.

A. Breton and P. Soupault, *Dictionnaire abrégé du surréalisme*, Paris: José Corti, 1938.

——, *Les Champs magnétiques*, Paris: Au Sans Pareil, 1920.

——, *The Immaculate Conception*, trans. J. Graham, London: Atlas Press, 1990.

C. Briolle, A. Fuzibet and G. Monnier, *Mallet-Stevens: La Villa Noailles*, Marseille: Editions Parenthèses, 1990.

J.B. Brunius, *En marge du cinéma français*, Lausanne: Editions L'Age d'Homme, 1987.

J.B. Brunius, 'Experimental Film in France', trans. Mary Kesteven, in R. Manvell (ed.), *Experiment in the Film*, London: The Grey Walls Press, 1949, pp. 60–112.

Noël Burch, 'A Primitive Mode of Representation?', in T. Elsaesser (ed.), *Early Cinema: Space, Frame, Narrative*, London: BFI: 1990, pp. 220–7.

P. Bürger, *Theory of the Avant-Garde*, trans. Michael Shaw, Minneapolis: University of Minnesota Press, 1984.

K. Burke, 'Dada, Dead or Alive?', in R.E. Kuenzli (ed.), *New York Dada*, New York: Willis, Locker and Owens, 1986, pp. 124–6.

——, *Cahiers d'art*, Paris: Editions Cahiers d'art, 1926–60.

M.A. Caws, *The Surrealist Voice of Robert Desnos*, Amherst: University of Massachusetts Press, 1977.

I. Christie, 'French Avant-Garde Film in the Twenties: From "Specificity" to Surrealism', in P. Drummond et al. (eds), *Film as Film: Formal Experiment in Film 1910–1975*, London: Arts Council of Great Britain, 1979, pp. 37–45.

R. Clair, *Cinema Yesterday and Today*, trans. Stanley Appelbaum, New York: Dover Publications, 1970.

J. Cocteau, 'Lettre ouverte à Man Ray, photographe américain', *Les Feuilles libres*, 26 (April/May 1922), p. 134.

D. Curtis, *Experimental Cinema: A Fifty Year Evolution*, London: Studio Vista, 1971.

M. Dachy, *Journal du Mouvement Dada 1915–1923*, Geneva: Albert Skira, 1989.

S. Dalí, 'L'âne pourri', *Le Surréalisme au service de la révolution*, 1 (June 1930), pp. 9–10.

E. De l'Ecotais, 'Man Ray: An American Artist', in S. Levy (ed.), *A Transatlantic Avant-Garde: American Artists in Paris, 1918–1939*, Berkeley: University of California Press, 2003, pp. 139–50.

——, *Man Ray: Rayographies*, Paris: Editions Leo Scheer, 2002.

A. d'Harnoncourt and K. McShine (eds), *Marcel Duchamp*, Philadelphia: Philadelphia Museum of Art, 1973.

P. De Haas, 'Les home movies de Man Ray', in Y. Beauvais and J.-M. Bouhours (eds), *Le je filmé*, Paris: Centre Pompidou, 1995, pp. 57–9.

R. Desnos, *Cinéma*, Paris: Gallimard, 1966.

——, *Nouvelles Hébrides et autres textes 1922–1930*, Paris: Gallimard, 1978.

——, *Œuvres*, Paris: Quarto, Gallimard, 1999.

M.A. Doane, *The Emergence of Cinematic Time: Modernity, Contingency, The Archive*, Cambridge, MA and London: Harvard University Press, 2002.

P. Drummond et al. (eds), *Film as Film: Formal Experiment in Film 1910–1975*, London: Arts Council of Great Britain, 1979.

M. Duchamp, *Marchand du sel, écrits de Marcel Duchamp*, Paris: Terrain Vague, 1958.

G. Dulac, *Écrits sur le cinéma (1919–1937)*, Paris: Editions Paris Expérimental, 1994.

G. Durozoi, *Histoire du mouvement surréaliste*, Paris: Editions Hazan, 1997.

D. Dusinberre, '*Le Retour à la raison*: Hidden Meanings', in B. Posner (ed.), *Unseen Cinema: Early American Avant-Garde Film 1893–1941*, New York: Anthology Film Archives, 2001, pp. 64–9.

S. Dwoskin, *Film is … The International Free Cinema*, London: Owen, 1975.

S. Eisenstein, *Film Sense*, trans. and ed. Jay Leyda, London: Faber and Faber, 1968.

S. Eisenstein, V. Pudovkin and G. Alexandrov, 'Statement on Sound', in R. Taylor and I. Christie (eds), *The Film Factory: Russian and Soviet Cinema in Documents, 1896–1939*, Cambridge, MA: Harvard University Press, 1988, pp. 234–5.

J. Elderfield, 'On the Dada-Constructivist Axis', *Dada/Surrealism*, 13 (1984), pp. 5–16.

T. Elsaesser, 'Dada/Cinema?' in R.E. Kuenzli (ed.), *Dada and Surrealist Film*, Cambridge, MA: MIT Press, 1996, pp. 13–27.

——(ed.), *Early Cinema: Space, Frame, Narrative*, London: BFI, 1990.

H. Finkelstein, *The Screen in Surrealist Art and Thought*, Aldershot: Ashgate, 2007.

M. Foresta (ed.), *Perpetual Motif: The Art of Man Ray*, New York: Abbeville Press, 1988.

R. Fotiade, 'Automatism and the Moving Image: from Visual to Verbal Metaphor in *L'Étoile de mer*', in M.C. Barnet, E. Robertson and N. Saint (eds), *Robert Desnos: Surrealism in the Twenty-First Century*, Oxford and New York: Peter Lang, 2006, pp. 263–84.

——, 'The Slit Eye, the Scorpion and the Sign of the Cross: Surrealist Film Theory and Practice Revisited', *Screen*, 39, 2 (Summer 1998), pp. 109–23.

——, 'Spectres of Dada: From Man Ray to Marker and Godard.' Paper delivered at the International Dada Conference, 'Eggs laid by Tigers': Dada and Beyond, Swansea University, 5–8 July 2006.

——, 'The Untamed Eye: Surrealism and Film Theory', *Screen*, 36, 4 (Winter 1995), pp. 394–407.

J. Freeman, 'Bridging Purism and Surrealism: The Origins and Production of Fernand Léger's *Ballet Mécanique*', in R.E. Kuenzli (ed.), *Dada and Surrealist Film*, MA: MIT Press, 1996, pp. 28–45.

A. Gain, 'Un Entretien avec Man Ray', *Cinéa-ciné pour tous*, 144 (15 November), p. 27.

N. Gambill, 'The Movies of Man Ray', in *Man Ray: Photographs and Objects*, Birmingham, AL: Birmingham Museum of Art, 1980, pp. 30–42.

N. Ghali, *L'avant-garde cinématographique en France dans les années vingt: idées, conceptions, théories*, Paris: Editions Paris Expérimental, 1995.

M. Gordon (ed.), *Dada Performance*, New York: PAJ Publications, 1987.

A. Gorlin, 'The Ghost in the Machine', in T. Mical (ed.), *Surrealism and Architecture*, London and New York: Routledge, 2005, pp. 103–18.

T. Gunning, 'An Aesthetic of Astonishment: Early Film and the (In)credulous Spectator', in L. Braudy and M. Coen (eds), *Film Theory and Criticism: Introductory Readings* (5th edn), New York and Oxford: Oxford University Press, 1999, pp. 818–32.

——, 'The Cinema of Attractions: Early Film, Its Spectator and the Avant-Garde', in T. Elsaesser (ed.), *Early Film: Space, Frame, Narrative*, London: BFI, 1990, pp. 56–62.

——, '"Primitive Cinema" A Frame-up? or The Trick's on Us', *Cinema Journal*, 28, 2 (Winter, 1989), pp. 3–12.

A. Hackenschmied, 'Film and Music'. First published in *Film Quarterly*, 1 (1933). www. logosjournal.com/hammid_1htm, accessed June 2008.

P. Hammond (ed.), *The Shadow and Its Shadow: Surrealist Writing on the Cinema* (3rd edn), San Francisco: City Lights Books, 2001.

A. d'Harnoncourt and K. McShine (eds), *Marcel Duchamp*, Philadelphia: Philadelphia Museum of Art, 1973.

I. Hedges, 'Constellated Visions: Robert Desnos's and Man Ray's *L'Etoile de mer*', in R.E. Kuenzli (ed.), *Dada and Surrealist Film*, Cambridge, MA: MIT Press, 1996, pp. 99–109.

P. Hill and T. Cooper, 'Camera-Interview', *Camera*, 54 (February 1975), pp. 37–40.

P. Hillairet, C. Lebrat and P. Rollet, *Paris vu par le cinéma d'avant-garde*, Paris: Editions Paris Expérimental, 1985.

D. Hopkins, *Dada and Surrealism: A Very Short Introduction*, Oxford: Oxford University Press, 2004.

J.C. Horak, *Lovers of Cinema: The First American Film Avant-garde, 1919–1945*, Madison, WI: University of Wisconsin Press, 1995.

R. Huelsenbeck, *Memoirs of a Dada Drummer*, trans. Joachim Neugroschel, Berkeley: Hans J. Kleinschmidt, 1991.

A. Hughes and J.S. Williams (eds), *Gender and French Film*, Oxford: Berg, 2002.

E. Hutton Turner, 'Transatlantic' in M. Foresta (ed.), *Perpetual Motif: The Art of Man Ray*, New York: Abbeville Press, 1988, pp. 137–73.

D. Judovitz, 'Anemic Vision in Duchamp's Cinema as Readymade', in R.E. Kuenzli (ed.), *Dada and Surrealist Film*, Cambridge, MA: MIT Press, 1996, pp. 46–57.

I. Katsahnias, 'Le Chasseur de Lumière', *Cahiers du Cinéma*, 390 (December 1986), pp. 45–7.

M. Kirby, 'Happenings: An Introduction', in M. Sandford (ed.), *Happenings and Other Acts*, London: Routledge, 1995, pp. 1–28.

S. Kovács, *From Enchantment to Rage: The Story of Surrealist Cinema*, London: Associated University Presses, 1980.

R. Krauss, 'Corpus Delecti', in R. Krauss and J. Livingston (eds), *L'Amour fou: Photography and Surrealism*, New York and London: Abbeville Press: 1985, 57–100.

R. Krauss and J. Livingston, *L'Amour fou: Photography and Surrealism*, New York and London: Abbeville Press, 1985.

R.E. Kuenzli (ed.), *Dada and Surrealist Film*, Cambridge, MA: MIT Press, 1996.

——(ed.), *New York Dada*, New York: Willis, Locker and Owens, 1986.

A. Kyrou, *Le Surréalisme au cinéma*, Paris: Le Terrain Vague, 1963.

V.A. La Charité, *The Dynamics of Space: Mallarmé's* Un Coup de dés jamais n'abolira le hasard, Lexington, KY: French Forum Publishers, 1987.

S. Lawder, *The Cubist Film*, New York: New York University Press, 1975.

C. Lebrat, 'Attention danger! Le Retour à la raison, ou la leçon de Man Ray', in N. Brenez et C. Lebrat (eds), *Jeune, Dure et Pure! Une Histoire du Cinéma d'Avant-garde et Expérimental en France*, Paris: Cinémathèque française, 2001, pp. 91–4.

C. Lebrat, *Peter Kubelka*, Paris: Editions Paris Expérimental, 1990.

F. Léger, *Functions of Painting*, trans. Alexandra Anderson and ed. Edward F. Fry, New York: The Viking Press, 1973.

M. Le Grice, *Abstract Film and Beyond*, Cambridge, MA: MIT Press, 1977.

J. Levy, *Surrealism*, New York: The Black Sun Press, 1936.

S. Levy (ed.), *A Transatlantic Avant-Garde: American Artists in Paris, 1918–1939*, Berkeley: University of California Press, 2003.

B. Lindemann, *Experimental Film*, Hildesheim: Georg Olms, 1977.

J. Livingston, 'Man Ray and Surrealist Photography', in R. Krauss and J. Livingston (eds), *L'Amour fou: Photography and Surrealism*, New York and London: Abbeville Press, 1985, pp. 115–47.

D. Macrae, 'Painterly Concepts and Filmic Objects', in D. Scheunemann (ed.), *European Avant-Garde: New Perspectives*, Amsterdam and Atlanta, GA: Rodopi Press, 2000, pp. 137–54.

S. MacDonald, *Screen Writings: Scripts and Texts by Independent Filmmakers*, Berkeley: University of California Press, 1995.

S. Mallarmé, *Œuvres complètes*, ed. Bertrand Marchal, Paris: Gallimard, 1998.

R. Mallet-Stevens, *Le décor moderne au cinema*, Paris: C. Massin, 1928.

Man Ray, 'Answer to a Questionnaire', *Film Art*, 3, 7 (1936), pp. 9–10.

——, *Champs délicieux*, Paris: Société Générale d'Imprimerie et d'Edition, 1922.

——, 'Emak Bakia', *Close up*, 1, 2 (August 1927), p. 40.

——, 'L'Age de la lumière', *Minotaure*, 3–4 (1933), p. 1.

——, *Man Ray*, introduction by Merry Foresta, London: Thames and Hudson, 1989.

——, *Man Ray Photographs*, trans. Carolyn Breakspear, London: Thames and Hudson, 1982.

——, 'Mort dans l'après-midi', *Voilà*, 192, 24 (November 1934).

——, *La photographie n'est pas l'art: 12 photographies*, foreword by André Breton, Paris: GLM, 1937.

——, *Self Portrait*, New York: Bullfinch Press, 1998.

——, 'Témoignages', in *Surréalisme et cinéma*, special issue of *Etudes cinématographiques*, 38–9 (1965), pp. 43–7.

F. Manchel, *Film Study: An Analytical Biography Volume 3*, London and Toronto: Associated University Presses, 1990.

R. Manvell, *Experiment in the Film*, London: The Grey Walls Press, 1949.

K. Martin, 'Marcel Duchamp's "Anemic Cinéma"', *Studio International*, 189, 973 (January–February 1975), pp. 53–60.

J.H. Matthews, *Surrealism and Film*, Ann Arbor: The University of Michigan Press, 1971.

S. McCabe, *Cinematic Modernism: Modernist Poetry and Film*, Cambridge: Cambridge University Press, 2005.

P. McGuinness, *Symbolism, Decadence and the Fin de Siècle: French and European Perspectives*, Exeter: University of Exeter Press, 2000.

C. Metz, *The Imaginary Signifier: Psychoanalysis and the Cinema*, trans. Celia Britton et al., Bloomington: Indiana Press, 1982.

T. Mical (ed.), *Surrealism and Architecture*, London and New York: Routledge, 2005.

J. Mitry, *Le Cinéma Expérimental*, Paris: Editions Seghers, 1974.

W. Moritz, 'Americans in Paris: Man Ray and Dudley Murphy', in J.C. Horak (ed.), *Lovers of Cinema: The First American Film Avant-Garde, 1919–1945*, Madison, WI: University of Wisconsin Press, 1995, pp. 118–36.

R. Motherwell (ed.), *The Dada Painters and Poets: An Anthology* (2nd edn), London: Belknap Press, 2005.

F.M. Naumann, *Conversion to Modernism: The Early Work of Man Ray*, New Brunswick, NJ, and London: Rutgers University Press, 2003.

F. Naumann, 'Man Ray, 1908–1921: From an Art in Two Dimensions to the Higher Dimension of Ideas', in M. Foresta (ed.), *Perpetual Motif: The Art of Man Ray*, New York: Abbeville Press, 1988, pp. 51–88.

D. Neumann (ed.), *Film Architecture: Set Designs from 'Metropolis' to 'Blade Runner'*, Munich and New York: Prestel, 1997.

F.M. Neusüss, T. Barrow and C. Hagen, *Experimental Vision: The Evolution of the Photogram since 1919*, Denver Art Museum, Colorado: Roberts Rinehart Publishers, 1994.

M. O'Pray, *Avant-Garde Film: Forms, Themes and Passions*, London and New York: Wallflower Press, 2003.

R. Passeron, *Encyclopédie du Surréalisme*, Paris: Editions Pierre Terrail, 2001.

——, *Surrealism*, Paris: Editions Pierre Terrail, 2001.

R. Pearson, *Unfolding Mallarmé: The Development of a Poetic Art*, Oxford: Claredon Press, 1996.

B. Péret, L. Aragon, Man Ray, *1929*, Paris: Allia, 1993.

R. Pincus-Witten, 'Man Ray: The Homonymic Pun and American Vernacular', *Artforum* (April 1975), pp. 54–9.

F. Popper, *L'Art cinétique*, Paris: Gauthier-Villars, 1967.

L. Rabinovitz, 'Independent Journeyman: Man Ray, Dada and Surrealist Film-Maker', *Southwest Review*, 64 (Autumn 1979), pp. 355–76.

A.L. Rees, *A History of Experimental Film and Video: From the Canonical Avant-Garde to Contemporary British Practice*, London: BFI, 1999.

S. Renan, *The Underground Film*, London: Studio Vista, 1967.

La Révolution surréaliste, Paris: Gallimard, 1924–9.

D. Reynolds, 'The Kinesthetics of Chance: Mallarmé's *Un coup de Dés* and Avant-garde Choreography', in P. McGuinness (ed.), *Symbolism, Decadence and the Fin de Siècle: French and European Perspectives*, Exeter: University of Exeter Press, 2000, pp. 90–104.

G. Ribemont-Dessaignes, 'History of Dada', in R. Motherwell (ed.), *The Dada Painters and Poets: An Anthology* (2nd edn), London: Belknap Press, 2005, pp. 99–122.

H. Richter, *Dada: Art and Anti art*, London: Thames and Hudson, 2001.

——, 'Dada and the Film', in W. Verkauf (ed.), *Dada: Monograph of a Movement*, Teufen, Switzerland: Arthur Niggli, 1957, pp. 64–71.

B. Rose, 'Kinetic Solutions to Pictorial Problems: The Films of Man Ray and Moholy-Nagy', *Artforum* (September 1971), pp. 77–82.

M. Rush, *New Media in Art*, London: Thames and Hudson, 2004.

W. Ruttman, 'Painting with the Medium of Time', in W. Schobert, *The German Avant-Garde Film of the 1920s*, Munich: Goethe Institut, 1989, pp. 102–3.

G. Sadoul, *Le Cinema français: 1890/1962*, Paris: Flammarion, 1962.

M.R. Sandford (ed.), *Happenings and Other Acts*, London: Routledge, 1995.

M. Sanouillet, *Dada à Paris*, Paris: CNRS Editions, 2005.

D. Scheunemann (ed.), *European Avant-Garde: New Perspectives*, Amsterdam; Atlanta, GA: Rodopi Press, 2000.

W. Schobert, *The German Avant-Garde Films of the 1920s/Der deutsche Avant-Garde Film der 20er*, Munich: Goethe-Institute, 1989.

A. Schwarz, *Marcel Duchamp*, New York: Abrams, 1975.

——, 'This is not for America', interview with Man Ray, *Arts Magazine*, 51 (May 1977), pp. 116–21.

——, *Man Ray: The Rigour of Imagination*, London: Thames and Hudson, 1977.

E. Sellin, '"Le chapelet du hazard": Ideas of Order in Dada-Surrealist Imagery', *L'Esprit créateur*, 20, 4 (Summer 1980), pp. 22–40.

S. Shaviro, *The Cinematic Body*, Minneapolis: University of Minnesota Press, 1993.

R. Short, *The Age of Gold: Surrealist Cinema*, New York: Creation Books, 2002.

K. Sierek, 'Architecture and film in the work of Corbusier, Mies, Mallet'. Lecture delivered at the frije Universiteit Amsterdam, 27 April 2001. www2.uni-jena.de/philosophie/medien/Vortraege/Amsterdam/architecture_and_film.ht, accessed February 2006.

P. Adams Sitney, *The Avant-Garde Film A Reader of Theory and Criticism*, New York: New York University Press, 1978.

——, *Modernist Montage: The Obscurity of Vision in Cinema and Literature*, New York: Columbia University Press, 1990.

S. Sontag, *On Photography*, New York: Farrar, Straus and Giroux, 1977.

J. Svenungsson, 'The Making of Man Ray', in *Man Ray*, Stockholm: Moderna Museet, 2004, pp. 27–37.

R. Taylor and I. Christie (eds), *The Film Factory: Russian and Soviet Cinema in Documents, 1896–1939*, Cambridge, MA: Harvard University Press, 1988.

A. Thiher, *The Cinematic Muse: Critical Studies in the History of French Cinema*, Columbia: University of Missouri Press, 1979.

K. Thompson and D. Bordwell, *Film History: An Introduction*, New York: McGraw-Hill, 1994.

T. Tzara, *Seven Dada Manifestos and Lampisteries*, trans. Barbara Wright, London: Calder, 1992.

M. Verdone, *Le avanguardie storiche del cinema*, Torino: Società Editrice Internazionale, 1977.

W. Verkauf (ed.), *Dada: Monograph of a Movement*, Teufen, Switzerland: Arthur Niggli, 1957.

D. Vertov, *Kino-Eye: The Writings of Dziga Vertov*, trans. Kevin O'Brian and ed. Annette Michelson, Berkeley: University of California Press, 1984.

A. Vidler, 'The Explosion of Space: Architecture and the Filmic Imaginary', in D. Neumann (ed.), *Film Architecture: set designs from 'Metropolis' to 'Blade Runner'*, Munich and New York: Prestel, 1997, pp. 13–25.

A. and O. Virmaux, *Artaud-Dulac: La coquille et le clergyman: essai d'élucidation d'une querelle mythique*, Paris: Editions Paris Expérimental, 2000.

——, *Les Surréalistes et le cinéma*, Paris: Seghers, 1976.

A. Vogel, *Film as a Subversive Art*, London: Weidenfeld and Nicolson, 1974.

P. Waldberg, *Surrealism*, London: Thames and Hudson, 1965.

I. Walker, *City Gorged with Dreams: Surrealism and Documentary Photography in Interwar Paris*, Manchester and New York: Manchester University Press, 2002.

W.C. Wees, *Light Moving in Time: Studies in the Visual Aesthetics of the Avant-Garde Film*, Berkeley: University of California Press, 1992.

H. Weihsmann, *Cinetecture: Film, Architektur, Moderne*, Vienna: PVS Verleger, 1995.

P. Weiss, *Cinéma d'avant-garde*, trans. Catherine de Seynes, Paris: L'Arche Éditeur, 1989.

M. White, 'Two French Dada Films: *Entr'acte* and *Emak Bakia*', *Dada/Surrealism*, 13 (1984), pp. 37–47.

J. Williams and A. Hughes (eds), *Gender and French Film*, Oxford: Berg, 2002.

L. Williams, *Figures of Desire: A Theory and Analysis of Surrealist Film*, Berkeley: University of California Press, 1981.

S. Winqvist, 'A MAN? – Thoughts on Man Ray's Sexual Identity', in *Man Ray*, Stockholm: Moderna Museet, 2004, pp. 39–46.

Filmography

L'Age d'or, Luis Buñuel and Salvador Dalí, 1930.
Anémic Cinéma, Marcel Duchamp, 1926.
Ballet mécanique, Fernand Léger, Dudley Murphy, Man Ray, 1924.
Biceps et bijoux, Jacques Manuel, 1928.
The Blue Angel, Josef von Sternberg, 1931.
Carmen, la de Triana, Florián Rey, 1938.
Un Chien andalou, Luis Buñuel and Salvador Dalí, 1929.
Cinq minutes de cinéma pur, Henri Chomette, 1926.
College Chums, Edwin S. Porter, 1907.
La Coquille et le Clergyman, Germaine Dulac, 1927.
Demolition d'un mur, Auguste Lumière, 1895.
Dreams That Money Can Buy, Hans Richter, 1948.
Emak Bakia, Man Ray, 1926.
Les Enfants du paradis, Marcel Carné, 1945.
Entr'acte, René Clair, 1924.
L'Etoile de mer, Man Ray, 1928.
Filmstudie, Hans Richter, 1926.
Ghosts Before Breakfast (Vormittagsspuk), Hans Richter, 1929.
L'Inhumaine, Marcel L'Herbier, 1923.
The Jazz Singer, Alan Crosland, 1927.
Jeux des reflets et de la vitesse, Henri Chomette, 1924.
Le Jour se lève, Marcel Carné, 1939.
King Kong, Merian C. Cooper and Ernest B. Schoedsack, 1933.
Lichtspiel Schwartz-Weiß-Grau, László Moholy-Nagy, 1930.
Manhatta, Charles Sheeler and Paul Strand, 1921.
The Man With a Movie Camera, Dziga Vertov, 1929.
Les Mystères du Château du Dé, Man Ray, 1929.
Paris la belle, Jacques Prévert, 1960.
Prague Castle (Na Pražském hradě), Alexandr Hackenschmied, 1931.
Le Retour à la raison, Man Ray, 1923.
Rhythmus 21, Hans Richter, 1921.
Rhythmus 23, Hans Richter, 1923.
Rigolboche, Christian-Jaque, 1936.

La Roue, Abel Gance, 1924.
Le Sang d'un Poète, Jean Cocteau, 1930.
Two-Penny Magic, Hans Richter, 1929.
Zen For Film, Nam June Paik, 1964/65.
Zouzou, Marc Allégret, 1934.

Works cited

50 visages de Juliet, 1941–1955.
A.D MCMXIV, Man Ray, 1914.
Admiration of the Orchestrelle for the Cinematograph, Man Ray, 1919.
L'Aurore des objets, Man Ray, 1937.
Autoportait ou Ce qui manque à nous tous, Man Ray, 1927.
Ballet français, Man Ray, 1957/71.
Ballet Silhouette, Man Ray, 1916.
Bd Edgar Quinet à minuit, Man Ray, 1924.
Breakfast in Fur, Meret Oppenheim, 1936.
Cadeau, Man Ray, 1921.
City Rises, The, Umberto Boccioni, 1910.
Dance, Man Ray, 1915.
Danger/Dancer, Man Ray,1920.
Dynamism of a Dog on a Leash, Giacomo Balla, 1912.
Enigma of Isidore Ducass, The (The Riddle), Man Ray, 1920.
Etoile de verre, Man Ray, 1965.
Fisherman's Idol, Man Ray, 1926.
La Gioconda (Mona Lisa), Leonardo da Vinci, 1503–5.
A l'heure de l'Observatoire – les amoureux, Man Ray, 1933–4.
Homme d'affaires, Man Ray, 1926.
Indestructible Object, Man Ray, 1923.
Lampshade, Man Ray, 1917.
L.H.O.O.Q., Marcel Duchamp, 1919.
Man, Man Ray, 1918.
Montparnasse, Man Ray, 1961.
Moving Sculpture, Man Ray, 1920.
New York, Man Ray, 1917.
New York, Man Ray, 1920.
Noire et Blanche, Man Ray, 1926.
Nude Descending a Staircase, Marcel Duchamp, 1912.
Nusch et Ady, Man Ray, 1937.
Obstruction, Man Ray, 1920.
L'oeil cacodylate, Francis Picabia, 1921.

Pain Peint, Man Ray, 1960.

Piscinéma, Man Ray, 1965.

La résille, Man Ray, 1931.

Le Retour à la raison, Man Ray, 1931.

The Rope Dancer Accompanies Herself With Her Shadows, Man Ray, 1916.

Rotary Demisphere (Precision Optics), Marcel Duchamp, 1925.

Rotary Glass Plates (Precision Optics), Marcel Duchamp, 1920.

Rotoreliefs (Optical Disks), Marcel Duchamp, 1935.

Self Portrait, Man Ray, 1916.

Self Portrait, Man Ray, 1932.

Self Portrait in ink, Ridgefield, Man Ray, 1914.

Suicide, Man Ray, 1917.

Suicide, Man Ray, 1926.

Suicide, Man Ray, 1930.

Theatr. Transmutation, Man Ray, 1916.

Three Standard Stoppages, Marcel Duchamp, 1913–14.

La Ville (The City), Man Ray, 1931.

Woman (Shadows), Man Ray, 1918.

Index

Figure 1: *Lampshade* (1917). Image courtesy of Man Ray Trust/ADAGP, BI, Paris 2009. Copyright: Man Ray Trust/ADAGP, Paris and DACS, London 2009.

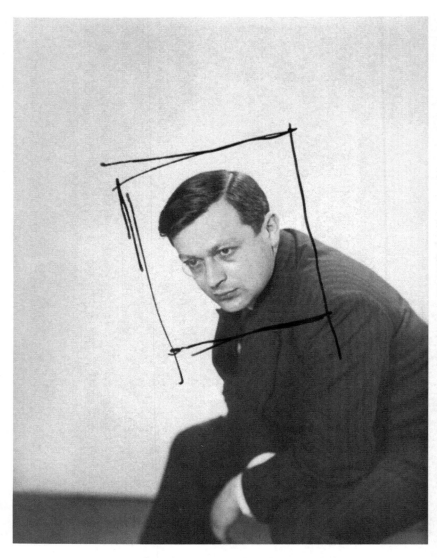

Figure 2: *Tristan Tzara* (1924). Image courtesy of Man Ray Trust / ADAGP, BI, Paris 2009. Copyright: Man Ray Trust / ADAGP, Paris and DACS, London 2009.

Figure 3: *Le Retour à la raison*. Image courtesy of CNAC /MNAM, Dist. RMN /Man Ray Trust /ADAGP, Paris. Copyright: Man Ray Trust/ADAGP, Paris and DACS, London 2009.

Figure 4: *Le Retour à la raison*. Image courtesy of CNAC /MNAM, Dist. RMN /Man Ray Trust/ADAGP, Paris. Copyright: Man Ray Trust/ADAGP, Paris and DACS, London 2009.

Figure 5: *Le Retour à la raison*. Image courtesy of CNAC/MNAM, Dist. RMN/Man Ray Trust/ADAGP, Paris. Copyright: Man Ray Trust/ADAGP, Paris and DACS, London 2009.

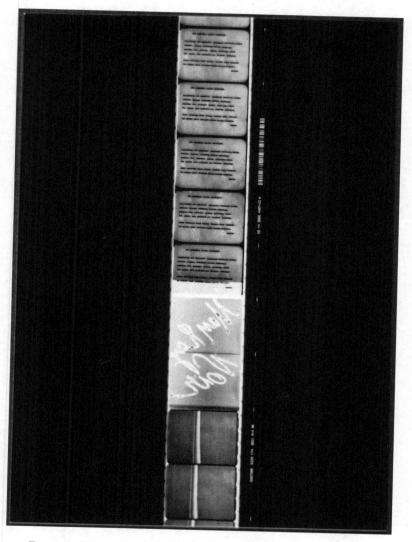

Figure 6: *Le Retour à la raison*. Image courtesy of CNAC /MNAM,
Dist. RMN /Man Ray Trust /ADAGP, Paris. Copyright: Man Ray Trust/ADAGP,
Paris and DACS, London 2009.

Figure 7: *Le Retour à la raison*. Image courtesy of CNAC/MNAM, Dist. RMN/Man Ray Trust/ADAGP, Paris. Copyright: Man Ray Trust/ADAGP, Paris and DACS, London 2009.

Figure 8: *Noire et Blanche* (1926). Image courtesy of CNAC/MNAM, Dist. RMN/Man Ray Trust/ADAGP, Paris. Copyright: Man Ray Trust/ADAGP, Paris and DACS, London 2009.

Figure 9: Man Ray, *Objet Indestructible* (1923). Image courtesy of Man Ray Trust /
ADAGP, BI, Paris 2009. Copyright: Man Ray Trust /ADAGP, Paris and DACS,
London 2009.

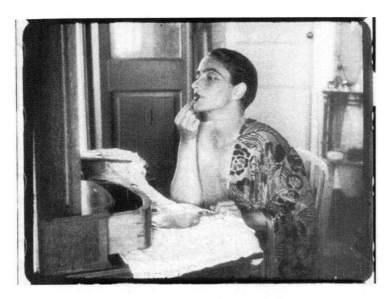

Figure 10: *Emak Bakia*. Image courtesy of CNAC /MNAM, Dist. RMN /
Man Ray Trust /ADAGP, Paris. Copyright: Man Ray Trust /ADAGP,
Paris and DACS, London 2009.

Figure 11: *Emak Bakia*. Image courtesy of CNAC /MNAM, Dist. RMN /
Man Ray Trust /ADAGP, Paris. Copyright: Man Ray Trust /ADAGP,
Paris and DACS, London 2009.

Figure 12: *Emak Bakia*. Image courtesy of CNAC/MNAM, Dist. RMN/
Man Ray Trust/ADAGP, Paris. Copyright: Man Ray Trust/ADAGP,
Paris and DACS, London 2009.

Figure 13: *Emak Bakia*. Image courtesy of CNAC/MNAM, Dist. RMN/
Man Ray Trust/ADAGP, Paris. Copyright: Man Ray Trust/ADAGP,
Paris and DACS, London 2009.

Figure 14: *Woman (Shadows)* (1918). Image courtesy of CNAC /MNAM, Dist. RMN /Man Ray Trust /ADAGP, Paris. Copyright: Man Ray Trust /ADAGP, Paris and DACS, London 2009.

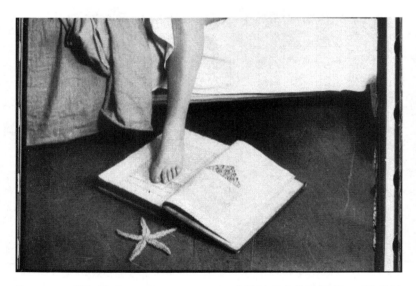

Figure 15: *L'Etoile de mer*. Image courtesy of CNAC /MNAM, Dist. RMN / Man Ray Trust /ADAGP, Paris. Copyright: Man Ray Trust /ADAGP, Paris and DACS, London 2009.

Figure 16: *L'Etoile de mer*. Image courtesy of CNAC /MNAM, Dist. RMN /
Man Ray Trust /ADAGP, Paris. Copyright: Man Ray Trust /ADAGP,
Paris and DACS, London 2009.

Figure 17: *Les Mystères du Château du Dé*. Image courtesy of CNAC /MNAM,
Dist. RMN /Man Ray Trust /ADAGP, Paris. Copyright: Man Ray Trust /ADAGP,
Paris and DACS, London 2009.

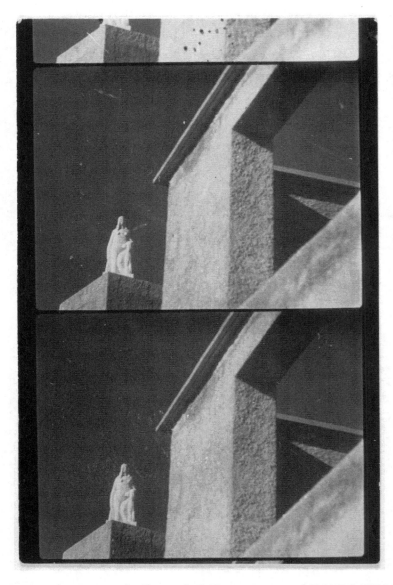

Figure 18: *Les Mystères du Château du Dé*. Image courtesy of CNAC/MNAM, Dist. RMN/Man Ray Trust/ADAGP, Paris. Copyright: Man Ray Trust/ADAGP, Paris and DACS, London 2009.

Figure 19: *Les Mystères du Château du Dé*. Image courtesy of CNAC / MNAM, Dist. RMN / Man Ray Trust / ADAGP, Paris. Copyright: Man Ray Trust / ADAGP, Paris and DACS, London 2009.

Rien dans le puits du Nord

ESSAI DE SIMULATION
DU DÉLIRE
CINÉMATOGRAPHIQUE

SCÉNARIO D'ANDRÉ BRETON ET PAUL ÉLUARD
RÉALISATION DE MAN RAY

Tu me retrouverais toujours, dit le sphinx

Et il signa...

Éteignez tout !

A la suite d'une vision sinistre, don Juan...

L'homme du crépuscule

Ils s'étaient rencontrés pour la première fois

Figure 20: 'Essai de simulation du délire cinématographique.'
Cahiers d'art, 1-4 (1935).

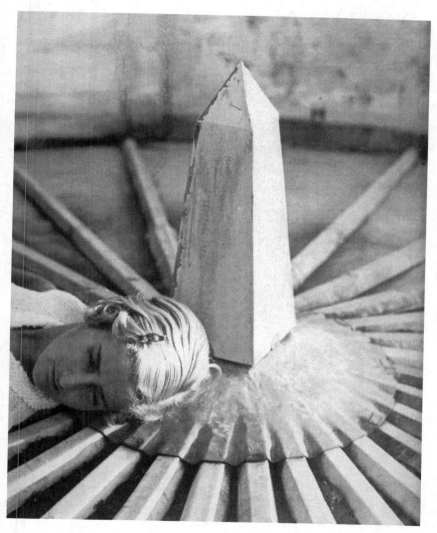

Figure 21: *L'Aurore des objets* (1937). Image courtesy of Man Ray Trust/ADAGP,
BI, Paris 2009. Copyright: Man Ray Trust/ADAGP, Paris and DACS,
London 2009.

Figure 22: *La Garoupe*. Image courtesy of CNAC /MNAM, Dist. RMN /
Man Ray Trust /ADAGP, Paris. Copyright: Man Ray Trust /ADAGP,
Paris and DACS, London 2009.